Raising a Creative Army for Conservation.

Technically they call it a "murmuration" – a spectacular coming together of hundreds if not thousands of starlings just before sunset. The flock twists and turns in perfect formation, every individual bird in perfect sync with the flight path of the majority.

Ghosts of Gone Birds feels like a creative murmuration: a flocking together of writers and artists around a single flight path: raising awareness of all the birds we have lost so we don't lose any more.

This is the story of the project – from conception to execution over four very distinctive exhibitions.

And throughout the book you'll hear the voices of the artists as they talk about why they have adopted their particular "gone" bird and brought it back to life through the Ghosts shows.

Published in 2013 by Bloomsbury Publishing Plc, 50 Bedford Square, London WC1B 3DP

www.bloomsbury.com

Bloomsbury Publishing: London, New Delhi, New York and Sydney

ISBN 978-1-4081-8746-3

A CIP catalogue record for this book is available from the British Library

This book is produced using paper that is made from wood grown in managed sustainable forests.
It is natural, renewable and recyclable.
The logging and manufacturing processes conform to the environmental regulation of the country of origin.

Commissioning Editor: Jim Martin

Designed by
Paul Beer & Peter Hodgson/GOODPILOT

Printed in China
10 9 8 7 6 5 4 3 2 1

Visit bloomsburywildlife.com to find out more about our authors and their books.

BirdLife
INTERNATIONAL

The creators of Ghosts will be donating 50% of their royalties to frontline conservation projects
chosen in collaboration with BirdLife International.

CHRIS ALDHOUS

GHOSTS OF GONE BIRDS

RESURRECTING LOST SPECIES THROUGH ART

BLOOMSBURY

LONDON · NEW DELHI · NEW YORK · SYDNEY

Contents

FOREWORDS

*'To find so many creative people engaged with
the subject of birds and the threat of extinction that
faces so many of them today, is truly inspiring.
This magnificent show will reconnect us to the
natural world, teach us about our past, and
fuel our interest in saving what we are losing daily.
See the show, love the show, add to the show,
and learn how to help'*
MARGARET ATWOOD Novelist

*'In modern times, species are going extinct at least
a thousand times the natural background rate.
Many more are so threatened that they are on the verge of
disappearing and urgent action is needed.
Ghosts of Gone Birds is a provocative new way to reach
out and inspire a wide audience about today's extinction
crisis and mobilise action to rescue the species at risk.
There is still hope and the BirdLife Partnership
has shown that, with the right resources and targeted
action, species can be saved.
Please join BirdLife and help us in the fight to stop any
of the magnificent species threatened today from joining
the Ghosts of Gone Birds'.*
DR MARCO LAMBERTINi Chief Executive of BirdLife International

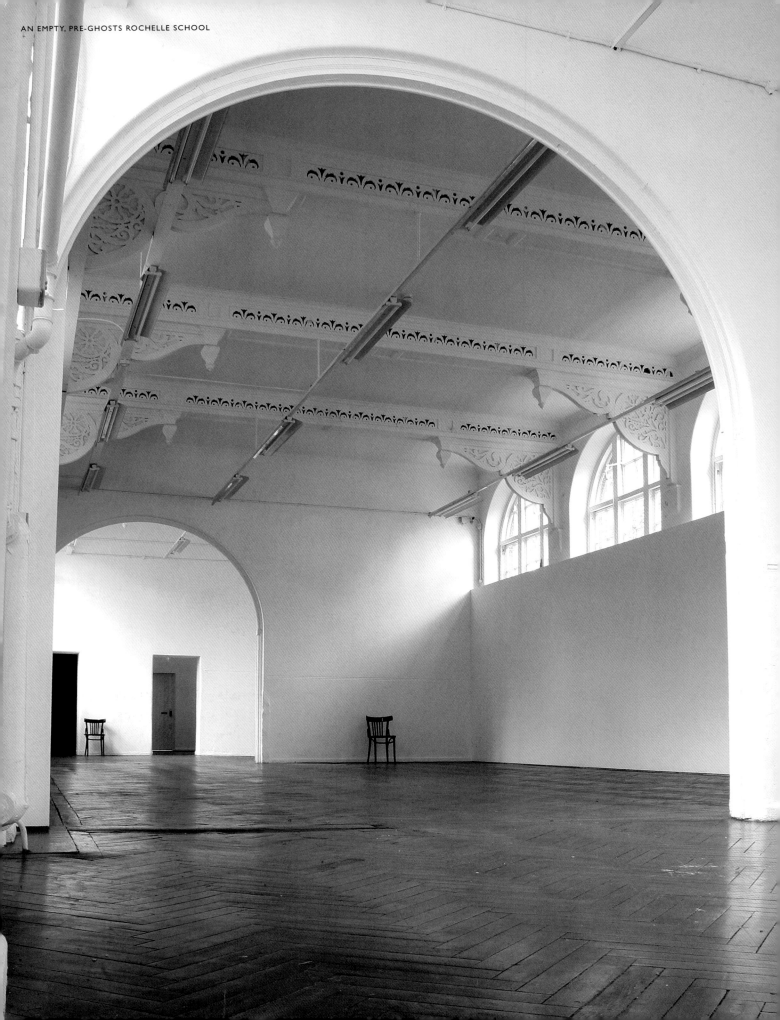

An introduction: Where does the story start?

What is the synaptic chemistry that actually sparks an idea into pulsing life?

Personally and for the sake of simplicity, I'm going to say the Cliffs Pavilion theatre, Southend-on-Sea, circa 1967/68. It's as good a place as anywhere to begin the *Ghosts* story. I was probably five or six. I seem to remember it was a slow, cold Sunday morning and a drive with my father along an unpopulated and windswept seafront, past the pier and Peter Pan's Playground, had led to a detour to the Cliffs Pavilion in the hope of something warm to drink/eat. Instead there was an RSPB stall featuring the work of the local organisation – birding

in Essex goes back a long way – and a cascading display of local maps, badges, bird books and binoculars.

That's all it took: suddenly every spare weekend was hijacked and dedicated to scouring the creeks and reed beds, marshes and estuaries of the south Essex coastline for warblers, plovers and other wonderfully named but impossible to spot (for an impatient six year old) birds. We marched past isolated homes huddled up against the North Sea wind, scrambled up rutted, crumbling sea walls and cautiously edged our heads over the tops to scan the endless mudflats and retreating tides for signs of avian activity. We hopped from island to island in flooded

gravel pits looking for the next strategic vantage point. We wandered around Little Wakering and Barling sand pits and followed the creek into the Crouch until it eventually emptied into the mighty Thames Estuary itself.

Alongside our bird-watching brethren we often encountered another all-weather breed, someone else determined to defy the elements and perch precariously alongside us on the scattered marshland outposts, surveying the horizon lines: the marine artist. I was fascinated by these equally wind-battered figures who, against all the elemental odds, hunched over their easels to painstakingly produce beautifully evocative watercolour sketches of the rotting jetties and skeletal remains of abandoned barges that cluttered the coastal inlets, and often provided infuriating cover for the birds we were collected there to watch.

It was wild, lung-busting activity that left your face and hands rubbed raw by the salted wind, and it never failed to generate an appetite for a 1960s-sized Sunday lunch that seemed to always involve a slab of Yorkshire pudding that could double up as your plate. Birdwatching and food – we'll come back to that later.

Another synaptic memory that hovers around the edges of *Ghosts* comes from a couple of years later and illuminates the art side of the project: long, hot summers watching my father paint. I'd discovered he had a secret second life as a weekend wildlife artist – but less as a bargain-basement Sir Peter Scott, and more like a Southend-on-Sea Jackson Pollock.

The school of Abstract Expressionism hadn't really taken strong root in our particular corner of suburban commuterville, but nevertheless my father, fuelled by a burning love of the unpredictable hard-bop rhythms of Miles Davis and Co, was determined to take his painting to the limit. He took over one end of the garage, carefully covered his treasured collection of Jazz Journals and let rip with both barrels – or rather, both brushes. Paint hit the canvas and splattered up the wall. It dripped and dribbled and pooled according to the laws of gravity until my father interceded, lifted the work, considered it for a moment, then set it back at a different angle, on a different side, persuading the paint to proceed in a different direction. He would repeat this routine several times until satisfied that the abstract canvas was complete.

Finally he would bestow a name on his creation. I remember 'African Elephants at a Watering Hole' being one of the more exotic titles. If you're naming something, make it memorable. That's another thing I learned as our abstract art collection grew.

So, even before the age of ten, my weekends had been dominated by birds and art.

I think deep down we all have these touch-points, these buried stories that inform the ideas we generate, because now I think about it, birds and art have been everywhere in my life. The first ad I ever produced when I finally got a job in an agency was for the RSPB. It was a small-space Christmas special that ran in the weekend supplements, designed to persuade doting grandparents to buy RSPB membership as a festive treat for their grandchildren. Even then we wanted to do something different, unexpected, so rather than reproducing a typical bird image, we got permission from Warner Bros to feature a picture of the *Merrie Melodies* cartoon character Tweetie Pie and above it, we asked the question,

'Is this the only bird your grandchildren will be watching this Xmas?'

I can't really remember how the campaign fared, but I do recall the creative thrill of taking the visual subject matter of an RSPB ad in a strange, left-field (but meaningful) direction. Birds and art: keep it unexpected.

Now images of birds are all around us. Avian designs are all the rage in fashion – they are on greetings cards and wallpapers, fabrics and furniture, book covers and album designs. Birds rule. So perhaps the time is right to really remind people of all the birds they're missing out on.

A final note before the real story begins: this is the only 'I' section you'll find in the book. There's a simple reason for this: *Ghosts of Gone Birds* was always an expression of collective will power. It was a 'we' project from the very start – a team effort to conceive, create and build what you see before you.

The 'we' of *Ghosts* is a vast array of talented people – from creators and contributors, friends and family, to close colleagues and one-off advisors. You'll get to meet some of them in the pages that follow. All the artists and writers that contributed to our first four *Ghosts* exhibitions are listed in Appendix 2: the creative army at the back of the book. It's a sort of Yellow Pages of artistic talent. Everyone featured produced something special for this project, so use it as a directory of guaranteed creativity. None of those featured will disappoint you.

I always conceived of *Ghosts* as an open-source project, a seed that I would plant, then enjoy watching growing organically and sometimes anarchically into something interesting and unexpected. I haven't been disappointed.

So this is 'I' signing off, as 'we' continue the work of raising a creative army for conservation.

Chris Aldhous, January 2013

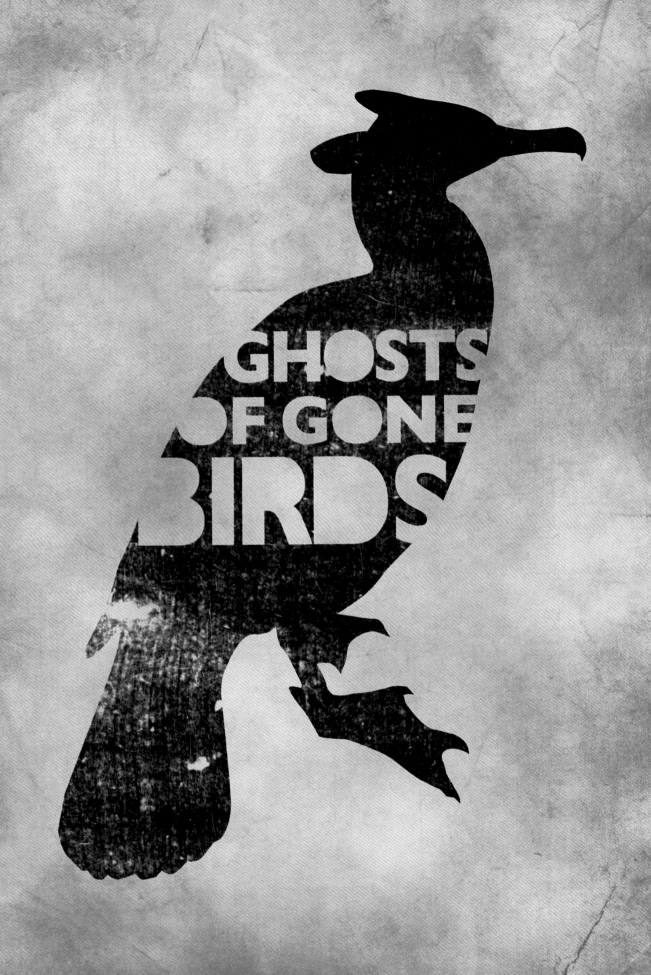

Raising an idea

Naming things always helps.

Our creative concepts often start with just a name, something odd, unexpected, evocative, conjured out of the ether and wrangled to the ground to be pinned to a purpose. Words open up worlds.

So a name was important to the project we were about to undertake. There was a need for something – a void to be filled. The subject matter was birds, or rather extinct birds. We'd been introduced to BirdLife International by the documentary film-maker and art collector Ceri Levy, who thought we could help them with a problem they had. They needed to raise awareness and funds for the work they were doing around the world to prevent endangered birds toppling into extinction. They oversaw and coordinated more than 100 national conservation organisations – including the RSPB in the UK – and helped them all to work together in partnership to protect birds and their habitats.

The work they were doing was amazing: hauling a crashed vulture population in India back from the edge of oblivion; tackling the electrocution of East European raptors by trying to outlaw uninsulated pylons and re-educating South American trawler men so they didn't bait their hooks in such a way that they caught more rare birds than fish. On every continent, in every corner of the world, teams from BirdLife were fighting to keep front-

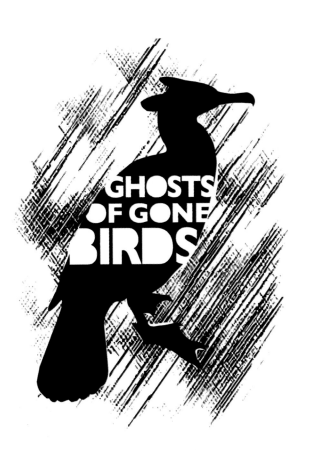

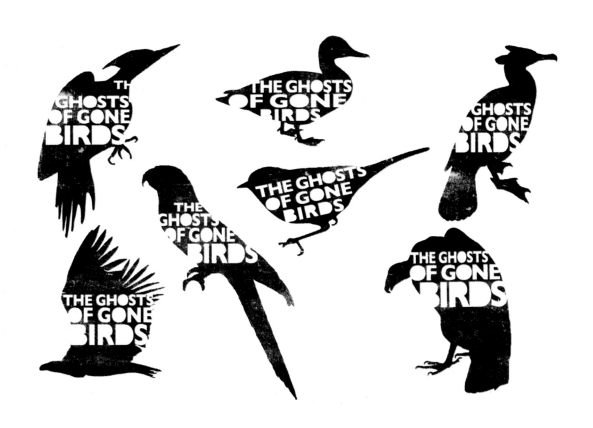

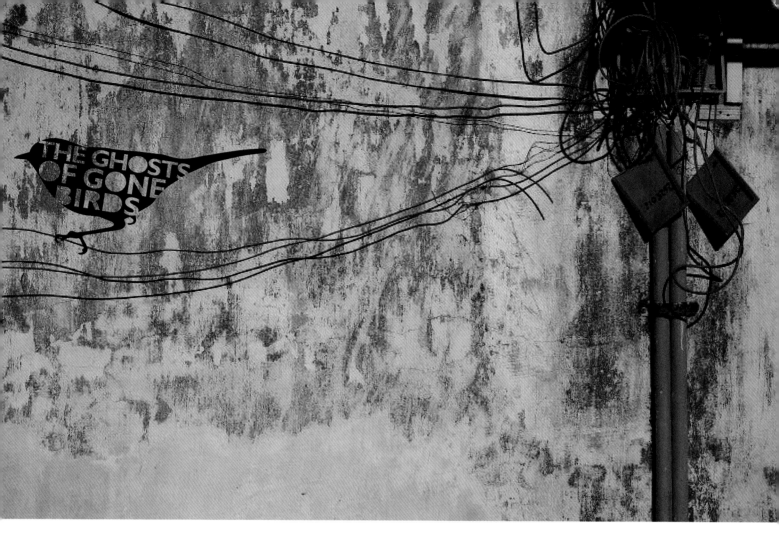

line conservation projects up and running to save endangered bird species. We sat back and considered the stories they were telling us.

At GOODPILOT we are storytellers, and every story BirdLife shared with us seemed worthy of sharing with a much wider audience. That seemed to be the second part of the task we should be undertaking – to spread the word, to get the message out there. To find a new generation of supporters who would respond positively and collaboratively to a project that really found the right way to articulate the blood, sweat and tears of contemporary conservation, and in particular the desperate fight to save the endangered birds of the world.

We'd worked with NGOs for several years and knew how difficult it was to engage people with global issues. However, we'd also created and run art projects that rallied people to a cause and built creative communities with real, meaningful momentum. Art therefore seemed

the key to unlocking people's love of birds – art that had an activist element to it, that could assemble and mobilise a community around a clear call to action.

First we needed a name. It would need to be a name that would dispense with any previous conceptions about what we were setting out to do, a name that would hook on people's imagination and persuade them to look closer and step inside to find out more. Maybe it was time to reinvent some language. We'd heard that birders had secret speak for some of the species they valued – and some that they dismissed ('rubbish bird' to describe a common or garden sighting seemed a great example of terminology tweaking), so we decided that this was the way forward.

'Extinction' and 'endangered' would not appear in the title of the project; instead we would conjure up a new phrase book to cover our conservation theme. We would reclassify all those lost avian species as simply 'Gone

Birds'. This term seemed to help liberate our proposed project from the existing wildlife sector and give it a more populist ring. We didn't want to lose the conservation bedrock of authority and authenticity, but we did want to throw the doors open wider than usual to get new people in.

The term 'Gone Birds' did that: here today, gone tomorrow. It talked to the fragility of existence. It was blunt and brutal – and truthful. If you're extinct, you're gone. However, the point of the project is that you won't be forgotten, which brought us to the second part of the title.

Gone Birds was our subject matter, the topic under discussion. The medium would be art: image making, word smithing and portraiture. It would be capturing the essence of what has gone and re-presenting it to viewers so they gained a better, more poignant understanding of what has been lost.

We wanted to encourage the artists to range far and wide in their attempts to effect a creative resurrection of their chosen subject. We wanted them to, if so inclined, go beneath the feathered surface, to quest for the inner spirit of their Gone Bird – to breathe life back into its essence, its existence, its life story and exit tale.

The word 'ghost' kept cropping up. It felt mysterious, melancholic, thrilling and *tragic*. We started to think of the gallery as an echo chamber, a space where you could capture an echo, a glimpse of what once was but now is gone. The art would not just seek to present the birds we had lost – it would also be a testament to the artistic inspiration those birds could provide if only they were still with us.

Ghosts of Gone Birds. It sounded right.

We started to cast our net as wide as possible in search of the right mix of creative talent to bring the Ghosts concept to life. Ceri Levy dipped into his art documentary and collecting contacts. John Fanshawe, the go-to man for arts and culture at BirdLife, provided a long list of names to share with us, artists who regularly exhibited at the wildlife shows in the Mall Galleries, but who might be tempted to tackle a slightly different brief – and show their work in a very different type of space. A simple invitation and *Ghosts* brief was written and sent out to each artist.

Each piece of art we wanted would be a celebration of the creative power birds have to inspire artistic endeavour, but with one terrible caveat. The asterix on the piece would provide the simple qualification that these birds are long gone. The art would live on, but the source of its inspiration, the subject of the portrait, will never breathe again. It would be a sad exhibition of ghost stories.

However, this wasn't really what we wanted. Sure, we had to get people to understand the magnitude of loss, but we didn't want a show that was so overwhelmingly tragic that it left people feeling powerless in the face of forces beyond their control. It had to offer the opportunity for victory, for a fightback against the odds to achieve a semi-happy ending. We therefore created the concept of Room Two. Every *Ghosts* show would have a Room Two. It would be somewhere that powered up the urge to resist, stoked up the anger and outrage, and channelled it into meaningful action.

The vast majority of work created for *Ghosts* would deal with historical extinction. Set in amber and aspic, it would retroactively return us to the lives of the birds we have lost. However, in Room Two we would move bang back up to date. We would go nose to nose, and toe to toe, with contemporary cases of endangerment, confronting the spectre of extinction as it rears up over the species around the world – and we would show people how to beat it.

Room Two would be our room of hope. It would be a space where we would take the opportunity to present the powerful stories of BirdLife's front-line action around the globe. We would focus in on a specific place, a real country or region where there was an urgent live conservation issue that visitors to the *Ghosts* gallery and the website and Facebook page could get involved with and help engineer positive change.

We then talked to BirdLife International's Preventing Extinctions Programme and looked around the world for the most potent hotspots of species conflict. We quickly found two such places: the horror shows of Malta and Cyprus would provide us with the blood-chilling evidence for why Room Two and the work of BirdLife

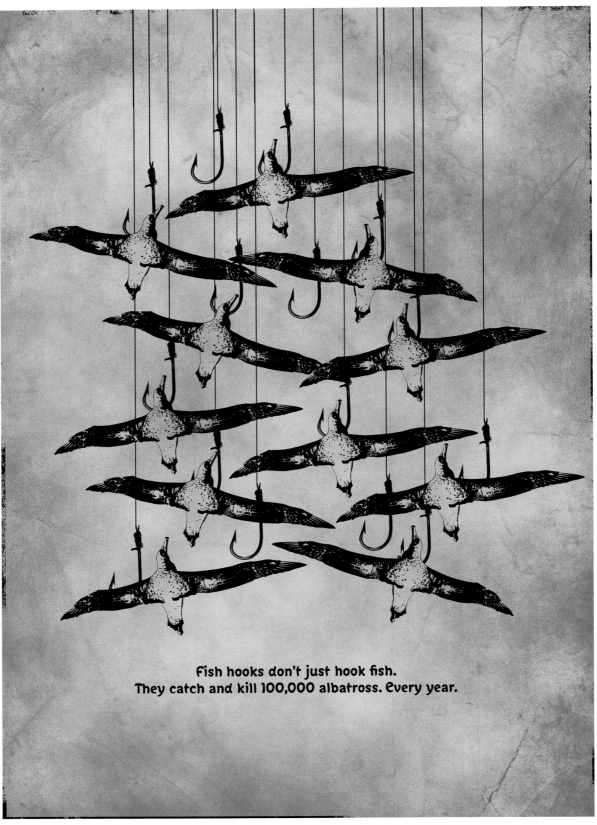

**Fish hooks don't just hook fish.
They catch and kill 100,000 albatross. Every year.**

Dying at a rate of around one every five minutes, the albatross family is fast becoming the most threatened family of birds in the world. In fact, they are disappearing at a rate faster than they can actually breed – so 18 out of the 22 species of albatross are now facing global extinction. BirdLife International set up the Albatross Task Force to work with local fishermen in countries throughout the world to introduce new practices that would reduce the life-threatening danger to seabirds. And as a result, in countries like South Africa there has been a 85% decrease in the number of seabirds caught in fishing lines.

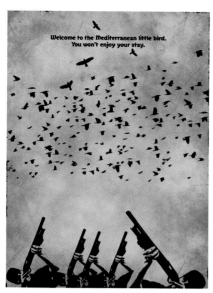

Welcome to the Mediterranean little bird.
You won't enjoy your stay.

There are certain unprotected flyways for migrating birds that as soon as they make landfall its open season. The result is an unrestrained slaughter of some of our rarest birds when they are at their most vulnerable. Spring "hunting" in Malta is one such extinction-level shooting festival. That's why BirdLife International worked with the European Commission to gather the evidence and file the complaint that led to an infringement procedure, forcing the island to change its laws and protect its seasonal visitors.

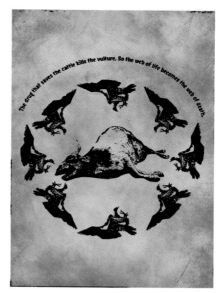

The drug that saves the cattle kills the vulture. So the web of life becomes the web of death.

When the vulture population in India crashed by 99%, BirdLife International and its local partner immediately sprang into action to identify the devastating causes of this near-extinction. Fast but meticulous detective work followed the trail of death back to a recently introduced veterinary drug for cattle called diclofenac. The BirdLife Partnership presented the Indian Government with the evidence it needed to get the drug banned and start working on finding a safe alternative.

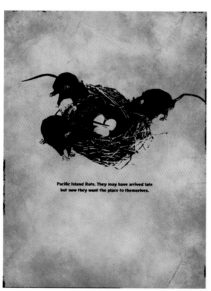

Pacific Island Rats. They may have arrived late
but now they want the place to themselves.

Introduced species, such as rats and cats, are one of the greatest drivers of biodiversity loss and have been implicated in almost half of all bird extinctions in the past five centuries. 75% of all threatened species on oceanic islands are under attack from invasives – 250 from rats, 170 by cats.

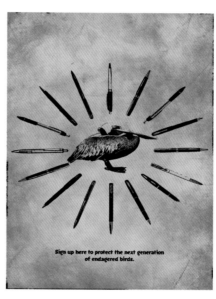

Sign up here to protect the next generation
of endagered birds.

There are still over 1,240 bird species on the endangered Red List so the fight to prevent any more joining the ghost of gone birds continues every day in every corner of the world.

International's front-line campaigners needed to exist. Birdmurderland was born.

Next up was the look and feel of *Ghosts*. Due to our design and marketing backgrounds, we were perhaps more aware than most gallery creators of the importance of having a distinctive look and tone of voice for everything we did.

We wanted to seed and spread the *Ghosts* project far and wide, across all the platforms and venues we could find, and to do that there needed to be some internal cohesion to the idea, so that wherever people encountered

the *Ghosts* project they would know it was part of a larger whole, and everything fitted together with the same spirit and sense of purpose. So, dare I say it, we started thinking about *Ghosts of Gone Birds* as a new type of conservation brand – something to build from the ground up and treat as a real commercial property as well as an art project, so that it had the capability to genuinely generate money for the artists involved, and funds to fight extinction around the world.

With this in mind, Peter Hodgson and Paul Beer, the *Ghosts* design team par excellence, embarked on creating

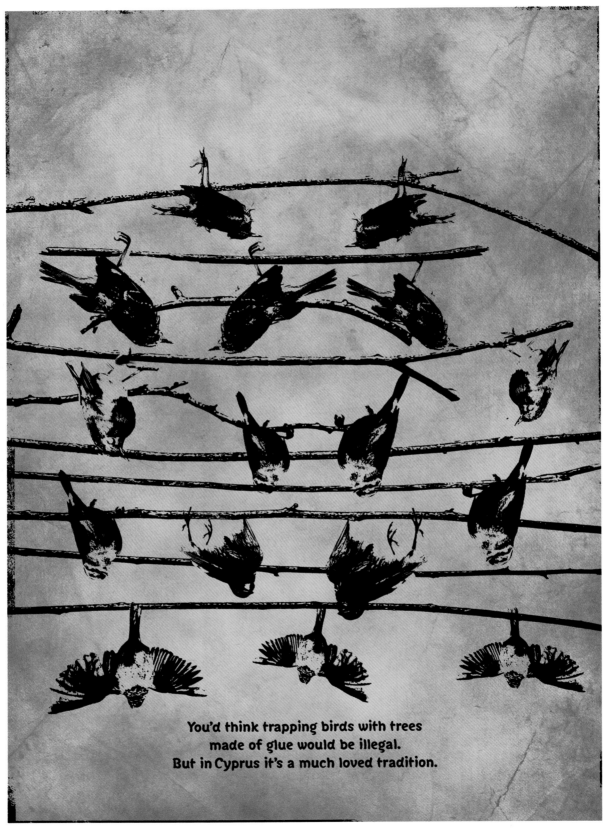

You'd think trapping birds with trees
made of glue would be illegal.
But in Cyprus it's a much loved tradition.

In Cyprus last year more than 10,000 lime sticks were confiscated by the authorities: lime sticks are twigs coated in a sticky 'glue' made by boiling up the fruit of the Syrian plum-tree, and placed in trees and shrubs as 'perches' to which the feet, legs and feathers of small birds adhere before hunters kill them. BirdLife estimates that trapping levels were sufficient to kill 1.6 million birds in its study area alone during autumn 2012 and over 2.1 million in Cyprus as a whole.

a Ghosts universe of distinctive typography and textures, iconic images and design elements that would house our message wherever it travelled.

The logo was partly inspired by a project we'd previously done (the Hype Gallery) with an artist called Paul Curtis, aka Moose, a wonderful advocator of the creative school of thought that says less is more. Paul had dedicated his artistic life to removing rather than adding to the surface layers of his surrounding environments by means of a truly inventive technique that has been at various times called 'clean graffiti' and 'reverse graffiti', but has most recently been reclaimed by the artist himself and more accurately dubbed 'refacing' – as opposed to 'defacing'.

If you don't know Paul's work (and you should!), the beautiful images he painstakingly creates emerge out of the dirt and pollution of the cityscape, their forms representing a restoration of original clean surfaces shaped and defined by the layers of accumulated grime that surround them. It was a process that we thought totally relevant to the ethos of *Ghosts,* and we knew that at some point we'd be recruiting Paul if possible, to repopulate the streets around our gallery venues with the shapes and shades of long-gone birds. As it turned out, we were lucky enough to get him involved in the Rochelle show, and when you reach the Ghosts Live chapter you'll see exactly how he created his 'Ghosts Flocks of Shoreditch High Street'.

In the meantime, our logo evolved as a variation on Paul's approach: a reverse stencil of an extinct bird that could appear anywhere, the silhouetted spectre of another lost species, half-glimpsed, a shadow of its former self – almost like those haunting images of atomic bomb-blasted citizens forever caught in the negative glare of their final moments.

We experimented with a range of Gone Birds, from the Imperial Woodpecker (RIP 1956) to the Black Backed Bittern (1900), Canary Island Oystercatcher (1945) and Paradise Parrot (1927), but settled on the image of Pallas's Cormorant as our iconic badge for the project. We loved the bird's upright defiance – here was a Gone Bird that was standing up straight and unshrinkingly

staring its fate squarely in the eyes. It felt strong and truthful – nothing fussy – a street-fighting bird prepared to take on the challenges ahead. *Ghosts* was going to be guerrilla when it needed to be, and this logo carried the right amount of grit.

Next up was the BirdLife International stories themselves – a series of images that would stand up alongside the art we were collecting and work hard to articulate the sorts of contemporary threats and dangers that front-line conservationists were having to tackle on behalf of the 190 Critically Endangered bird species around the world.

We started visually mapping out a Torquemada-like array of vicious threats, a tapestry of the avian apocalypse in action: firing squads of illegal hunters; egg thieves; out-of-control logging companies; over-zealous coastal developers; poisonous cattle carcases; invasive species, red of tooth and claw; fatally humming power lines and oceans of deadly fishing hooks. It felt like the storyboard for a particularly psychotic instalment of *Total Wipeout,* an obstacle course of chronic habitat depletion, tides of unexpected predators and the rapacious greed of a cruelly indifferent mankind. Nothing natural. No indication of a fair fight. That was before we had even got onto the subject of songbirds versus mist nets and lime sticks.

This was the grim wake-up call we were looking for to end each of the exhibitions – the visceral rallying cry to those that cared about protecting nature to sign up and join the struggle.

Art would bring in our new audience, but hopefully conservation would fire it into action.

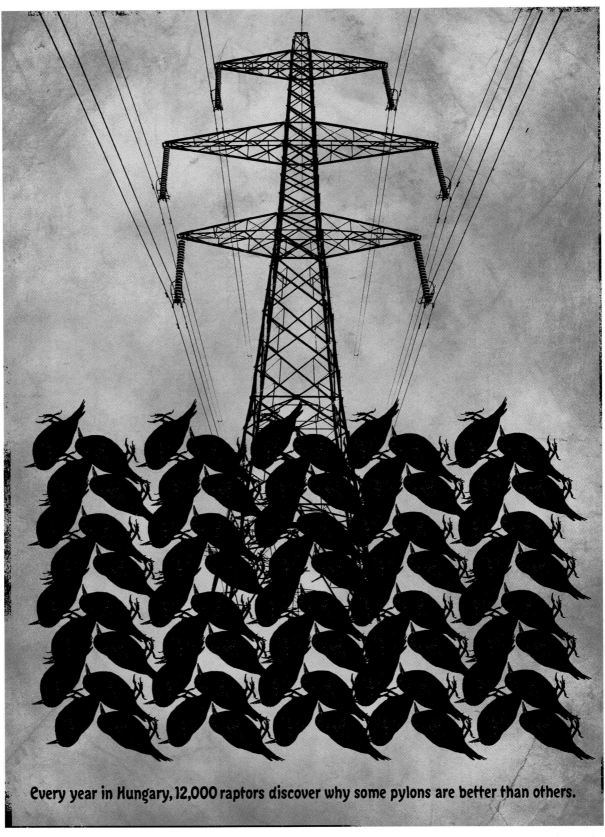

Every year in Hungary, 12,000 raptors discover why some pylons are better than others.

Lack of proper safety regulations means that even in Europe there are thousands of un-insulated pylons that will prove a deadly perch for local birds, especially raptors. In Hungary, it is estimated that every year one in seven pylons kills a bird and one in eighteen kills a raptor. So BirdLife with its local partner has worked with electricity providers and the Ministry of Environment and Water to create a new 'Accessible Sky' agreement and make all power lines safer by 2020.

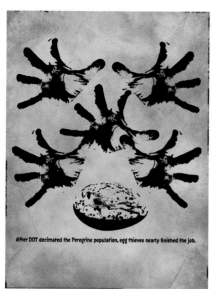

After DDT decimated the Peregrine population, egg thieves nearly finished the job.

The RSPB tirelessly campaigned against pesticide use in the 1960s/70s when it first threatened to wipe out the peregrine falcon. Then they stood guard 24/7 over peregrine nests to discourage the egg-thieves that were targeting the precious few breeding peregrine falcons that were left. In the end their vigilance triumphed and as a result, the RSPB successfully rescued the world's fastest creature from becoming another ghost species.

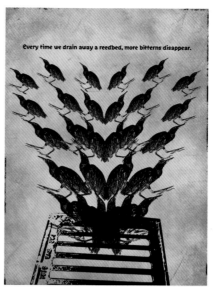

Every time we drain away a reedbed, more bitterns disappear.

The widespread destruction of the bittern's natural habitat is why the RSPB is rolling up its sleeves, digging ditches and turning carrot fields back into bittern-friendly reed beds. As a result, bittern numbers are finally on the increase - but this is only the beginning of the bird's long hard climb back to species-safety. It's our dream that the bittern's bass-heavy booming call will once again rumble out across reed beds from coast to coast.

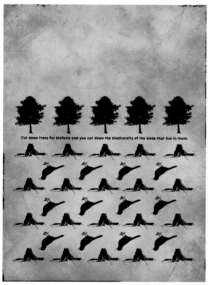

Cut down trees for biofuels and you cut down the biodiversity of the birds that live in them.

Loss of habitat through tropical deforestation is another engine of extinction: in Paraguay, forests are being lost at the rate of almost 1,300 ha per day – the equivalent of more than 1,500 football pitches. The cleared land is used for cattle ranching, primarily to provide beef for European consumption.

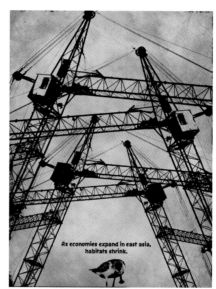

As economies expand in east asia, habitats shrink.

Ongoing industrialisation around the globe is impacting on species by eliminating critical but vulnerable breeding grounds. As economies boom, precious habitats are lost to rampant and unrestrained urban developments.

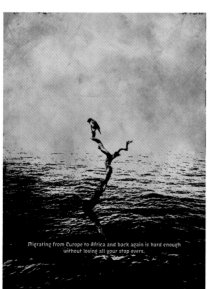

Migrating from Europe to Africa and back again is hard enough without losing all your stop overs.

Broken flyways are occurring more and more frequently especially where climate change is altering the landscape, eliminating natural sanctuaries and safe resting places. This is compounded by dramatic adjustments to local land use where the intervention of man is often causing additional draining or flooding of important stopovers.

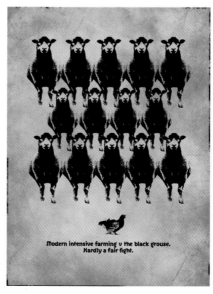

Modern intensive farming v the black grouse. Hardly a fair fight.

The RSPB is determined to turn the tide of land-use change back in favour of the Black Grouse before it disappears completely from this country. So whether it's on RSPB reserves or working with upland land-owners, they are reducing sheep numbers, planting trees and hay meadows to re-create the 'space' this dandy of the moors needs to thrive once again. Where they have managed to do this, the decline is halted - but there are many other places where the Black Grouse is just hanging on and rapid action is needed to prevent their bizarre 'lek' dances from becoming just another ghost-memory.

Liverpool spring

The driver pulled away from Liverpool Lime Street station in his Audi without realising that the man from the RSPB he'd had in the boot of his car was still trying to frantically retrieve his travel bag and laptop before they disappeared in the general direction of Greater Manchester.

He was one of several passengers who had been crammed into the vehicle for an early-evening tour around the Liverpool warehouse district, but while everyone else had remained relatively upright, the man with the laptop accelerating away from him had volunteered to lie prone on the dog blankets in the back of the station wagon and watch the Merseyside skyline pass by from an entirely horizontal position. Fortunately the bag and laptop were successfully rescued – but only

after the man made a high-speed dash on foot, dodging buses, in pursuit of the Audi, which still had its boot yawning wide open, much to the bewilderment of the steady stream of people heading for their commute home.

It was a suitably surreal end to a long day touring around the city, scouting out possible venues for our first *Ghosts* show. Artists had started to deliver their work; what we had seen so far had blown us away and we were feeling bullish about putting on our first exhibition. Bullish – but cautious.

We had decided that we wouldn't debut the project straightaway in London, but would migrate the idea north and find a more forgiving home where we could try out a few things beyond the critical gaze of the Sunday magazine set. The initial idea had been to add an art pop-

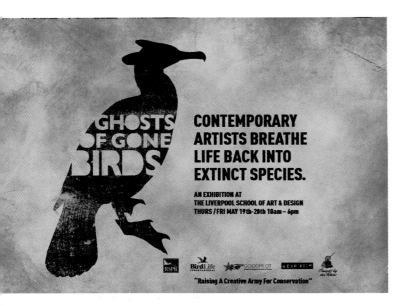

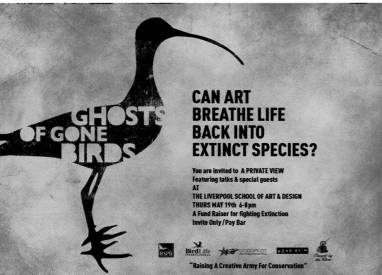

up to the Sound City music weekend happening at the end of May 2011, so we'd been talking to some of the more experimental city-centre art venues clustered around the late-night clubs of Wolstenholme Square and found a wonderful crumbling four-storey building with just the right level of gothic splendour. It had warped and creaking floorboards, peeling walls, a mysterious staircase and a hidden cellar. We were all feeling it: a haunted house for the *Ghosts of Gone Birds*.

Then a rat the size of a cat ran across our feet.

Our enthusiasm waned. On-tap rats would be great for dramatising our tales of invasive species – but they might disturb a few people at the private view. There was also a health-and-safety form to fill in somewhere down the road, and we were sure it didn't have a section covering rodent attack. Reluctantly we resumed searching. We even stole a look at the exhibition space at Tate Liverpool – nice, but not what we were looking for.

Then we met Mike O'Shaugnessy. He showed us the *Ghosts* venue the John Moores School of Art and Design could offer us. Upstairs they had a terrific photography exhibition by Stuart Borthwick, examining the end-of-terrace street murals of Belfast. Downstairs, however, there was a separate space. It had clean white walls and was glass fronted all down one side with greenery beyond. It felt light and airy, and led onto a small auditorium – nothing gothic, but something strangely peaceful, even restorative.

The school itself looked out across to the city's relatively new Metropolitan Cathedral (affectionately

known locally as 'paddy's wigwam', someone informed us): a startling unapologetic modernist statement of soaring faith that you reached rather fittingly via Hope Street. We took time out and wandered around the exterior, marvelling at the Portland stone fortress that seamlessly evolved into a lantern tower crowned at its summit by a circle of sky-piercing pinnacles. Inside, it was no less breathtaking. We returned to the School of Art and Design knowing we'd found our first *Ghosts* venue: it was now down to the logistics of assembling and hanging our emerging collection of *Ghosts* pieces.

Clem Fisher of the Liverpool World Museum became an invaluable ally in everything we did in the city. Even before we selected the venue she had been helping to arrange for our artists to see whatever they could in terms of inspirational material, and we also knew she would be a wonderful guest speaker at the *Ghosts* show.

The poet John Barlow had contributed a written piece, 'The Ghost Auks', to the project, and we invited him over to perform his work surrounded by the *Ghosts* collection. Artist Lucy Willow also offered to talk about her Ghosts experience in creating her exquisite memorial to the Snail-eating Coua. It was May and late afternoon sunshine poured through the windows, bathing everything in a warm glow as John slowly took us back to the final days of Queenie, the last of the Great Auks.

Man's cruelty to birds echoed around the *Ghosts* gallery and up the stairs into the main body of the art faculty. Phil Knott's series of digital prints, 'Kill Agreed', were bulldog clipped up the stairwell and read like a PowerPoint presentation on corporate greed strategising a new campaign of species extinction.

The hive mind of Le Gun had documented a brigade of bloodthirsty and dissolute whalers beaching their boats and preparing to butcher an unsuspecting 'White Gallinule'.

For Neal Jones there's only the Buddha-like face of 'The Laughing Owl' seeking to forgive the man who has just smoked it out of its cave.

This is a world of infinite cruelties: the cold, mortuary moment of John Keane's 'Cuban Macaw', toe-tagged in traditional *CSI* fashion and all prepped for the afterlife.

Hannah Bays's death's head 'Passenger Pigeon' portrait is populated with gun-happy cowboys looking to shoot down the bird that rises defiantly above them, and suddenly you sense that glory can trump gory.

For every brutal end there seems to be a counter-balancing moment of transcendent beauty where a *Ghosts* artist has chosen to discard the death story and simply stare in wonder at what was there before – the pre-extinction vitality of a life being lived.

We christened one part of the *Ghosts* Liverpool show the 'Great Auk Corner', and there we placed Bruce Pearson's utterly astonishing reimagining of a Great Auk feeding frenzy from two centuries ago. It's the *Ghosts* process at its most powerful: history re-engineered to allow us a glimpse of what might have been, an exploding bait-ball of herring bisected by the muscular dynamic hunting instincts of Queenie and her clan.

For all of us, spring in Liverpool brought with it an enormous sense of renewal and optimism.

GHOSTS LIVERPOOL VENUE

The Ghost Auks *by John Barlow*

The last accepted record of a Great Auk in Britain comes from St Kilda, circa 1840,
the bird being held captive for three days before being killed as a witch. A later sighting
was reported from Belfast Bay in 1845, a year after the species is now widely considered
to have become extinct. A pair of 'large birds, the size of Great Northern Divers . . .
but with much smaller wings' were described as 'almost constantly diving', going
'to an extraordinary distance each time with great rapidity'

I died at sea.
The details need not concern us,
but it was somewhat unfortunate, before my time.
Queenie stayed around for three days, searching for me.
I'd dive with her, to the depths of Bailey.
Forty fathoms she'd go, deeper
than we'd ever dived before. Even the shoals
that would splinter at our spear bills
began to ignore her.
She wouldn't feed. Just rested on the surface,
then dived again, for fifteen minutes
or more. But I could swim forever now,
reach five hundred fathoms a dive.
Let me tell you, the sea bed, when I saw it,
was far more interesting then.
Teeming. Alive.

After three days Queenie was exhausted. She drifted,
in and out of consciousness, and sometimes, I know,
she thought she saw me, guiding her to land.
A summer storm was at our backs, and then the sound
of the water changed; different smells
hinted in the air. Stac an Armin loomed into view,
a hundred fathoms high,
its hard, gabbroic edges the only thing now
between Queenie and the next world. With one huge effort
she hurtled through a wave crest, made landfall
on a narrow ledge. Spindrift whipped into the crevices,
drove her from the edge. We'd been here before, a few of us,
many tides ago, and Queenie knew the way. A grass incline,
up the stack, away from the waves.

I didn't hear them, the men.
They crept up on us, three of them, as Queenie slept.
The most grizzled one, MacDonald, crouched down
and grabbed her neck. I stabbed at him,
but I went straight through his weather-
scarred arms, his stinking groin, the twisted femurs
of his cliff-bowed legs. He never saw me;
didn't feel a thing. Queenie was struggling
as hard as she might. And then the other two
caught her legs, and lashed them, the brined rope
wincing through her skin; tight.

They carried her off then, to their bothy,
Queenie slung between them
in a burlap sack. There was little else I could do
but follow. Stooping through the doorway
they slammed the door. I took the wall. They tipped Queenie
out of the sack, feet-bound, in a corner; lit a fire; slit
some fish. One of them, McQueen, threw a few scraps
to Queenie, but they lay there too, gathering the dirt.
Every now and then the third man, McKinnon, would
look over at her as she groaned, as if he wasn't quite sure
what to make of her. We'd been common here once,
us Garefowl, but I don't think any of the three
had seen one of us before. And no wonder.
In these parts, me and Queenie, we were the last
of the Garefowl, last of the King Murrs, last
of the Great Auks.

By evening the storm was upon us.
The rain sliced in hard, the wind found every gap
between the stones. For two nights and days
the men huddled over their fire, uttering the odd prayer
to their god. Smoke thickened and thinned in the bothy,
making its way out of the walls when the gale
gathered itself between howls. And Queenie lay
where they'd dropped her, silent now.

By nightfall on the third day the smoke
was almost gone with the fire. The occasional glow
caught the streams from their nostrils,
their cracked, quietened lips, their furrowed brows.
They ate
what they ate
raw.
Lightning flashed across the walls, the makeshift
shelves, the two-bit-of-driftwood crucifix, the rough-
hewn door. It picked out the embers, the scattered pots
and pan, two rain-soaked lumps of gabbro,
and Queenie,
in her corner,
giving it her all.

It was McKinnon who said it, that perhaps she was a witch,
that perhaps it was her that brought the storm. The men
huddled together, for what seemed an age, muttering
between themselves. Then in a lightning flash
MacDonald picked up a lump of gabbro, took a few steps
in the thunder-rolling darkness and hurled it at Queenie.
The stone missed, thudding into the floor.
And so it went, with each flash:
a stone retrieved, a stone thrown; each man
hesitating in turn.
The end, when it came, came mercifully,
came with a stick. It had taken an hour. Maybe more.

The storm abated, moved away. Under bright skies
they threw Queenie's body behind the bothy, rowed
their small boat back to Hirta, to kith
and kin. But Queenie and I were long gone,
diving to depths we'd never dived to, King
and Queen of the Murrs.
We kept well clear of men after that, not
that they could harm us. They saw us, just the once,
five years later off the coast of Belfast.
Carried away, ghosting, beneath the waves.

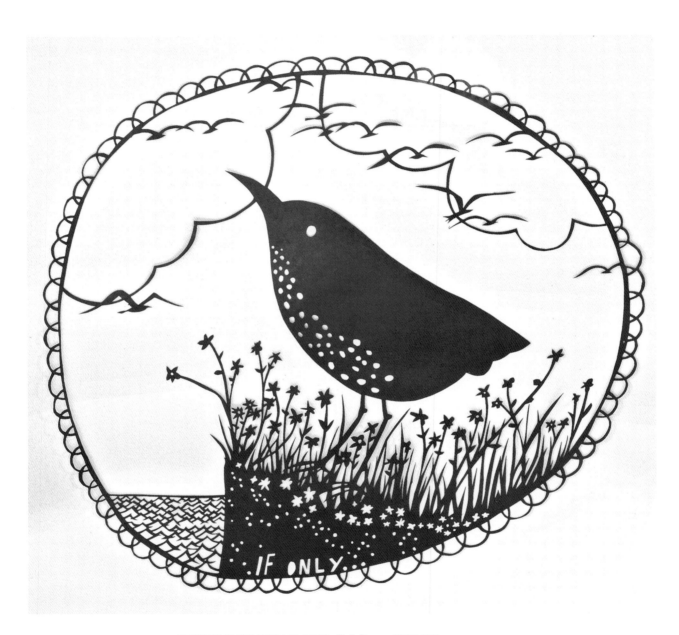

STEPHENS ISLAND WREN: 'IF ONLY' – **Rob Ryan** – PAPERCUT

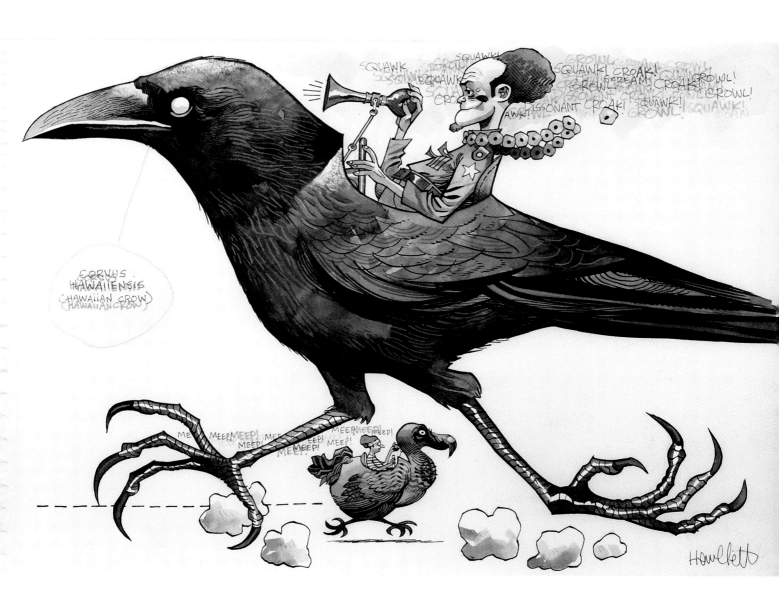

HAWAIIAN CROW – *Jamie Hewlett* – WATERCOLOUR

'PINK HEADED DUCK – BEFORE PEOPLE' – *Dafila Scott* – PASTEL

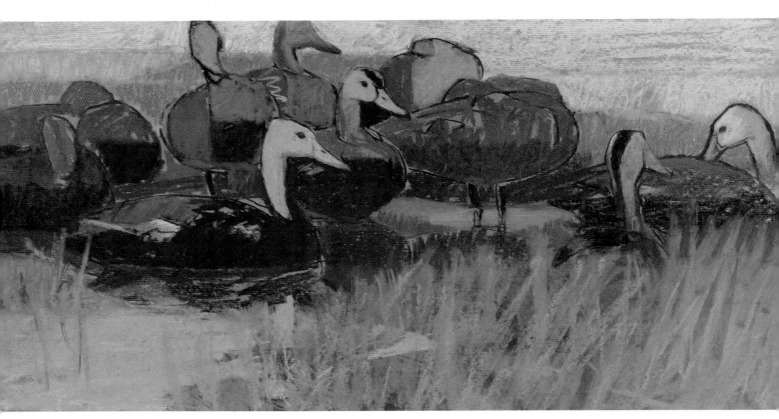

PINK HEADED DUCKS – *Dafila Scott* – PASTEL

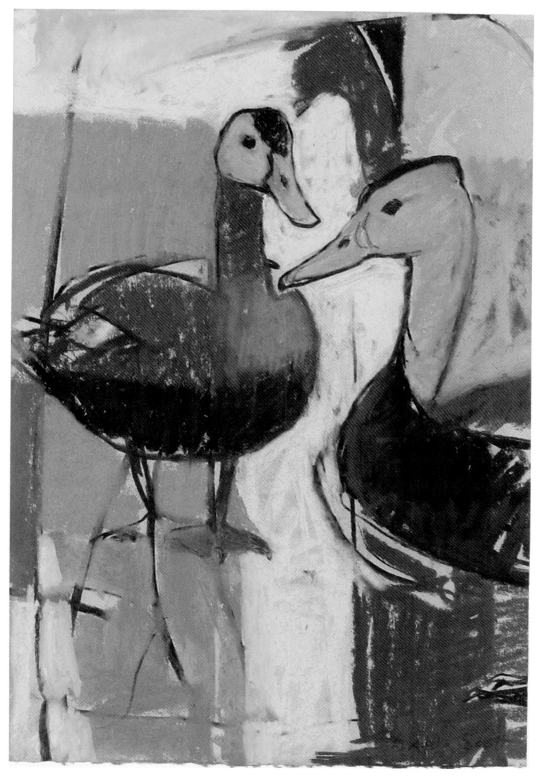

PINK HEADED DUCKS – *Dafila Scott* – PASTEL

'I chose them because I was brought up with waterfowl at Slimbridge
and because my father had painted them. There was a small watercolour
of a male pink-headed duck which lived on the shelf in the studio which
was somehow memorable...'

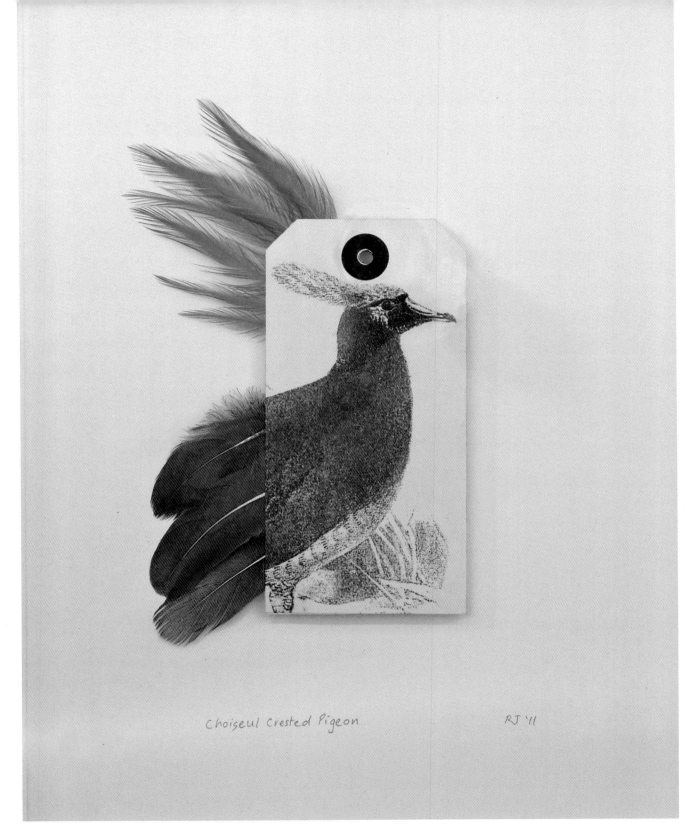

Choiseul Crested Pigeon RJ '11

CHOISEUL CRESTED PIGEON – *Rebecca Jewell* – MONOPRINT

'I made several pieces. The first series was done by the 'paper litho' method, printing from the original drawing of the pigeon by Keulemans, 1904, and printing one of my photos onto a label which lies beneath the image of the pigeon. The idea is to show how such a magnificent bird became just another specimen, labelled and preserved in a museum. The second work I made was also using a label and printing the Keulemans drawing and attaching feathers to the label. Again, this is to show the reduction of such a beautiful bird to a labelled artefact.'

RED RAIL – **Rob Ramsden** – INK & WATERCOLOUR

'It struck me that it had a comic look about it, a look not unlike the Dodo, and this appealed to the same sense of why I like the underdog comedians of history; Buster Keaton, Stan Laurel, etc. At different levels they appear pathetic, funny and heroic, and for any of these reasons why would you want to pick on them, and why would you want to wipe them off the face of the planet?'

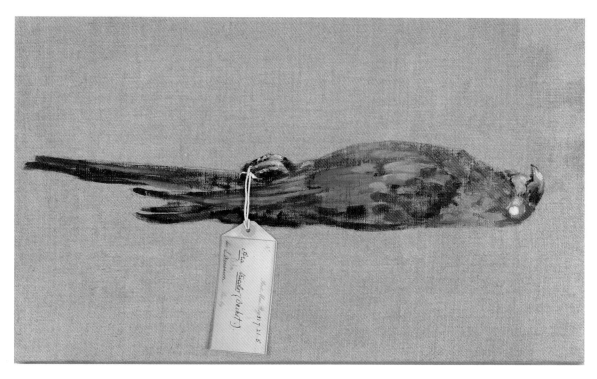

CUBAN MACAW: 'DEAD PARROT SKETCH' – **John Keane** – OIL ON CANVAS

'I was unceremoniously presented with the dead, stuffed specimen from a drawer in a large room full of other such dead, stuffed specimens. I felt like I was there to identify a corpse in a morgue. The experience was both moving, as this bird had been dead 150 years and was one of the last of its kind, but also funny, as I was immediately reminded of the Monty Python Dead Parrot sketch. This once beautiful specimen, although a bit faded, retained much of its exotic colouring, but it had cotton wool for eyes. It felt very dead.'

THE TRAGIC DEMISE

OF

THE WHITE GALLINULE

– *Le Gun* –

PEN AND INK

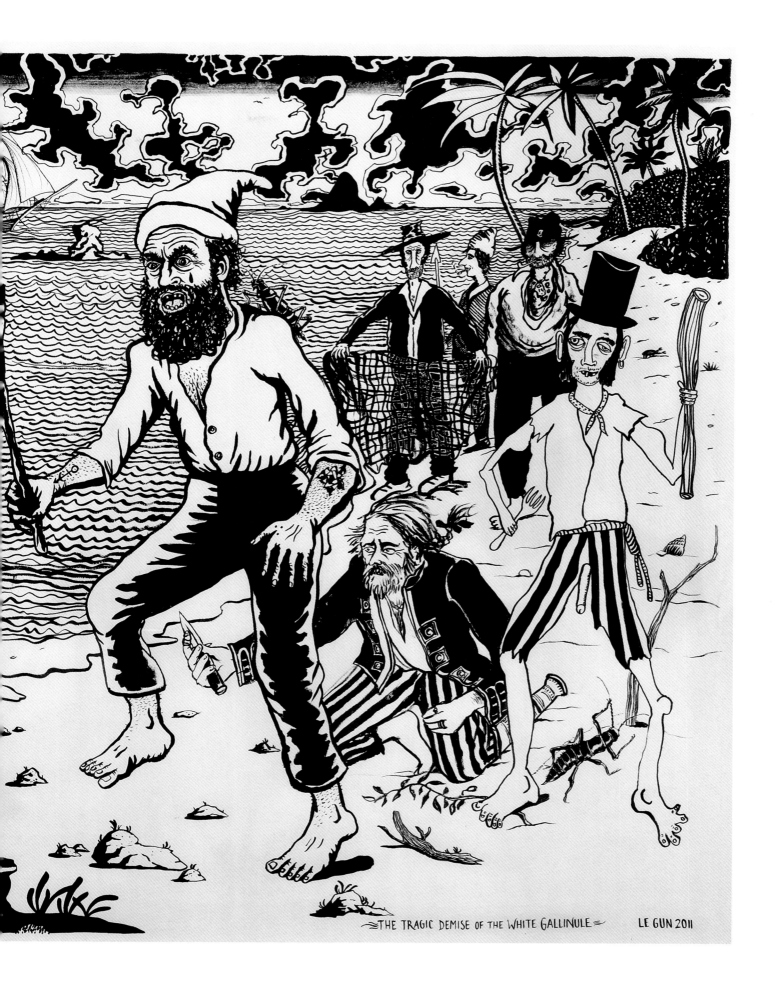

≈THE TRAGIC DEMISE OF THE WHITE GALLINULE≈ LE GUN 2011

ELEPHANT BIRD

Catherine Wallis

PENCIL AND BONE

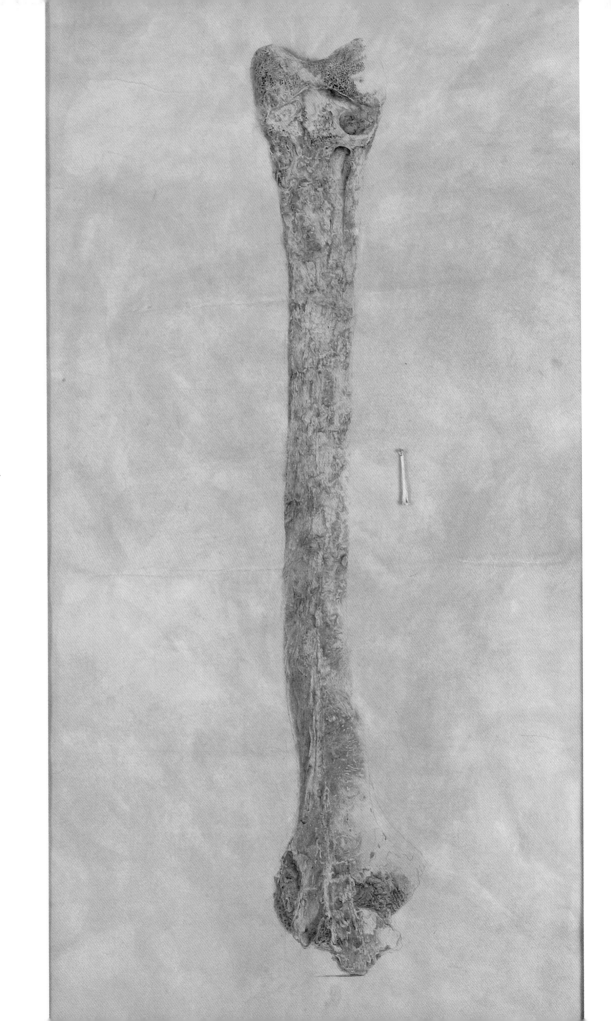

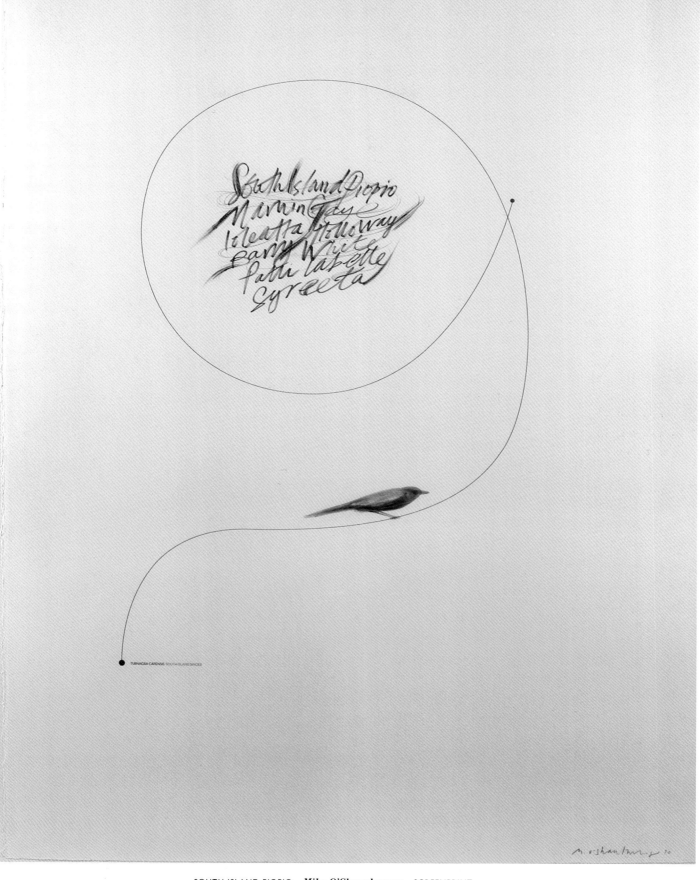

SOUTH ISLAND PIOPIO – *Mike O'Shaughnessy* – SCREENPRINT

'It was known for its beautiful song. Although, it wasn't a great looker.'

GREAT AUK

*— **Bruce Pearson** —*

OIL ON CANVAS

*'Researching the
species it seemed that
they might have fed
a great deal on the
vast shoals of herring
that were once equally
abundant in northern
waters. And knowing
that herring shoals
sometimes form into
great 'bait balls' when
predators attack
there must have been
times when a feeding
frenzy of great auks
could have been seen
plunging through
'bait balls' of herring.
Having been sub-
aqua diving in the
cold waters of Western
Scotland a few times,
and once or twice
seen razorbills and
guillemots flash by
underwater, I tried to
imagine what a feeding
frenzy of great auks
might have been like a
couple of centuries ago.'*

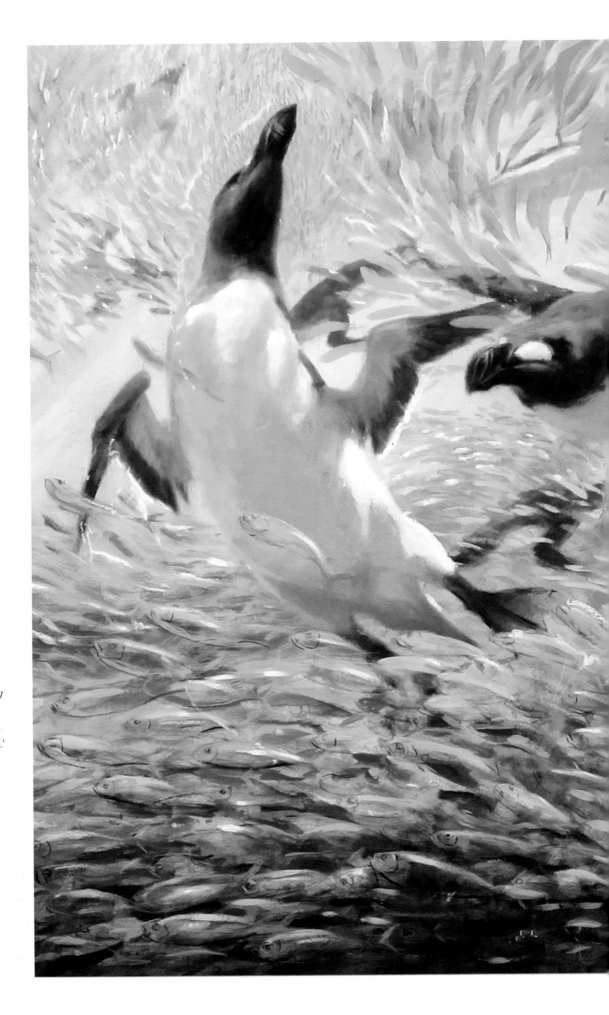

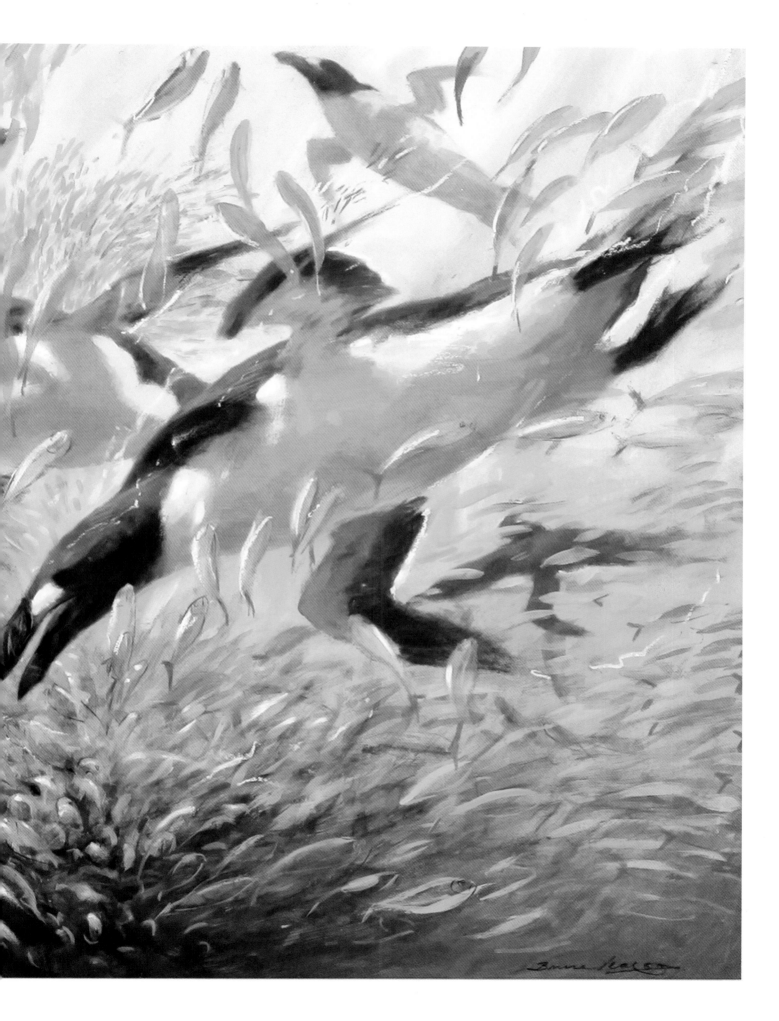

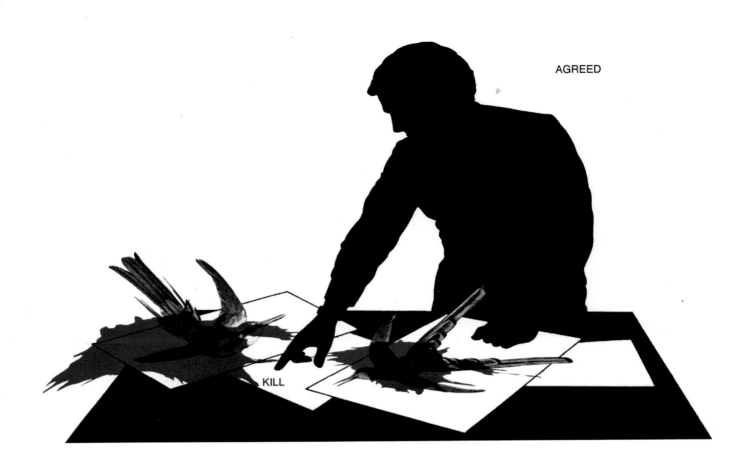

AGREED

KILL

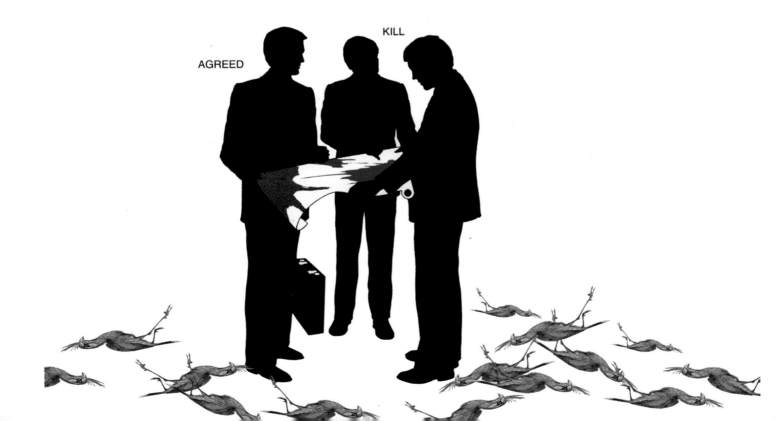

AGREED

KILL

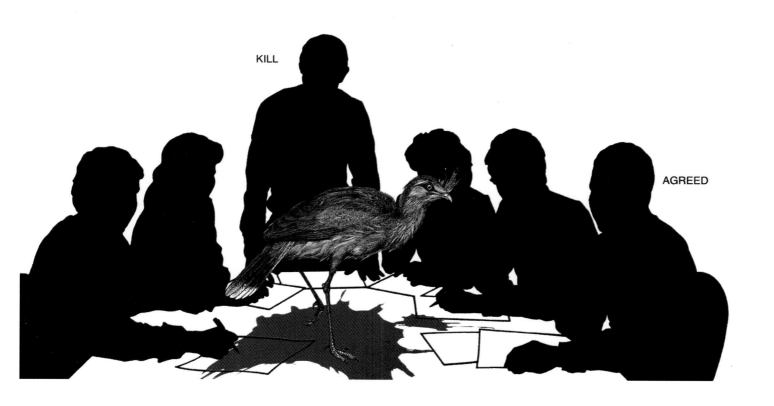

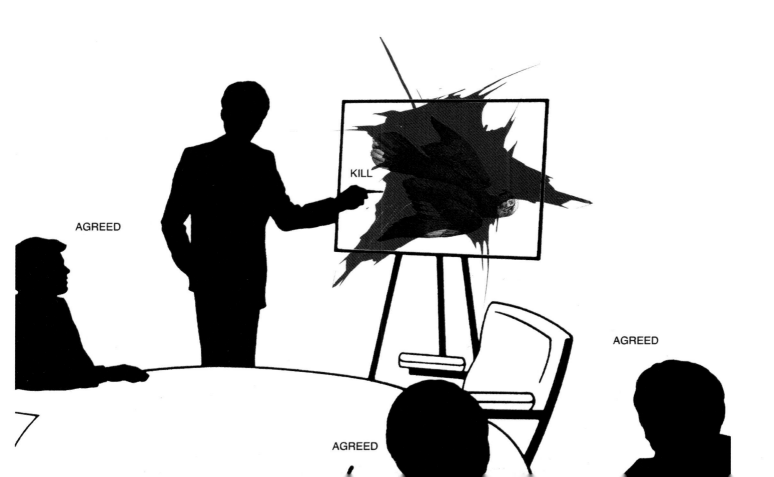

MONARCH

WE SHALL REIGN FOREVER

MAUPITI MONARCH – *Adam Bridgland* – HAND-COLOURED SILKSCREEN

TAHITIAN SANDPIPER – **Luke Pearson** – PEN & INK

LAUGHING OWL – **Neal Jones** – MIXED MEDIA

'I looked at pictures of the laughing owl - smiling and chuckling away
- and it broke my heart, I thought I could make something absurd
with this tragi-comic story, dragged off to extinction - laughing!'

'Much of my work is about the spirit world, concepts of ghosting and theories on the after-life. Analyzing what form a spirit could take, and what forms are generally accepted to represent them in culture, objectifying the non solid. I discovered that Hawaii is the extinction capial of the world.'

'OUR EXISTENCE REMEMBERS OUR EXISTENCE 1, 2 & 3' – *Russell Maurice*

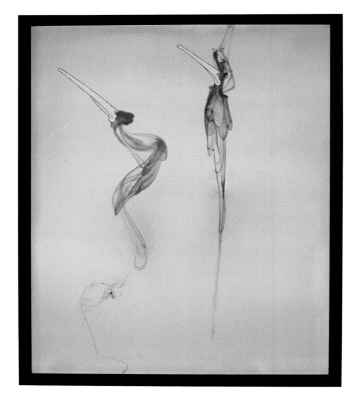

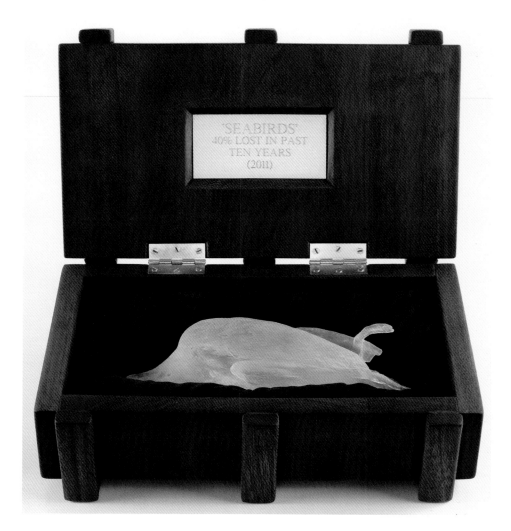

'SEA BIRDS: 40% LOST IN PAST TEN YEARS' – *Stephen Melton* – MIXED MEDIA

'*I liked the look of it and the species was once considered extinct but is now thought not to be – which stands the whole exhibition nicely upon its head.*'

JERDON'S COURSER – *Errol Fuller* – OIL ON CANVAS

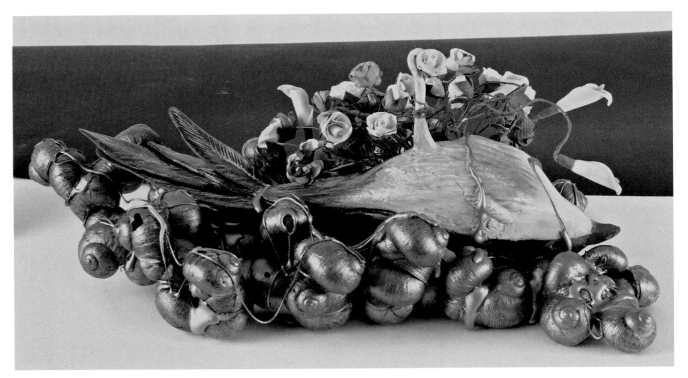

SNAIL-EATING COUA – *Lucy Willow* – MIXED MEDIA

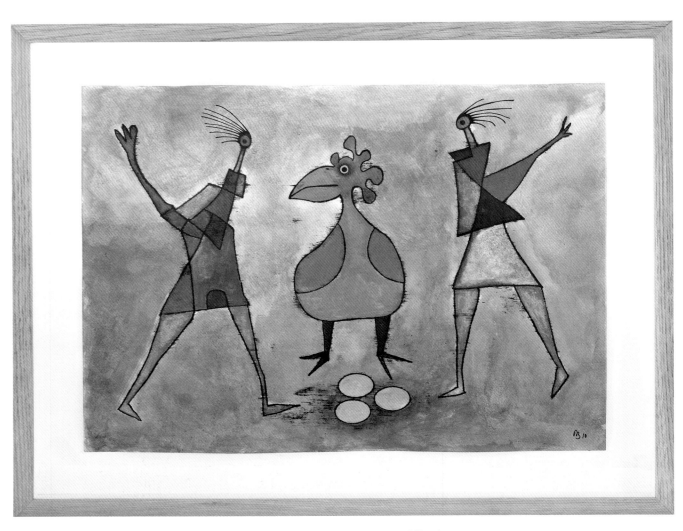

'THE INCONVENIENT GIFT' – *Desmond Morris*

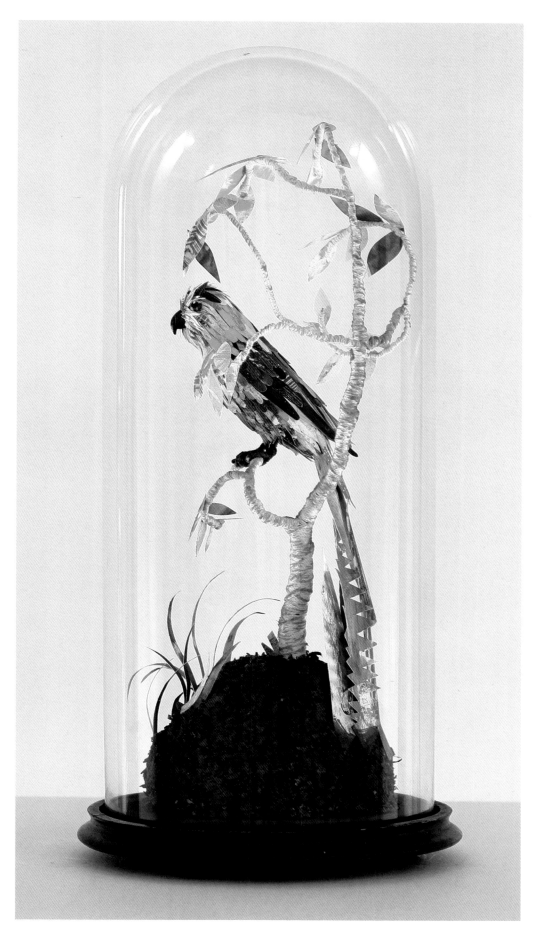

PARADISE PARROT – *Ed Kluz* – MIXED MEDIA

Slack time

We'd been to hell – and had come away with some smart ideas on how to hang the *Ghosts* London show. In this instance, hell – or rather Hell's Half Acre as the press release described it – was located in the Old Vic Tunnels beneath Waterloo station and had been assembled by gallery owner Steve Lazarides to showcase a range of his more startling artists and offer a subterranean alternative to the big-tent glitz of the Frieze Art Fair.

We'd been added onto the guest list by a good friend, Tim Fennell, who had enlisted Charming Baker and Stephen Melton into the *Ghosts* creative army for us. We wandered the maze of damp catacombs and marvelled at the installations by Paul Insect, Polly Morgan, Conor Harrington, Mark Jenkins, et al. This was art as we liked it – provocative, immersive, mixed up and unpredictable.

We liked everything we saw. We liked the way it made us feel and surprised us at every turn. It was a group show that splintered apart in a lot of different directions, but the attitude and mood glued it back together. It gave us a cohesion and a diversity to aim for – a means of sharpening what we had done in Liverpool into a more powerful show.

Funding remained eternally frustrating. The self-sustaining model we had mapped out was simple: *Ghosts* would operate as a commercial gallery, giving everyone the opportunity to buy the art on show, with 50 per cent

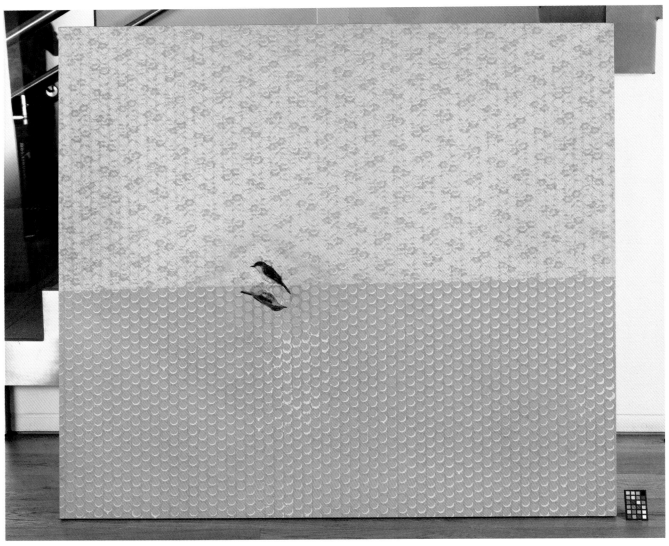

ONE DAY OUR PAST WILL BE ALL THERE IS TO LOOK FORWARD TO – *Chaming Baker* – OIL ON CANVAS

of the money going back to the artist, while the remaining 50 per cent would be split between *Ghosts'* running costs and a front-line conservation project chosen in collaboration with BirdLife International. In respect of this last part, it was very important for us to get the money directly to the people who could best engineer and implement change on the ground in the local preventing extinction hotspots.

Our prospects of achieving all this would become a lot brighter if we could get the right sort of brand or media partner on board, someone who had a clean green bill of health and genuine interest in what we were doing, and who could help underwrite the growing costs of a London show.

Corporate Social Responsibility was becoming a driving factor for a lot of companies, and big business still seemed in love with art sponsorship, so we felt that *Ghosts of Gone Birds* would be the perfect project for a brand to come out and declare a meaningful commitment to both the environment and the arts. It had worked for us in the past: Hewlett Packard had bankrolled our HYPE project for three years as we opened a series of DIY pop-up art galleries across Europe.

This time around there was no one signing on the dotted line. Sure, we had interest, but never from the right sort of potential partner. We'd rather say no than take on someone who was going to distort the shape of the project, so the deadline we had set ourselves for

unveiling Ghosts London grew ever closer, and while we were confident we had the art, we still had no venue and no way to pay for it. We began to feel as though we were somewhere halfway between just treading water and starting to drown. It was not a nice place to be – slack time; the doldrums; becalmed in the horse latitudes without a hint of movement on the horizon.

To tackle our funding issue we decided to see if we could presell a couple of the pieces, get the new owners to agree to loan the work back to us for the London show, then use *Ghosts'* share of the income to start covering some of our upfront costs. It worked. With some critical help from Tim Fennell and Charming Baker, *Ghosts* sold its first major piece of art. Now we needed to confirm a venue.

We scoured the northern postcodes and took a site tour around the ruins of old Kings Cross, checking out the abandoned Western Goods Yards, transit sheds and forgotten platforms that would soon be housing a fresh influx of creative talent as Central St Martins decamped to its new location in the Granary Building. We liked the wrecked feel of the spaces, but there were too many holes in the Victorian roof. Birds skittering around in the rafters of our *Ghosts* space would be cool, but torrential rain pouring in onto the art was less appealing.

We went urban birding to the summit of Canary Wharf and talked to the local cultural kingpins about a pop-up Ghosts space squeezed in between the glass and steel financial powerhouses of their relocated Square Mile. The guys from Measure found us some wonderfully evocative old abandoned buildings. London & Newcastle offered us an interesting canal-side space and the Empty Shops Network pitched a *Ghosts* experience that could breathe life back into the empty sites that had previously housed local Woolworths.

OTHER LOCATIONS WE CONSIDERED FOR GHOSTS LONDON

Then someone suggested we should go and talk to Mike Carney at the Rochelle School in Shoreditch.

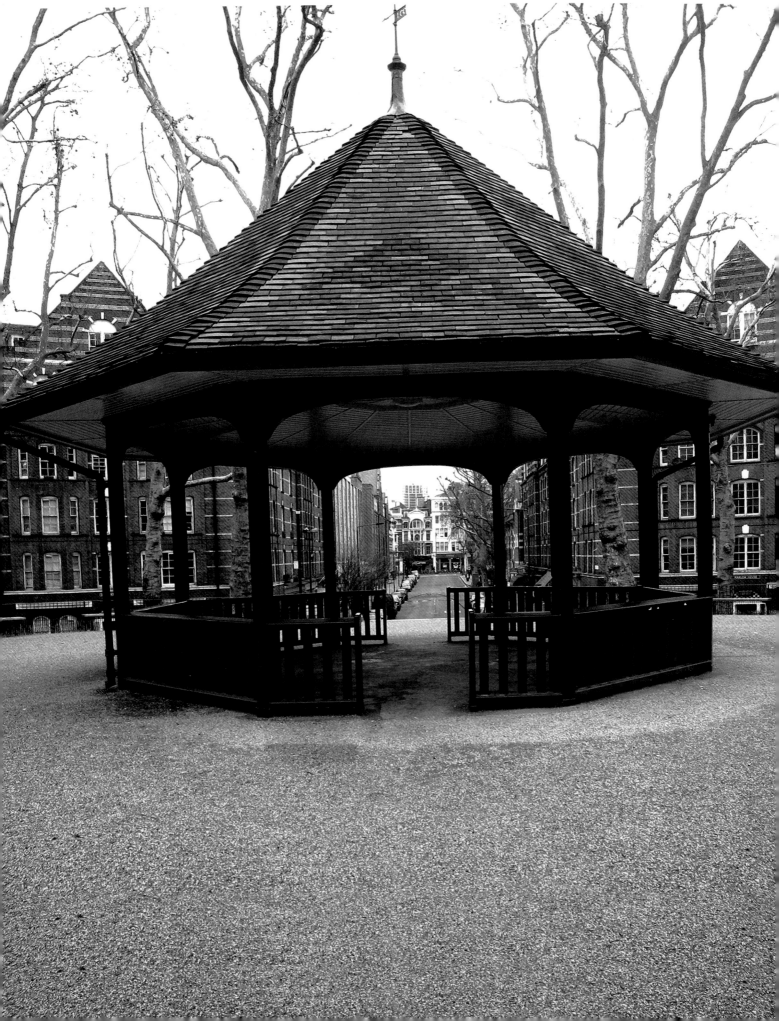

Welcome to the Circus

From the Victorian bandstand you can orientate yourself in any direction, as the six different streets converging on Arnold Circus conveniently operate as all the points of the compass you need.

We'd just had a fine communal lunch (here you go: the food subtext of our narrative resurfaces) of Polish ham and eggs fried with sage at the delightful Leila's Shop on Calvert Avenue, where it seems that no matter how many of you are ordering their signature dish, they'll always find a frying pan big enough to accommodate everything in one sizzling service – and leave it up to you to dive in and divvy up the items.

Suitably refuelled, we were using the elevated vantage point of the bandstand to familiarise ourselves with the surroundings of our newly chosen *Ghosts* London venue. The neighbourhood felt secretive – its history of offering sanctuary to successive displaced generations of incoming refugees gave it an air of reclusive defiance. The bandstand itself had been built out of the rubble of the notoriously overcrowded and decaying 19th-century parish of 'Ragged London', where over 1,400 houses had been crammed into an area of less than 400 square yards. In a strange coincidence (and we kept on spotting these), the area at that time had been called the Old Nichol Street Rookery, so perhaps *Ghosts* London had always been fated to come to roost in Arnold Circus.

The social housing development that rose out of the rubble of the Rookery is even now known as the Boundary Estate and radiates out in every direction from the bandstand. In Victorian times strange trades such as boiling tripe, melting tallow and preparing cat meat were all the rage: more recently, Club Row was the site of an animal market until it was closed in the early 1980s. Now the same street would be the official address and entrance for *Ghosts* London.

The site itself was fantastic: a set of three old Victorian buildings dating back to the 1880s. The Studio Block housed various community art groups and creative start-ups, while the old playground featured a restaurant simply called the Canteen, but the building we were most interested in was the old infants' school with two floors of exhibition space. We'd visited shows there before and it was often used by the RCA, Tate and Saatchi Gallery for their more discrete projects. We hadn't even considered it as a possibility for *Ghosts* London, but then we had taken the suggestion and popped in to talk to Mike about the project, and he had been very supportive of what we proposed to do. Now we were here.

We pounded the pavement and introduced ourselves to some of the neighbours. We were only two minutes away from the high-rise babylon of Shoreditch House, yet the Rochelle School felt as though it existed in a different time zone – the *Ghosts* zone.

The high wall that encircled the grounds of the school only added another layer of mystery: the blank face of impenetrable metal gates gave you no clue to the venue beyond. It was as though someone had decided to circle the wagons and keep the Hoxton Square hipsters at bay. It all seemed rather fitting for the theme of our show: lost, forgotten species being quietly resurrected behind the closed doors of an old school.

Our only concern was the location's status as a fiercely defended conservation area of Grade II listed buildings. Our intention of adorning the site with dazzling bird posters and all-night projections announcing *Ghosts* arrival was abandoned fairly quickly. In fact, it soon became clear that signage of any description around the outside of the venue was not going to happen. Suddenly

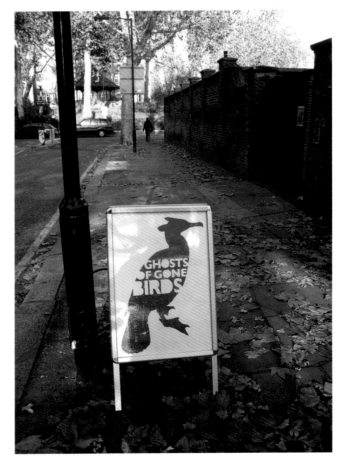

our one very modest little A-board bike-chained to a lamp post looked as though it was going to have to carry the weight and responsibility of all our directional marketing. *Ghosts of Gone Birds* at the Rochelle School was in danger of becoming invisible to the passing public.

One of the strangest stories we heard later was that the buskers at Old Street underground station were being asked on such a regular basis for directions to Ghosts at the Rochelle School that they became unofficial tour guides, politely pointing people in the right direction and reciting the route east almost off by heart.

PR helped. Michael Barrett and Kirsten Canning at the Press Office were the ringmasters of this particular media circus and they did a fantastic job. On a very modest budget, they got the Ghosts gallery story out there to as many audiences as possible. *BBC Wildlife* magazine, EasyJet's in-flight November issue, Visit *Britain's* Britain magazine, *Grafik,* notcot.com and *Creative Review,* as well as the *Financial Times, Spectator* and *Big Issue,* all ran features on the show. Louise Gray at the *Daily Telegraph* gave us a five-star review. We seemed to be on all the BBC radio stations *simultaneously,* nationally and locally.

It was amazing. And revelatory. We started to realise that we'd stumbled onto something way more powerful and compelling than we could have anticipated. Two very different communities seemed to be converging on us even before the show had opened. We were getting editorial coverage in the science and arts sections of the broadsheets. We were doing interviews for *Country Life* and *Time Out London;* for *Harper's Bazaar* and the *Hackney Gazette.* Suburban nature lovers and inner-city artisans were all showing interest in what we were doing.

Ghosts was developing a double-helix DNA. Two separate communities were entwining themselves around the project: conservationists were finding their campaigns and concerns articulated in a totally fresh form, while contemporary art lovers were discovering a project with a clear brief and open-door policy to talents from every imaginable genre. Now we just had to make sure that the show lived up to all the prepublicity and hype.

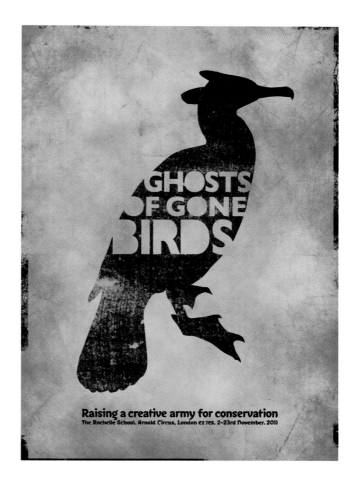

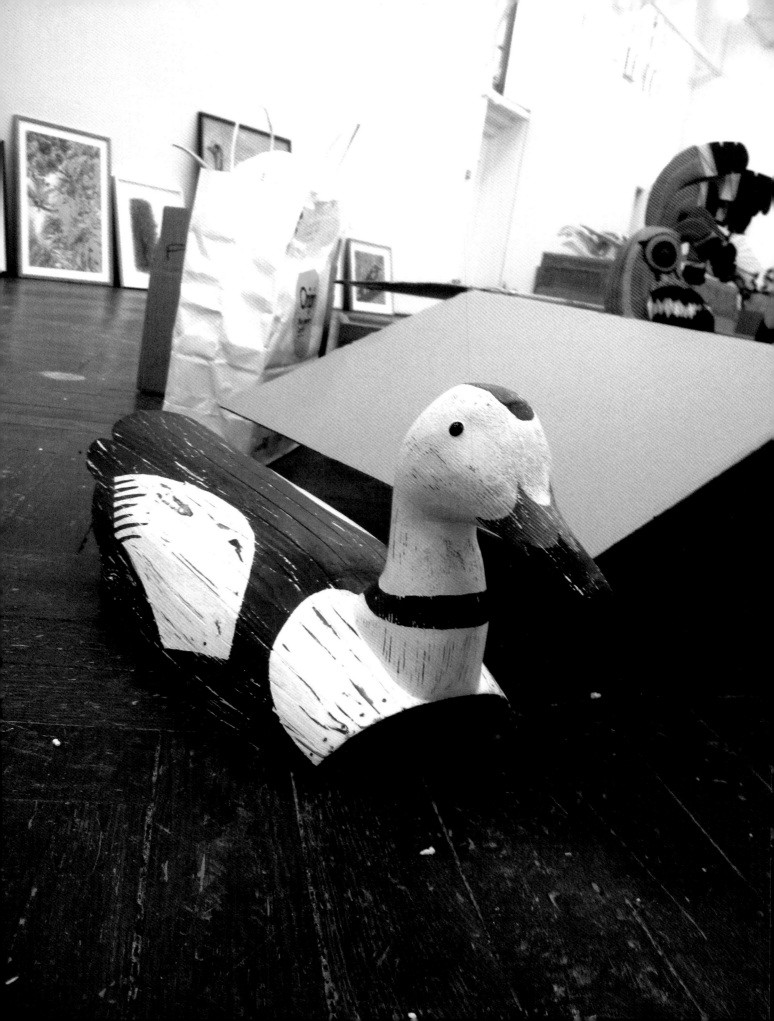

Hanging the Rochelle

The artist was crouched down in an ice-cold corner of the upstairs gallery using a pair of tweezers to carefully position the freeze-dried soldier ants she'd bought off the Internet in such a way that they would appear to be pouring out of a small crack in the floor and attacking the Moorhen. She'd only just flown in from working on a project in New York, but in all the time she spent quietly assembling her installation, her only request was for the odd cup of black coffee to keep her warm as she diligently amassed her insect army on the stone stage of the Rochelle.

It was indicative of the passion and commitment from all the artists that had signed up for the *Ghosts* project. Over the long weekend of the Rochelle Hang, we were lucky enough to meet many of them as they dropped off their work or even rolled up their sleeves, fetched the tool kits from the back of their battered estates and got stuck into helping to put up the work on the walls.

There was a democratic spirit of collaboration –

everyone seemed happy to accept their role in the grand scheme of things. Artists were not only hanging work, but also volunteering to return the following week and help out with the rota for warm bodies to run the reception desk or keep an eye on the upstairs gallery (that really was the short straw: it had its own microclimate that seemed to be permanently set several degrees below the rest of the building, but more of that later). Special mention needs to be made of *Ghosts* artists Gail Dooley, Anita Bruce, Jackie Hodgson and Matthew Killick for their time served in the Siberian section of the gallery.

Over the constant soundtrack of drilling and hammering, the football commentary on the radio kept us in touch with the outside world, announcing on one memorable occasion that Arsenal had beaten Chelsea 5–2 at Stamford Bridge, and although it was a result that none of us would normally have celebrated, we all had to smile. Coffee and croissant runs to Albion were soon supplanted by the arrival of an ancient tea caddy that once nursed

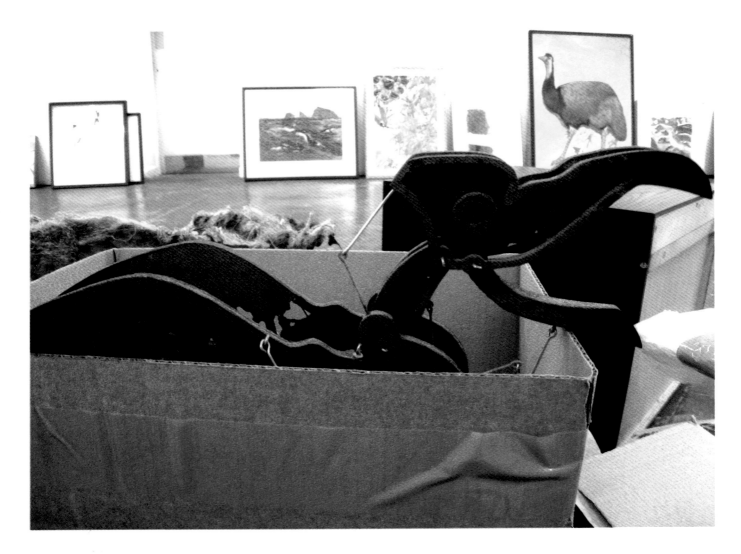

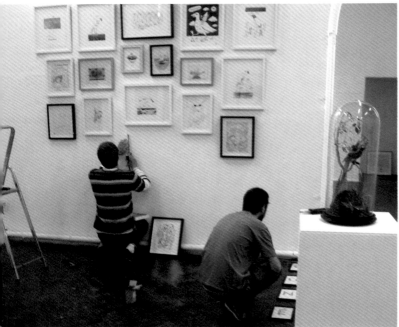

and cajoled into action, wheezed its way to an endless supply of builders' brew tea, honey and Lemsip (it was November and all of us were feeling the cold and damp), and the odd Cup-a-Soup or jug of Java.

The hang itself was proving a little more problematic. The range of work was a joy to behold, but the layout of the Rochelle provided us with a fundamental dilemma: downstairs versus upstairs. Hell's Half Acre beneath Waterloo station had had its torturous nooks and crannies, but they were all consistently damp, dark and unsettling. The Rochelle School, however, was a space of two halves. Downstairs was light and airy – the two rooms at the far end worked as subsets of the main space – while the ground-floor layout even allowed us to decamp our WC1 office into a side room discretely tucked away off the central walk-through.

There was a natural flow to the way you walked this space, and the rhythm of the hang would reflect that: big and small moments; step-ins and step-backs; shades of dark and light, and some nice long perspectives down the full length of the gallery. We sometimes found ourselves thinking like birders, working out the best angle to spot an artwork at a distance.

Diversity was key: we wanted each wall to show as much variety as possible, juxtaposing the most unexpected combination of artists. You therefore might move from a grand master like Sir Peter Blake to a hot contemporary talent like Charming Baker to a young, first-time exhibitor like Barbara Ana Gomez, all within one small stretch of the gallery.

Then there was getting the right variety of birds; *Ghosts* had a big educational point to make. In fact, one of our earliest mission statements for the project was to persuade people to understand that 'Dead as a Dodo' was just the variation of a phrase that could equally be 'Dead as a Hawaiian Crow', 'Dead as a Kangaroo Island Emu' or 'Dead as a Labrador Duck'.

There was also an important role for the first selection of work the visitor would encounter; we wanted people to know that it was OK to smile, even laugh at/with some of the pieces. After all, this wasn't a maudlin, self-flagellating show about the despicable extermination of animal-kind (although that kind of thinking would have its moment upstairs in Room Two). No – this was a celebration of creative life restored to some of the spectacular creatures that most of us never knew existed. It should feel upbeat, life-affirming, approachable, big-hearted and, at certain moments, even huggable. With this in mind, we front-loaded the show with some of our most colourful and charming pieces: Felt Mistress's 'St Helena Hoopoe', Ben Newman's beautiful 'Bishop's O'O" and Emily Sutton's 'Red-Moustached Fruit Dove'.

There was a whole wall of black-and-white illustrations from the pages of Matt Sewell's *Ghosts Colouring Book* (we loved Jon Boam's fairytale-style Rodrigues Solitaire and were sorely tempted to colour it in ourselves on several occasions).

Nick Blinko's 'Bonin Grosbeak' seemed to carry the same bewilderment at extinction that characterised the dark humour of John Keane's 'Dead Parrot Sketch'. Moving further into the show, Edd Pearman's 'We All, Us Four, Will Fly' is a wonderful pastiche of portraited absence, four intricately depicted perches tragicomically relieved of the burden of the bird that should be sitting upon them. It's funny, and terribly sad at the same time. It was that Ghosts double-helix approach working again but in a different way, this time entwining the conflicting emotions the show often provoked – laughter and tears.

The Ralph Room downstairs was a no-brainer. Everybody knows the story (and if you don't, then shame on you: go out and invest in our sister publication, *Ralph Steadman's Extinct Boids,* to fill in the gaps). Anyway, the short version is that we asked Mr Steadman for one portrait of a Gone Bird and he supplied us with 102 Extinct Boids.

Even with Ceri Levi as his valiant wingman, it was impossible to keep Ralph on brief : his imagination obeys no instruction but its own inclination to furiously create, so *Ghosts* London got a fabulous collection of both real extinct birds and imaginary extinct Boids – all on loan from their life of limbo on Toadstool Island (you really need to get the Ralph book if you're not following this).

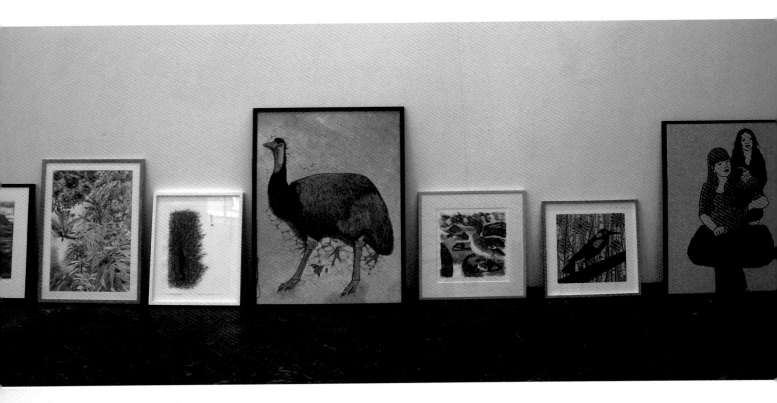

One hundred and two pictures. It didn't get any less frightening when we wrote it down in words rather than digits. That was a lot of art. A floor-to-ceiling amount of art. Some *Ghosts* artists had got back to us and asked if they could do two pieces for the London show – and most of the time we'd said no. Now we were planning a room with 102 pieces by the same artist. We liked the madness of it. We carefully calculated if floor to ceiling would actually be *enough* space. It worked. Just.

Then there were Keith Newstead's wonderful automata creations – a sort of mutant offshoot of the Boids universe, taking Ralph's visuals and bringing them to mechanical life. They'd have to sit on pedestals just outside the Ralph Room. We therefore chose the back room on the right for all the Boids to roost in – floor to ceiling, sometimes four high, tier upon tier of resurrected birds/Boids; tight into the corners of the room; perched precariously over the doorway, waiting to ambush anyone who wandered in.

By the time we'd hung everything, the space had become less of a room and more of a cathedral: the Cathedral of Ralph. It was dizzying. We got in long, low benches because we knew people would *need* to sit down

to take in this body of work. They would need to take their time. They'd also need binoculars to birdwatch the Boids. We were doing exactly what we said we'd do on the tin: breathing life back into the birds we'd lost so we don't lose any more. Art fans were picking up binoculars and discovering the pleasure of birdwatching through the medium of Ralph. It all made so much sense, in a crazy sort of way.

The room next door had a tough act to follow, so we didn't try. It was startling in its un-Ralphness. On the surface, it was cool and cerebral *Ghosts*. It played a different game in muted colours and restrained lines. There was the intricate typography of Brigitte William's word-egg 'Gone', and Cally Higginbottom's wonderful stitched triptych of Bachman's Warbler all embroidered into the canvases of peeled tree bark.

Katrina van Grouw's monolithic study of a Moa skeleton reared up in one corner, threatening to stomp any puny human that dared get too close: for a show about extinction, we had very few artworks that dealt directly with death and its physical legacy. Here we had bones, the structural remains of a Gone Bird, but rather than feeling tragic and defeated, they radiated an immense physical power, an aura of heavy-duty stubbornness that despite the inscribed Maori lament ('We are lost like the Moa') made it clear that this

particular bird would not go quietly into the night.

Then there were Marcelle Hanselaar's two bawdy, almost Hogarthian celebrations of the last moments in the life of the Amsterdam Duck, where the artist is clearly determined to make sure the species goes out on a high. Dark and gothic, they nevertheless have an intense vitality to them. Like Katrina's 'Moa', these birds feel fleshy, feathered and real, part of a primitive ritual of renewal, as if some arcane sex-show performance is going to grant the Amsterdam Duck one last extended moment of fulfilment before it is swallowed up by oblivion.

It suddenly felt like a room bursting with defiance.

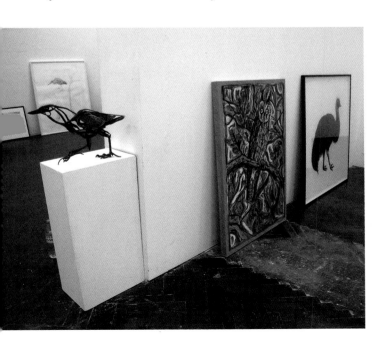

Just look at Desmond Morris's 'The Inconvenient Gift'. Enigmatic to the end, you can still nevertheless decode the bravery of a creature that will not abandon its offspring no matter how overwhelming the threat.

This led to one of the central pieces of the downstairs show: Diane Maclean's sculptural piece, 'Preen', a startling evocation of *Caloenas maculata* or the Spotted Green Pigeon, also known as the Liverpool Pigeon, here captured in a fragmentary reminder of the distinctive plumage of the bird, a delicate iridescent feather necklace recast and resized in shaped panels of stainless steel. The accompanying sketches revealed more of Diane's working process, her growing fascination with the one section of feathers that seemed to have defied the onslaught of time.

A lot of visitors, having completed the downstairs gallery circuit, wandered back into *Ghosts* reception in the false belief that they had completed their tour of duty.

They looked a little shell shocked and frazzled by all the different extinction stories, but they also looked dazzled and delighted by all the art.

Then we would ask them that question: 'Have you been upstairs yet?'

It would sometimes take a while to register, as if we had said something in the wrong language. Then it dawned on them: there was *more* – and when they got upstairs they realised there was a lot more. A whole unsuspected second storey of *Ghosts* London.

Some people said they would come back another time. Others asked if the Canteen was still open. Others just smiled and followed our directions: out of the door, turn right and straight up the stairs. Second floor Ghosts was a different deal. For a start it was a totally different space from that downstairs. It was also cold. You noticed the temperature drop on the stairs and it never climbed

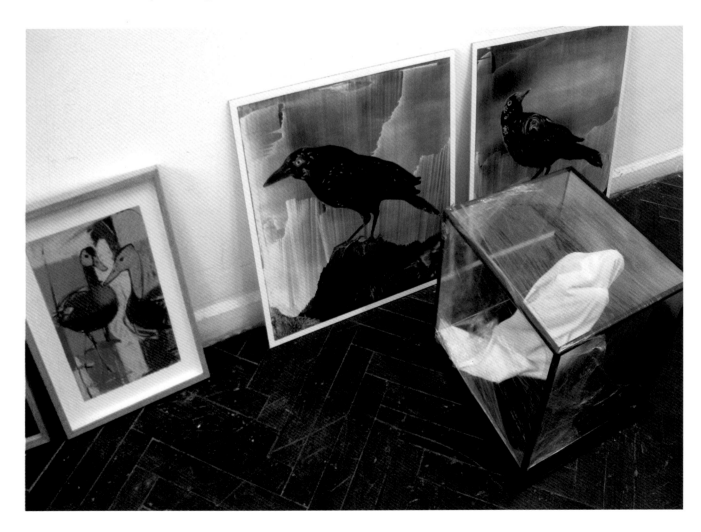

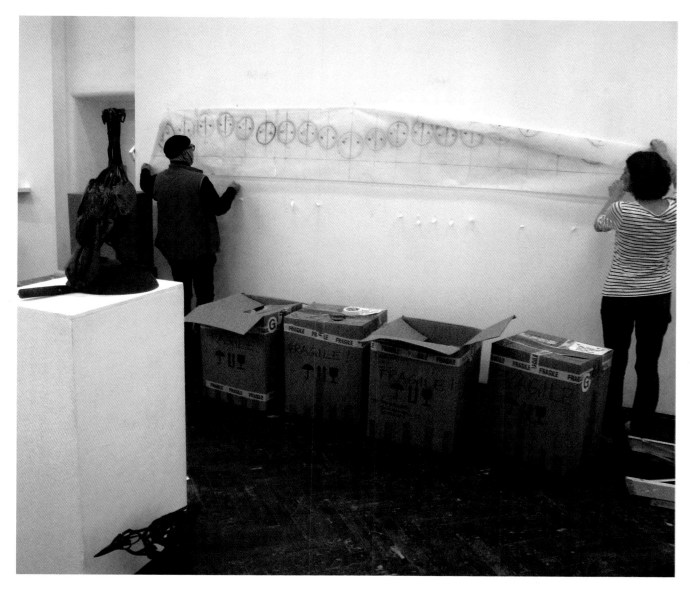

back. Just to emphasise the point, as you walked in there was invariably a member of Ghosts staff wrapped up in several borrowed coats, hunched over an electric heater: it was mid-November and just a tiled roof separated you from the stars above.

There was more to it than just the chill in the air. The place felt darker in mood. The ceiling was low and all the walls seemed to tighten up the space and drill you into a tighter formation. We hung the work to do two different jobs: some walls embraced the gloom (we called this particular spread of work our Gothic Nature selection) while other sequences of art determinedly defied the tone with vivid colour and energetic subject matter.

As soon as you walked in, you were eye to eye with Harriet Mead's 'Ghost of an Emu/Ghost of a Mower', a King Island Emu reimagined from rusting, weather-worn farming and gardening equipment. Wire-wool eyebrows and a chain-mail neck flowed down into a plumage of spokes and spikes, and the powerful legs were seemingly re-engineered out of the nuts and bolts of a scrap-metal yard – resurrection via the god of Meccano.

Its close relative lay plastered against the far wall: Julian Hume's portrait taking the subject of a Kangaroo Island Emu and painting the bird hammered into the dry, cracked ground, impacted like a stray asteroid.

New dangers loomed; in Matt Sewell's delightful 'Stephen Island Wren', the bird's natural nemesis, the cat, lurked in the night sky that engulfed the lighthouse home

exhibition
Continues
Up stairs

(just follow stairs)

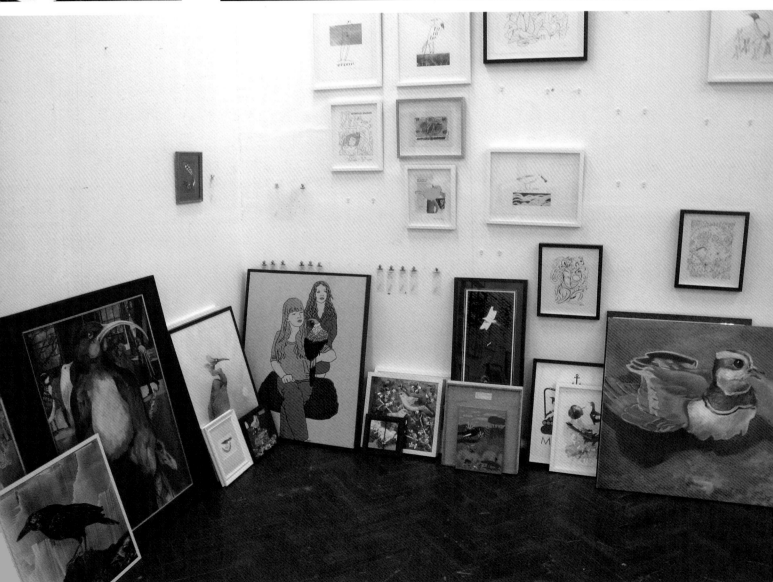

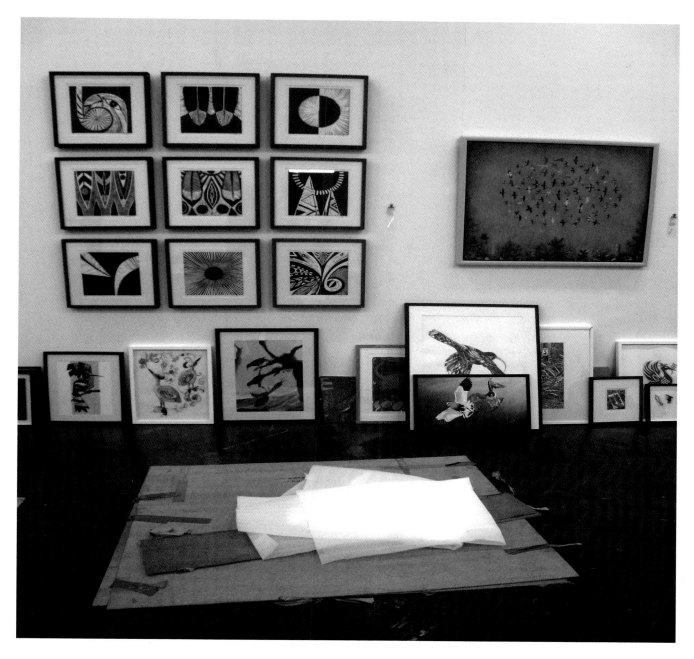

of the species, so oblivious to its impending extinction it happily perches on the tail of its would-be assassin.

Around the corner, *Ghosts* Gothic Nature took hold – from the hunched, bed-sheet ghost impersonation of Polly Morgan's 'New Zealand Little Bittern' and Matthew Killick's duo of black, molten 'Slender Billed Grackles', to Gregori Saavedra's bleak, hyper-realist cry for help from a devastated habitat, advertising its absent 'Reunion Flightless Ibis' with a forlorn missing poster tacked onto one of the battered trees.

Once again, however, there's laughter in the dark:

who could fail to be charmed by Jamie Hewlett's retro-cool 'Hawaiian Crow-mobile' honking its way past a Dodo heading in the opposite direction. Which one is really on the road to extinction, or are both species just stalling for time?

Julian Hanshaw's comic-strip tribute to the Lord Howe Gerygone uses his panel-to-panel story structure to show how a simple chain of events led to devastating consequences. Just check out that last frame. That's the essence of *Ghosts* in one image – two buried bird skeletons simply asking: Why us?

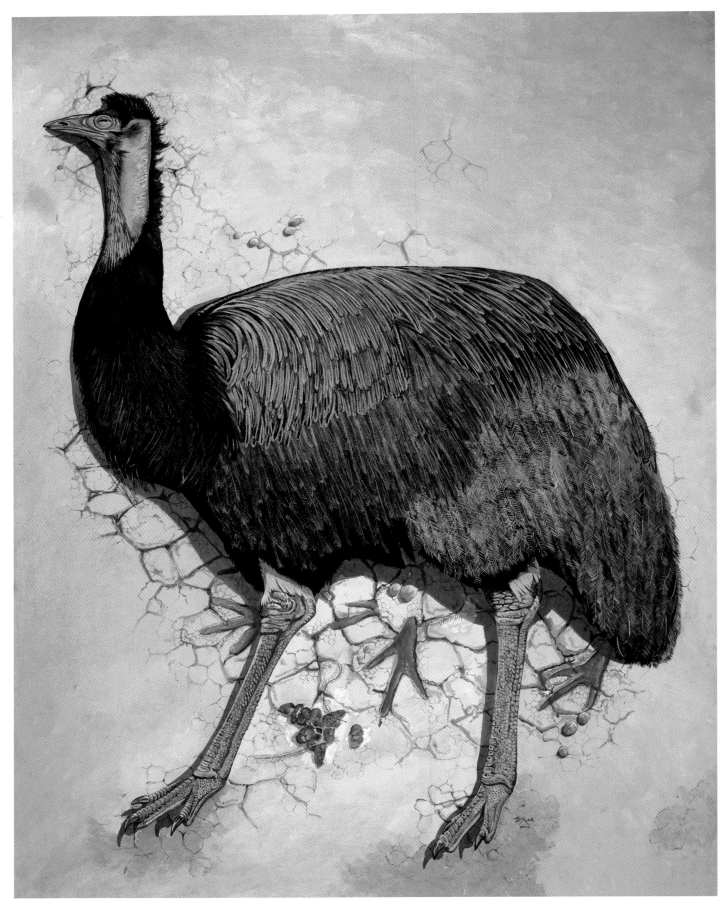

KING ISLAND EMU – *Julian Hume* – OIL ON BOARD

'*The King Island Emu was portrayed life-size in a pose of death representing the very last of the species.*'

REUNION OWL – *Billy Childish* – OIL ON CANVAS

STEPHENS ISLAND WREN – *Matt Sewell* – WATERCOLOUR

'I wanted to paint a small bird such as a finch or a wren then through research I was particularly saddened how this small, green, flightless wren was simply snuffed out by one cat. I wanted to show the whole story of the extinction of the Stephen Island Wren within one simple composition. The massive lighthouse structure shows mankind as an equal villain as the cat in this story of the wrens extinction. Alas the wren is now amongst the stars.'

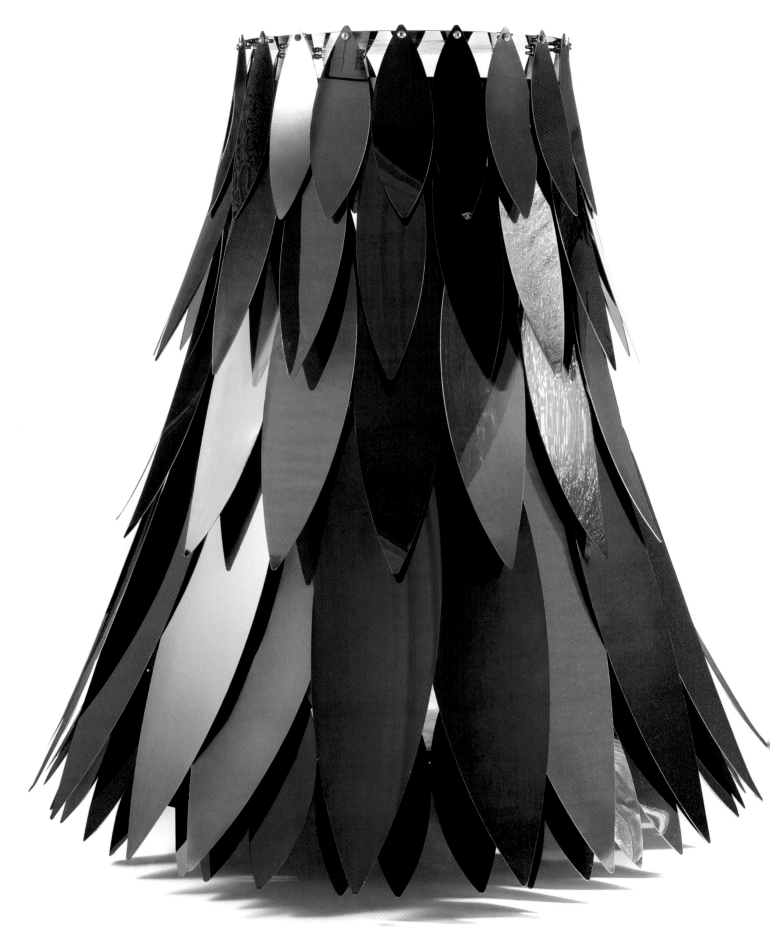

LIVERPOOL PIGEON: 'PREEN'– *Diane Maclean* – COLOURED STAINLESS STEEL

LIVERPOOL PIGEON:
'PREEN' MARQUETTE
– Diane Maclean –

'I went to Liverpool Museum with Ceri and met the curator who brought out the only known specimen in a box. I had fully expected a stuffed bird on a pedestal, and here was a limp bundle of dull feathers, cotton wool protruding from the eye sockets – but! - the long neck feathers were still green and faintly iridescent and I decided this was what I would try to capture. My piece is a neck sculpture, a sort of collier, made of layers of feather shapes of different sizes green coloured stainless steel which is iridescent. It stands alone, a fragment, a reminder.'

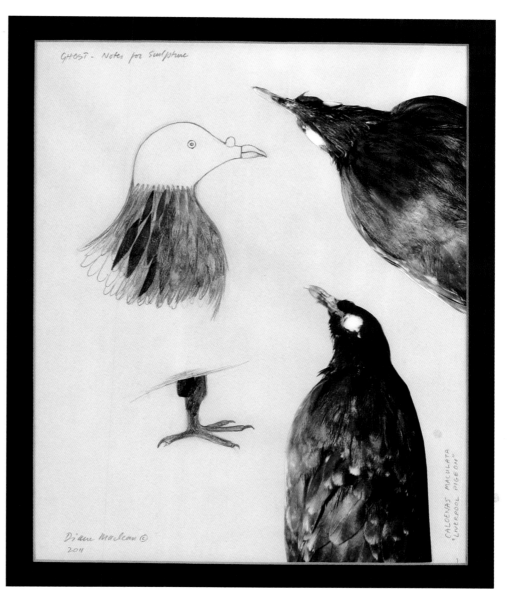

LIVERPOOL PIGEON: 'PREEN' STUDY DRAWING *– Diane Maclean –*

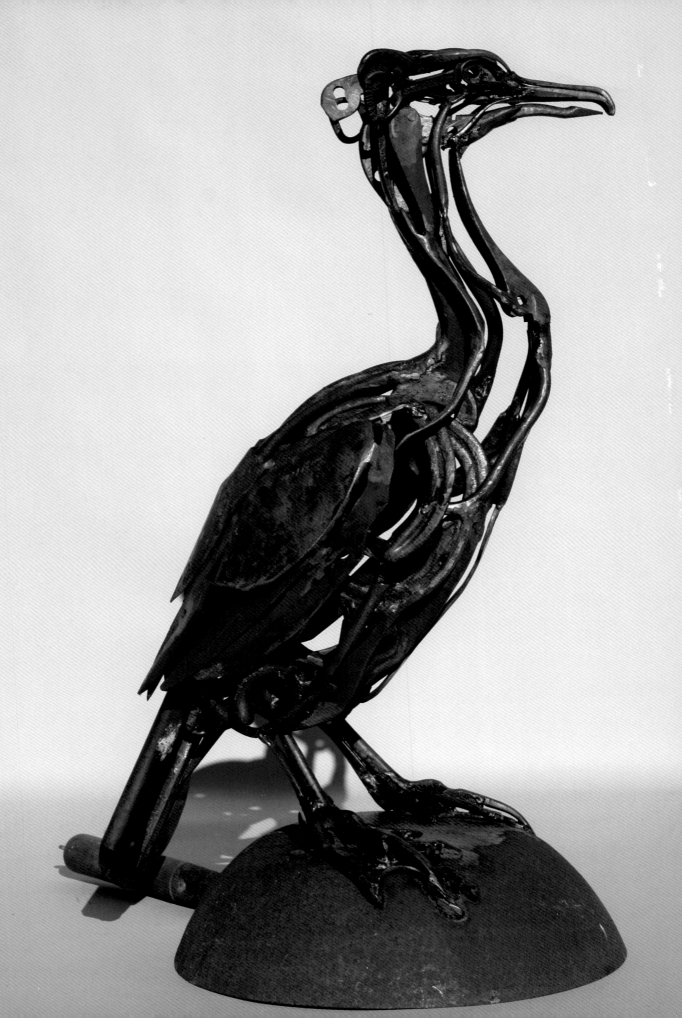

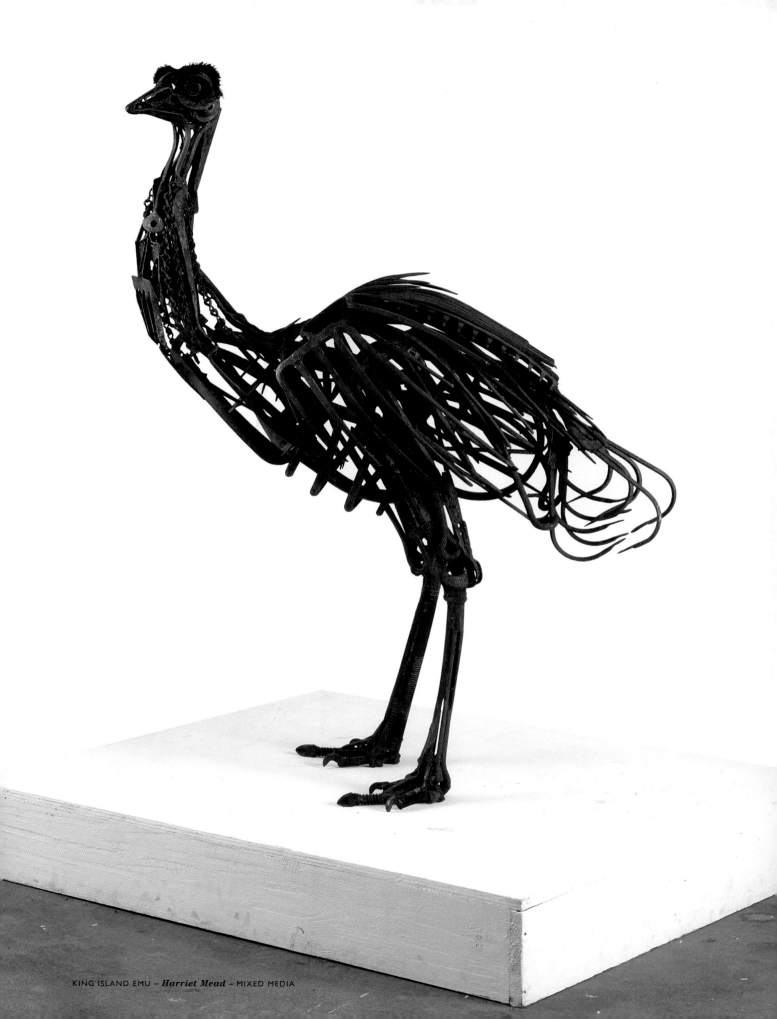

KING ISLAND EMU – *Harriet Mead* – MIXED MEDIA

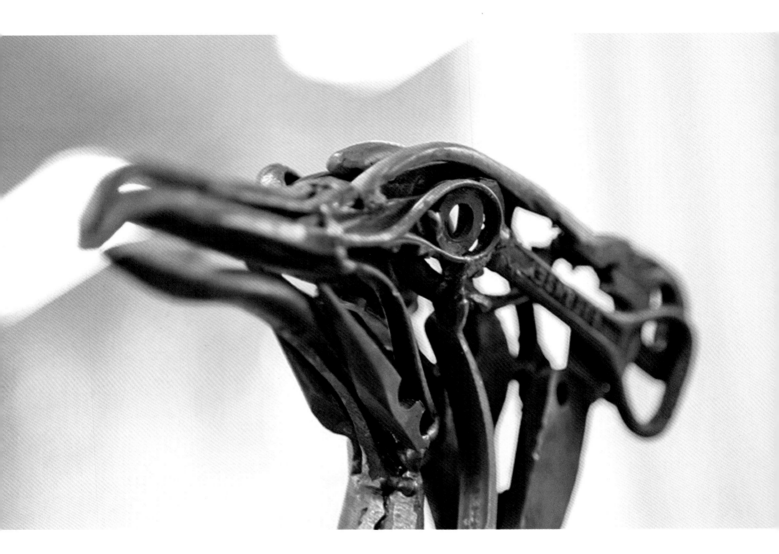

PALLAS'S CORMORANT (DETAIL) – *Harriet Mead* – MIXED MEDIA

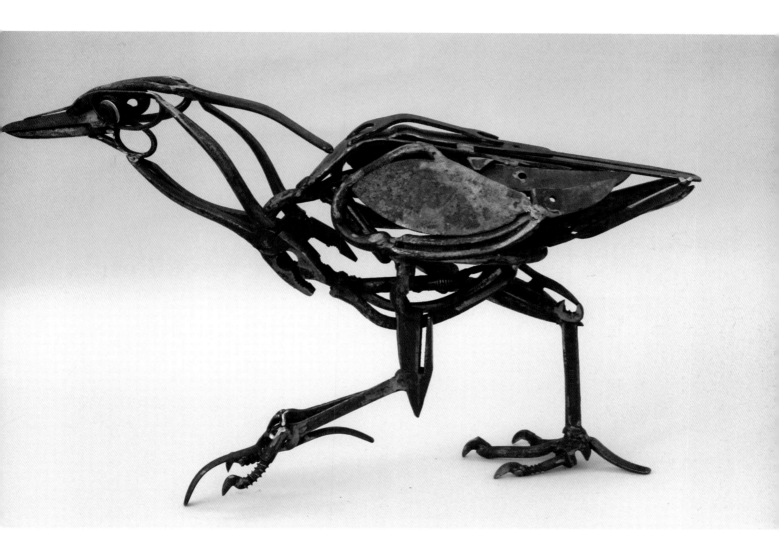

REUNION NIGHT HERON – *Harriet Mead* – MIXED MEDIA

KANGAROO ISLAND EMU – **Hugo Wilson** – PENCIL

'I wanted to give him a sort of defiant look as though
he is aware of the circumstances of his resurrection.'

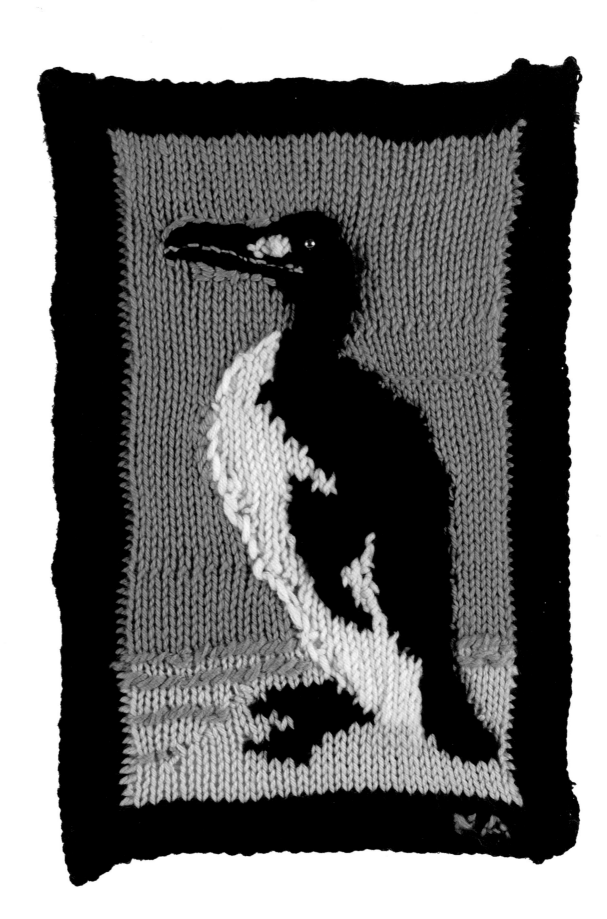

GREAT AUK – *Margaret Atwood* – KNITTED

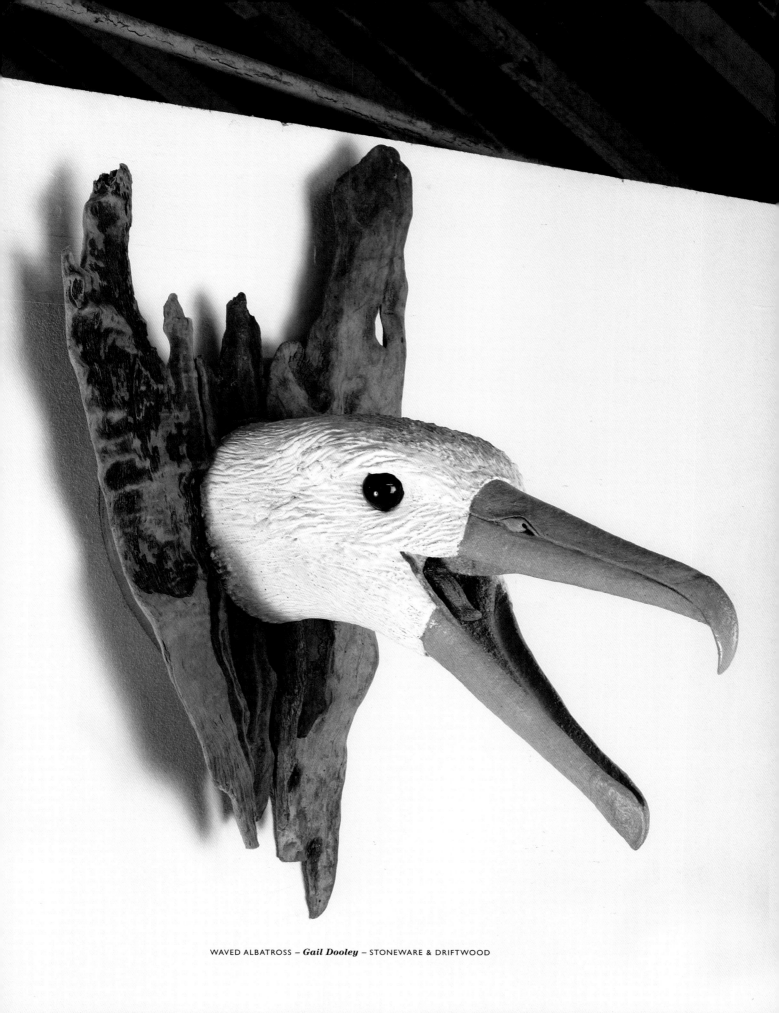

WAVED ALBATROSS – *Gail Dooley* – STONEWARE & DRIFTWOOD

NEW CALEDONIA GALLINULE – **Brin Edwards** – OIL ON CANVAS

'Watching Gallinules digging around in cow pats up to their necks in dung,
I thought maybe I could show the bird picking at a carcass.'

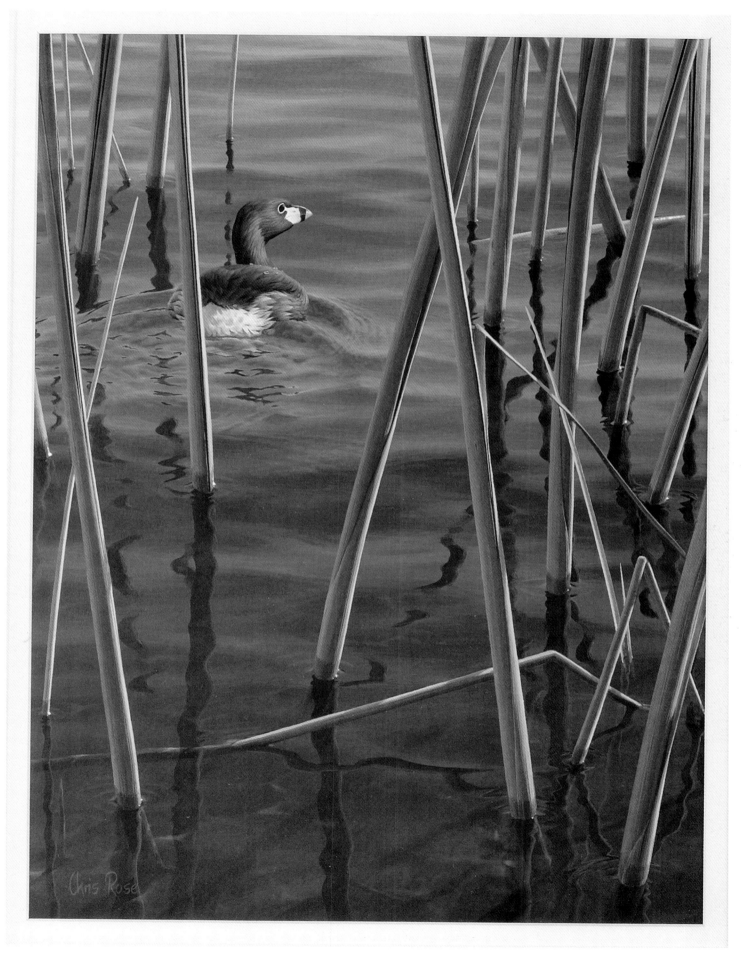

'ATITLAN GREBE' – *Chris Rose* – ACRYLIC ON PAPER

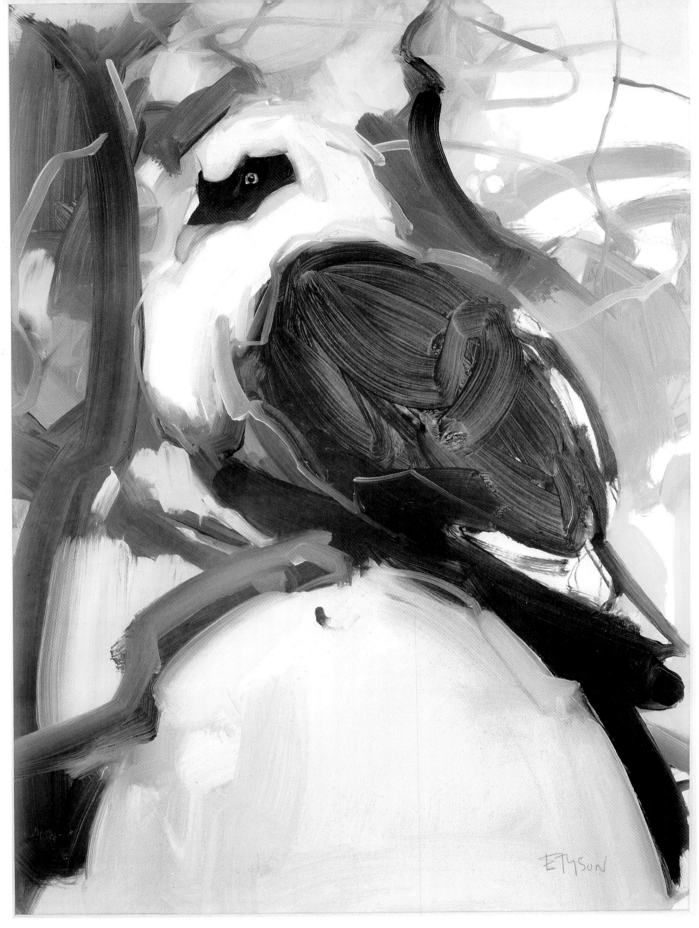

MAURITIUS BLUE PIGEON – *Esther Tyson* – OIL ON PAPER

'I've spent time on Aride Island (in the Seychelles) where I drew the Seychelles Blue Pigeon;
he was drunk but a lovely bird. Thus, I had a starting point and a soft spot.'

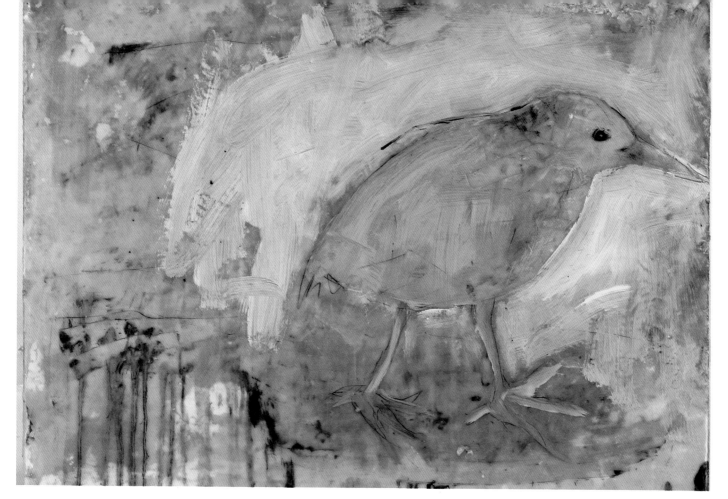

TAHITI RAIL – *Harry Adams* – ENCAUSTIC & OIL PAINT

'The only evidence of them existing is a watercolour painting by George Foster from 1773. It seemed appropriate for an art show about extinct birds that the only way we could do a painting was to work from another painting.'

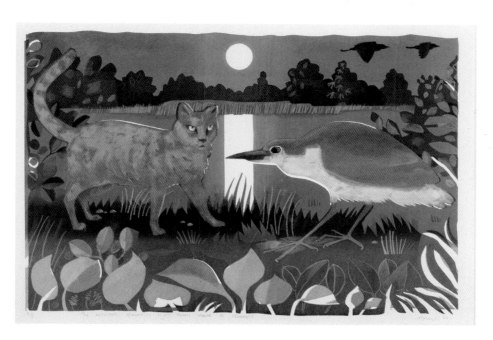

'THE DELICIOUS MAURITIUS NIGHT HERON MEETS HIS NEMESIS THE CAT' – *Carry Akroyd*

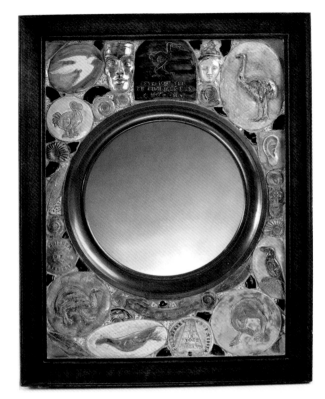

'EXTERMINATED BY CIVILIZED MAN' – *Philip Hardaker* – MIXED MEDIA

HAWAII 'O'O
– *Felt Mistress* –
MIXED MEDIA

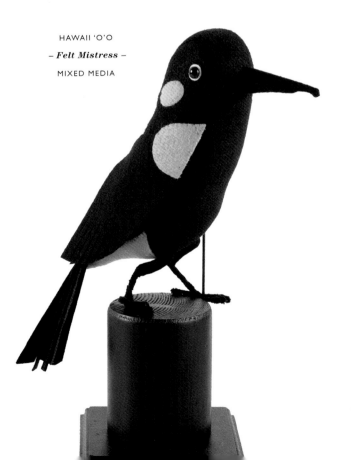

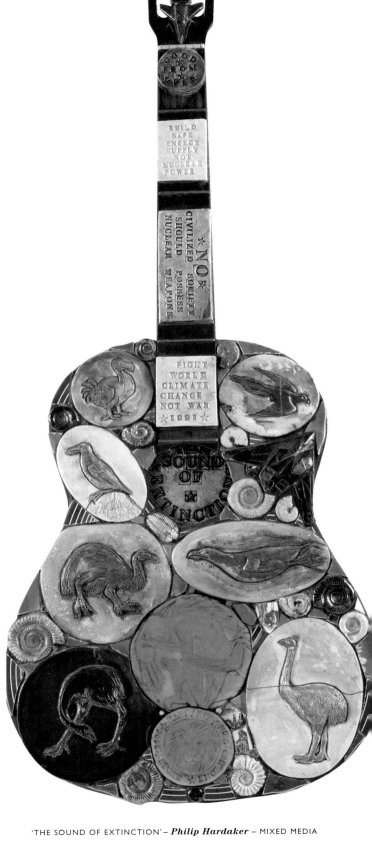

'THE SOUND OF EXTINCTION' – *Philip Hardaker* – MIXED MEDIA

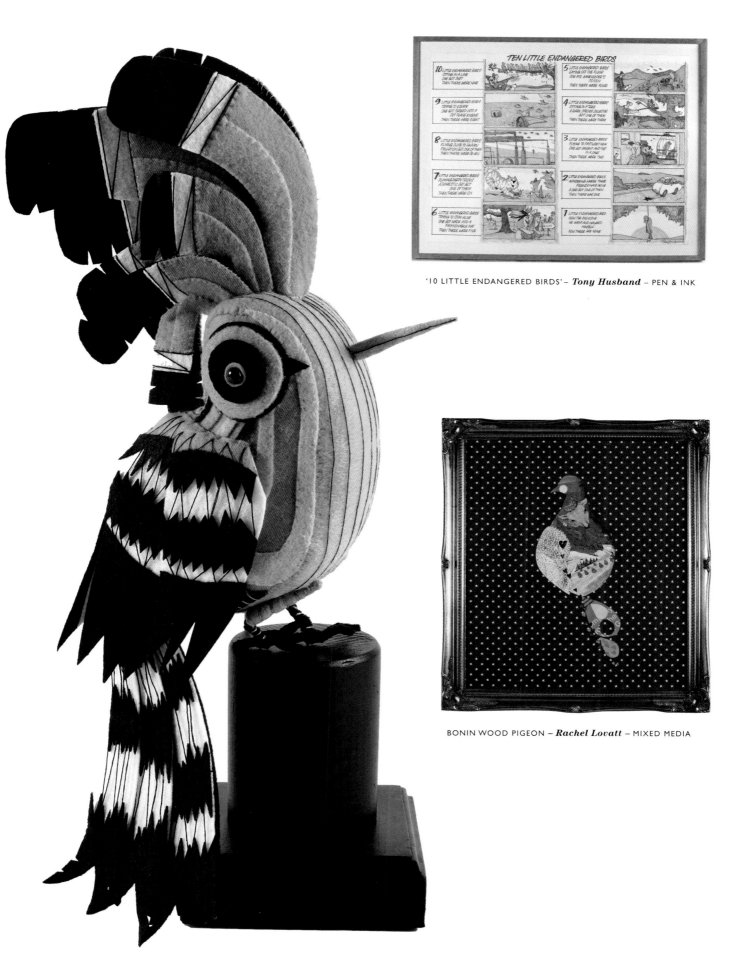

'10 LITTLE ENDANGERED BIRDS' – *Tony Husband* – PEN & INK

BONIN WOOD PIGEON – *Rachel Lovatt* – MIXED MEDIA

ST HELENA HOOPOOE – *Felt Mistress* – MIXED MEDIA

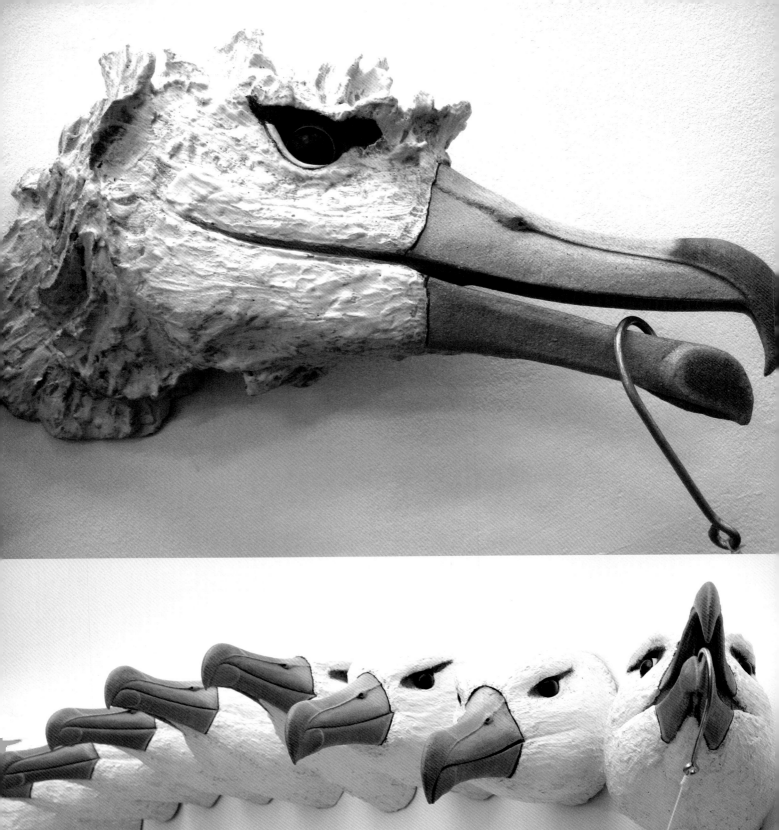

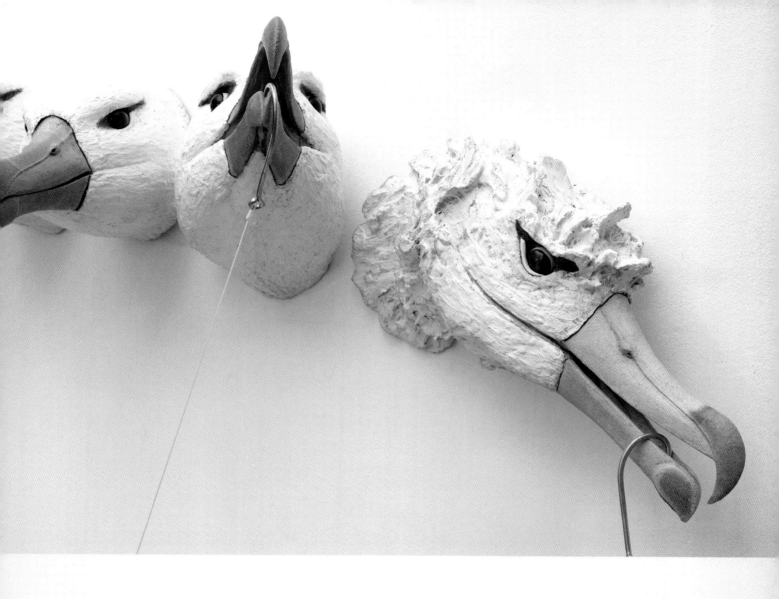

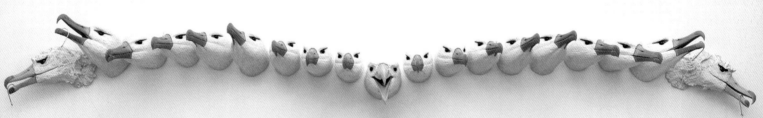

ALBATROSS – *Gail Dooley* – STONEWARE

'My work takes the form of large scale ceramic sculpture. Some of it is humorous and other aspects are derived from a deep concern for the animal kingdom. The Albatross sculpture falls in the latter category. A wandering albatross is surrounded by black browed albatrosses. The sculpture spans 13ft (4 metres), the actual wingspan of the largest albatross, the wanderer. Every year, long line fishermen set out 3 billions hooks killing an estimated 300.000 seabirds of which 100.000 are albatrosses. It's quite a literal piece but I wanted to convey the beauty of the birds whilst at the same time describing their vulnerability and this horrible statistic. 'Albi' is a beautiful musical accompaniment written by Dave Fuller especially for 'Albatross' and produced by Duncan Fuller. It is, I feel, integral to the piece.
https//soundcloud.com/davefullermusic/albi

MOA

Katrina Van Grouw

OIL ON BOARD

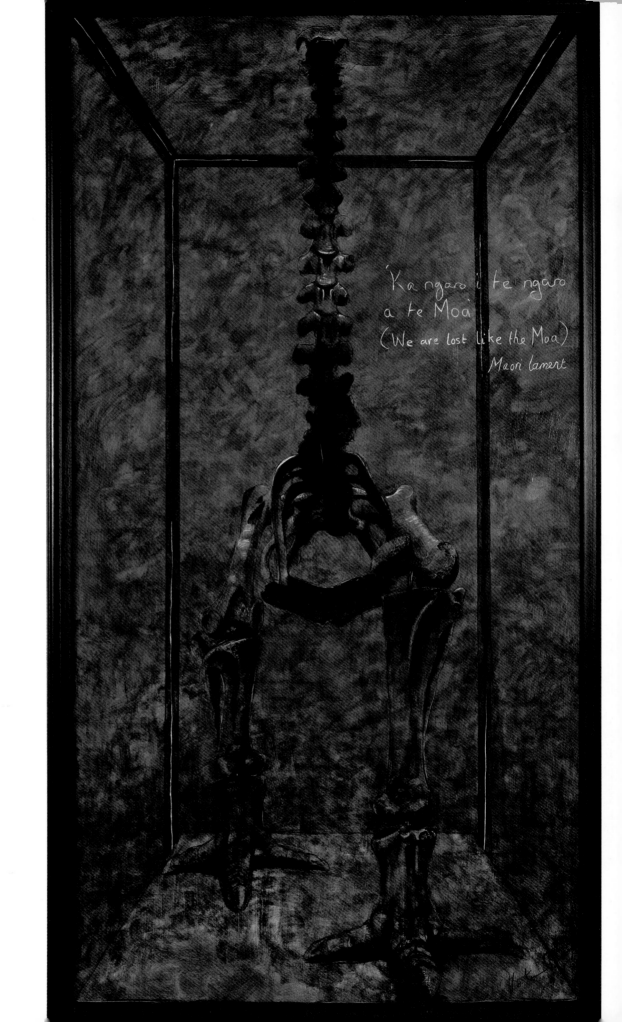

'The triptych piece consists of three embroidered birds, stitched onto a piece of tree bark. The reason for this is because the Bachman's Warbler was a woodland bird and it is embroidered because this is a dying handcrafted profession due to technology development. This piece represents deterioration as it starts with a perfectly stitched bird followed by a lesser finished bird with missing stitches. With the use of the dying craft, this piece represents the death of the Bachman's Warbler.'

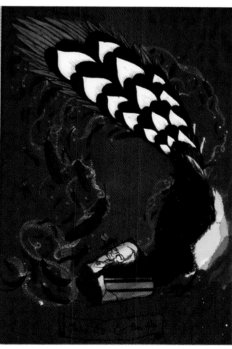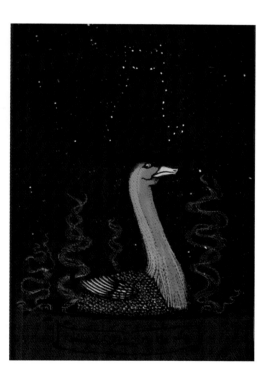

BACHMAN'S WARBLER – *Cally Higginbottom* – EMBROIDERY ON BARK

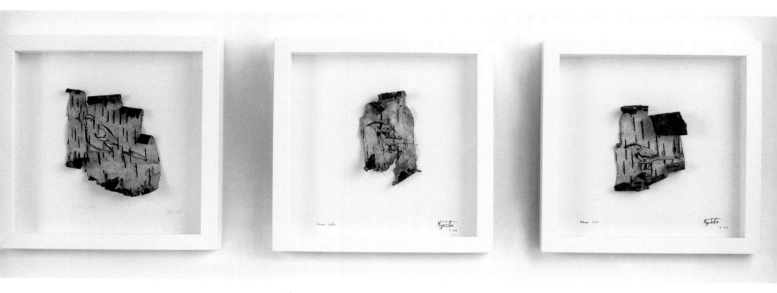

RAIATEA PARAKEET & THE CITY, OAHU O'O' & THE CITY, RODRIGUES SOLITAIRE & THE CITY – *Barbara Ana Gomez* – PEN & INK

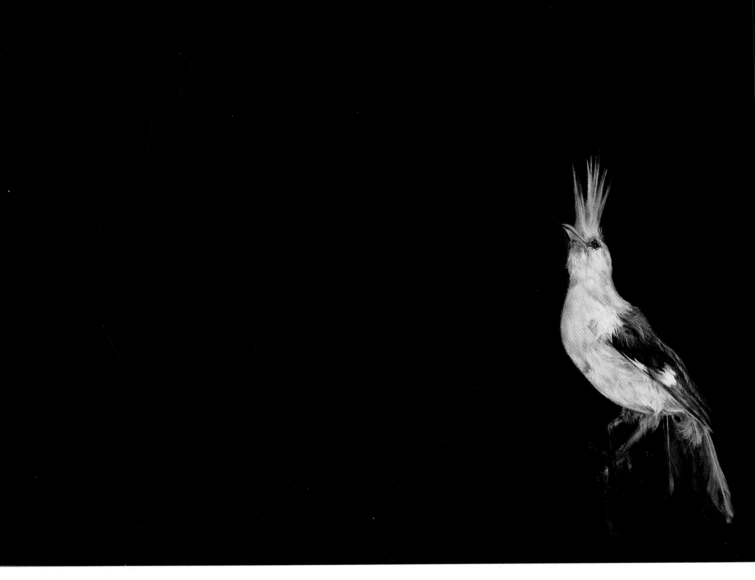

REUNION STARLING – *Rebecca Foster* – OIL ON CANVAS

'I was lucky enough to be able to visit the Natural History Museum archives out in Tring. The work I created was a reaction against the static, dead bird I was faced with and the sadness of this. I wanted to animate him and create a painting that looked as though he was alive and about to take flight. I think I was quite taken by the Mohican hairstyle.'

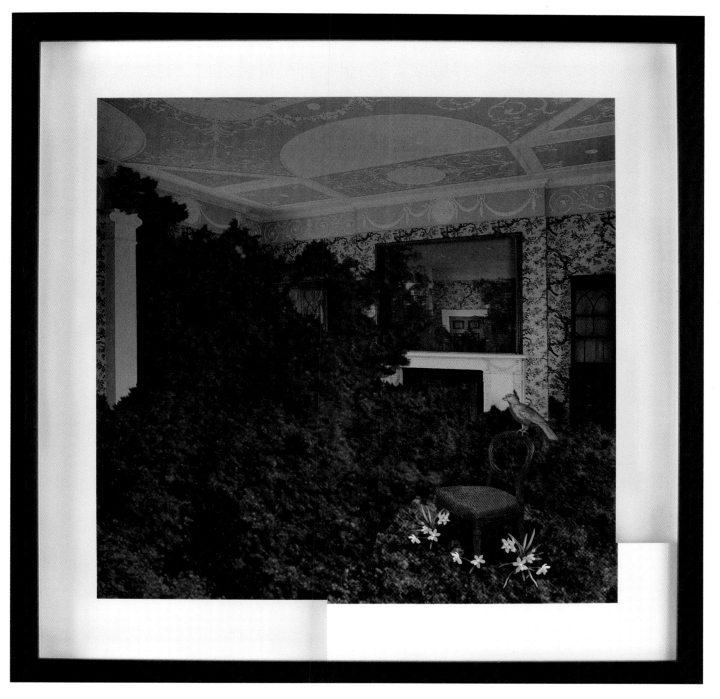

MARTINIQUE AMAZON: 'THE JOURNEY HOME' – *Suky Best* – PHOTO COLLAGE, EDITION OF 5

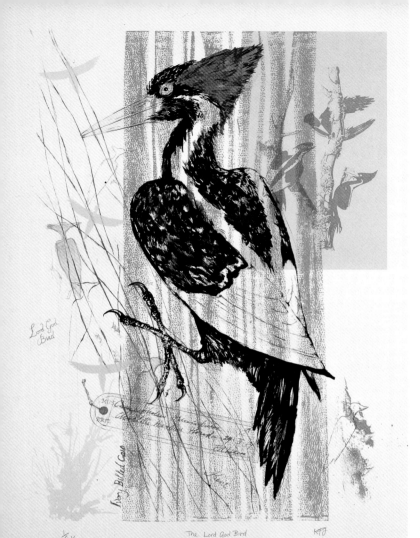

Lord God
Bird

Ivory Billed Cone

The Lord God Bird KFJ

⅙ V

IVORY-BILLED WOODPECKER – *Kate Fortune Jones* – SILKSCREEN

'The Ivory Billed Woodpecker is a bird that I find endlessly fascinating, from an historical context, as well as for being a significant player in the birth of the conservation movement. The bird's story is one of many chapters which clearly define a modern tale of extinction, one which could have been prevented if man's greed for commerce and drive to modernity had not been so recklessly pursued.

For a long time I've had a keen interest in the birds of North America. Having been fortunate enough to visit America frequently since I was 13, I have grown familiar with American birdlife and unlike the UK, where we only have a disappointing 3 species (and one of those is in trouble), the US boasts a fine range of colourful woodpeckers. A while before Ghosts was conceived, I had become a little 'obsessed' by the Ivory Bill, by the tragic fact of its very recent extinction and the whole controversial saga of ongoing sightings; the desperate attempts to rediscover the bird in some secret fragment of America's remaining ancient forests.

The Ivory Bill has been listed by the American Bird Association as a Class 6 Species -"definitely or probably extinct", hence my choice for inclusion in this exhibition. Interestingly my first pocket guide to American Birds recorded the Ivory Bill as "very rare, but extremely localized to southern swamp forests." So as a teenager I thought that the bird still existed and daydreamed about seeing one!

To me, the bird represents a very contemporary understanding of extinction, it is significant because its demise feels tangible, the bird exists in photographs and film from the 1930's, and there are a few people still alive today who have witnessed its disappearance. The Ivory Bill's story is important because every episode of its loss has been documented, every reason for its disappearance traceable and unequivocal, unfounded rumours of re-appearance are still happening, which in turn initiate a frenzy of international discussion. The upside of this is the heightened awareness of species in peril and real efforts being made in the conservation cause.

Another reason for my choice is one of historical interest and the connection with James John Audubon – the French-American ornithologist and artist, of whom I am great admirer. Audubon's famous depiction of Three Ivory Bills foraging on a rotten tree is inspiration enough, but it is also his writings that offer the historical context, documenting the changing face of frontier America. Through his journals we are able to imagine the wild, virgin landscapes he encountered, where flocks of Passenger Pigeon 'darkened the skies' in their mass abundance, but were extinct by 1914.

Of particular interest are Audubon's descriptions of prime Ivory Bill territory along the Mississippi delta– the vast swathes of ancient cypress forest that once carpeted the bottom lands of America's broad southern rivers. It was in the early 1800's that Audubon collected and painted his Ivory Bill Woodpeckers for his groundbreaking book The Birds of America. Yet at this time he records a marked decline in the bird's number. Sadly it seems the path to extinction for the Ivory bill had begun in Audubon's day, as timber companies were embarking on their rapid destruction of millions of acres of primordial forest.'

ULAI-AI-HAWANE, KAUI O'O', GREATER AKIALOE, KONA GROSBEAK – *Mike Warren* – ACRYLIC ON PAPER

'I visited Hawaii in the late 80's. When I was on Kauai, in the vicinity of the Alakai wilderness, I recall pondering the fact that species had become extinct there in the 50's, just some thirty years earlier while I was at school.'

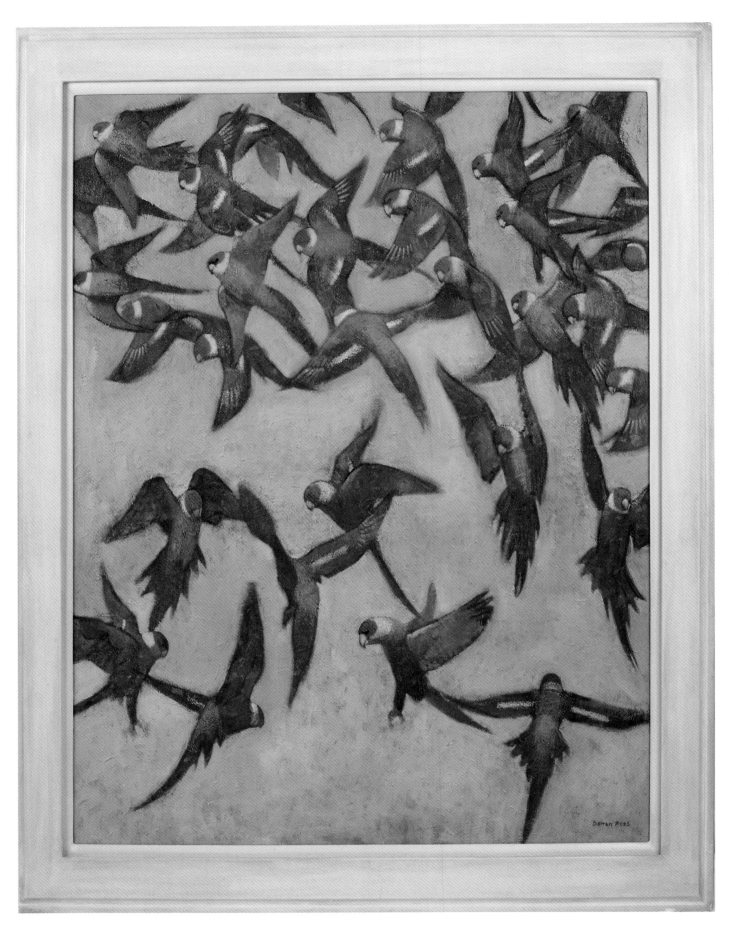

CAROLINA PARAKEET – *Darren Rees* – OIL ON CANVAS

'MYTHS NOT LEGENDS' – *Justin Wiggan* – SOUND INSTALLATION

'*This takes UK bird song and reduces its speed by 200%, opening out the huge range of complex melodies that they possess and also beginning to mimic whale song. I then forged this with the sped up song of humpback whales to reverse the species. The birds become whales, the whales become birds. The juxtaposition of sound explores how we have lost our original given-role to take care of the planet and how the gap between man and wildlife has ever increased to the point of non-recognition. Our husbandry has been lost: we stare in disbelief into a void of noise whilst the songs of these creatures is ignored and misunderstood, leading to a symbolic swap of their roles, the whales being passed into the sky and the birds doomed to land / sea habitation. The wall piece was created by designer Stephen Paxford, who looked at the mythical elements of the golden age of creature discovery / ocean woodcut maps to create WHALEBIRD and the beautiful headphones were created by artist Karen Garland.*'

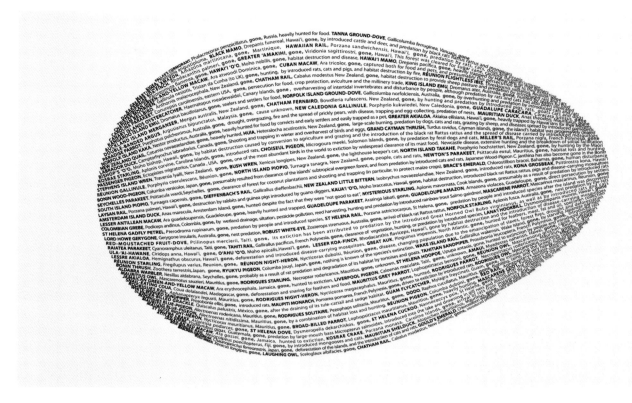

'GONE' – *Brigitte Williams* – PRINT, EDITION OF 100

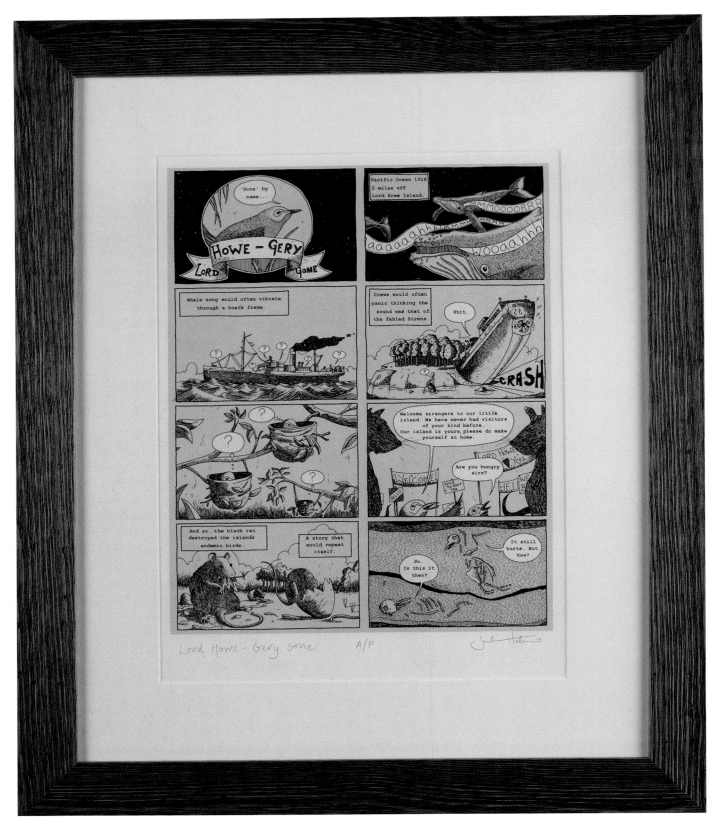

LORD HOWE GERYGONE – *Julian Hanshaw* – PRINT

'I found out that its demise was due to a cruel stroke of bad luck, a ship running aground on the island. The ship wreck that started the chain of events suited the sort of sequential art form that I do.'

NEW ZEALAND LITTLE BITTERN – *Jonathan Gibbs* – WOOD ENGRAVINGS

WHITE GALLINULE – *Al Murphy* – PEN & INK

HUIA BIRD – *Guy Mckinley* – WATERCOLOUR & GOUACHE

BLACK MAMO – *Showchicken* – PEN & INK

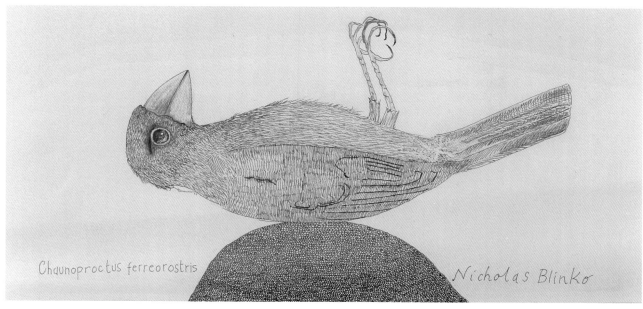

BONIN GROSBEAK – *Nick Blinko* – INK ON PAPER

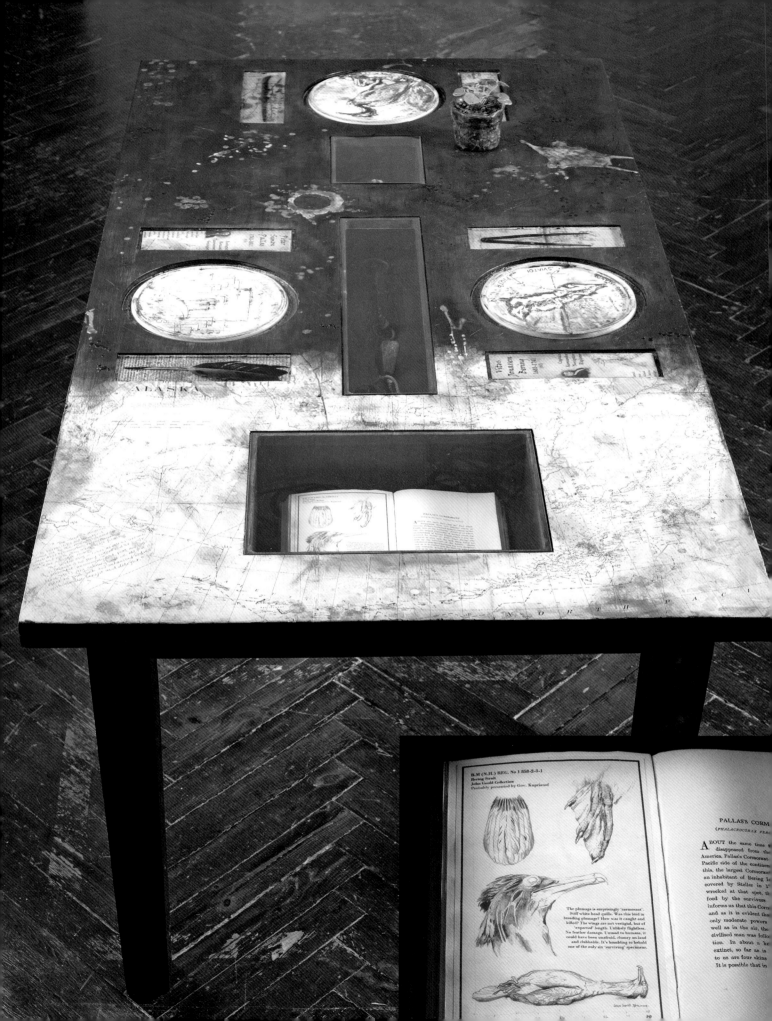

B.M (N.H.) REG. No 1 858-2-3-1
Bering Strait
John Gould Collection
Probably presented by Gov. Kuprianof

PALLAS'S CORM
(PHALACROCORAX PERS

ABOUT the same time t
disappeared from the
America, Pallas's Cormorant
Pacific side of the continent
this, the largest Cormorant
an inhabitant of Bering Is
covered by Steller in 1
wrecked at that spot, th
food by the survivors
informs us that this Coro
and as it is evident that
only moderate powers
well as in the air, the
civilised man was follow
tion. In about a hu
extinct, so far as is
to us are four skins
It is possible that in

The plumage is surprisingly 'cormorant'.
Stiff white head quills. Was this bird in
breeding plumage? How was it caught and
killed? The wings are not vestigial, but of
'expected' length. Unusual to humans, it
could have been unafraid, clumsy on land
and clubbable. It's humbling to behold
one of the only six 'surviving' specimens.

'When I first googled Pallas's Cormorant, it was also described as a clumsy, stupid and ludicrous bird by its observers, so I guess that cemented it in a supporting the underdog sense!

What I didn't expect however was how involved I would become with this bird and its history, what journeys it would take me on in my research and what ideas for new ways of working this would propel me towards. Pallas's Cormorant introduced me to an intriguing array of characters, a gripping plot line and I became more delighted with my choice as time progressed, and strangely possessive of it also. So for all these experiences, I feel immensely grateful to the wonderful, if clumsy, *Phalacrocorax perspicillatus!*

Rather than a basic portrayal of Pallas's Cormorant, I needed to convey some of the wider issues around its unfortunate demise – a hint at the sequence of events leading up to the fateful last sighting in 1850, and the characters involved in the repercussions of its discovery. It took a mere 100 years from the first written description by naturalist Georg Steller for humans to hunt this bird to extinction.

In 1741, the Russian-commissioned voyage of the Sviatoi Piotr captained by Vitus Bering saw their first discovery of American shores. Steller was the naturalist and doctor on board, writing copious journals throughout from which the full story can be gleaned.

It was a result of bad navigation, a chance shipwreck on Bering Island and the ingenuity of Steller in saving some of the crew's lives that eventually lead to the bird's downfall at Russian hunters' hands. Ironically the consumption of some cormorants played an important part in this survival of the naturalist and the scurvy-ridden crew, and so were an unwitting party to their future demise. Bering, however, died on his eponymous island.

Naturalist and scientist, Peter Simon Pallas translated Steller's journals of that fateful 1741 voyage, studied and classified the cormorant, hence giving it, through this one written account and a handful of specimens, its final place in avian history.

The piece is an in memoriam, perhaps also an altar, to this clumsy, tasty, easily-caught cormorant that satisfied the appetites of three hungry men. A testament to the last supper of the last cormorant played out through the gathering of the three men who were the key to the bird's discovery, description, destruction and taxonomy.

The inscriptions and objects pertain to details and hardships of the voyage, key dates and the wider story concerning my personal entanglement with this bird. The piece hints at the physicality of the bird through the plumage colours of the varnished finish and box interiors. The weight box contains a navigational sounding lead and the related weight of the cormorant, 13lbs. On one leg is a gentle reminder of the current endangered species on Bering Island'.

'NORFOLK ISLAND KAKA' – *Lyndall Phelps* – MIXED MEDIA

'I had been thinking about making a series of camouflage nets for endangered or extinct birds, and this seemed to be the right occasion to start. The net will be made from crochet cotton and glass beads, using colours from Gould's illustration of the Norfolk Island Kaka. These materials reflect the killing of birds for their feathers, for fashion and the goods used to barter for specimens on expeditions. Beads were used by Alfred Russel Wallace on his trips to Malaysia and other locations to search for and collect exotic specimens.'

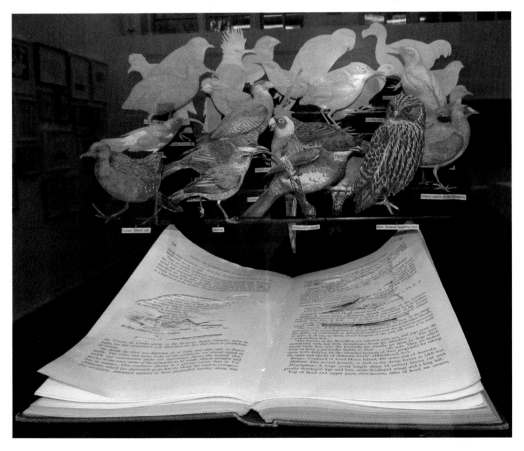

'EXTINCT AND VANISHING BIRDS' – *Su Blackwell* – MIXED MEDIA

'VOLATILE' – *Giulia Ricci* – SHORT FILM

'Volatile was inspired by the wider concept of Ghosts of Gone Birds and is a reflection on the fragility of all birds that risk extinction; the word volatile has a double meaning because in Italian it's a synonym for bird. The film is a collaborative piece, which is supported by Jimi Goodwin's emotive music, and was filmed and edited by Ceri Levy.'

LABRADOR DUCK – *Alex Malcolmson* – WOODEN SCULPTURE

'The 'Labrador Duck' is based on drawings from two of the very few remaining examples in Liverpool Museum. The body of the bird is a slatted form, which combines the idea of a bird and a boat. It is in part inspired by the Shetland tradition of upturning worn out boats for use as a roof which gives the vessel a new lease of life; sadly not something that can be done for the Labrador Duck. The form also draws on the tradition of decoy carving - this species was shot by wildfowlers.'

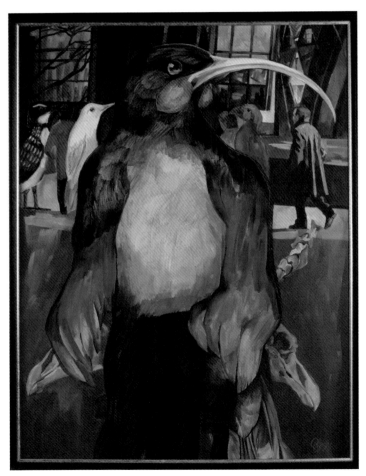

PASSERS BY – *Olga Brown* – OIL ON CANVAS

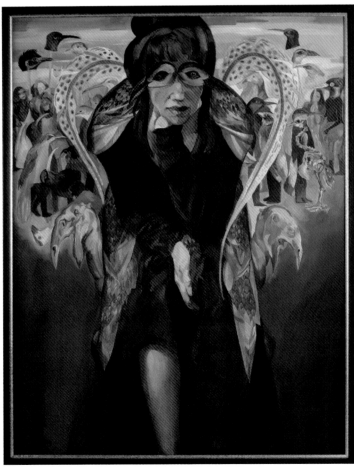

CARNIVAL – *Olga Brown* – OIL ON CANVAS

'NO GO FOR THE DODO' – *Robert Gillmor* – LINO CUT PRINT

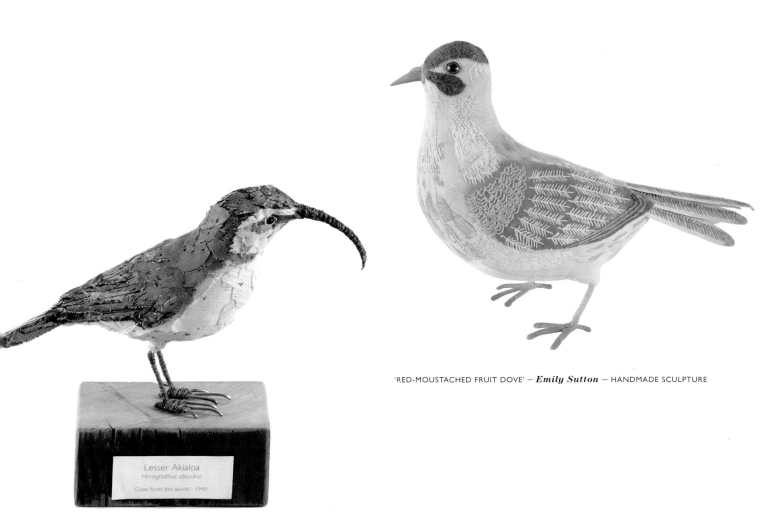

'RED-MOUSTACHED FRUIT DOVE' – *Emily Sutton* – HANDMADE SCULPTURE

'LESSER AKIALOA' – *Abigail Brown* – MIXED MEDIA

Lesser Akialoa
Hemignathus obscurus
Gone from this world - 1940

The Spotting and Jotting Ghosts Colouring Book was beautifully put together by Matt Sewell and featured a wonderful selection of illustrations by artists such as Ghost Patrol ('the Mauritius Owl'), Alex Jako ('the Giant Hoopoe'), Oliver Jeffers ('the Rodrigues Owl'), Kevin Waldron ('Five Bonin Grosbeaks'), Marcus Oakley ('the Laughing Owl'), Oliver Hibbert ('Dodo') and You Byun ('the Greater Amakihi').

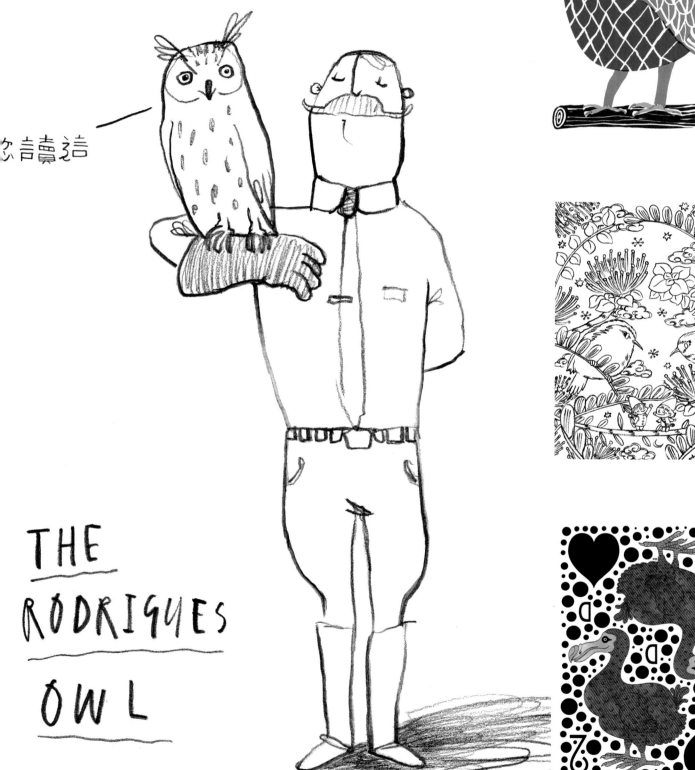

您讀這

THE
RODRIGUES
OWL

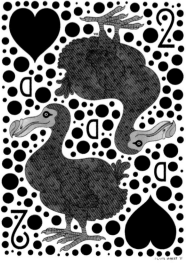

RODRIGUES STARLING – *Melanie Tomlinson* – MIXED MEDIA

'I love all birds and particularly the Starlings that crowd the tree in my back garden in inner city Birmingham. I chose the Rodrigues Starling as I wanted to explore this member of the Starling family. I had no previous knowledge of this bird and was interested to find that some of the plants sharing its habitat also became extinct along with the bird itself. The two Rodrigues Starlings in my piece sit amongst flora from the island of Rodrigues – the home of the Rodrigues Starling before it became extinct. Flowers include Dianthus Caryophyllus a wild Carnation, Conkerberry, Bay Cedar and Hibiscus. Each flower has been painstakingly created in gouache before printing onto sheet tin. The white flowers are called Cafe Marron and were also thought to be extinct from the island. But they were rediscovered in 1980 and nurtured. I dream that the Rodrigues Starling like the Cafe Marron is simply hiding from humans and that one day it will re-emerge and flourish again.'

GREATER KOA & LESSER KOA FINCH – *Claire Brewster* – MIXED MEDIA

'The idea was to show the beauty of something we have lost and the general fragility of nature.'

ALDABRAN BRUSH WARBLER – *Kim Atkinson*

'I wanted to make a piece that would seem like a museum drawer with a sonograph of the last recorded song of the bird...
The sound of a bird lasting beyond its body, an imagined trace of that sound. The bird was studied in the 1970's using
recordings played to birds to get the bird to respond and thus give away its presence. Often all we know of a bird's
presence is its sounds: if we don't hear it, if for whatever reason we are deaf to it, does it cease to exist?'

EMPTY NEST – *Jackie Hodgson* – RAW SILKS, NATURAL FIBRES AND STITCH

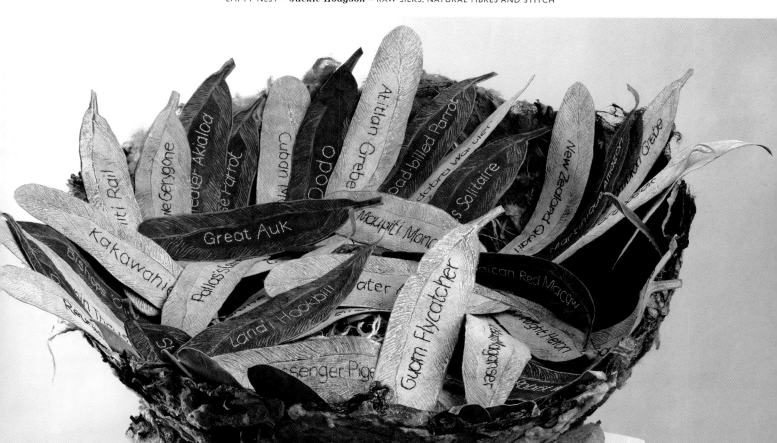

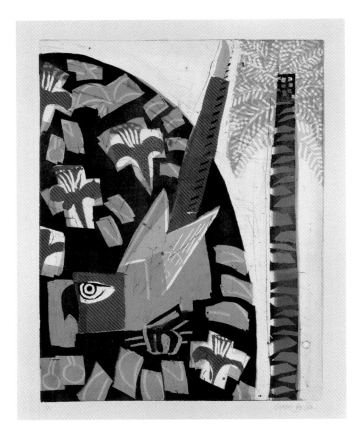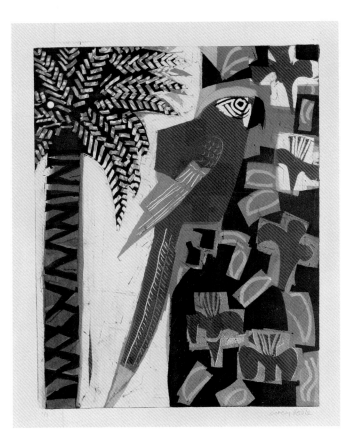

JAMAICAN GREEN-AND-YELLOW MACAW & JAMAICAN RED MACAW – *Greg Poole* – MONOTYPES

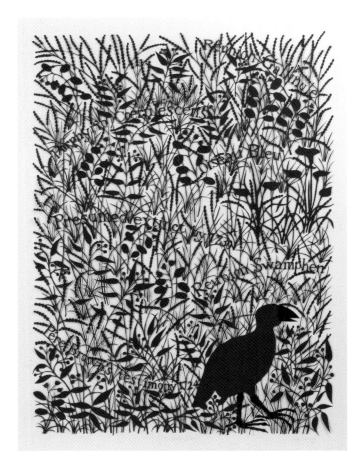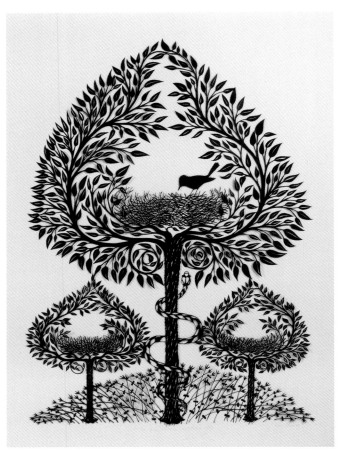

THE REUNION GALLINULE – *Ian Penney* – PAPER-CUT

'THE LAST GUAM FLYCATCHER' – *Ian Penney* – PAPER-CUT

'I wanted to create a pattern within which is a naive looking bird striding around oblivious to its own impending oblivion.'

CHATHAM ISLAND FERNBIRD

– Lucy Wilson –

ACRYLIC ON PAPER

'The paintings are positioned a certain way; the female looking towards the male, both in their bare and minimal forms. They both stand to be admired, literally to show their features in an examination like from a book. The female is surrounded at her feet by the bird's native foliage. This idea supports the only way we can ever make reference to this bird now that they are extinct.'

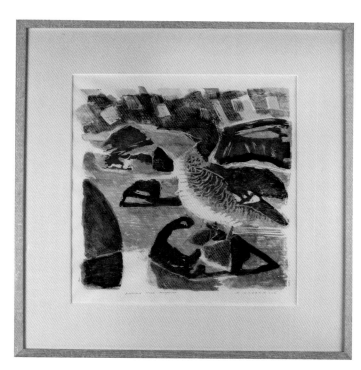

'AUCKLAND ISLANDS MERGANSER' – *Matt Underwood*

CALIFORNIAN CONDOR – *Roy Wright* – PENCIL

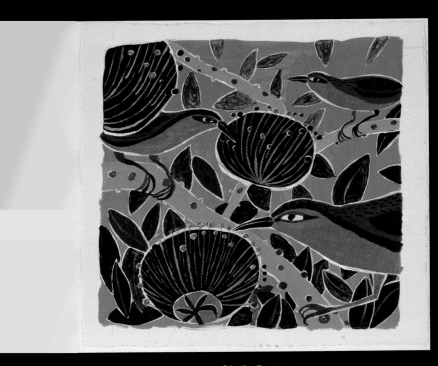

GREATER AMAKIHI – *Linda Scott* – ACRYLIC ON PAPER

RODRIGUES RAIL – *Erin Petson* – ACRYLIC ON PAPER

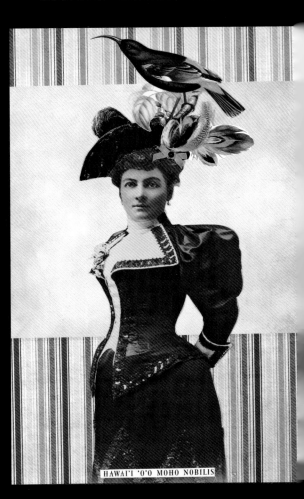

HAWAI'I 'O'O MOHO NOBILIS

HAWAI'I 'O'O MOHO – *Paul Beer* – MIXED MEDIA

NORFOLK STARLING – *Julia McKenzie* – MIXED MEDIA

CANARY ISLANDS OYSTERCATCHER – *Viktor Wynd* – MIXED

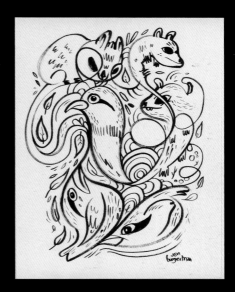

ROBUST WHITE-EYE – *Jon Burgerman* – PEN & INK

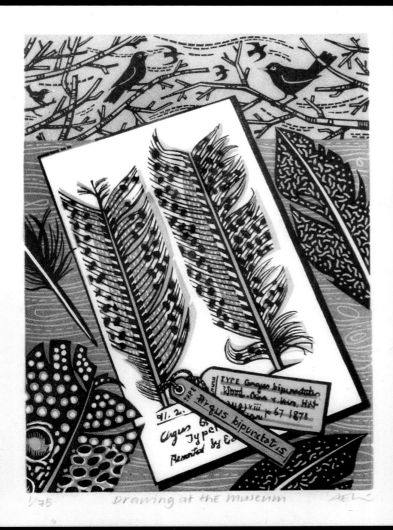

DOUBLE-BANDED ARGUS – *Angie Lewin* – ETCHING & AQUATINT, EDITION OF 75

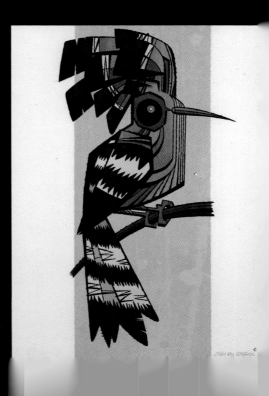

Room two

The *Ghosts* tour of the Rochelle School would end with just one final space – Room Two. Welcome to Birdmurderland, dedicated to exposing and isolating the places where the illegal killing of endangered birds continues on a regular, daily basis. It is a place where the fight is on, and battles can be won.

We'd already captured some of the contemporary threats BirdLife International and the RSPB were dealing with in our first set of *Ghosts* posters. Here in the Rochelle, each image was accompanied by a full description of the front-line conservation work that was being carried out to overcome those dangers.

Downstairs, Gail Dooley's remarkable 'Albatross' installation, mapping out the full wingspan of an adult bird with a line of stoneware heads, all savagely hooked to trawler lines, had already alerted visitors to the plight of the species.

Upstairs we resumed the narrative, taking people through the cold facts of potential extinction: 19 out of 22 albatross species had already been Red Listed and were under threat of being lost altogether. The reason was stupefyingly simple: the use of shallow bait lines by South American trawlers resulted in more birds than fish being caught – sometimes more than a 1,000 birds per line. The maths was simple: the albatross breeding cycle is so long that typically only one chick is reared at a time,

Ghosts invited Panos photographer Kieran Dodds to bear creative witness to the seasonal slaughter in the skies above Malta. In 2012 he joined fifty volunteers from across Europe who converged on a tourist hotel in the small town of Bugibba in northern Malta then fanned out across the island to track the migrating birds. This is part of what he saw.

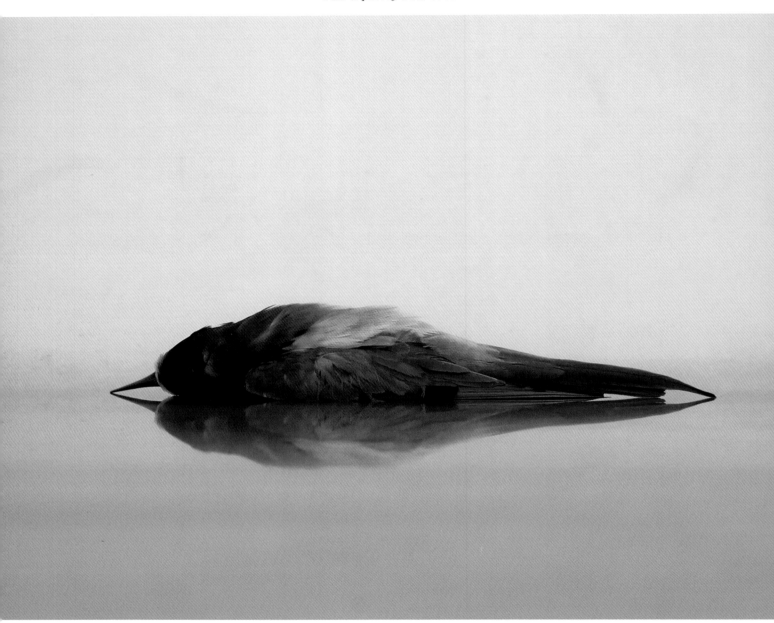

A dead Bee-eater found at Xemxija on 20 April 2011 by Spring Watch Malta lies on a table at a veterinarian in Valetta. It suffered gunshot injury to the left side of its body.

so there was a genuine threat that the number of birds lost to hooks could easily outweigh the number of new birds being born each year.

Extinction was imminent. Then BirdLife International intervened. They set up an international albatross task force to work across a range of countries and help educate local fishermen to change their fishing techniques so that they caught more fish and less albatross. In the south Chile Seas and off the coast of Argentina, accidental capture of seabirds by long-line fishing has been reduced to almost zero. It's still early days and many species of albatross are still under threat – but the numbers are moving in the right direction.

So the message of Room Two was that change can happen. Species can be hauled back from the edge of extinction.

That was the good news. The bad news was Malta. We'd wanted to do something in the show that brought extinction close to home. A lot of the *Ghosts* work featured birds that had disappeared half a world away – or half a century ago.

In filming footage for his *Bird Effect* documentary, Ceri had been to BirdLife Malta's Raptor Camp and witnessed firsthand the avian massacres that happen twice a year, with unchallenged hunters roaming across the countryside, and migrating birds shot out of the sky for no other reason than they were passing overhead when the gun was loaded. It was senseless and indiscriminate – and illegal and on a scale unseen anywhere else in the EU.

Malta was part of the EU – it benefitted from all sorts of financial handouts and subsidies as part and parcel of that membership – but it was not prepared to abide by the rules of the EU when it came to protecting rare and endangered birds flying through its airspace. Every other EU country spent money and resources protecting these

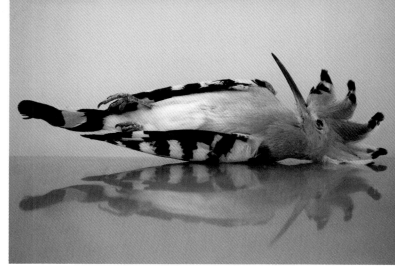

A dead Hoopoe retrieved from Attard on 20 April 2012 by Spring Watch Malta at BirdLife Malta's office. It was diagnosed with missing primaries as well as an injury to the wing consistent with gunshot.

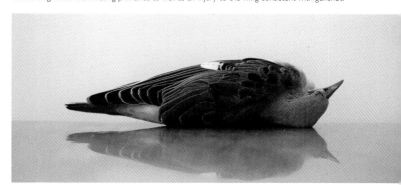

A dead Golden Oriole, recovered from Mellieha on 10 April 2012 by Spring Watch Malta lies on a table at a veterinarian. The post mortem by a vet certified gunshot injury as the cause of death.

A Common Kestrel recovered from Hal Far. The bird was found to be suffering multiple fractures to its left wing with embedded shotgun pellets. The bird was put down by a vet.

creatures and trying to ensure their continued survival – until they strayed over Malta and were blasted out of the sky. We talked to BirdLife Malta about the idea of trying to put a financial figure on the work that EU members put into protecting each individual rare bird – then presenting the Maltese government with an annual bill for the cost of the illegal killings it was condoning. We also wanted something there at the end of the *Ghosts* show that captured our collective horror at what was happening on the island.

We created 'Crime Scene Malta: 2011'. You could smell the cordite from the spent shotgun shells before you saw them. Then you'd catch a glimpse of the photos pinned down under the mountain of cartridges – the snapshots of dead and dying birds retrieved by BirdLife Malta, but often too late to do anything to save them. On the walls we'd mounted a series of lightboxes displaying X-rays of the injured birds, all too clearly illuminating the horrific damage done to each of them by the hunters' firepower.

In Malta, the installation became a lead story on timesofmalta.com. You can still read the seething comments from indignant hunters wondering what right we had to interfere in their local traditions.

As for Birdmurderland, what say we tackle domestic cats and royal hunting grounds next?

X-RAY OF SHOT BIRD PROVIDED BY BIRDLIFE MALTA

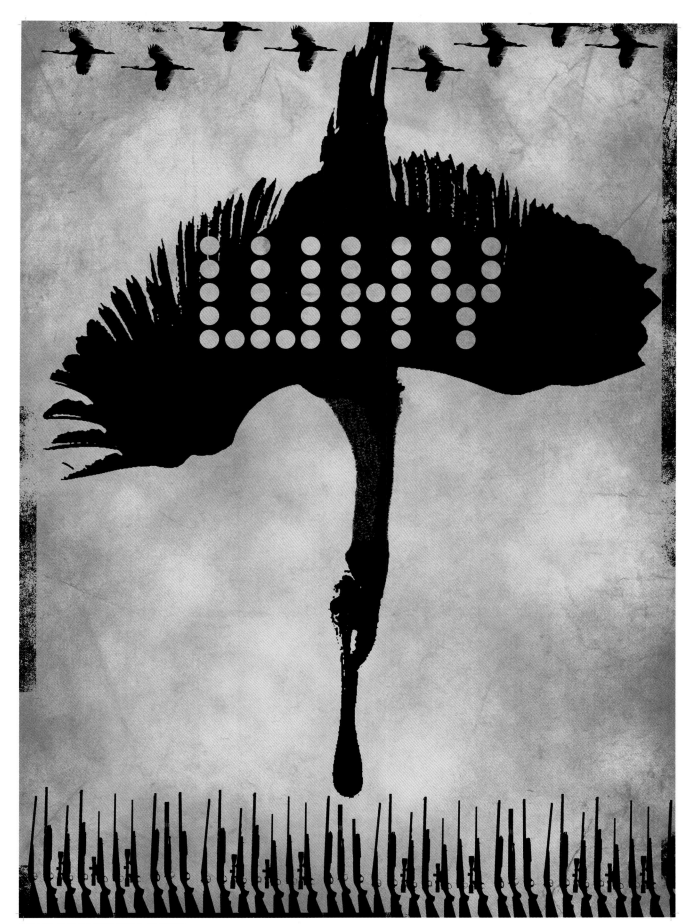

ONE OF OUR GHOSTS MALTA POSTERS

GHOSTS OF GONE BIRDS MAP

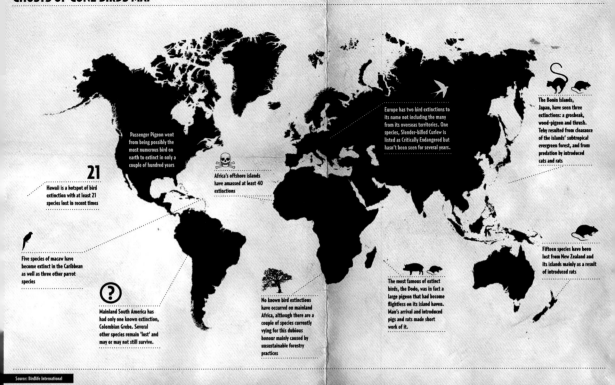

Passenger Pigeon went from being possibly the most numerous bird on earth to extinct in only a couple of hundred years

21

Hawaii is a hotspot of bird extinction with at least 21 species lost in recent times

Africa's offshore islands have amassed at least 40 extinctions

Europe has two bird extinctions to its name not including the many from its overseas territories. One species, Slender-billed Curlew is listed as Critically Endangered but hasn't been seen for several years.

The Bonin Islands, Japan, have seen three extinctions: a grosbeak, wood-pigeon and thrush. Tehy resulted from clearance of the islands' subtropical evergreen forest, and from predation by introduced cats and rats

Five species of macaw have become extinct in the Caribbean as well as three other parrot species

Fifteen species have been lost from New Zealand and its islands mainly as a result of introduced rats

?
Mainland South America has had only one known extinction, Colombian Grebe. Several other species remain 'lost' and may or may not still survive.

No known bird extinctions have occurred on mainland Africa, although there are a couple of species currently vying for this dubious honour mainly caused by unsustainable forestry practices

The most famous of extinct birds, the Dodo, was in fact a large pigeon that had become flightless on its island haven. Man's arrival and introduced pigs and rats made short work of it.

Source: Birdlife International

CAUSES OF EXTINCTION

NUMBER OF EXTINCT SPECIES

OTHER CAUSES

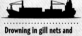

Drowning in gill nets and disturbance by increasing boat traffic were factors in the extinction of the Atitlán Grebe

One of the causes of the Carolina Parakeet extinction was the competition with introduced bees.

Chatham Rail extinction resulted from competition with the larger Dieffenbach's Rail Gallirallus dieffenbachii (also extinct).

Wake Island Rail was presumably eaten to extinction by the starving Japanese garrison between 1942 and 1945

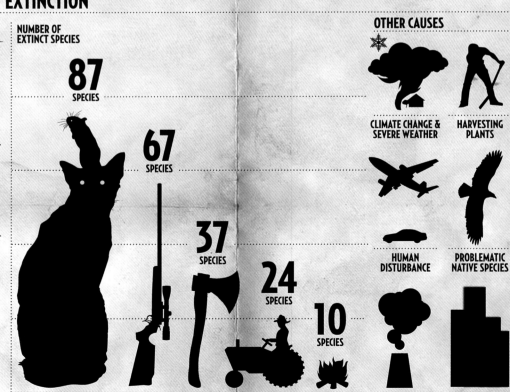

87 SPECIES

67 SPECIES

37 SPECIES

24 SPECIES

10 SPECIES

CLIMATE CHANGE & SEVERE WEATHER

HARVESTING PLANTS

HUMAN DISTURBANCE

PROBLEMATIC NATIVE SPECIES

POLLUTION

RESIDENTIAL DEVELOPMENT

INVASIVE SPECIES

HUNTING TRAPPING

LOGGING

AGRICULTURE

FIRE

Source: Birdlife International

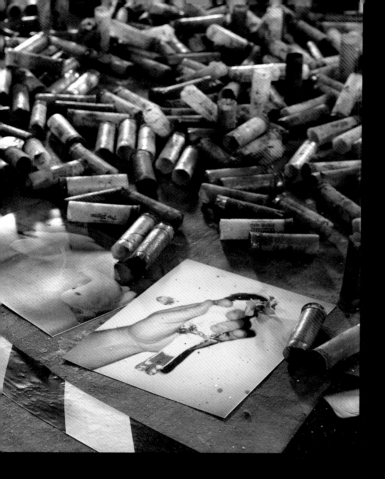
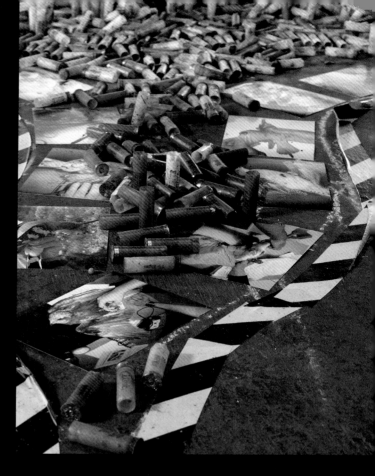
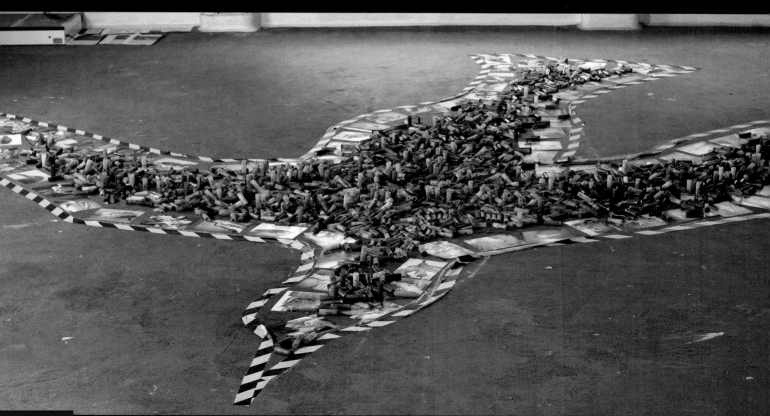

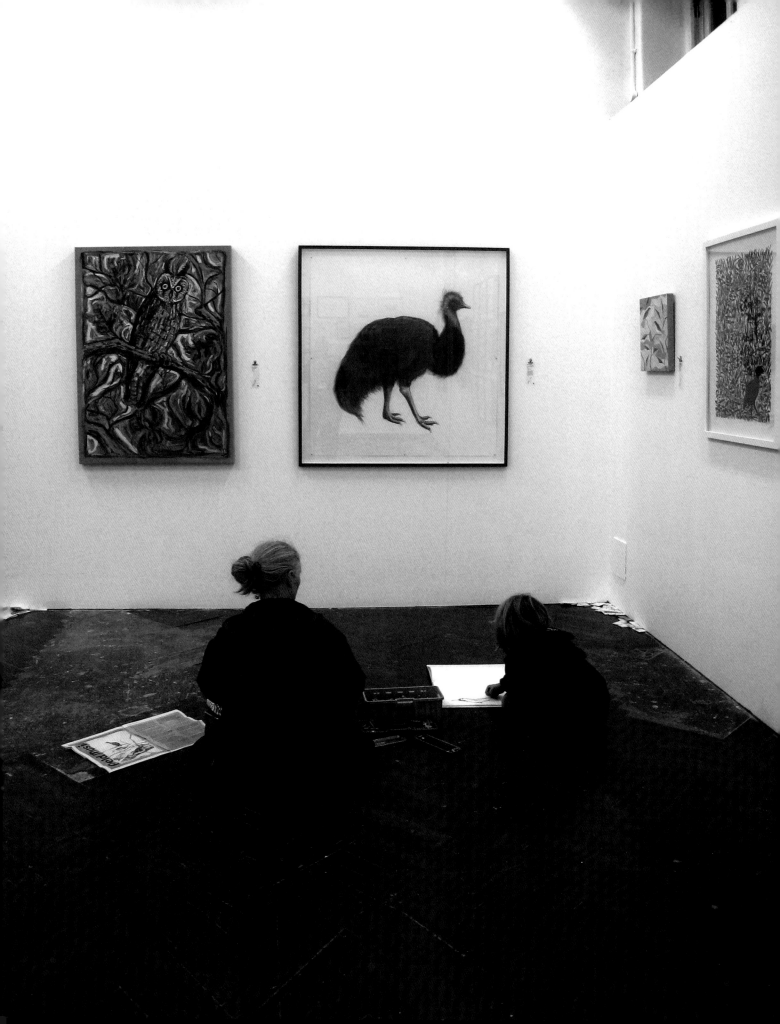

People powered

In just three weeks, 8,500 visitors walked through the doors of the Rochelle School to see the *Ghosts* London exhibition. None of us expected numbers like that.

The mornings always started off slowly – we didn't open until midday, but despite our best efforts to inform people of this fact online and in the articles, still they knocked on our door and rang the bell from 9.30 onwards. We let in most of these early visitors and often accompanied them around for a private tour of the show. Many had travelled in from out of town and we appreciated the effort everybody was making just to find us, let alone turn up early intending to spend several hours wandering round the exhibition. (One of the reasons why Ralph's Room was so popular was the fact that it had seats: we often spotted visitors who seemed to have been in the building for several hours making a beeline back to the Boids to rest their weary feet, perched on a pew, soaking up and refuelling on the sheer creative energy that fizzed and crackled around that particular part of the gallery.)

We simply put up a sign that said 'Photography Positively Encouraged'. We weren't going to be the sort of venue that unleashed an army of security guards on anyone who sneaked a smartphone shot of our art – not when people power could do our marketing for us.

Social media images of the *Ghosts* collection went viral.

We started receiving emails of support from around the country – then around the world. A Russian sculptor in Tbilisi, Georgia, offered to get involved. Joel Greenberg from Chicago wanted to introduce us to the Passenger Pigeon Project. The Director of the Walnut Gallery,

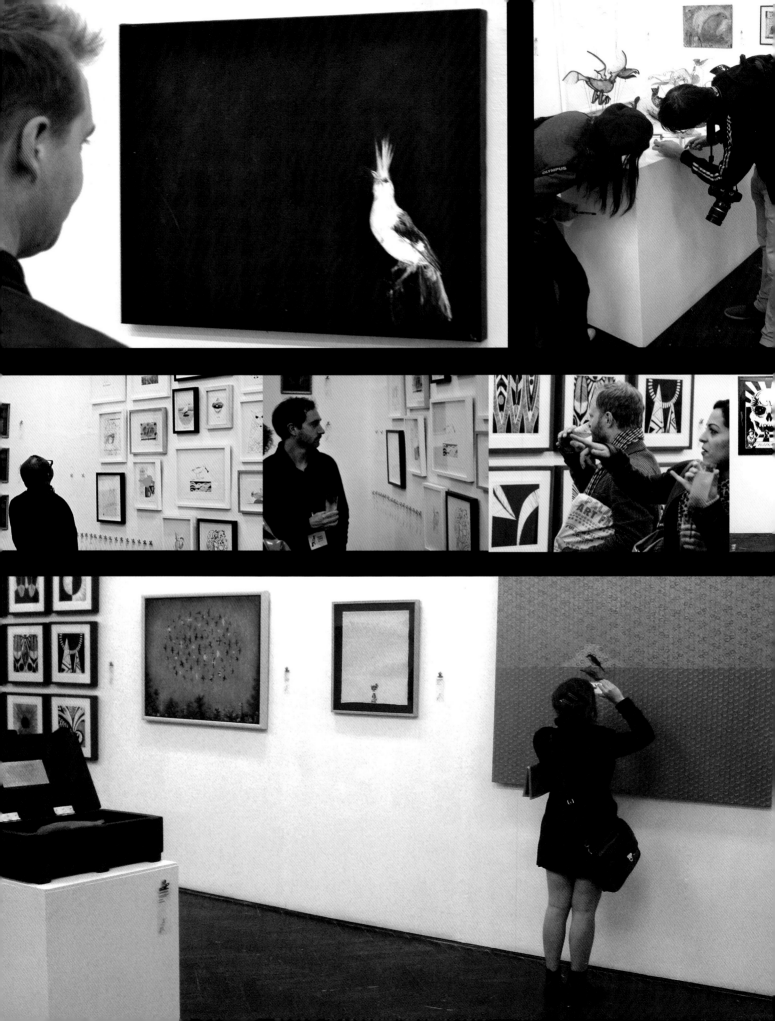

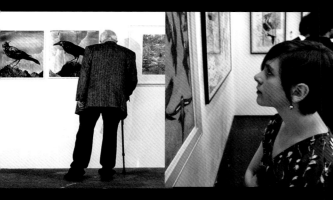

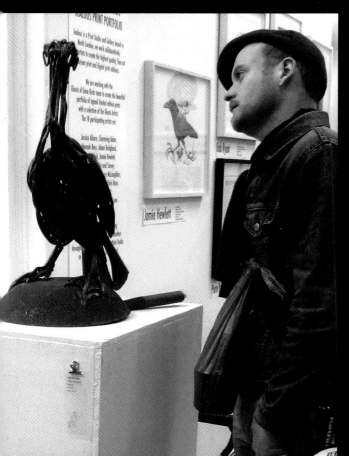

Northeast Alabama invited us over. Sallie Harker from Antigua, said she was concerned about her local Frigate birds and Brown Pelicans. Ivy from Alberta, Canada, told us how proud she was of the show whilst Christy Rupp, a NYC artist, showed us how she reconstructs extinct birds from the bones of fast food chickens. A Ghosts t-shirt request came in from Patrick Air force Base in the Ascension Islands. Facebook showed a sudden spike in Likes from a campus in the Philippines.

And that was just the first week.

Art college classes commuted in from the South Coast with their tutors to sit and process the ideas on show and notebook their own thoughts on how to approach the brief (we later heard that several colleges decided to give their second year students the Ghosts task and produce their own portfolios of Gone Birds).

People we'd never met before rallied to the cause. Suddenly the rota for sitting in the upstairs space started filling out with volunteers. Week day lunchtimes and after work, visitor figures surged. Weekends were phenomenal. Kids. Dogs. It became an all-inclusive family outing.

It was the Ghosts murmuration in full effect. All of it people-powered.

Ghosts Night Out.

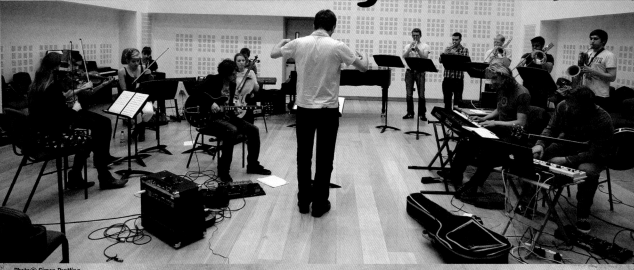

Photo© Simon Pantling.

Featuring the first London performance by

JIMI GOODWIN (DOVES)
AND THE BIRD EFFECT ENSEMBLE

a 15-piece orchestra, premiering the new
"Ghosts of Gone Birds" Theme.

Plus more gone birds music from Trevor and Hannah, poetry from Will Burns,
an appearance by artist Marcus Coates
and other special ghosts guests and Djs to be announced soon on twitter @gonebirds

Rich Mix Bar. Nov 10th 8pm till late.

TICKETS: £6 ADVANCE & CONCESSIONS/£8 DOOR

• •

 GOODPILOT
Creative Strategists & Connective Thinkers

HEAD FILM

 Caught by the River

BirdLife INTERNATIONAL

"Raising a creative army for conservation"

 facebook.com/ghostsofgonebirds twitter.com/gonebirds www.ghostsofgonebirds.com

Ghosts live

Of course it could have been a funeral march into oblivion, the most depressing art exhibition you had ever been to, but fortunately we dodged that one. The sheer joy and inventiveness of the work produced by our contributing artists banished any possibility of that. We just wanted to bang an extra nail in that particular coffin and make sure the word 'maudlin' never got out.

So 'live' became an extra mantra for what the show could do: live art, live printing, live performances, live online – anything that could take us even further away from the dusty inertia of a glass-boxed, glassy-eyed museum piece.

On the first Saturday we were open, Paul Curtis, aka Moose, unloaded his barrels of collected rainwater, uncoiled his trusty power hose and set to work 'refacing' the brickwork surrounding the gallery with a stencilled flock of *Ghosts* birds, etching away the layers of dirt and dead grey lichen to reveal and restore the original architectural surfaces. The piece was entitled 'The Albatross Celebrates Its Golden Anniversary' and stretched from the actual doorstep leading into the gallery, around the outside of the building, south down to Shoreditch train station and west via Calvert Avenue out onto the High Street. The birds may still be there even now. Ghosts of *Ghosts*.

The wonderful thing about Paul is that he's one of the most easy-going artists you'll ever meet – he's fiercely defensive of his philosophy, but he'll gladly pause in its application to explain what it means and what he's doing (this may have been the necessary result of the patient explanations he's had to provide local constabulary when they spot him at work refacing buildings in the middle of the night). He was a joy to watch around the Rochelle, always taking time out to talk to the gathered spectators as he jet-washed another flock of *Ghost* birds into existence.

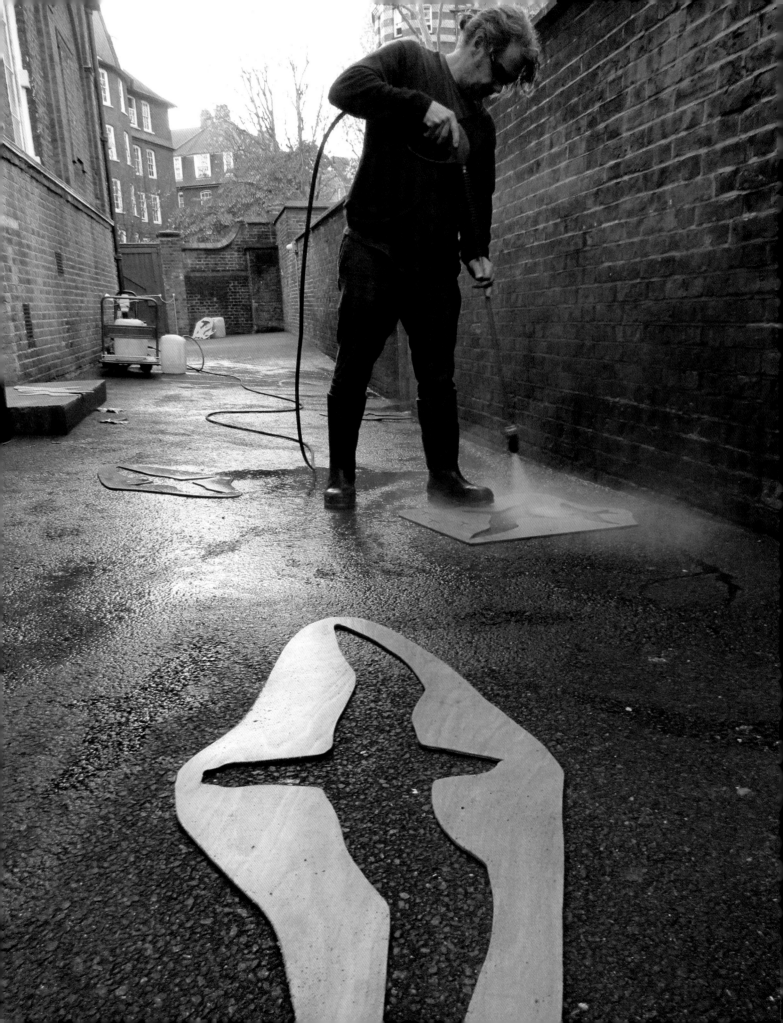

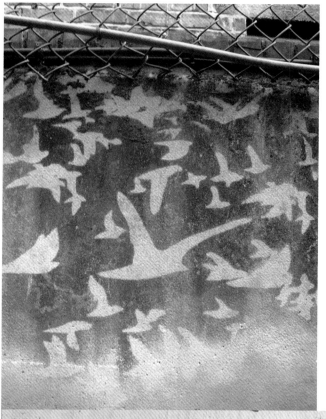

Another key ally of our 'live' strand was Dario Illari of Jealous Studios, who had come aboard early on in the project to help us with all the *Ghosts* prints we wanted to produce. They were later instrumental in getting the Ghosts Box Set accepted into the V&A print collection, but we had first met Dario and his team at Charming Baker's Covent Garden exhibition launch, where we loved what they were doing with a live print studio. Each weekend at *Ghosts* London, Jealous Studios and one of the *Ghosts* artists would do a live print run of a new limited edition piece of work. It was messy but great fun.

On the music front, Jeff Barrett of Heavenly Records and *Caught by the River* fame had done a great job of spreading the word about the *Ghosts* project, and helping to involve people like Jimi Goodwin of Doves in what we were trying to do. Jimi's Bird Effect Ensemble had made the trek across the Pennines to perform in Liverpool for us, and they repeated the gesture with a headlining turn at the afore-mentioned Rich Mix Ghosts gig.

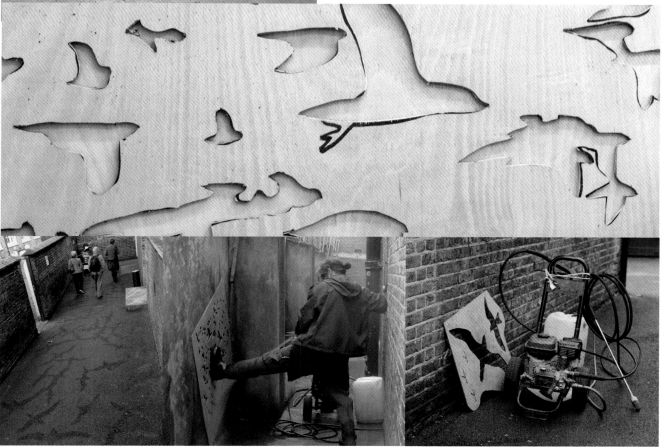

'A great idea, a very good cause, a cool location - live printing with families and carte blanche to work with an amazing bunch of artists we respected. Brilliant! From very early on I think that we also recognised that working with the Ghosts team how important this was to them and all the hard work that was going on to raise awareness internationally. Because of this we approached The V&A with the Ghosts print portfolio as we believed it would sit very well as part their permanent collection documenting the response of contemporary artists to a changing world at a particular point in time. And so it does.'

Dario Illari – DIRECTOR, JEALOUS

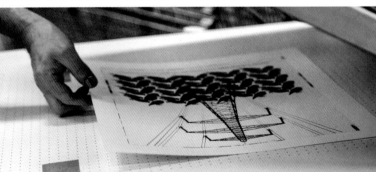

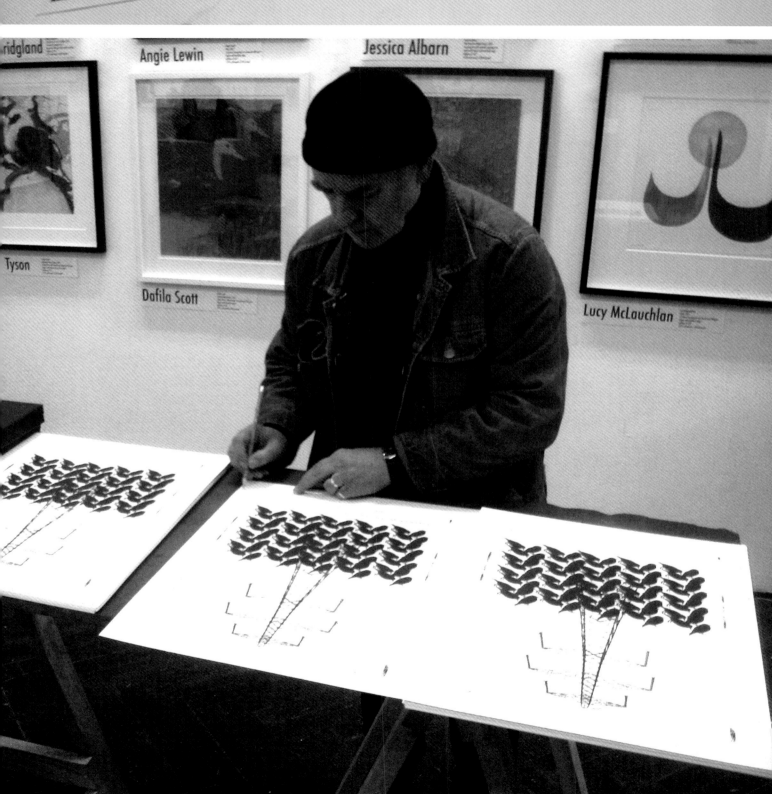

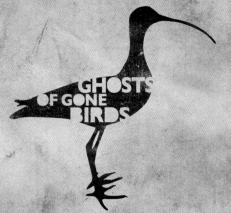

GHOSTS OF GONE BIRDS

WordPLAY presents:

A Flock of Poets.

wordPLAY London hosts an evening of
spoken word vs extinction
featuring new works by today's writers
including pieces inspired by
the art of Ghosts of Gone Birds.

Thursday Nov. 17th 7.30pm sharp till 9.30pm
Rochelle School, Arnold Circus, London. E2 7ES

(arrive early and visit the rest of the show)

Nearest stations: Liverpool St./Old St.
Admission £3/Bring-a-bottle

FOR LATEST DETAILS OF THE LINE-UP JOIN US ON:
facebook.com/people/wordplay-london facebook.com/ghostsofgonebirds
twitter@wordplaylondon twitter@gonebirds

. .

wordPLAY GOODPILOT HEAD FILM BirdLife INTERNATIONAL

"Raising a creative army for conservation"

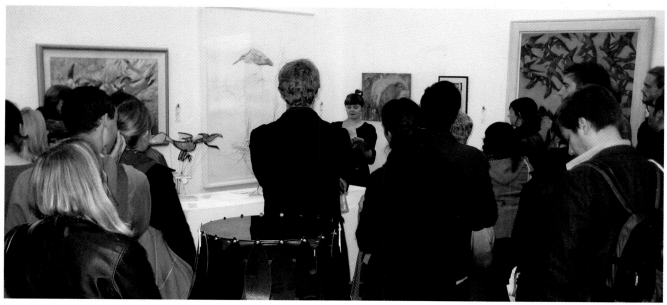

BRONAGH FEGAN READS AT THE ROCHELLE SCHOOL

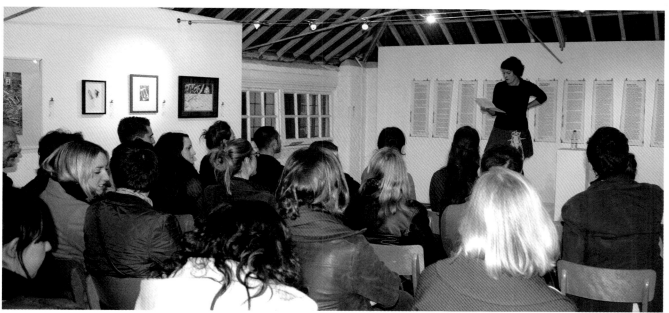

REBECCA FENTON FOUNDER OF WORDPLAY LONDON, READS AT THE ROCHELLE SCHOOL

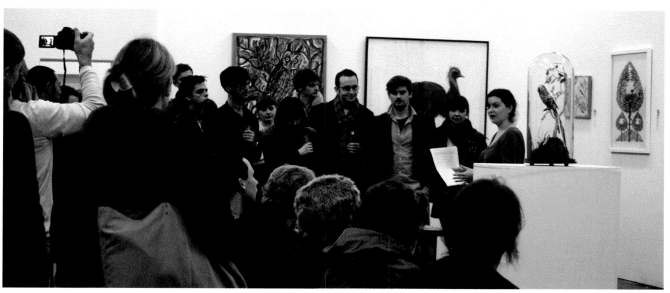

SARAH DAY READS AT THE ROCHELLE SCHOOL

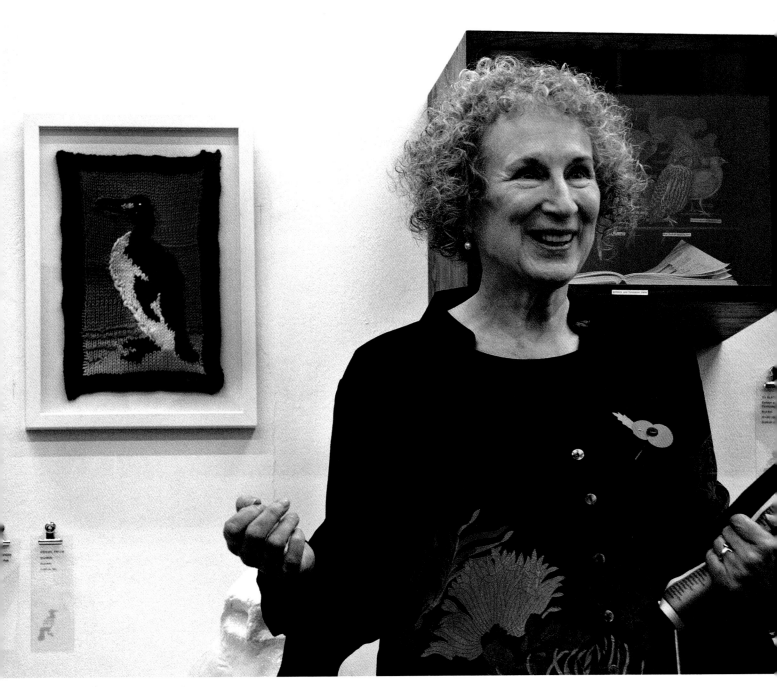

MARGARET ATWOOD HOSTED AN EVENING FOR THE RARE BIRDS CLUB AT GHOSTS LONDON

Still voices, distant lives

Words were always welcome at *Ghosts*. Whether it was John Barlow's 'The Ghost Auks' performed in the low, late sunshine of the Liverpool School of Art and Design, or Phil Daniels reinterpreting the Clash's 'Guns of Brixton' as the 'Gulls of Brixham' on stage at the London Ghosts Night Out, which we held at Rich Mix on Bethnal Green Road.

We'd encouraged all the artists to write a piece to accompany their work, to reveal some of the thinking that shaped the selection of their adopted bird and what had influenced their actual creative approach to breathing life back into it. The words that came back were always revealing and often very moving: you'll already have encountered a lot of them. The voices of the artists were very important to us in this project: it was our job to almost remain invisible in the process and let them come forward to champion the cause of their chosen species. We were simply providing the platform.

What about writers in their own right? Didn't we want them to contribute to *Ghosts* in some way? John Fanshawe introduced us to writers he knew through the New Networks for Nature organisation, and the work they then produced on the subject of extinction appeared on the walls of the Rochelle alongside the *Ghosts* art. People paused to take the words in, refining and refocusing their lens on the art around them.

Meanwhile John Barlow had proven how powerful poetry could be in taking on the same brief as the artists, so we invited Rebecca Fenton and her wordPLAY London collective to contribute new work to a live poetry performance at the Rochelle and later on at *Ghosts* Brighton. Each writer preselected a piece of Ghosts art and wrote something inspired by it that they could then perform live in front of the work. It was the creative echo chamber of *Ghosts* at work again.

As the *Ghosts* creative community continued to grow we came to realise that in some ways we had in fact set up our own new networks for nature, perhaps a little more organic and undisciplined, but nevertheless dedicated to the same mission of stepping beyond conservation's traditional cultural outreach programmes to cultivate fresh connections with new creative groups.

The Great Auk or Garefowl

by Tim Birkhead

In the 1980s I spent three summers studying seabirds – mainly auks - on a group of tiny islands known as the Gannet Clusters some 30 km off the coast of Labrador. Five of the six species of auk extant in the North Atlantic bred here: Common Guillemot, Brünnich's Guillemot, Black Guillemot, Atlantic Puffin and the Razorbill. The only one that didn't breed here was the Little Auk, although we saw them as they occasionally passed through. The seventh species of North Atlantic auk, the Great Auk is of course extinct.

The Gannet Clusters comprised six small islands a few kilometres apart, with a further island, Outer Gannet, lying 8 km to the north. All the islands were low lying – ideal habitat for the Great Auk - and similar to Funk Island further south off Newfoundland's eastern seaboard, which was one of the species' last known breeding places.

Early in the season as the seabirds returned, the Gannet Clusters were often still beset by ice which often extended to the horizon. Occasionally a male King Eider would appear, its bright beak burning like a hot coal amidst the blue ice. On other days flocks of migrating phalaropes would settle on the sea opposite our cabin and feed like frenzied machines, twisting and circling, before flying north. Just once a white phase gyr falcon harried the guillemots.

The return of tens of thousands of seabirds in the spring was spectacular. With the sea ice-covered the birds simply flew past to inspect their breeding areas from the air, but as soon as there were patches of open water they settled on the sea adjacent to the colonies. One year when the birds returned the breeding areas lay under a metre of snow: the Guillemots eventually settled on the snow over their sites and waited – for several days – for their body heat to melt them down to the rocks below.

Labrador was once described as the land that God gave Cain – an apt description of the backside of the island on which our camp was located. This remote and almost birdless part of the island comprised little more than a jumble of dark, forbidding rocks, some as large as houses, with no vegetation other than lichens. I came here when I needed an hour or two away from my colleagues – six researchers living in a small cabin for months at a time was sometimes claustrophobic.

Apart from the sound of the sea breaking its back on the rocky shore, the silence here was profound and my imagination would run free. A recurring fantasy was that one day as I explored the coves and bays on this remote coastline I would stumble on to a colony of Great Auks. The location was perfect, the birds could clamber directly from the sea and walk up to their breeding sites and on this side of the island they would be invisible to the occasional fishing boat that sought shelter from bad weather between the islands.

It was a fantasy, of course, and in fact no Great Auk was ever known to breed this far north in Canada. Yet further south off Newfoundland, the Great Auk – or 'Penguin' as it was known - was once so numerous it provided reliable 'indicator of position' for the Grand Banks and from 1671 was mentioned in successive editions of the English Pilot. When Funk Island was discovered in 1520 it may have held as many as 100,000 breeding pairs of Great Auks. Anyway, there were enough

to survive year after year of predation by fishermen and those travelling to the New World, in search of fresh meat.

It was the demand for feathers - for stuffing mattresses – rather than meat that signalled the end of Funk Island's Great Auks. From the 1770s, the level of destruction increased considerably as men were left on the island all summer, killing birds for the fat, flesh and feathers. The birds were 'tried' in great metal vats and their reduced corpses flung onto the ground where they eventually contributed to the meagre patch of soil in which a handful of Funk puffins now nest.

Writing in his journal on 5 July 1785 while moored in Shoal Cove off Fogo Island, Newfoundland, George Cartwright commented: 'If a stop is not soon put to that practice, the whole breed will be diminished to almost nothing, particularly the penguins'.

By 1800 the Great Auk had disappeared from Funk Island. Successive expeditions found abundant evidence of the killing, including the stone structures into which the birds were once herded and the occasional mummified corpse lodged in amongst the rocks. Even today the soil is still riddled with the bony remnants of this mysterious and magnificent bird.

On the eastern side of the Atlantic, by the time historical records began the number of Great Auks was much reduced – almost certainly by human predation. As far as we can tell, the species' stronghold had been the Faeroes, St Kilda and southern Iceland. In the early 1800s a few Great Auks were still breeding on Geirfuglasker off southwest Iceland, but once this site disappeared as a result of volcanic activity in 1830, the few remaining birds

moved to the nearby Island Eldey.

They didn't last long. Natural history museums, desperate not to miss out on specimens, created a market and successive expeditions to Eldey over the next fourteen years finished them off. The last two birds – a pair apparently – were killed on 3 June 1844 and their egg broken. Preserved in brandy the innards of at least one of these two birds ended up in the Copenhagen Museum; their skins were mounted and sold. The Great Auk was not alone: other rare birds have been hounded by collectors in the ethically dubious business of collecting for perpetuity.

Generations of researchers have tried to reconstruct the Great Auk's biology. Its closest relatives - the two Guillemot species and the Razorbill – have an unusual breeding biology in that their single chick leaves the colony at just 18-21 days of age – one quarter of adult weight and long before they can fly. The chicks of some other auks, like the Ancient Murrelet of the Pacific, leaves the colony at the tender age of just 2 days; whereas puffin chicks leave after seven or eight weeks. Such enormous variation in the age at which the chick departs, within a single family of birds, is exceptional. What is remarkable about the Great Auk, is that despite all that killing, hardly anyone saw a chick. Or if they did, they failed to put pen to paper and tell us about it. We simply do not know how long – before humans threw their breeding seasons into terminal chaos – Great Auk chicks remained at the colony: did they depart after two days, after three weeks, or after eight weeks? We don't know, and we probably never will.

I often wonder what would have happened if the events I've described

had occurred a century later: a handful of remaining birds in 1930 – or less probably, if I'd discovered a small colony in Labrador in the 1980s. Would we have left them to it, to take their chances? I think not. More likely they would have been rounded up and taken into captivity, where they would have lived out their long lives. Guillemots and razorbills can live up to 30 or 40 years, so Great Auks – being larger - might have lived to 50, which means if they had, some of us might have at least have seen them. As it is, all that's left now are some badly stuffed specimens, a few eggs, and gaping hole - not only in our avifauna – but also in the Great Auk's biology.

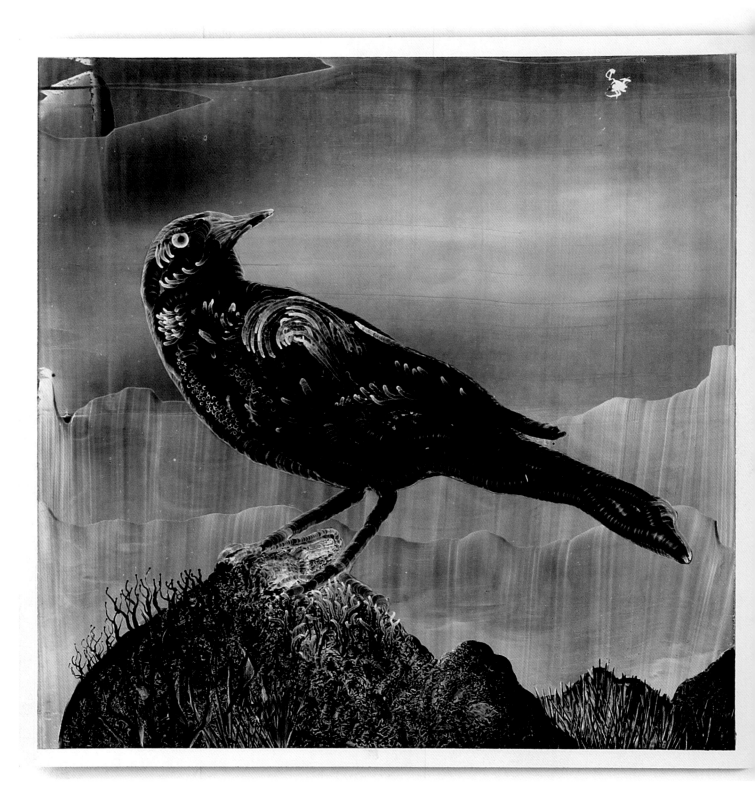

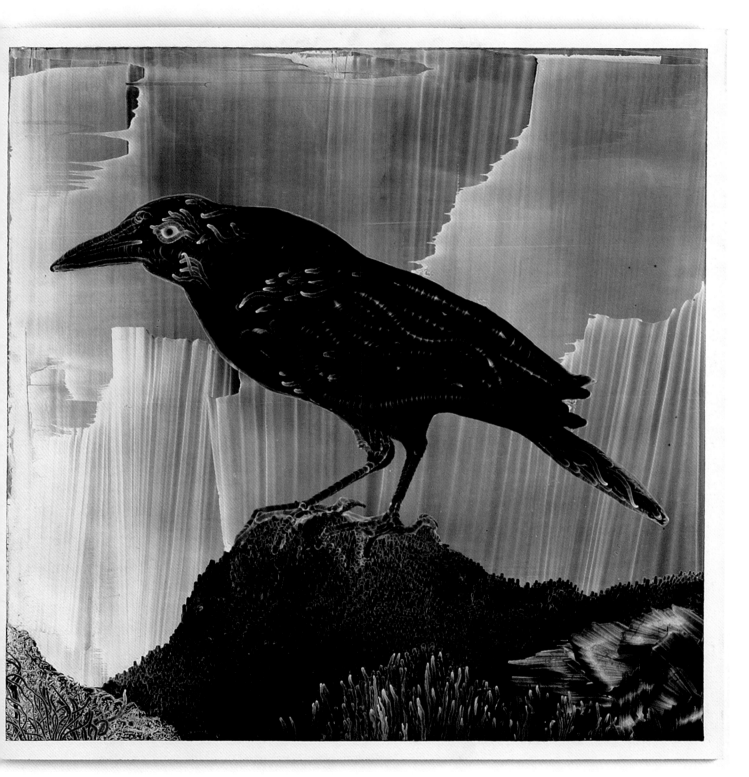

SLENDER BILLED GRACKLE 1&2 – *Matthew Killick* – OIL ON BOARD

'*My favourite birds are the members of the Corvus genus. Crows, Ravens, Rooks, etc. and the Grackle
has a similar look to them (although unrelated). There is something magical about their manner,
that invokes in me a feeling of the ancient. The Indians considered them so intelligent that they would
feed their brains to children to help speed their learning, so folklore says. I have no desire to eat one.*'

Personal extinction: memory, loss and hope.

by Lucy McRobert

It is hard to reflect upon something of which one has virtually no experience. As a naturalist, I am passionate about the world around me, and how it has shaped my childhood and identity; as a twenty-year old woman dealing with undergraduate essays, a fluctuating and maturing love life, and ever-increasing petrol prices, I have tended to find myself distracted from such pleasures as simply sitting and listening to the birds. Except of course at 4:30am on a summer's morning when I'm only just arriving home, in one hand my stiletto shoes, and in the other the key fumbling ungraciously in the lock.

Accordingly, when I was asked to reflect upon my view of extinction, you may imagine why problems arose. I have never travelled to the Galapagos Islands to experience firsthand the melancholy that is 'Lonesome George,' the iconic sole survivor of the Pinta Island giant tortoises, and perhaps the rarest animal in the world; and I have never, as Stephen Moss has done, held a stuffed passenger pigeon in my hands. I have read Rob Lambert's social and cultural history of the great auk and I was moved, however, I have never been to the Great Auk Monument on the Orkney Islands, commemorating the loss of the last bird there in 1813.

I have grown up in a three bedroom semi-detached house, on an estate in a small market town, surrounded by woodpigeons, blackbirds and blue tits, all of which are still in abundance in my garden. I have always loved nature, respected it and admired it, but my experience of extinction extends to the World Wildlife Fund television adverts asking for £3 a month to adopt a Bengal tiger (which I have done), and consequently saved the world. Yes this is hyperbole, but only a little. I imagine I am typical of many people my age; was it shallowness that prevented me from opening my eyes to such truths as the recent decline of the house sparrow, or naivety? Is it that I don't care about the melody of the song thrush disappearing from the English countryside, or that I don't have time to stop and consider it? So maybe, as a budding environmental historian and an ardent lover of the great outdoors, I should delve into my own past, if only to better understand a situation which has for so long been in the periphery of my life.

When I was sixteen, I lost my mother to a three-year battle with cancer.

For the three years prior to her death, I was told that my mother was going to get better. I was truly convinced that life would return to the way it had been, full of the laughter and happiness and love that defined my first thirteen years. Over time, that life has returned, but she has not. My regrets are deep and many: why did I sit silently when others had the courage to speak? Why didn't I ask more questions? Why did I close my eyes, when in hindsight (a sweet and blessed thing) the truth was plain for all to see, if only I'd chosen to look?

So let us open our eyes.

A small yet profound change occurred in my mind in May 2011, when for the first time I experienced the addictive delights of birdwatching, out on the Ouse Washes on the Norfolk/Cambridgeshire border. Yes, I was cynical about certain aspects; one that springs to mind, is an analogy between obsessive twitchers, constantly perusing each others birding equipment (who had the most expensive 'bins?'), and a changing room of egotistical rugby players casually glancing down and sizing up the competition: ornithological penis envy? However I shall never forget that feeling that the world was so utterly peaceful, removed from the sounds of the distant traffic and busy commuters, and yet so utterly animated, as avocets swooped gracefully overhead, protecting an unseen chick from an unseen enemy,

the hedges quivering as we ambled past, tiny unseen treasures tensing and trembling at our presence. I was walking back though a childhood memory that had been brushed aside by education, work and pressing social engagements. I saw at least 36 different species of bird that day, maybe an unimpressive figure to some, but at least my eyes were open.

Let us ask questions.

That day in May was the first time I had ever heard a cuckoo, the first time I had watched yellow wagtails dancing nimbly around the hooves of a placid cow. Imagine my dismay, therefore, to find that both of these species are Red-Listed by the RSPB, due to dramatic breeding population declines. The birds that I had grown up with, the starlings and house sparrows in my garden and the lapwings at the local Water Trust present a similar story. So would I hear that forlorn yet distinctive call of 'cuck-koo' again? When and where could I watch the elegant yet risky tango between bird and hoof in the fields? In my mind, I assumed that there would always be more time to see these little creatures. Well, that's a haunting mistake that I've made before. And what of the little grasshopper warbler, whose continuous whirring in the inky darkness had me totally entranced? I have heard him once: will I hear him again?

Let us speak out.

There will forever be a part of me that regrets not speaking out; I clearly remember sitting by my mother's bed in the hospice, knowing that her time (and mine) was seeping away, and yet I stepped back, in order to let my family have their moments of solitude and privacy. Maybe it was compassion for them that made me do it, maybe it was

the fear of being alone with the frail and broken ghost of a once strong and proud woman. Whatever the reasoning, the action was foolish. It is not in human nature to sit quietly. In recent history we spoke out for the freedom of slaves in 1807 and 1833, for women's suffrage in 1918 and 1928, for animals in 1824, for children in 1884, and in 1889, those 'ornithological suffragettes' who spoke out for birds, against mere fashion. It seems only right that I, an undergraduate student of history, should learn not only from their example, but also from my own. I shall not step back again, but speak out for the anonymous little bird in the hedgerow.

Here is extinction in its most personal form and yet it should not take these severe, frank and painful reflections to make me realise that I did not appreciate what I had got until it was gone. Extinction is something that is far more particular to me than I imagined. It changes and oscillates for each individual, bringing a new perception of loss, regret, guilt and grief to an already confused and cluttered picture. Loss, of a childhood memory: my mother and I plodding through a field, a flash of yellow atop a tree, darting swiftly to a bramble hedgerow, a tiny chirrup from a tiny bird, chestnut body and golden head, then nothing but a ghost, a memory. Regret, for a silent voice that failed to ask the questions for fear of the answers, who believed that there would always be another day, who assumed that someone else would make it better. Guilt, knowing that you made mistakes, of knowing that you are conscious of everything, but do nothing, the same guilt that makes us susceptible to all those emotive television adverts. Grief, well, is an explanation really necessary?

But then there is also hope. Learning from our mistakes is often the point of historical reflection, and so I hope that whether it is through a focussed career, a passionate hobby, or even just keeping my eyes open, I can give a voice, and consequently hope, to another creature. I hope that I can prevent my own history from being repeated. All of this I do this in the name of my mother, Alison Joyce McRobert who, almost as if for the sake of parody, harboured a genuine phobia of birds, who admired from a distance but shrieked like a banshee at close proximity, and who, in all the sixteen years I knew her, would flinch at the sight of a harmless feral pigeon feather, wafting gently in the breeze around her feet. Somewhat ironic, one feels.

Monuments to extinction: a chronicle at once personal and historical *by Rob Lambert*

I first confronted extinction, the loss of a species of a bird from a particular place, head on in September of 1988. Two birding pals from Bolton (James Walsh and I) headed north that autumn to be real ornithological pioneers. We planned to maroon ourselves on a remote island, Papa Westray, in the Orkney archipelago, and if the weather blew from the east, we were sure that we would find rare migrant birds and thus achieve some sort of personal birding nirvana (and perhaps some notoriety as finders of 'rares'). In the end, birding greatness was not to be. In a week of searching we only found a pied flycatcher huddled out of the wind in a walled garden. But when I look back on that expedition over twenty years ago, the lasting legacy is far more complex, both brutal and spiritual, and overwhelmingly and deeply 'cultural'. For striding out across the RSPB-owned north end of the island, and heading for the now empty seabird colony at Fowl Craig, we ran head long into a monument to extinction…to the last Orcadian great auk. As we rounded a stone wall, there it was, a small rather unobtrusive cairn (clearly fashioned by loving human hands) and atop sat a pottery great auk, longingly gazing seaward enraptured by the boundless possibilities of a maritime life, but instead rooted to a stone plinth grave. A metal plaque on the cairn told a cautionary tale: 'Fowl Craig. Here lived one of the world's last Great Auks. It was shot in 1813'.

Over two decades later I am still captivated by great auks (or 'garefowls' as the Victorian's called them). Think of a great auk as a large flightless razorbill on steroids, ill-suited to life in the track of developing North Atlantic commercial fisheries. The competitive birder in me knew that I would never be able to tick off the bird on my British List and mourned that gap; the ecologist in me wanted to know how great auks worked; the environmental historian in me wanted to find out the complete 'story' of British great auks; the environmental geographer in me wanted to unearth the species relationships with place; but equally as powerful was a longing within me to understand why a monument had been erected, what it was meant to symbolise and to whom: loss, hope, guilt, shame, failure, wisdom, a new future? I was never driven by anger, rather curiosity. So, in the mid-1990s as I was writing a socio-cultural history of the great auk for my edited book Species History in Scotland (1998), I turned garefowl-detective. The trail led away from the northern cliffs on Orkney, and down to the gentler farmscapes of South Devon and to the front door of Ralph Faulkner. Resident on Orkney in the late 1980s, and a leading light in the Orkney Field Club, having just planted a small wood on treeless Hoy, Faulkner turned his attention in spring 1988 to a project suitable for the junior members of the club, something that would have a lasting legacy, both physical and mental. He hatched on the great auk monument

idea as a way of teaching through doing, 'to promote care and conservation of our living world'. In his words: 'we couldn't count great auks, or draw them, or plot their nests on the cliff-face. The monument cairn was the only thing I could think of'. This was, in his view, a rare opportunity in a modern fast-paced cluttered sound-bite world, to powerfully teach - 'care for it, or lose it'. Each Orcadian child added a stone to the cairn; a time capsule was placed inside; each child was given an enamel lapel badge as a memento. Faulkner gave me one of those badges as a gift, and asked me to wear it whenever I voyaged across the world with the 'ghosts' of great auks swimming in my mind. The final event on that windswept cliff-top was an act of dedication by Alistair Skene, attended by the island community, where the hushed group of children asked for future generations to remember the loss of the great auk, and to care for a planet which those very children would hand on to them. Here then was a powerful message about 'wise use', to us now in the twenty-first century, a message about sustainability and how we must seek an accommodation with the entire natural world. Whilst this project screams of parochialism and localism, we must not be fooled into thinking that. There is something much bigger and wider and more all-embracing at play here. For surely, such a visible memorial cairn on Papa Westray offers a strong socio-cultural focus for our future

consideration of species extinctions here in Britain. Might future generations in Britain be called to erect memorial cairns in our busy countryside to the last cuckoo, or the last turtle dove? A sobering thought.

Our responses to extinction are diverse and have changed over time and space. Just as each generation has constructed Nature in a different way, so each generation has responded to the idea of extinction (the threat, or the reality) differently. Many species have come on a socio-cultural journey with us, a path from exploitation, to extinction, to some sort of environmental iconography. In the nineteenth century our responses would have ranged from ignorance, dismissal, to incredulity, to the first emergence of a genuine concern. We were, in the Western World, still caught up in the folly of 'the myth of superabundance' (which still refuses to die in some fishing communities), and enslaved by an almost fanatical religious devotion to the idea of 'manifest destiny', that it was all there for us to simply harvest at will, and it would be wasteful for us not to do so. The post-extinction blues were rarely played! And if they were, it was by a lone trumpeter, a voice in the wilderness, founded more on hope than anything else. In such a fashion, eminent Cambridge zoologist Sir Alfred Newton refused, through desperation or arrogance, to accept that the great auk was globally extinct in 1844, and so in 1858 he voyaged north to Iceland with oologist John Wolley to capture some birds and bring them back for captive breeding at London zoo. It was all in vain, the great auk was lost forever. But surely Newton is the patron saint of all current Birdlife International 'species champions' across the world? In hope, still we search

for birds 'missing in action', be they ivory-billed woodpeckers, night parrots or slender-billed curlews. By the late twentieth century, our responses (fuelled by the rise of ecology and modern environmentalism) were dominated by ideas of extinction as loss, as bereavement, as impoverishment both for ecosystems and for us; as a pearl missing from the necklace of global biodiversity.

For over twenty years, the Greak Auk Monument on Papa Westray was the only such monument to species extinction in Britain. That is now changing, as our attitudes to environmental stewardship and the way we confront and memorialise loss evolve. Two new memorials are being built in the landscapes of home. The Mass Extinction Memorial Observatory (MEMO) at Portland in Dorset was originated in 2009, and will include a stone petition and a bell to toll for all extinct species each year on International Day of Biodiversity (22 May). It has behind it that renaissance man, Tim Smit, who gave us a place called Eden. A second monument, The Life Cairn, is to evolve on Mount Caburn, overlooking Lewes in East Sussex during 2011. Conceived by the outspoken Christian ecologist and broadcaster Rev. Peter Owen-Jones and land artist Chris Drury (in anger at the 'litany of peril' contained in the IUCN Red List of species teetering on the edge of extinction), it will urge individuals to lay a stone on the cairn as a personal act of reflection about species loss.

In the modern word, certainly since the early twentieth century, we have shown a cultural need to establish contact with an accessible, and with what we construct as a benevolent and sympathetic Nature. We often try

to search for something human in the animals that we watch or cherish. This enables us to then construct each animal as a sensate creature and accept it as most like ourselves. To still do that we must start to tell more stories about the changing relationships between Nature and People over time; in the case of vanished birds, as American writer and poet Christopher Cokinos has urged, we must restore ('re-story') them into our national consciousness. In doing so, we will learn not just about Nature in all its glorious complexity and diversity, but also a great deal about human nature.

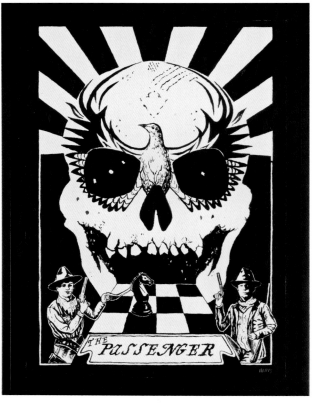

PASSENGER PIGEON – *Hannah Bays* – PEN & INK

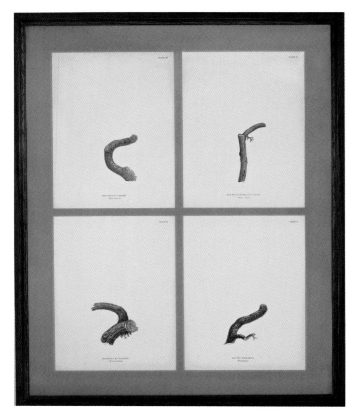

'WE ALL, US FOUR, WILL FLY'- MYSTERIOUS STARLING,
MAURITIUS BLUE PIGEON, MAUPITI MONARCH,
RED-MOUSTACHED FRUIT DOVE – *Edd Pearman* – SCREENPRINT

SOCIABLE LAPWING – *Omar Fadhil* – OIL ON CANVAS

BUSH WREN – *Little Theatre of Dolls* – PENCIL

Extinction *by Jeremy Mynott*

'Extinction', the very word has an icy finality about it. We think of huge cosmic events – the death of suns, stars and volcanoes, the fire and the energy gone out of them. We may even try to imagine the collapse of whole galaxies sucked into nothingness, as the astronomers speculate, an immensity of extinction language itself is unable fully to capture or convey. But in the end we usually sheer off such vertiginous thoughts, dizzied by an enormity we can scarcely conceive, let alone affect. So, we return to our world – to things we can see, hear, touch and feel. What sort of extinctions do we face here?

They seem to be both more and less important. The scale is many billion times smaller, to be sure – which is precisely why we can relate to it and engage. But the losses here are also of a different kind. We are not in this case contemplating the running down of purely physical system – the exhaustion of energy and the snuffing out of fires ('extinction' comes from the Latin, literally meaning 'to quench' or 'put out'), but rather the disappearance of forms of life. And since we are ourselves a form of life our sympathies and responses are quite differently involved. Or should be. And that is the deep point of this exhibition. What is it like to lose a life? How are the inhabitants of this tiny planet affected by the loss of one of their members?

Our own species certainly is affected, at least emotionally. We carry in our cultural history strong, if not always accurate, folk memories and stories about the demise of such famous birds as the dodo, great auk and passenger pigeon. The story of the first is pure pathos: a large flightless bird – fat, clumsy, helpless and trusting – butchered by sailors and exterminated in its last island home in Mauritius in 1662. The second is told as tragedy: the last known British survivor killed off St Kilda in about 1840 by fishermen, who had captured it but then became terrified by its unearthly shrieking and clubbed it to death, thinking it a witch. The third is mystery: how could what was one of the most numerous birds in the world in the mid-19th century become totally extinct in less than 50 years? Their immense flocks were said to darken the skies and one such gathering was estimated in 1866 to measure one mile wide and 300 miles long; yet on 22 March

1900, in Pike County, Ohio, the last wild passenger pigeon died. These and other accounts have entered our psyches, and in the case of the dodo our language too, as symbols of human depredation of the planet, mythologised in their historical details no doubt, like the tales of 'Alfred and the cakes' or 'Drake playing bowls', but like those performing a function in telling a story we want to hear.

We carry over these same emotions to our hopes and fears for other species: both those currently endangered – like the Californian condor, Siberian crane, Indian vulture and spoon-billed sandpiper; and those probably already lost – like the ivory-billed woodpecker, Spix's macaw and Eskimo curlew. There is a similar but even higher level of public awareness and concern about the fate of large charismatic mammals such as the mountain gorilla, tiger, giant panda, polar bear and black rhino. Yes, but this word 'charismatic' should give us pause, a little worm of doubt about our motivation in all this. The fashionable green rhetoric is all about biodiversity and the protection of endangered species. But shouldn't we in that case be equally concerned about such bird species as the pale-headed brush-finch, the Pohnpei starling, the Liben lark, the Iquitos gnatcatcher, and Bachman's warbler – all on the critical list, even if the general public has never heard of them?

The same hesitation might attach to some of the reintroduction schemes for the sea eagle, osprey and red kite in the UK. Wonderful in their way, but why not also the tree sparrow, corn bunting, willow tit and spotted flycatcher, all declining fast but not such good box-office? Are we ultimately interested in conservation or in theatre?

These doubts might be deepened by an aggressive, hard-nosed Darwinian challenge along the following lines. 'These affectations of concern about other species are just displays of sentimentality. Yes, it may be a shame to see the passing of all these failing species, but that is the story of evolution. Natural selection has always ensured that some species evolve, adapt and survive while others lose their niches, become marginal and die out. There's no overarching morality or purpose to it – it's just that the human species is now the dominant one and our environmental needs are ousting other

species, exactly as they would us if the situation were reversed. It's a competition for survival. Moreover, those species conservationists are agonising about are mostly now so small in numbers that they are no longer a significant part of that overall web of interdependencies that ecologists study and celebrate. No other species would suffer if they disappeared from the face of the earth altogether. Wanting to preserve them artificially is just an indulgence of our own aesthetic preferences.'

We need to be able to answer that hypothetical challenge, and the answer must lie in precisely the fact that it is our species which for some time now has been the top predator and the principal cause of environmental change. In aeons past huge, natural geological and climatic changes accounted for the disappearance of the dinosaurs and the teeming life of the Jurassic, and species continued to emerge, evolve and adapt in more or less successful ways thereafter; but it wasn't until comparatively recently (very recently indeed in geological time-scales) that human pressure, predation and interference became a major factor affecting the prospects of other species. And now we are so populous, successful and dominant that we can in effect decide who lives and who dies. A truly god-like power, though we are not gods and have largely ceased to believe in them. But there is the crucial difference. Unless we are radical determinists as well as Darwinians, and deny the very existence of freewill, we must believe that we do at least have this power of decision. For the first time a species has evolved that is self-conscious and believes itself to have the freedom to act as it chooses. We also now have, again for the first time in history, enough scientific knowledge about the world to understand the consequences of many of our choices. This generates the moral equation: freedom plus knowledge equals responsibility. The question is, do we have the will and the wisdom to act on this knowledge and fulfill this responsibility?

What is lost, along with the disappearing species, if we fail? There is perhaps an analogy with human languages. There are some 6,000 living languages in the world today, but 96% of these are spoken by only 4% of the world's population, 133 have fewer than 10 speakers, 1500 fewer than 1,000, and on current trends more than 50% of the world's languages may have disappeared by 2100. That would be more than one language dying every fortnight between now and then. What would be lost in this case? Well, we would be losing a rich and

irreplaceable cultural heritage, each language a unique, subtle and complex way of relating to the world and to other people. Languages too are living organisms, containing within themselves all the memories, understandings, distinctions and associations that define a culture. When we lose a language we lose with it a little world and a whole realm of meaning.

The situation with birds is surely comparable. Of the 10,000 species of birds in the world today some 1,200 are already classified as 'critically endangered'. What we will be losing in each case here is not just a biological form but another kind of cultural inheritance. Birds too are unique carriers of meanings: through their associations with seasons, places and times, through their interactions with other species, through their voices and behaviour, and through their roles in our own lives. And extinctions can be local as well as global. If the cuckoo no longer comes to our villages in spring, or the skylark disappears from the fields, or the nightingale and the turtle dove are no longer to be heard in their traditional haunts, these too are extinctions and bereavements. Such losses drain from the landscape some of its meaning and significance.

Our world may be just the wrong size for our imaginations, alas. The earth seems to us so large that we cannot believe we can seriously damage it. But it is also so small in cosmic terms that it is in fact very vulnerable. We turn out to be the only species with the power to make a dead planet or to create meanings in a live one.

It passes like a thought

by Tim Dee

All men are islands and island-makers. It is what we do. Before we took cats and rats to the oceanic islands they weren't islands. They had everything the birds that lived on them needed. And because they had what the birds needed within reach, many birds didn't need to stretch into the air. They could walk their lives. Some never ran. They never needed to. Nothing was running after them. They put their efforts into other things: serenades, burrowing, laying eggs the size of mangos.

On Henderson Island in the south Pacific Ocean my neighbour Mike Brooke is at work as I write this. There is a crake on Henderson that has lived there so long and so out of touch with the rest of crakes, and other birds and other places, that it has become itself. Part of this becoming was to give up flying. It wasn't needed, as there was nowhere to fly to and nothing to fly from. The island was the crake and the crake was the island. It is all black with red eyes and red feet. Its song goes clackety-clack. Then we came like magicians. Rats came out of our cuffs, down our trouser legs, and from under our hats. And the rats got on well with Henderson and started eating the island. They liked its endemic seabird chicks and eggs, but also its crakes. The rats got strong and bold and would think nothing of lunching off a living chick. Now Mike has captured as many of the surviving crakes as he can, put them in cages on the island and has ushered helicopters from above to deposit poisoned food for the rats. He must wait while the rats eat the food and die. The crakes must wait in the cages until the rats have died and any remaining poison is cleared away. Then they will be let out. It is a complicated matter to compensate for flightlessness. It might have been no harder to knit or saw wings for the crakes, except we remember that Daedalus tried that.

This summer was the first of forty I remember in Britain when I didn't see a spotted flycatcher. I saw two at Chernobyl in the Ukraine in September and that reminded me that I hadn't seen any at home. You don't know what you've got till it's gone. But what does it mean to not see something? How might we register that or record it? How do we make absence tell? To not see something needs knowledge of the not seen. My children didn't see any spotted flycatchers either but they wouldn't have known if they had. I remember being eighteen and lying in bed in my attic room in the centre of Bristol through luxuriously stretched mid summer mornings when the only sound I could hear through the window was the snap of the beaks of the pair of spotted flycatchers that nested in a chink in the garden wall. This year I haven't heard that sound.

Red-backed shrikes have been breeding on Dartmoor in recent years. The first in England I think - or at least the first declared - since the pair that bred in a thorn thicket in a scrappy meadow near the River Lark at Santon Downham in the Brecks. I think there is a commemorative plaque there to those birds. I saw them before they died. The blissful ordinariness of the coming and going to their nest. The lovely silence a sitting shrike gathers about itself. The male's pink shirt. Their blackcurrant eyes. And the hook of their beaks, like a lace-maker's needle. Every red-backed shrike has this. I knew the two were rare but I didn't know they were the last. After this pair ended the birds were called extinct in Britain. But there are shrikes just over the Channel on the European mainland. In my lifetime the species in Britain have always been identified as being at the edge of their range. How do we feel the loss of them as British breeders? The great ball of birds bowled out of Africa every spring falling shorter and

shorter each year? But then what are the little egrets doing? Dotting our marshes and estuaries like errant shards of ice, melting into our lives their brilliant white, stretching the planet as the shrikes pull it back.

John James Audubon wrote as well as painted. It was he who described how flocks of passenger pigeons obscured the noonday light. Of the nine billion birds estimated in North America at the time of the continent's European discovery, three billion were passenger pigeons. Martha, the last of the three billion, died in Cincinnati zoo in 1914. Audubon also wrote this of the pigeon: 'When an individual is seen gliding through the woods and close to the observer it passes like a thought, and on trying to see it again the eye searches in vain: the bird is gone.'

Imagine if somewhere on the Mascarenes, like an unsurrendered Japanese soldier walking out of the forests of Burma, a dodo was found quietly getting on with things. What would it do to our minds? How would we think the dodo now? How does the gone become the here? All the living words we have for dodos, all the words spoken and written by those who saw them, are now hundreds of years old, so the bird shifts in our heads with the language. It creaks with age. And all extinctions and losses will be like this. Why do dinosaurs only have scientific names? Because there was no Maori to call them moa, no Dutch sailor to call them dodo.

Eighty years after the Dutch discovered it on Mauritius in the early seventeenth century, the dodo was extinct. Some say dodo means stupid, others that it describes their cooing. They were flightless birds and laid their eggs on the ground. They walked towards men. Oliver Goldsmith wrote: 'It is a silly simple bird…and very easily taken. Three or four dodos are enough to dine a hundred men'. Despite all the eating there are no complete dodo skeletons anywhere in the world. No one thought to keep a hold of the bones after dinner. Stuffed dodos in museums are models. The Grant Museum of Zoology at University College, London has a box of twenty or so tobacco-juice coloured bones. It looks like a tub of chicken remains after a fast-food blowout. A part skeleton found recently in a cave in Mauritius may yet yield dodo DNA. It is the dodo in Alice's Adventures in Wonderland that puts on the race that ends when it says: 'Everybody has won and all must have prizes.'

It is night and I cannot sleep. Midsummer Sutherland night is not night at all. The daylight has merely dimmed like a headache and pushes at my eyelids. Outside my room in the potato patch a corncrake is rasping his love song, singing his scientific name, crex crex, over and over. I count a hundred croaks and still cannot sleep. It carries into my head like carpentry. Once the whole of the British Isles was kept awake by corncrakes. When the day lifts at last I look out from my window and see two adult corncrakes stamping about on a pile of old potato plants like chickens. Later I learn how lucky I was to see the birds in the open. They are habitual skulkers and ground runners. They hate to fly and yet something at the end of summer pulls them from their fields up and out over the Atlantic and down the western edge of land towards the bigger grass of sub-Saharan Africa. They leave their chicks behind to follow as and when they can. Think of the Bay of Biscay where the European continental shelf falls away into deep oceanic water, the seas there where sunfish float and fin whales light the surface with their huge pale jaws. Think of the young corncrake unseen by me, hatched from the pair on the potato pile, directed alone into the sky and over the sea, but tired out. Listen for the sound it makes as it falls into the saltwater.

*'I made up a situation which
shows the last moment of the
last of the Amsterdam island
Ducks. The moment before he
flew into the sunset so to speak.
In one of my pictures he is
being strangled by a woman,
while her lover sleeps in the
background. The bird is the
intruder, the outsider,
someone of no consequence.
In my second picture the duck
is on stage, sniffing or
nibbling the pussy of a strip
dancer, amidst throbbing
music and passive onlookers.
But we know his last moment
is not far off. To be a ghost of
your kind is sad, to diminish
the variety of beings leaves
us with a sameness of a kind
and a little less wonder.
So in a way I made a kind of
homage to a variety of last
moments of this duck, and let
it be extinguished on a high.'*

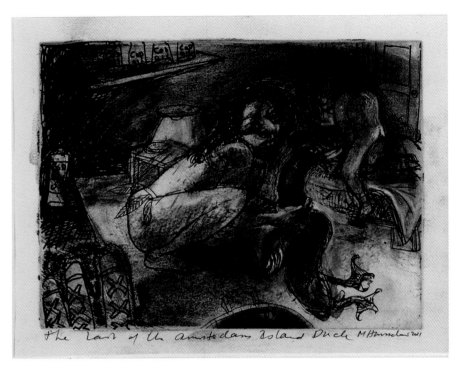

THE LAST AMSTERDAM ISLAND DUCK I – *Marcelle Hanselaar* – ETCHING & AQUATINT

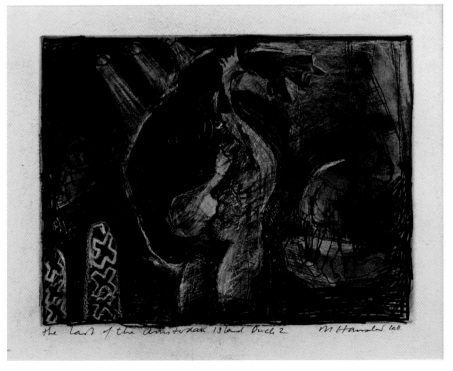

THE LAST AMSTERDAM ISLAND DUCK 2 – *Marcelle Hanselaar* – ETCHING & AQUATINT

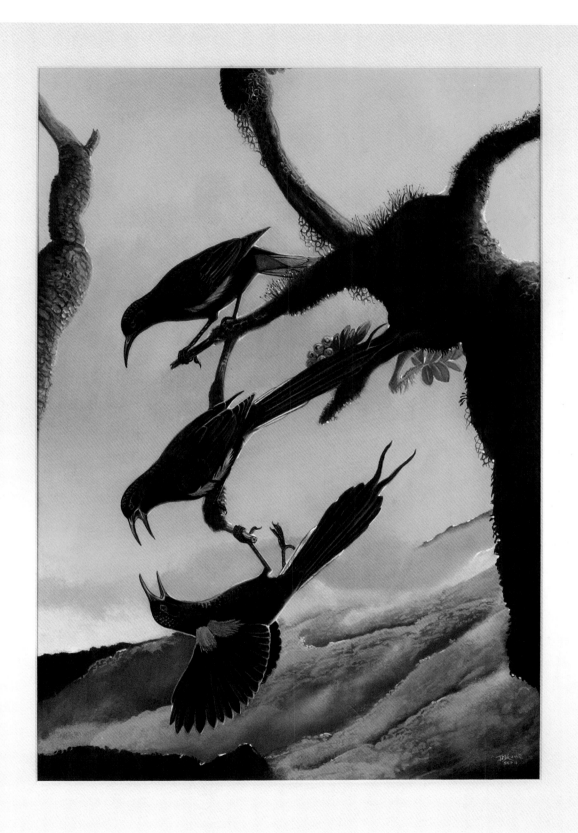

HAWAII O'O' – *Julian Hume* – OIL ON BOARD

'The 'O'o was reconstructed as active, very much alive birds based on the accounts of observers who studied them in the wild. The idea was designed to recreate a dynamic scene of a bird now extinct, and not to portray the usual staid image of an extinct species.'

The last free bird in England
by Bronagh Fegan

The lady of the house cooed over the sparrow as it fluttered its dappled wings in panic. Nearby, a jackdaw shrieked, startled by a door slamming in the house. Almost 30 cages were suspended from the ceiling, each containing a variety of birds, chirruping and cawing as the sun rose high in the sky. The windows were wide and tall, and were opened to let fresh air in from the rich green lands beyond. Outside, the lady's husband had constructed great aviaries of glass and chicken wire to hold the larger birds, ravens and hawks, anything that screamed rather than sang. The pond in the far field was surrounded by a wide fence with netting hung above to keep in the waterfowl. They swam round and round, sometimes venturing down the stream before stopping at the dam that kept them from the world outside. The lady surveyed her collection with a shiver of pride. It was very fine indeed.

The fashion had sprung from nowhere, as fashions tend to. Suddenly ladies kept magpies on bejewelled leads, sitting on their shoulder. Parrots were chained to stands and urged to mimic voices for seed, as their rich plumage wilted and dropped out. People kept pens of chickens and turkeys, expanding to pheasants and peacocks when they seemed too parochial. Birds became currency, a way to make a living, then after a while it became a way to make a fortune. Men left at dawn, chasing wild birds like Nabokov's butterflies. Meadows and grasslands were shattered by panicked squawks and an explosion of a flock upwards to freedom. Smarter men scavenged nests of blue eggs, speculated on the creature within, and lost their lives when the egg instead hatched a lizard or an adder, or nothing at all. The world changed. Mornings were silent. As the birds gradually vanished, the natural balance was disrupted. Insects erupted from every tree trunk, flitted in the air like a plague, unafraid. Trees bore fruit which ripened then rotted, falling to the ground and poisoning the earth.

The men came to realise they had overhunted. Weeks had passed without a bird to be found. They observed cornfields, sent dogs into the undergrowth, threw rocks at the treetops, but nothing came. Dealers had accepted payment in advance for the idea of birds. Now, as their hunters returned empty handed, furious customers demanded reparations. Bailiffs knocked down doors to take custody of valuable swallows and wrens. Robbers struck at night to purloin hissing peacocks for the black market. An accountant was stabbed in an alleyway for his shackled falcon. It was the people who were wild now.

But mostly they didn't mean to cause damage. There was a man called Harold, lame and desperate. He traversed an abandoned quarry with a torn net over his shoulder, driven on by his family's hunger. It had started to rain, and he fought his way into the deep forest that sprung up in the borders, shins bloody from rusted barbed wire and thorny undergrowth. He thought of the stream he used to fish in, as a boy, before this land was bought up. The wildlife that frolicked in the lush surroundings. He was putting all his hope on that memory. His feet sunk deep into marshland, the environment so secluded it seemed like night time. His heart soared when he saw the heron, appearing through the reeds, legs like stilts, like pins, stepping elegantly from the bank. Harold thought it incredible, an illusion at first. It had been so long since he had seen such a creature outside iron bars. He wished it would sing for a moment, or stretch its wings. It glanced at him without concern, as he negotiated the path behind it, trying to keep his balance as he raised the net and caught the bird. It struggled only slightly, beak and wings instantly tangled within the gaps. Gently Harold transferred it into a Hessian sack he had pulled from inside his coat, and carefully carried it back to civilisation. It was a struggle to resist the urge to peek inside, to reassure himself that he had indeed caught a bird where everyone else had failed.

A little further along, the heron's nest lay hidden on the bank, undisturbed apart from the gentle lapping of the water. In it lay a single white egg, shielded from the mania outside the confines of the nest. It would not be long until it discovered its first sense of freedom, and after that, the madness of the world it had inherited.

Today, my dear Icarus, you look like a planecrash

by Rebecca Fenton For Jessica Cooper

It's a bitch that you got grounded.
Smack
Head on the tarmac – sound of rattling wheels over rough ground resounding.

It seems that you were never meant to fly away, my love.
Just sway gracefully. Occasionally spin – a feverish dervish.

You sometimes stretched up
and branched out:
roadmapped hands flexing and grasping for a fistful of daylight.
Or punching back at that ever-elusive Air.

But never thee to be, my lady, a clichéd tree. Because you have curious roots
– pipes and wires, looping and tangled. Your sinewy
binds are so strong
that your wings which once opened as impressively as an ornate fan
have been clipped

you even said
It is as if they've been clipped, somehow.
Or singed.

The water catcher

by Anna Selby

She'd turn from a cannonball
to a curl of feathers,

detonate the water:
a white bruise mushrooming

a trail of sparks. Lakes
waited only for her.

In her uprising,
their flat planes shattered.

Wherever she went
the water flung up its arms.

In one gulp,
it would take her in.

All year, she'd climb
and sink, climb and sink,

burst from the tombs of the earth,
white fish roaring through her fingers

and after each dive
always that shock of crown.

Fuertes Parrot: Gone but not lost!

by Nicola Boulton

Everyone's personal connection to birds tells a different story about people and place; for me, birds not only hold a childlike fascination which has now developed into my chosen academic career in zoo-biology, but also a deeper spiritual connection. Birds allow us the opportunity to engage with the natural world, more so - in my opinion, than any other species of animal. They are charismatic, enticing and uplift us. Their plumage, their ability to fly and in some species, monogamy, can only be deeply admired. Many species allow us the pleasure of viewing their intricate lives and behaviour if we pause to look, and some we openly invite into our gardens and happily pay for annual feeding requirements! Many academics tell us to accept the rate of current extinction, that it is part of a natural process and should be left to develop at will; after all, didn't Charles Darwin state that natural selection would only permit the strongest species to survive? For me, this will never be an acceptable reality. To lose any bird is a tragedy.

My grandma Abuela was the first person who shared her immense love of birds with me. Her house in Caracas, Venezuela, was small and narrow, but the birds always had the best treatment. Her Amazon parrots were her favourites; they would be fed before her and would receive the best fruit she could obtain. Venezuela is an amazing contradiction at times. I would often walk around the concrete jungle that is Caracas- devoid of trees and plants yet only 2,000 yards away would be dense untouched rainforest. From here would often come flocks of striking parrots flying overhead, squawking- a dazzling and almost fictional sight when I was no older than 5 years. I would spend many an hour trying to gain the trust of my grandma Abuela's parrots but they were way too smart for me and would always take the treat before I could reach out and pet them. They were only loyal to her, and after she passed away, her favourite bird- which would follow her around the house, sleeping in her slippers, soon followed her. Parrots as a bird family to me represent South America perfectly; they are bright, colourful, noisy birds with a passionate headstrong quality. I remember from a young age sitting by my Abuelas' parrots and drawing them for hours - their plumage and bright eyes always inspired me to paint them- my other passion in life. Parrots thus not only fuel interest from scientific and behavioural viewpoints, but because they link me to my Latin heritage, and inspire me to undertake my passion for art.

Throughout my study at university I tried as much as possible to concentrate on South American fauna, with an emphasis on northern South America. During research for an assignment on evolutionary ecology, I stumbled upon Fuertes Parrot *Hapalopsittaca fuertesi*, sometimes called the Indigo-winged parrot. A small enigmatic parrot: they once inhabited a volcanic cliff face in Columbia within cloud-forest of elevations up to 3,300-3,500m. This of course made them susceptible to the problems brought about from deforestation and human population encroachment. In 1911, Fuertes Parrot was added to the ever growing list of 'gone' birds.

A picture of Fuertes Parrot must be seen before the true artistic beauty of this bird can be truly appreciated... like a painter got excited by the possibility of all the available colours; the bird is splattered with every colour across the spectrum. The body is a luminescent green, topped with a turquoise crown, an orange/yellow breast, scarlet red shoulders, then wing tips dipped in royal blue and a deep indigo. Fuertes Parrot represents a typical story of how human encroachment can effect a bird population so greatly that they can slip into extinction. To lose a species such as Fuertes Parrot makes me sad, not only from my scientifically-informed biologist viewpoint, but because of the massive loss it represents to South America's natural visual aesthetic beauty. If you feel sadness over the loss of this enigmatic little bird then like me, you will now love the next part of the story. For in 2002, Fundacion ProAves President, Alonso Quevedo, rediscovered an extant population of 14 Fuertes Parrot in Andean Colombia. A bird that had been believed to be extinct for over 90 years was found again! Now about 160 are said to exist in Cordillera Central, Risaraldo-Quindio border region in western Colombia. It had not gone the way of the world's 10 extinct parrots, now only known to us from museum specimens or written accounts. Although this story of re-discovery is without doubt unusual, it resonates with an important message of hope; and that I personally refuse to accept that extinction is an inevitable future for many species of birds.... and I am sure in 1911, that a handful of these rare little parrots thought much the same. So whilst we may commemorate the loss of many species of extinct birds, we should also remember that we must not give up hope on those that still exist, or may still exist. Miracles can happen. Lost birds can be found again. Fuertes Parrot.....in Spanish 'fuerte' means 'strong'.....my fellow South American, the Strong Parrot.

Song of the Crane & the Fish
by Liz Adams

A carmine day suffused with blood
the crane upon his bank of mud
that bill awash with yellow hate
looks down towards the pool, his bait:
fishes gleaming beneath the weeds
petals floating amidst their seeds;
various shapes and sounds unfurl
the silver sliding light now twirls:

& so I begin my song
 fragmented by the form
a bird white feathery my yellow
bill tips fins
 swish like dreams
shadows of fish tempt;
 their lives in this shallow pool
soon gasp upon the banks;
 the silvery pampas grass
bejewelled the liquid light aglow:
 a crayfish rises –

& night arrives – dark seeping slow
the crayfish snaps: his flamenco
circles across the sand, ignites
the red-azures in all the whites,
deeply within the shaking silt
the earth upon its axis tilts –
rousing the songs of light and shade
again, again, they rise self-made:

this yellow hum towards my brain a tap against
 my scarlet shell I scuttle off & still he flies his thunderous wings
 dipped black above the pool's red eyes

the crane with hunger aching on
does not declare his warning song –
killing each fish with florid lies
his stories bound by thorny ties;
delicate bones the banks display
the ruby shining shell now greys;
lucid diamonds begin to sink
splattered with black, his feathers blink –

 & yes they blink
 through the light of this blood-bright
 day I carry the crayfish on his way
 his pincers around my slim
 white neck my yellow
 bill jaundiced now; my blackened
 wings to quicken,
 fold a crayfish
 concertinas as I fall
 my head plummets
 on & on towards
 a pool: the white
 of the lotus gone.

Feathery Lies
by Liz Adams

Lotus flowers
white as the crane's neck,
opened their thoughts to the dark red sky –
they felt it too.

The crane flew by:
every petal trembled a little with the feathery white
thought of him.

The tree-God foresaw his bloodied plan,
his talk of flight, the endless promises –

his sweet-song charged the blue-green
with thin white ripples of thought.

Red-black diamonds sank –
the crane drank.

Fish span around his bill
love breathing through each scarlet gill.

Except the crayfish.

He liked his pool.
He liked the dark green-blue, the bright algae
racing through the white thought of the lotus flower.

Where is this pool you speak of?
the crayfish said. The crane smiled,
his yellow bill looked startling, wild.

He spoke of the pool's peace, its depth
the brightly flowering weed;
he didn't tell the crayfish
of his meditations charged with bright
red hate. His fantasies of killing:
leaving their bodies
parched in the sun. To coax them,
to drop them, one by one.

Instead he spoke of charity,
beguiled them with the water's bliss:
It's so cold and bright,
so impossibly deep.

The crayfish felt those lies creep.
The day turned red,
he killed him with one quick pinch.

The tree-God caught his head.

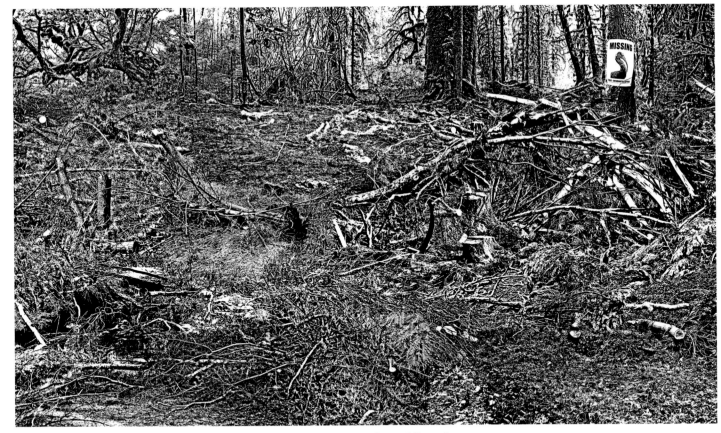

THE REUNION FLIGHTLESS IBIS – *Gregori Saavedra* – GICLEE

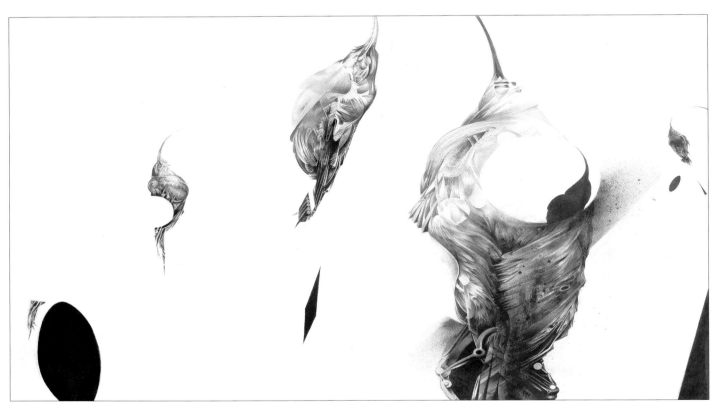

GREATER AKIALOA- *Hello Von* – PENCIL

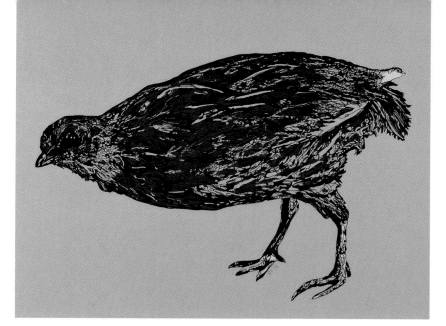

'NEW ZEALAND QUAIL' – *Susie Wright* – PRINT

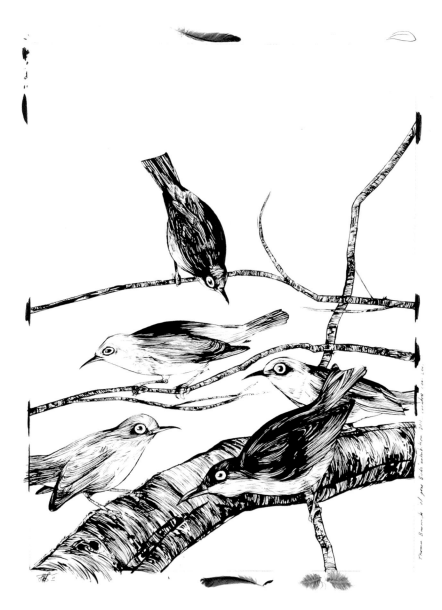

ROBUST WHITE-EYE – *Tom Barwick* – PEN & INK

Spectacled cormorant
by Sarah Day

We have found land. After dreaming of your feet next to mine when I stand on dry rock again, of the sound of your voice, your warmth, your face, I felt no joy as our broken vessel brought us safely in.

The men, half dead with scurvy, hunger and the storms we have endured, were loud in celebration. Even the sickest made an effort to go out on deck to see the land approach. Those who survived the waves, those who did not die as soon as they came into the air, who did not die crawling from their bunks, celebrated with cups of brandy brought suddenly out of hiding and congratulated the navigator. Their joy was indescribable. Somewhere amongst them, loud and distinct, a voice declared that 'if there had been a thousand navigators, they could not have hit it within a hair's breadth like this in their reckoning! We are not even half a mile off.'

Some of the men are trying to rebuild our ship, dragging pillars of rotting wood along the sand and piling them high as if they could make a raft to heaven. The cormorants circle above them, wings to the sun, and I envy their view. They cannot know what it is, to be unmapped in this great sea. All we know is that we came from the west, and we must return that way.

A few weeks ago, the first shot was fired. A sound this place has never heard before, and the bird came spinning through the air towards us, its wings arched out behind it.

It landed far along the beach. We went to meet it; some of the men were cheering, they have not tasted meat for days. It lay on its side in a hollow of sand, one black wing still moving, as if to feel the air through its feathers again. Its belly was rising and falling like a fish on land. I could see into its unlidded eye, black and glassy.

Then a great wind came — the weather here is filthy — and lifted its feathers into the air, and I thought of you on the shore as we said goodbye, and whether you found somewhere warm to spend the winter.

One of the men stepped forward and prodded it with the butt of a rifle, and then it was just meat, its feathers ripe for plucking, and our mouths hung dryly open at the thought of a fresh meal.

We wrap them in clay and bury them, a sombre rite; then they are baked in the hollow of the earth and resurrected, each one feeding three men with ease. I wish I could describe to you their sour flesh, but we have tasted nothing but salt meat and biscuits for so long, our tongues have lost their senses.

We brought down many more that day, and in the weeks which followed, and still the skies are full, and we can eat without rations.

I have begun to dream of them at night, in my wooded shelter, as the storms break through the timber. Their shadows crossing ours, their lidless eyes which see everything I want to see; the places where the continents meet, or fail to meet, how far we are from home, the unmapped parts of you.

I dream of your hand anchored in mine, then letting go. The sight from deck as we sailed from Avacha, green land shrinking into an envelope of sea and sky until there was only water, clouds and rain.

They brought me cormorant meat today and I could not eat it. I cannot even watch them fall. Steller is already talking of the notes he will send back to the Academy, the papers he will read. He has been cataloguing every creature he can find, sketching its anatomy, observing its behaviour, then storing the carcasses and skeletons for more research — which the crew are reluctant to allow. They are more than meat, then; they are a piece of nature to be mapped and understood, to be brought down. Steller's cormorant, he would have them be called.

You told me on the shore that you were mine, that you would wait. I hope that you will not. I hope the cormorants will stay in the sky, that the two continents do not and will not ever meet, and that every trace of us, the shadows we have brought here, will diminish.

Our feathered friends

by Nia Davies Inspired by Edd Pearman's Mysterious Starling Mauritius Blue Pigeon Red Moustached Fruit Dove Maupiti Monarch.

There's talk of birds
feared dead
by those who talk in language.
 The unsettled perch,
 by way of leafless twigs,
 by way of slim wrists bent back.
 Talk of the perch that presents itself
 empty of its purpose.
Now you see your friend,
now you see the perch.
 Talk of the language-speakers who
 speak bird, feared dead.
 The Lesser Fear: of your own friends.
 The Common Fear: the fear of birds.
 Then the waves
made by feather
or sound of imagined flap.
 Talk and song are waves. And words
 are only waves.
 Just because waves are invisible
 to the naked eye, doesn't mean
 they aren't irrigating you in your sleep.
But thought,
thinks the unthinking feathered friend,
is no wave is perimeter fence.

 To a naked eye the birds are invisible.

 The Local Fear: loss of words for lost birds.
The Younger's Fear: fear of your own words.

 To the naked eye, talk is invisible,
 this talk, this language, now feared dead,

 by those who write in English.

 Poor little perch without friend. Poor wretch.

The Last Fear: to wake up, superseded
by the eye that bites.

Ghosts of gone birds *by Paul Jepson*

Back from the brink transformed. Musings on Bali Starling conservation.

4pm, 20th September 1991 and I'm standing on a low escarpment on the Teluk Terima Peninsular of West Bali National Park. I'm taking part in the annual census of the last wild population of the critically endangered Bali Starling. Bas van Balen, the BirdLife Bali Starling Project Officer, is half way up a tree to my right. Three national park rangers are with us: another 20 or so are strategically positioned at points along known flight routes from foraging areas to roost trees. Intermittently our radio crackles into life as other groups check in. Around 5.30pm things start to happen - the radio reports birds flying our way. I scan the open landscape of dry monsoon forest in front of me with rising anticipation. This is it! I'm about to add to my list one of the world rarest and most iconic species! And then they come, 'chirup' calls, beautiful white, sailing flight, black wing tips. Concentrate…how many? I count 24. The others concur. The previous year's count had recorded just 14 birds and I reflect on the fact that the total world population of a species may have just flown through my binocular vision.

12 midday, 12th August 2009 and I'm squatting on my haunches on the edge of a dry terraced field on the island of Nusa Penida off the south-east coast of Bali. Ten meters away a Bali Starling is preening and singing its gentle sub-song perched among the lower branches of a bushy tree. The midday sun pounds down, the starling drops down snatches up a grasshopper and returns to its perch. I immerse myself in observation and thought. What is this bird really? It has always been an enigma: a highly distinctive myna, discovered relatively late in the history of western ornithology (in 1911) and apparently endemic to the north-west of Bali. What explains its absence from the same monsoon forest habitat in East Java which is clearly visible from its West Bali habitat and separated by only a narrow sea straight?

As I watch this bird, released two seasons earlier from a captive breeding programme, my mind starts to make comparisons with the Bank Myna, a species that I know from many birding trips to India. Something resonates - the shape, its flight, the way it sits shrike-like and then drops to the ground to catch insects with a short hop and run? I think 'Why didn't I spend more time observing the foraging behavior and

ecology of Bank Mynas?". But in those days my mode of bird-watching was focused on identification and listing. Not to worry, an interesting train of thought is emerging as I squat and watch. Maybe the Bali Starling and the Bank Myna evolved in dynamic landscapes of forests and savannah along the vast rivers that once drained the Indian sub-continent and Sunda shelf. Could it be that as sea levels rose 20,000 years ago and flooded these landscapes the closest analogue was the agricultural mosaics of early civilizations? Perhaps the Bali Starling is a refuge from lands lost long ago to sea-level rise that survived in the Balinese countryside. Perhaps trapping for unregulated international cage bird markets in the 1950s, 60 and 70s led to it being caught out from these accessible landscapes and the population I saw in the West Bali National Park was a remnant population hanging on in sub-optimal habitat?

With these thoughts in mind I returned to my family waiting patiently in the shade of a road-side tree and overlooking a small valley of maize fields. Overhanging one corner was my birds nest tree. We bumped back along the little roads, happily sliding up and down the bench seats in our hired bemo, to the simple compound of the Friends of the National Parks Foundation (nothing to do with Bali Barat National Park) with its tree nursery, row of Bali Starling breeding cages and their progeny flying free in the surrounding coconut plantation. That evening Bayu Wirayudha, founding director of FNFP and mastermind of the Nusa Penida releases invited me to walk over to meet a prominent traditional leader on the island. For generations his family had managed the famous Balinese temple of Ped located a little way down the road and the old leader was a key supporter of FNFP's conservation vision on the island. During the walk I quizzed Bayu and his colleague Made on how they saw the relationship between people and birds and between society and landscape as well as their views on a Balinese conservation philosophy. Our conversation confirmed much of what I already knew or suspected about the more integrated and holistic Balinese world views on these themes and the absence of the nature-society, wild-domestic, science-religion dualisms that are so evident in western-thinking and conservation logics. However, I was struck by how these Balinese conservationists had

assembled their spiritual worldviews, training in veterinary science, experience of conservation ecology and management and a keen sense of politics into a conservation approach that made sense locally and that seemed to be achieving remarkable success.

Outside the traditional leader's compound stood on old fig tree with a hanging beehive where one pair of released Bali Starlings had fledged four broods. Sitting with the Bayu, Made and the old leader, my Indonesian too rusty to keep up with their conservation, my thoughts drifted back to my musings of the morning and to my broader interests in questions of expert knowledge and authority in endangered species conservation. My visit to Nusa Penida had been prompted by an instance I'd witnessed a year earlier in the Burung Indonesia office in Bogor (West Java). This involved a western conservation official asking his Indonesian colleagues what they were doing to block the Nusa Penida release. His attitude had struck me as a bit disingenuous to me given that the international project to save the species in the Bali Barat National park had failed and the wild population had as near as dammit gone extinct in 2006 (four birds recorded, of which 3 were know recently releases). The comment was made in the content of an acrimonious controversy relating to the locus of expertise in conservation and which had seen the RSPB/BirdLife and the Indonesian state conservation department doing there utmost to stop FNFP's planned release of Bali Starlings on Nusa Penida: in the end the Governor of Bali stepped in to lend his support to the view that if the Bali Starling was the official mascot of Bali then it was right and proper that a local group should act to conserve it in a Balinese way.

It seemed to me that at its root, this controversy revolved around opposing visions on the identity of the bird being saved from extinction. For establishment conservationists the Bali Starling was a wild species unique to dry monsoon forest on Bali that needed to be conserved as such under the guidance of expert bodies. For FNFP the Bali Starling was part of the Balinese cultural heritage and it made sense to save it as a free-living inhabitant of everyday landscapes by mobilizing traditional cultural institutions. From this perspective it is perhaps not surprising that a local project which de-linked the conservation of a critically endangered species from conservation institutions and enrolled local citizens along with their forms of knowledge would appear a challenge to establishment interests.

Interestingly, there is limited scientific evidence to support either one of these two Bali Starling identities. Whilst my earlier musings on the biogeographic origins of the Bali Starling are merely speculation, the authoritative view that Bali Starling is a species of dry-monsoon forest also lacks a water-tight evidence base. Until recently ornithologists visiting Bali oriented towards 'pristine' habitats and it may be that they over-looked the species presence in the wider Balinese countryside. Put another way the Bali Starling may well have always been a bird of the countryside but it was trapped out from these more accessible landscapes before field surveys took off in the 1980s. We currently have no way of knowing whether this was the case though Bayu recalls seeing Bali Starlings around his village when he was a boy.

Perhaps one lesson from this 'back from the brink' story of Bali Starling is that conservationists should avoid being too prescriptive about the identity of the species to be conserved. Perhaps by being more flexible about who saves species from extinction and in what way and where, we will be better able to avoid the future extinctions of bird species. The Bali Starling I watched on Nusa Pendia was as alive, as entrancing and valued as those I saw in the 'official conservation' space of West Bali Barat National Park.

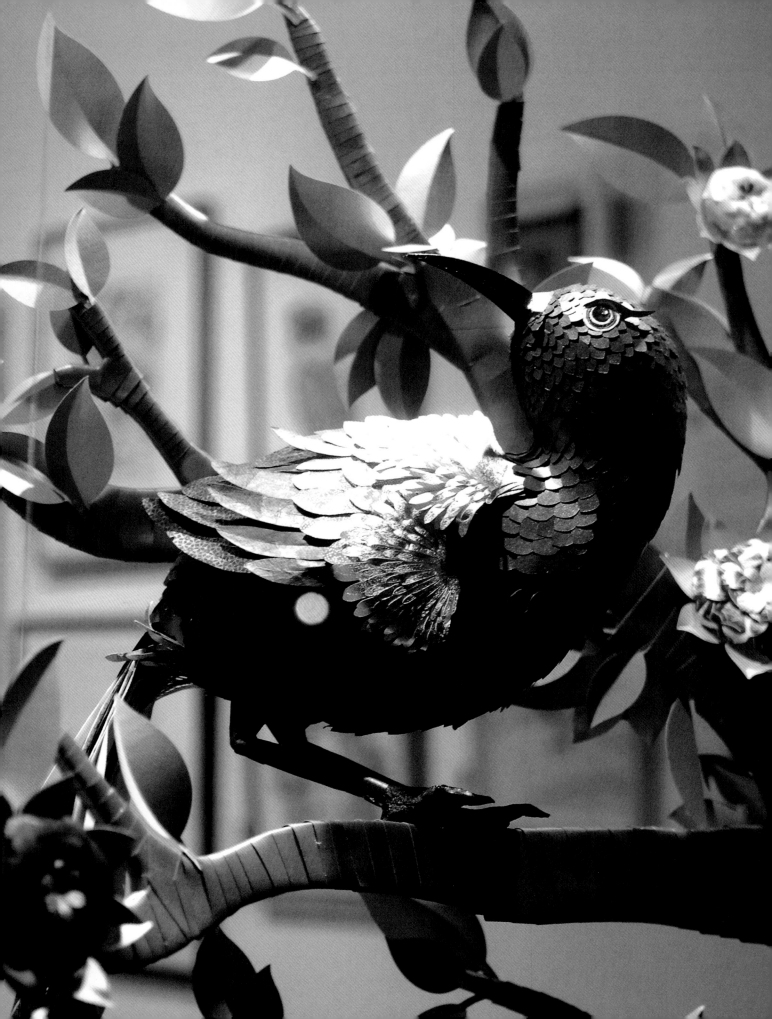

Beside the seaside

It was the hill that nearly beat us: maybe we were out of practice.

It had been almost eight months since *Ghosts* London and we were becalmed again. Slack time. False starts. We'd had a grandiose plan to take *Ghosts* to Australia that ended in disarray and a lot of recriminations.

Oxford University Museum of Natural History was intrigued by our offer of a *Ghosts* remix of their collection. We'd been allowed to nose around all the nooks and crannies of the building, and discovered all sorts of hidden delights such as the Victorian Spirit Store. There was lots of potential, but once again lack of funding tripped us up.

We'd designed Ralph's *Extinct Boids* book. We had artists emailing us from all over the country asking about the next show and how they could get involved. We had four and a half thousand followers on Facebook patiently waiting for new news. We had to do something. So we went to the seaside – and the hill nearly beat us.

Anyone who visited *Ghosts* Brighton by train will know what we're talking about. Exit the station and turn left, not straight left but a sort of right, then twist under the bridge and left down the steeply descending Trafalgar Street to St George's Place.

It's a pleasant stroll if you keep your wits about you. Overhead, the gulls are wheeling, letting you know that this is a place with piers and a seafront promenade. The benevolent face of John Peel stares down from a mural on the side of the Prince Albert pub, like a fatherly bouncer nodding you into the neighbourhood, letting you know it's his kind of town so be prepared to put a little extra effort into uncovering the gems on offer.

Then in quick succession you descend past a series of staggered music and bike shops (the Wax Factor was our favourite vinyl outlet), followed by more wall art, this time dedicated to whale-fest.com and Prince Fatty versus the Drunken Gambler. The gradient stays steep as you shuffle past the shanty-town street-market chic of Sydney Street and the ominous signs outside Pelham Square declaring it a place 'where alcohol restrictions apply'. Here are old-school pubs like the Prince George and Great Eastern. Reach the bottom of the hill and you're rewarded by a pawnbrokers promising you 'cash for a gold' and a Domino's pizza where all that gold-converted cash can be lavished on a ten-slice Texas BBQ special.

So that was the hill: steep but unquestionably the fastest route from A to B, from Arriving at the station to Being at the gallery. We took it on a regular basis as we

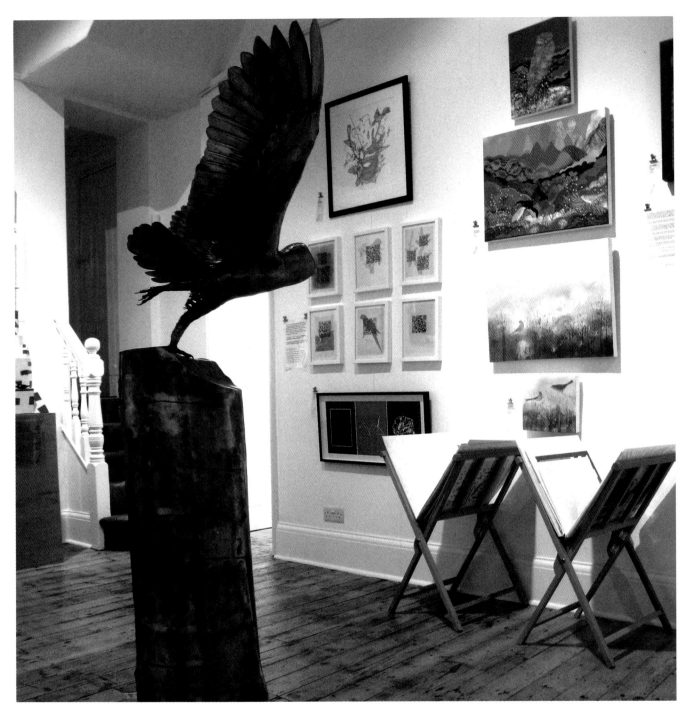

got together with Laura Coleman and plotted how to make *Ghosts* Brighton the perfect means of launching her vision for a new south-coast art space dedicated to supporting artists and communities to articulate and celebrate their relationship with the changing environment.

They were good, constructive meetings among the paint pots, ladders and scaffolding of the slowly emerging ONCA Gallery. We had crazy ideas – like *Ghosts* art classes on the beachfront, or a festive window display of 25 advent-calendar bird boxes. We worked through the list of artists we thought would give the exhibition a distinctive flavour from the Rochelle. We reconfigured the space around different themes, sequenced the art so that the *Ghosts* narrative unfolded over two floors, a courtyard and an unexpected crypt. (Unexpected here means something not on any plans or schematics for the

gallery space, so its sudden discovery behind a stack of rubbish in the courtyard was rather, well, unexpected.)

After all the discussions and decisions, we would pack up our stuff and pause, contemplating the climb back up the hill to get to the station and catch the train home. It tired us out just thinking about it. We would huff and puff and wheeze our way back up the gradient, realising just how unfit an occupation involving organising art projects kept you. We vowed to cut out the early-morning coffee and croissant-fests on the commute down to the gallery. We checked on Google maps for alternative routes back to the station, but all to no avail.

So we made the hill just another one of those hurdles that got tossed in front of us as part and parcel of the *Ghosts* challenge. Obstacles happened all the time. We just stared them down and got on with the project. They never beat us.

Ghosts Brighton at the ONCA Gallery opened on Thursday, 8 November 2012. The vibe was different from that in London. Laura was giving us the space for three

months, an incredibly generous gesture, so we could afford to stretch out a little more, relax and try out some new ideas. There could be more live events, talks and different types of performance, more workshops and educational projects – and window displays. We had a beautiful floor-to-ceiling window at the front of the galley that looked out across the bustling road to St Peter's Church. Everyone walked past it. It would be our job to make sure they stopped walking past it and looked in. We started planning window installations, thinking of artists that would take on the specific space and make it their own. We sat down with Laura and looked at the calendar. Three months was a long time for a show unless you were late-period Picasso. We decided that if we could get enough new artists involved, we'd do a rehang every four weeks.

We included photography for the first time, with a selection of chilling images by US photographer Carolyn Drake, depicting her experience of mist nets and lime sticks in Cyprus. Ready-mades made a comeback with

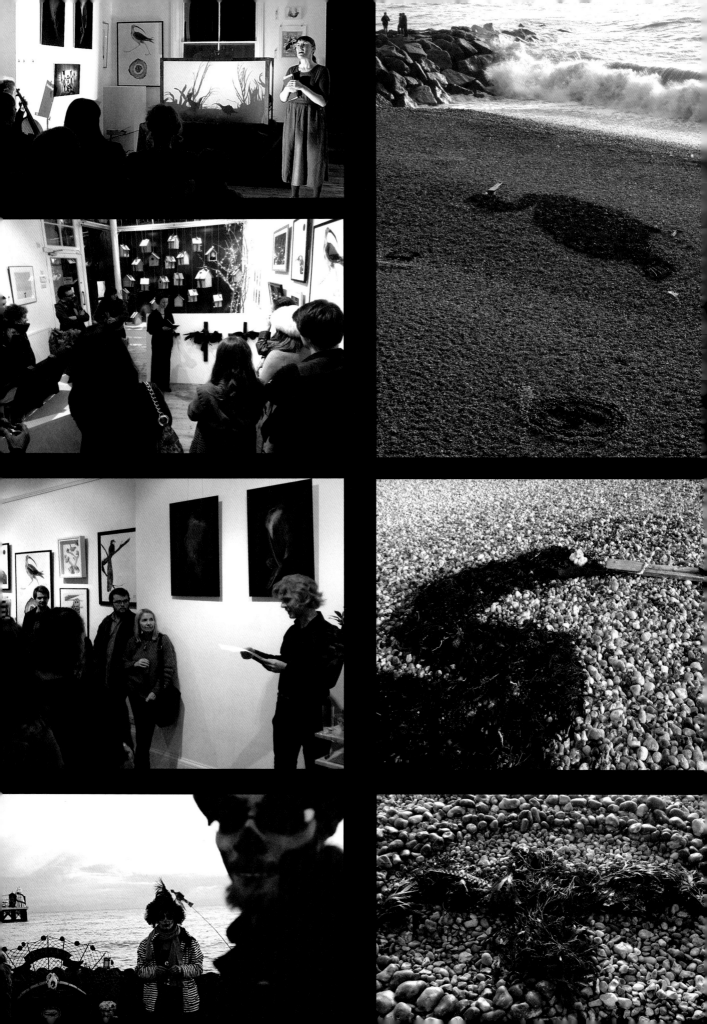

the fantastic found art of Roy Kelf's 'Birdfeeders', Beth Dawson's 'Ghosts of Gone Brollys' and Richard Crawford's 'Memorial to the Stevens Island Wren'.

For pure pen-and-ink draughtsmanship, we had four stunning pieces by Brandon Lodge – the work represented our engagement with a second generation of *Ghosts* artists, as Brandon had been introduced to us by his tutor Tom Barwick, an artist who had exhibited at *Ghosts* London, then set the Ghosts brief for his second-year students at Plymouth. Brandon was one of those students, and we received the first jpeg of his portrait, 'Guadalupe Caracara'. It was a picture that seemed to connect the bird with its prehistoric roots, more old-school raptor than feathered hunter.

Stuart Whitton's 'Huia', all economical charcoal-tinted pencil and pastel lines emerging out of the black abyss, recalled Rebecca Foster's lonely 'Reunion Starling' from the Rochelle. Stephen Melton provided our first

eye-catching window installation with his 'The Key To Life: A Lesson To Be Learnt' series of three crucified birds, looking at the countryside casualties of man's less than harmonious relationship with nature.

December provided an excuse for *Ghosts* to go a little bit festive as we created the award-winning *Ghosts* Bird Box Advent Calendar window installation to count down the days to Christmas, with a different sculptural piece sitting behind each of the numbered doors. The work was created by a combination of local schools and established Ghosts artists. Poetry returned with another wordPLAY event.

Then in January we unveiled our most ambitious installation yet: the Makerie Studio recreated a lush, overgrown-forest setting for their exquisitely paper-cut 'Hawaii O'O'. Ghosts Live continued with Persephone Pearl and Feral Theatre organsing a Mexican Day of the Dead tribute and producing a wonderful new performance of their shadow puppet story 'Last of the Curlews'.

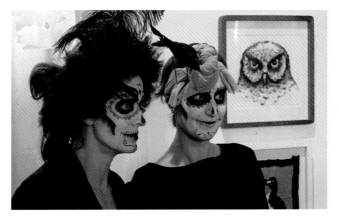

'When I went to see Ghosts of Gone Birds in London, I had just come back from five years in the Bolivian Amazon. I found it hard, no longer being in the jungle - but I had an idea for setting up a gallery space, where artists could tell stories about nature, raising awareness of how it's changing and at the same time raising funds for conservation projects. I didn't quite know how to do it, or if it could work. Then I walked into the Rochelle School, and Ghosts of Gone Birds hit me in the face. It was magical, beautiful and sad. It was wonderful. A year on and One Network for Conservation and the Arts had started to become a reality. Ghosts agreed to be my first exhibition - it couldn't have been more perfect, neither could I have felt luckier. ONCA began with stories of turquoise-throated pufflegs, pagan nightingale reed-warblers, elephant birds and dusky seaside sparrows. And as the walls of the gallery grew fuller, so did the visitors book - stuffed with amazing comments from people enchanted by the strange ghosts, the loud ones, the happy ones and the difficult ones. At the end of the exhibition, we performed a (long) roll call of extinct birds - a roll call that just showed how many more stories there are to be told. The birds have now flown away, to perch on other lucky walls, but they gave me and ONCA the best start possible. I hope ONCA will continue to be a permanent home for projects like Ghosts - projects that give voice to those we are losing, or have already lost; those that we now only find in footnotes and have to conjure up in our imaginations.'

Laura Coleman – FOUNDER OF ONCA

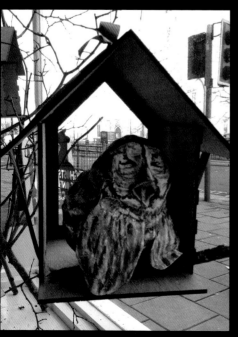

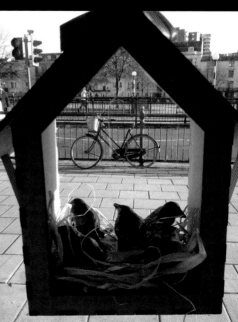

THE GHOSTS XMAS ADVENT CALENDAR BIRDBOX DISPLAY

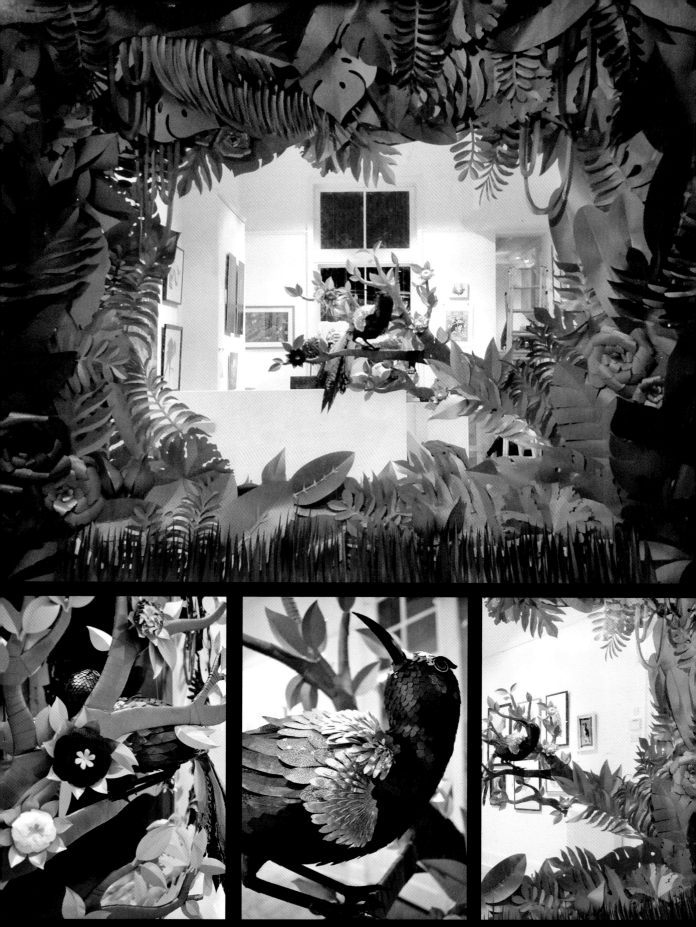

HAWAII 'O · *Jeux* · *Horecraft & Juli Wilkinson* · *Aka The Malezia Studio* · IRIDS. BENT AND JAPANESE HAND PRINTED PAPER

'WHERE HAVE ALL THE SPARROWS GONE?'

– Maxine Greer –

PAPER, BOUND & LACQUERED

'In 2007 Sparrows were put on the International Union for Conservation of Nature red list of threatened species. "Where have all the Sparrows gone?" explores the narrative we have with birds, in particular Sparrows. Our relationship with Sparrows has been one of agriculture, urbanisation money, religion and love. Tracking a species' decline in population provides an opportunity to reflect on change and the passage of time. We infer human characteristics onto birds and project our own characteristics onto them. If the birds that surround us change over time does this change reflect changes in our relationships as we mature?'

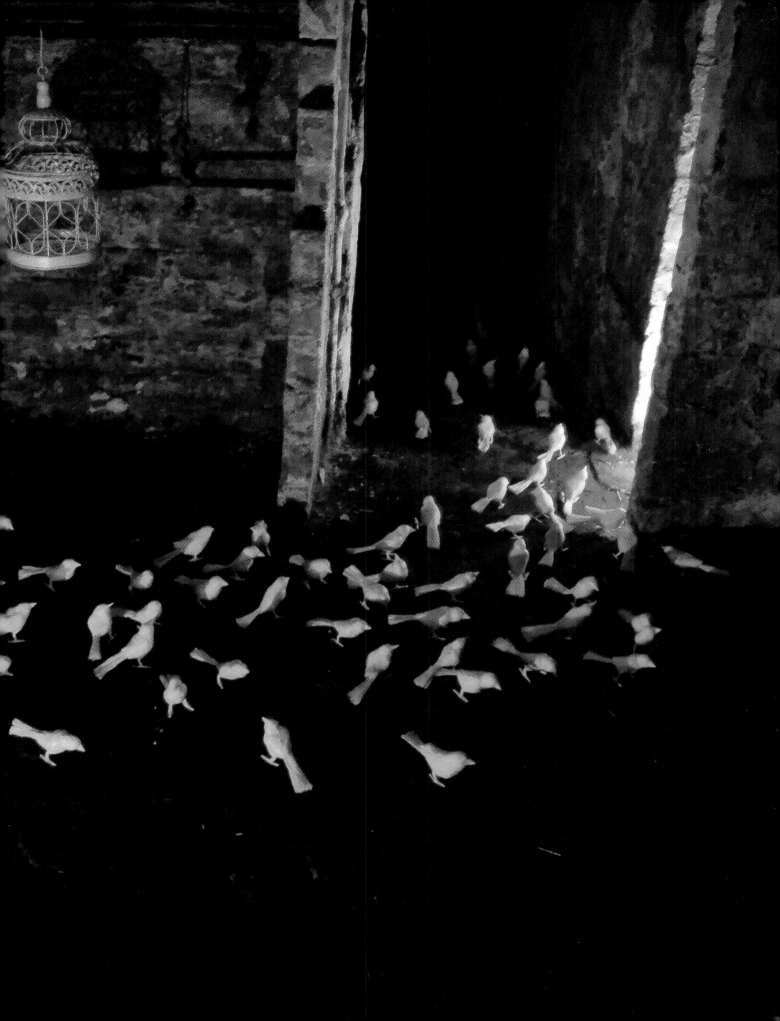

'SPIRIT OF THE BIRDS' *Faunagraphic* MURAL

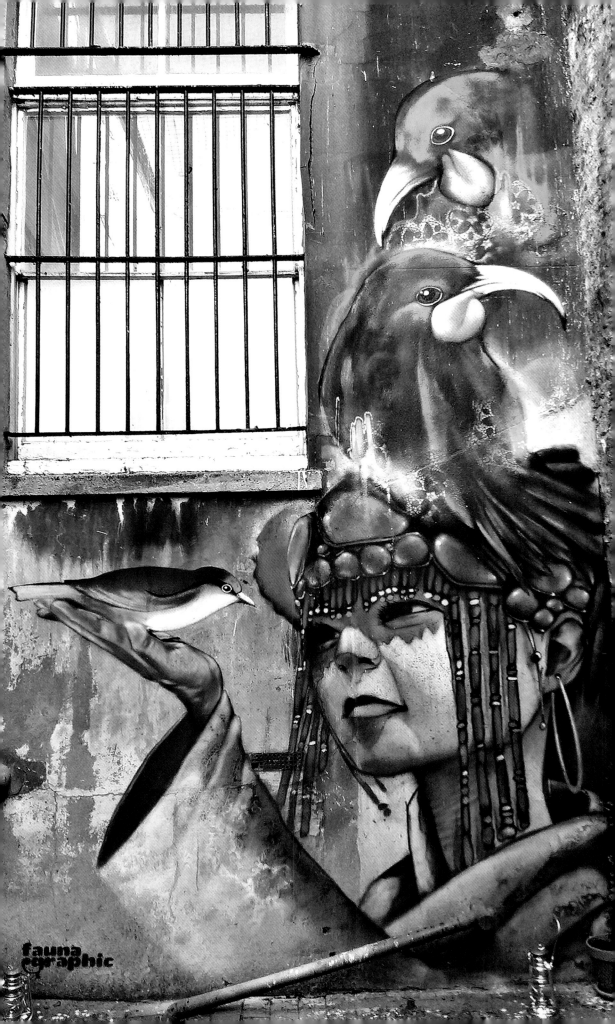

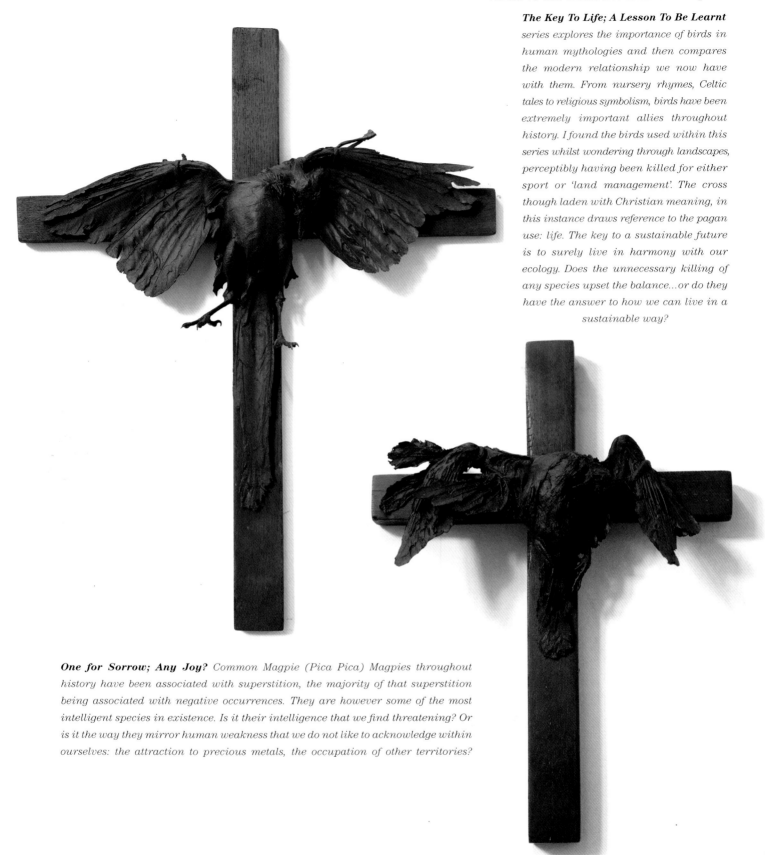

The Key To Life; A Lesson To Be Learnt *series explores the importance of birds in human mythologies and then compares the modern relationship we now have with them. From nursery rhymes, Celtic tales to religious symbolism, birds have been extremely important allies throughout history. I found the birds used within this series whilst wondering through landscapes, perceptibly having been killed for either sport or 'land management'. The cross though laden with Christian meaning, in this instance draws reference to the pagan use: life. The key to a sustainable future is to surely live in harmony with our ecology. Does the unnecessary killing of any species upset the balance...or do they have the answer to how we can live in a sustainable way?*

One for Sorrow; Any Joy? *Common Magpie (Pica Pica) Magpies throughout history have been associated with superstition, the majority of that superstition being associated with negative occurrences. They are however some of the most intelligent species in existence. Is it their intelligence that we find threatening? Or is it the way they mirror human weakness that we do not like to acknowledge within ourselves: the attraction to precious metals, the occupation of other territories?*

Peace and Pacifism; where does the garden grow? *Dove Columba (Livia Domestica) Doves are domesticated pigeons, and are one of the oldest domesticated birds in our history. We have employed them to act in war; and then as signs of peace. This contradictory but eternally linked relationship, from pest control to religious celebration, has been recorded for over 5000 years. Our aesthetic judgement from one colour to another determines their fate or reverence.*

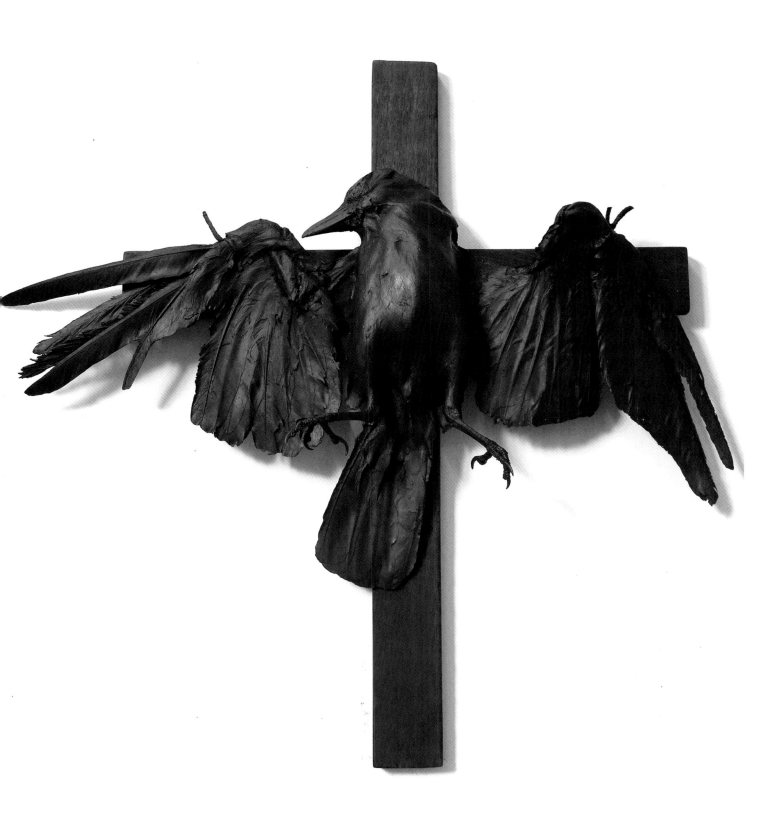

It is at the guarding of thy death that I am; and I shall be. *Carrion Crow (Corvus Corone)*
Crows show signs of remarkable intelligence and are used throughout religion as powerful
symbols, but in this instance I drew upon Morrigan. A goddess of strife and battle who transforms
into a crow. She is a symbol of power, a warrior queen.

BLACKCAP 2012

– Alison Stolwood –

DIGITAL C TYPE PRINTS

'I am interested in how we use technology to observe and understand our environment and ecosystems. We find our encounters and knowledge of nature through watching a wildlife documentary, visiting a natural history museum or viewing published media and art. These experiences become the way we understand and imagine the natural world. The Blackcap images consider methods of studying nature'.

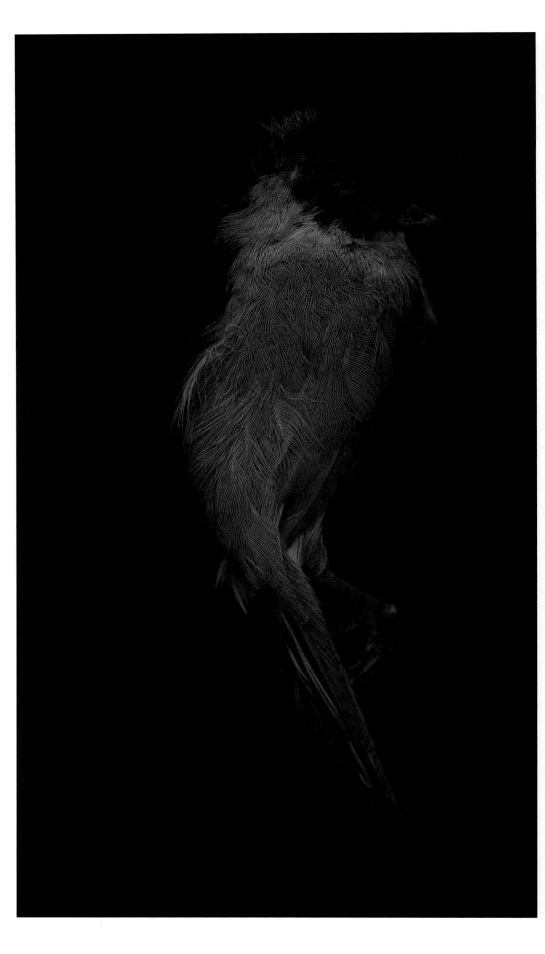

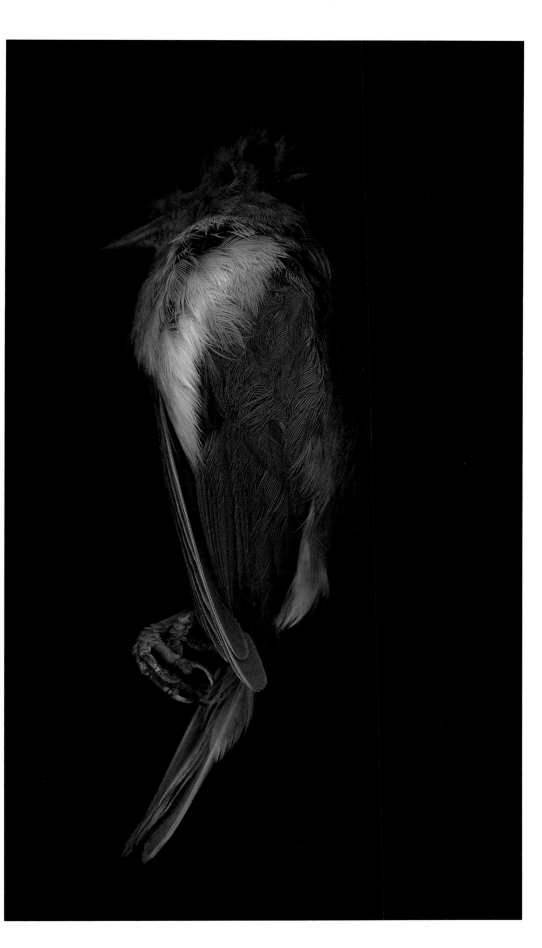

'They serve to represent change
and loss of habitat, rather than
represent the Blackcap species.
I isolated the Blackcap from
its environment, scanning it
on either side using a flatbed
scanner at a high resolution.
Then printed the images larger
so the detail of the feathers can
be seen. The sharp scan fades
into soft focus as the shape
of the bird moves away from
the glass, as if changing state.'

'A lighthouse keeper's cat brought about the sad demise of the Stevens Island Wren, a small flightless bird that couldn't escape predation because it was trapped on Steven's Island. That a building intended to protect seamen from the rocks around Steven's Island should bring about such a catastrophe, is ironic. It is quite likely that the well-meaning people who were so anxious to protect seamen were oblivious to the effects of their project: in 1895, bird populations probably seemed inexhaustible to most people. Today few would adopt this blind stance towards our neighbour species. I have made my memorial to the extinct Wren by bringing together elements from a 19th century lighthouse (home of the feral cat), with the sombre monolithic forms of Charles Jaggers' Royal Artillery memorial at Hyde Park corner. The extermination of a species deserves our sincere remorse, and Jagger's memorial has for me a feeling of weight and sobriety that gives expression to grief. The red tape I used to hold my blocks in place during construction have become integral to the meaning of my memorial, suggesting bloody bandages, red cross signs or the red and white warning bands that encircle a lighthouse. Two black wrens lie dead on top of red-draped biers at the base, but on the summit of the lighthouse the ethereal presence of the wren remains; a memory that won't go away and a reminder of the incalculable harm that inept people have brought about through ignorance.'

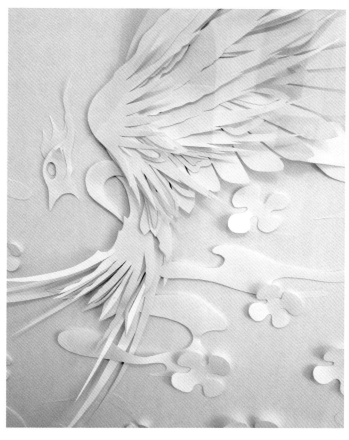

'GHOST' – *Si Scott* – HAND-CRAFTED 3D PAPER PIECE

'FOLDED' – *Adam Bridgland* – Print

'I wanted to create a work that simply and effectively encompassed the idea of extinction. The use of an origami bird as a central image worked to convey that something as simple as a piece of paper with time and craft can be made in to a beautiful but complicated form. However in a matter of seconds this can be destroyed. The title folded plays on the dual meaning of something both disappearing but also the practice of origami.'

BISHOP'S 'O'O – *Oliver Harud* – PRINT

'Reading through the depressingly long list of eradicated species, these happen to be
birds but I was well aware that equally long lists of mammals, insects, fish etc. exist
elsewhere, there was a description of the bird, some idea of its habits and then almost
without exception the story ends abruptly when the hapless species runs up against
man. So in all honesty I could have chosen at random but the victim of my little piece,
Bishop's 'O'O, seemed to typify man's impact. Like so many other creatures that until
very recently lived happily on this planet, Moho bishopi found itself swept aside by
the two horsemen of our own brand of apocalypse. Man's unquenchable thrust for
land, transforming any aboriginal habitats we encounter into homogenous farms
and urban spaces and our ever present and ever willing henchmen Rattus rattus.'

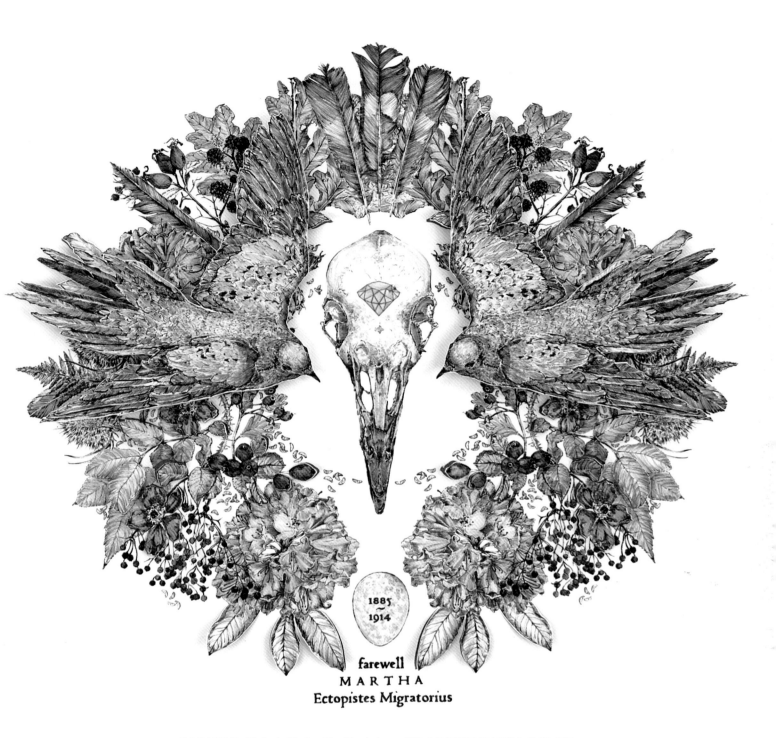

1885
~
1914

farewell
M A R T H A
Ectopistes Migratorius

'OH MARTHA' – *Victoria Foster Aka The Aviary* – PEN, INK, WATERCOLOUR & PAPER CUT

'Oh Martha' is a memorial piece in keeping with the decorative and elaborate design of the 1900s, employing detail and reverence usually reserved for the rich and the great. Placing emphasis on Martha, the last of her kind, seems a natural way to draw attention to both her personal story and the plight of her species. The floral 'wreath' comprises of berries, seeds, leaves and flower heads that would have been found in abundance in the deciduous forests that the Passenger Pigeon made home, similar to the ancient woodland that surrounds my own home and studio.'

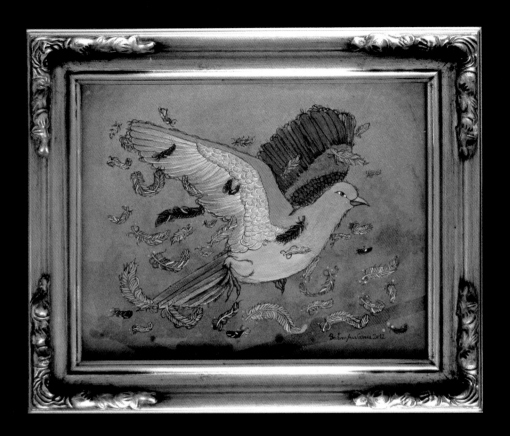

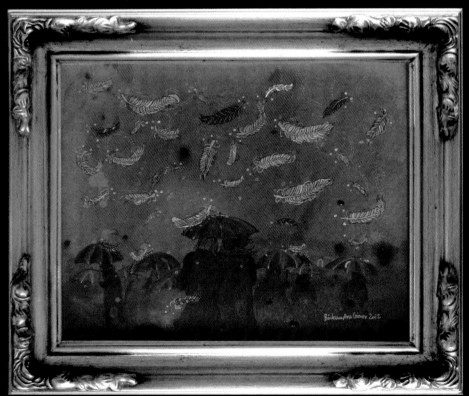

COLUMBA VERSICOLOR I & II – *Barbara Ana Gomez* – MIXED MEDIA

*'I was instantly in love with the green-purple iridescent colours of the
Columba Versicolor. My inspiration came from its beautiful feathers.'*

CHATHAM ISLAND FERNBIRD IN HIS HABITAT"

– Lucy Wilson – MIXED MEDIA

'The book 'opens up' their world, back to 3D form whilst remaining on paper. The 'carousel' construction allows us to see this. The book brings back to life this 'Ghost of a Gone Bird' and gives us an insight into what the Fernbird's habitat would have been like. The cover is a faint material, mimicking the curvaceous waves of the sea [the surroundings of the Pitt and Mangere Islands, belonging to the Chatham Islands). This idea might be the pathway to making a wider audience aware of the emergency of this cause. By approaching the people who have always looked upon nature as their personal influence and inspiration, Ghosts are creating a very unique attack to solving the problem; because art touches everyone. We are influenced by art and creativity every day, whether you are an artist or not. This army of artists can portray the urgency from the very heart.'

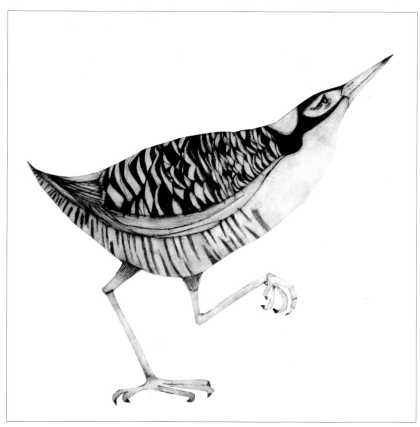

TAHITIAN RAIL – *Beatrice Forshall*

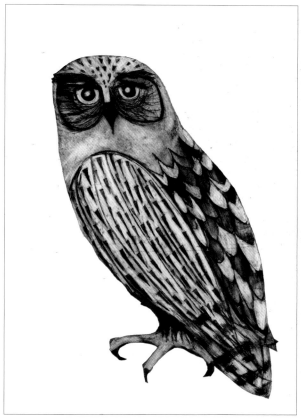

LAUGHING OWL – *Beatrice Forshall*

'I had previously illustrated a few species of endangered birds and so I was interested in looking at ones that had become extinct. It took me a few days to choose which birds I was going to illustrate as each had wonderful qualities of their own. What particularly drew me to the species above, was: the Eskimo curlew's perilous migration from the High Artic to the southern extremes of South America. The sacred and ancient Huia, who's bill is a distinct feature that marks the males and females of the species apart (see both next page). And the character and shape of both the Laughing owl and the Tahitian rail.'

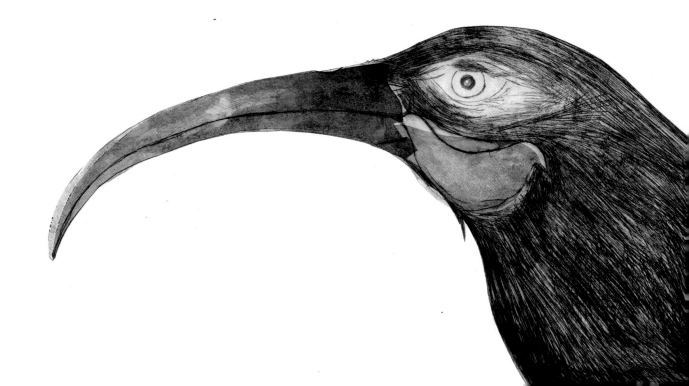

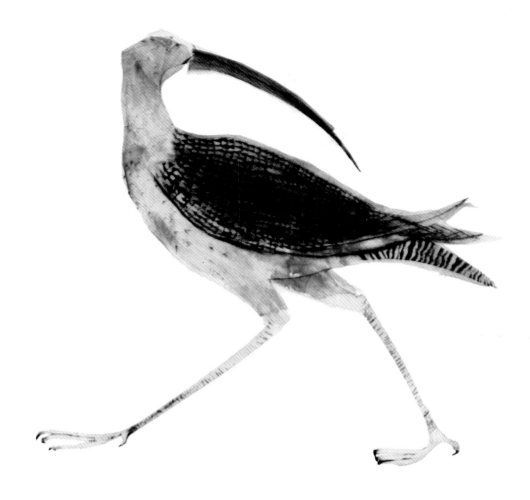

THE NORTHERN MOCKINGBIRD, AFTER JAMES AUDUBON
– *Jo Lawn* – PENCIL ON WATERCOLOUR PAPER

HUIA
– *Stuart Whitton* –
CHARCOAL TINTED PENCIL
& PASTEL

*'The black
background and
application of
charcoal were
introduced in
order to make
the bird emerge
from the
darkness and
back from
extinction for
a frozen moment.'*

HUIA AND PALLAS'S CORMORANT (PHALACROCORAX PERSPICILLATUS) – *Mark Greco* – GICLEE PRINT

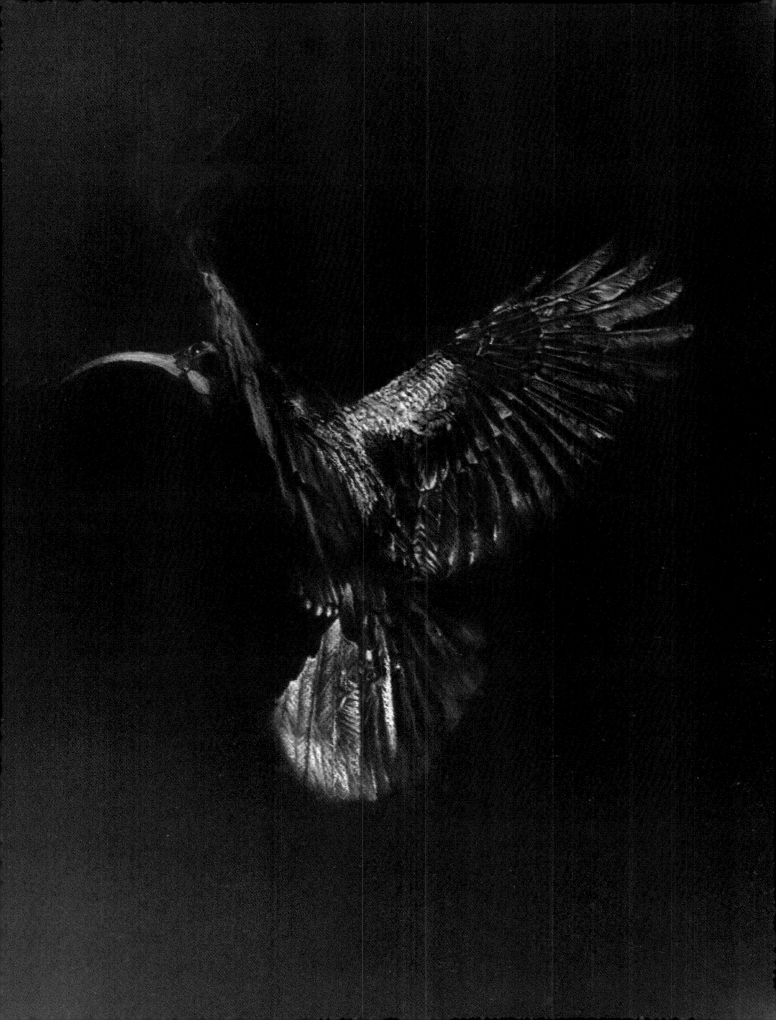

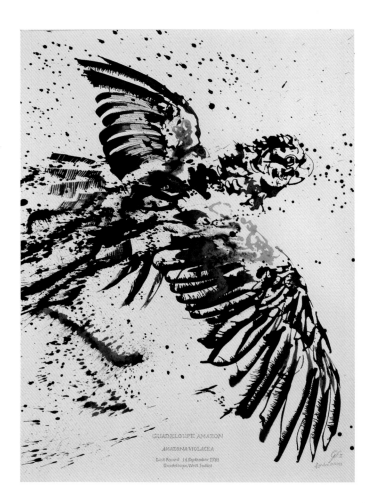 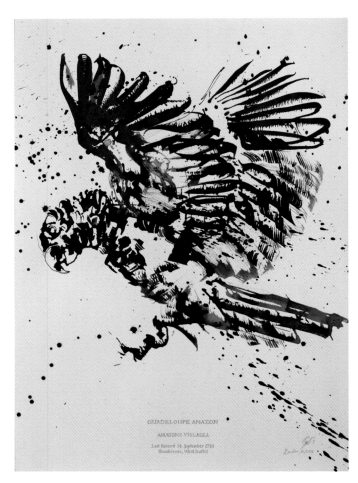

GUADALUPE AMAZON 1&2 – *Georg Meyer-Weil* – OIL ON PAPER

'YOU'VE GONE BUT YOU WILL SING IN MY HEART FOREVER' – *Vicki Turner* – PAPER & ACRYLIC COLLAGE

'I chose the Maupiti Monarch, a bird from the French Polynesian islands because I had a feeling no one would care for it.
With its simple colouring and crow like form, it might seem it's nothing special. Yet all species in nature are valuable and
each has its place in the wondrous eco-system that we all belong. Lives are precious despite their aesthetic. I am pleased my
curiosity found the Maupiti Monarch and so my heart will cherish it forever.'

BISHOPS 'O'O,

LANA'I HOOKBILL & KAKAWAHIE

– Eduardo Fuentes –

PRINTS

'*I liked those Hawaiian birds because I was also interested in showing a bit of their habitat and the reasons for their extinction (they're all there: rats, cats, lumberjack, grazing species... even the pineapples). I liked the fragility of the birds, being small and colourful. And I enjoyed a lot drawing the forest and the palm trees! I draw inspiration from old zoology and botanical books, but I like to give it a geometrical twist. I try to combine the best of vectorial imaging with textures and raw pencil. Charley Harper was also a big influence, the best animal illustrator ever!*'

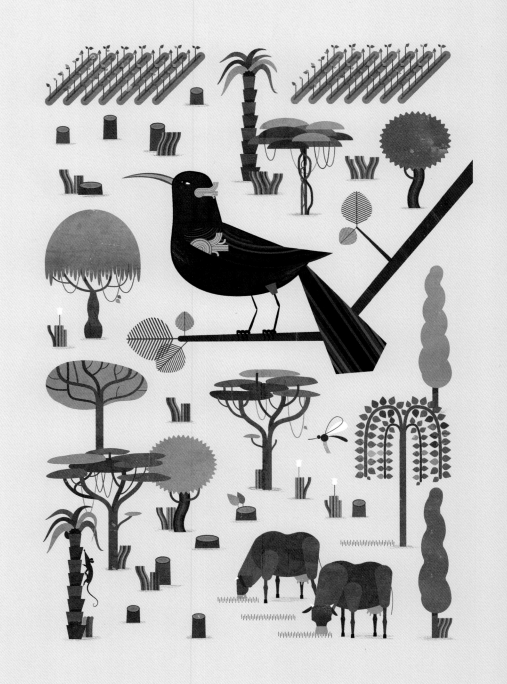

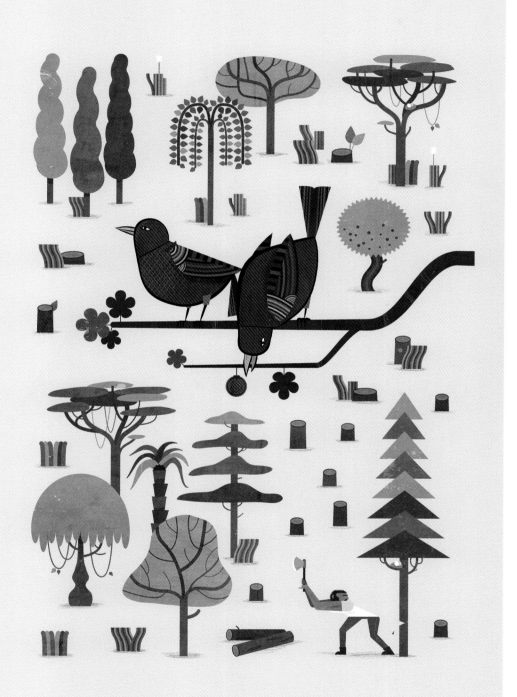

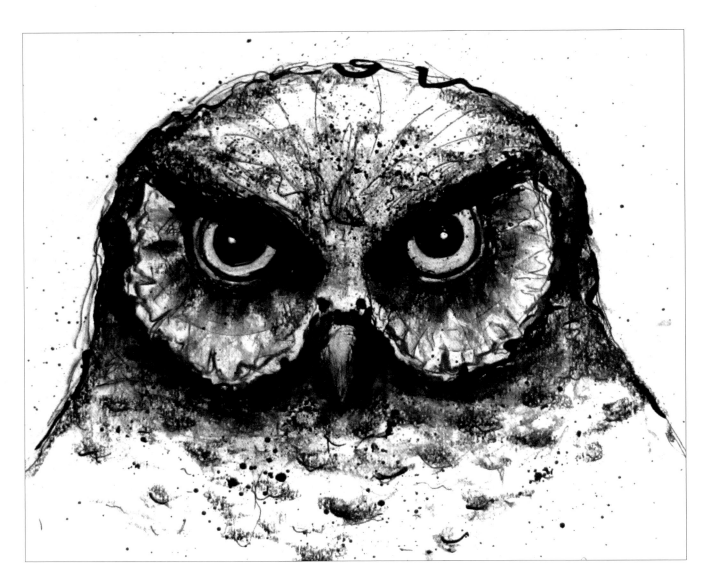

LAUGHING OWL – *Alexia Claire*

'As an avid bird watcher and life-long member of the RSPB I have always had a love for owls. Being from Leeds, the owl is the city's logo so it was my first choice! It saddens me greatly that such a majestic and wise looking bird could be the victim of extinction. My drawing style has always been quite sketchy and realistic and I wanted the bird to be staring at the viewer from any point in the room, which is why I chose his portrait-like position.'

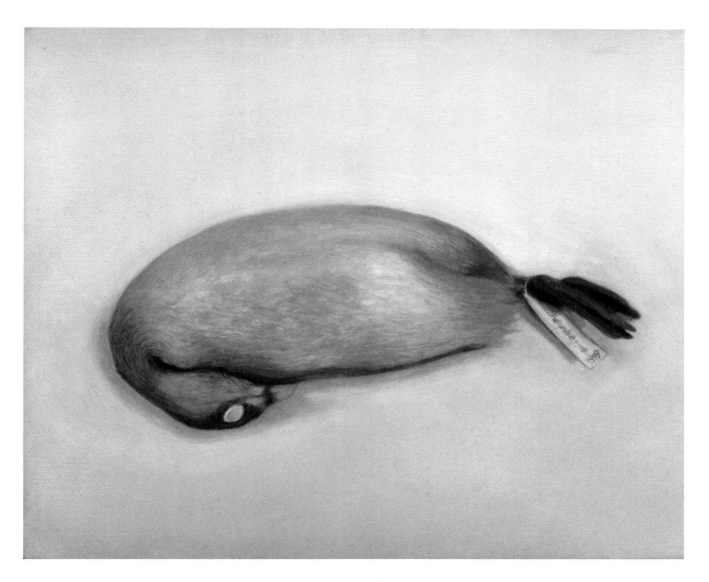

PODILYMBUS GIGAS 1989 – *Jennifer Hooper* – OIL ON BOARD

'I was inspired by the conservationist Anne LaBastille, her work trying to save the Atitlan Grebe and a research trip to Guatemala to visit lake Atitlan and the habitat of the Giant Grebe.'

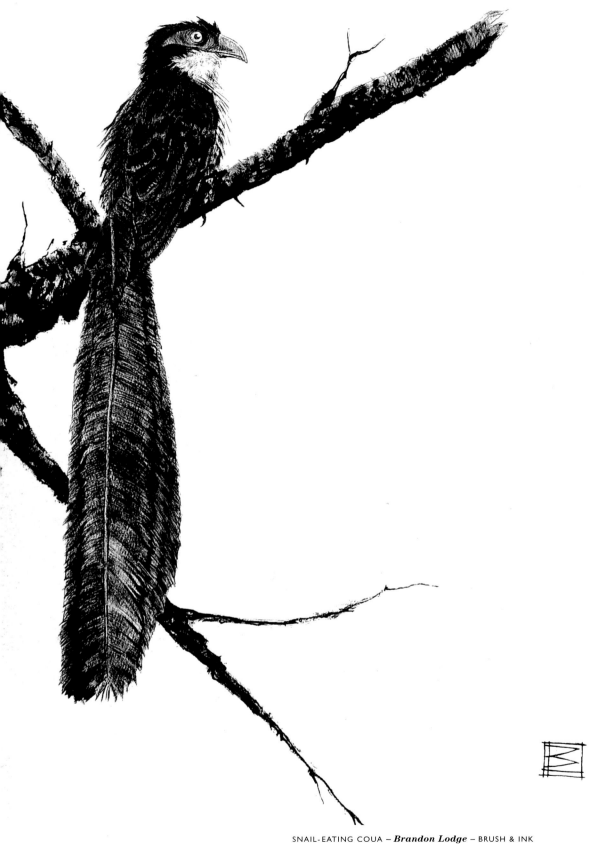

SNAIL-EATING COUA – **Brandon Lodge** – BRUSH & INK

'*I almost entirely work in black and white using sumi-ink (and other black media)
and a large variety of tools to create marks; Chinese calligraphy brushes, twigs, reeds,
make-up brushes, homemade brushes, anything that I can make an interesting mark
with. I strive for my work to be full of energy, a reflection of the drawing process.*'

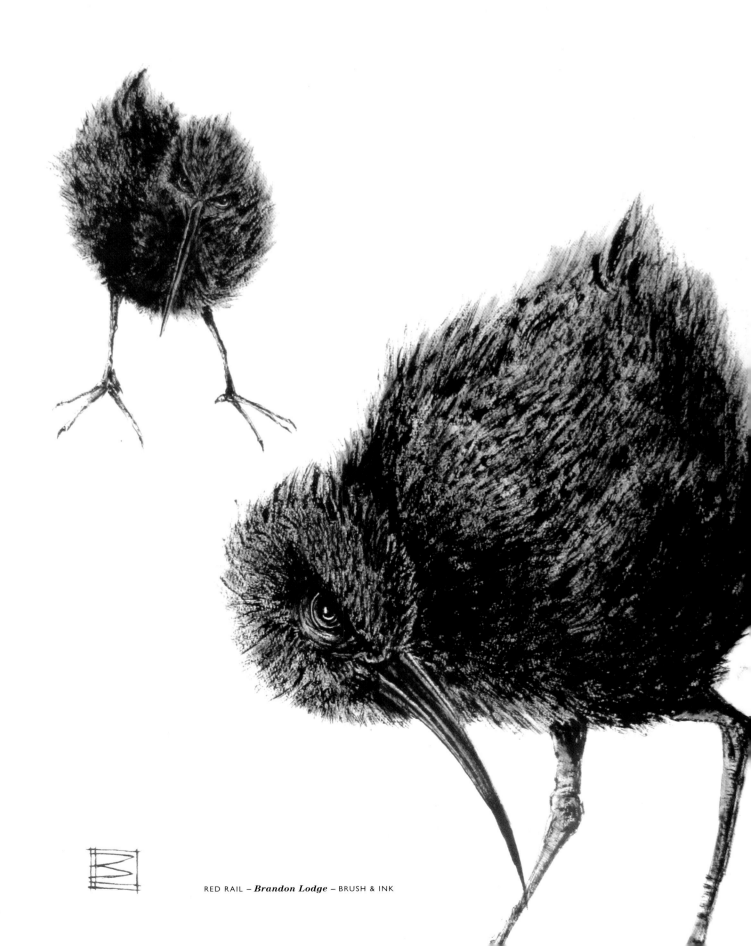

RED RAIL – *Brandon Lodge* – BRUSH & INK

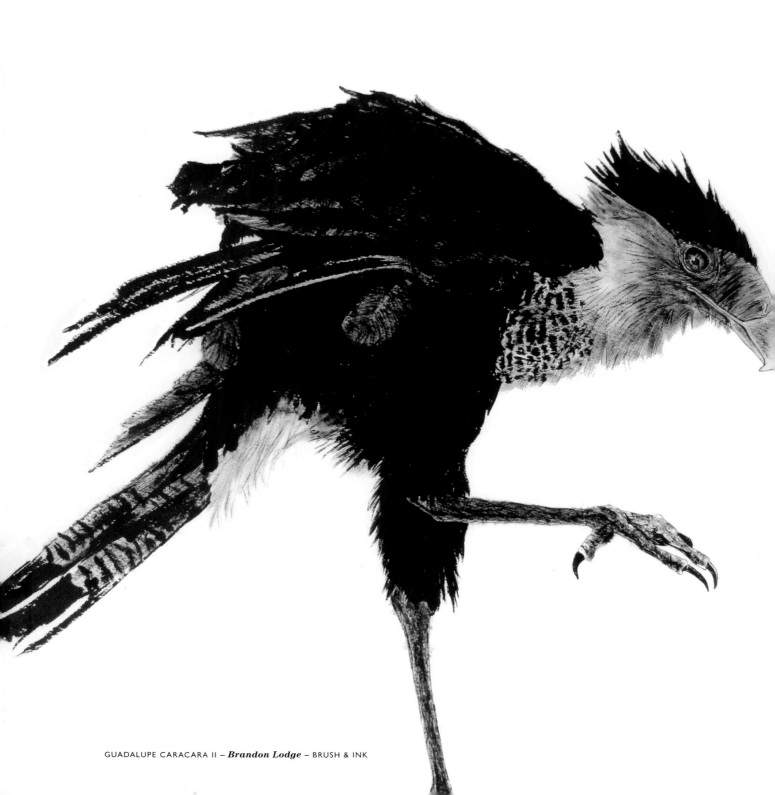

GUADALUPE CARACARA II – *Brandon Lodge* – BRUSH & INK

'The 'Man Eater' title instantly drew me to the Guadalupe caracara. After researching the Guadalupe Caracara's non-extinct cousins (northern and southern caracara) I was hooked on the bird. I loved their intelligence and huge personalities. Their fleshy faces are full of character and really enjoyable to draw.'

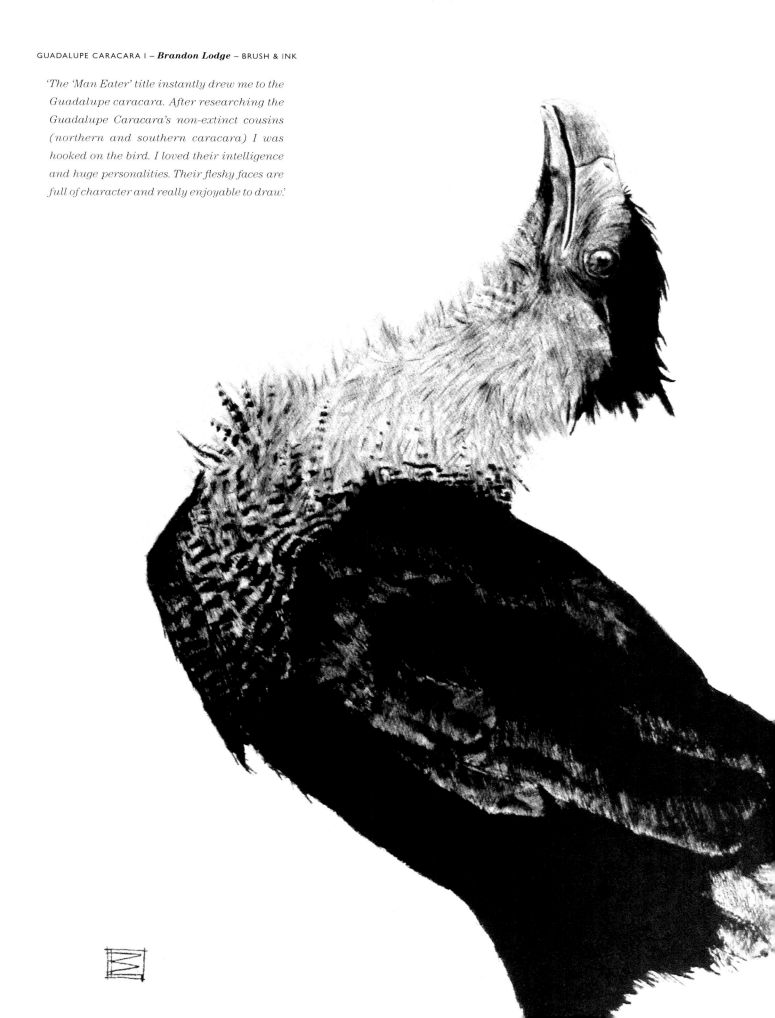

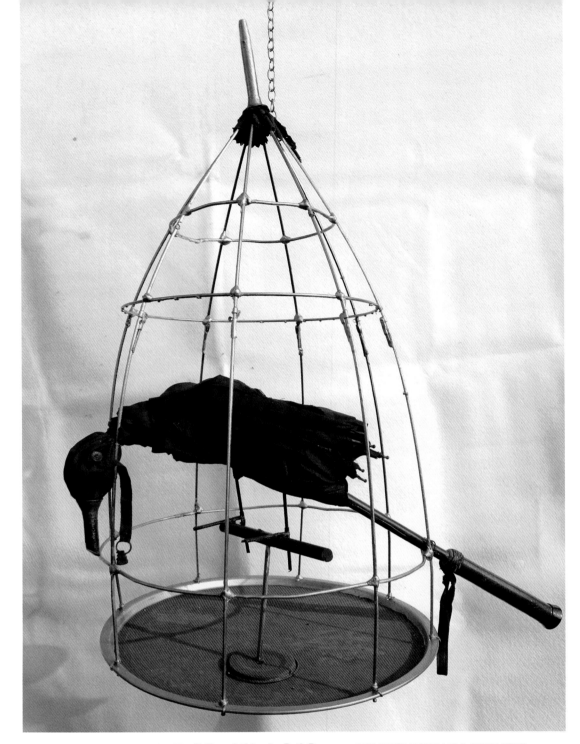

'GHOSTS OF GONE BROLLYS' – ***Bethmadethis aka Beth Dawson*** – RECLAIMED UMBRELLAS & OTHER ITEMS

'It was a wet, blustery day in Leeds when I first stumbled upon the idea for a brolly bird. The rise of affordable fashion retail outlets in the city centre had caused a surge in purchases of cheap, gaudy umbrellas that of course, could not withstand the northern weather. Every time it rained the city's bins would fill up with broken, sodden umbrellas and in the gutters the abandoned brollies would flap their arms like broken wings as the taxis drizzled past. I thought it sad that these wonderful contraptions that haven't been bettered in design since victorian times should be reduced to landfill and so I started to pull the umbrellas out of the bin. Maybe I could make them into something beautiful again, bring them back to life with a little maker's magic? And this is how the brolly bird was born. Well now, a few years have passed since then and of course I've spent my time on other tiny crusades. But I still have a fondness for the brolly bird. When' Ghosts...' came to Brighton I had a long, hard think about all those gone birds that we've hunted to extinction and destroyed the habitats of. We humans have treated whole species with little more respect than those umbrellas in the bin.'

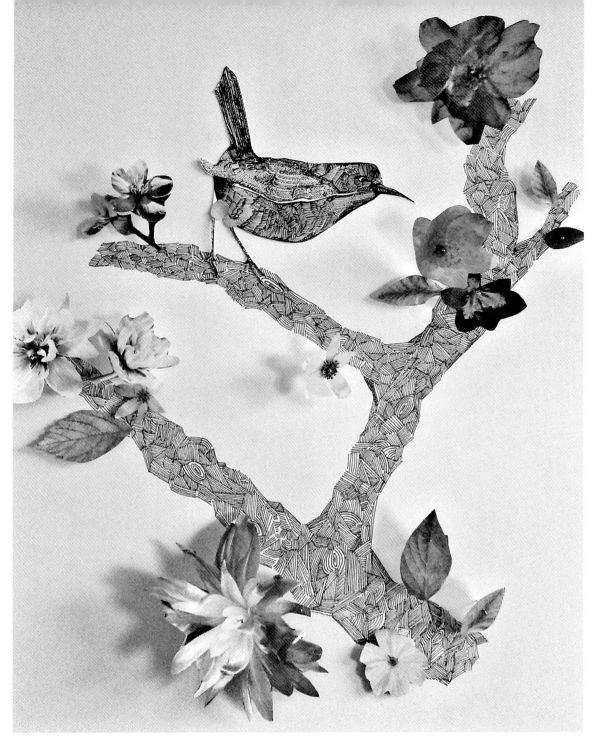

KAUA'I'O'O – *Deborah Moon* – PEN AND COLLAGE WITH PINS

'When Kauai O'o the smallest of the honey eating birds, was first recorded, there were many living on the islands of Hawaii. It had a beautiful song, with hollow, flute-like calls, that I listened to many times, while making my piece. Due to European settlements and the introduction of rats and wild pigs, the local flora, the habitat of the Kauai O'o became destroyed, meaning that this beautiful bird could not survive in its rapidly changing environment. By 1981 there was only one breeding pair left and in the 1982 a hurricane hit the islands, which meant that the female was lost. One male survived, the last of its species. His last reported song was heard back in 1987. While researching I came across one of Hawaii's most renowned and celebrated naturalists, David Boynton who recorded the last song, a call for a mate. Boynton was especially interested in this bird, and always on the lookout for a possible survivor. He tragically died back in 1997. This search and this song inspired me. I wanted to bring this beautiful bird back to life in the branches where he and his birds once lived, surrounded by flowers and beauty, with a lifted head in song. I wanted to create depth and camouflage, hence my birds is in the same style as the bark/tree, rooted in the history of the Hawaiian islands, a ghost amongst the flowers and fauna.'

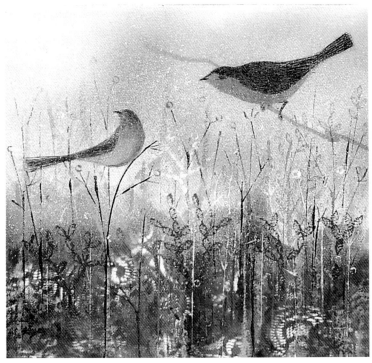

WARBLER CRY – *Tiffany Lynch* – OIL ON CANVAS

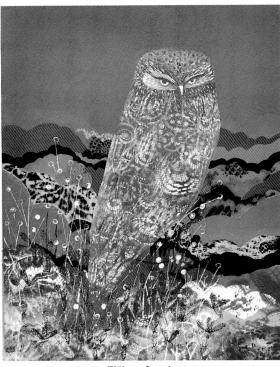

LAUGHING OWL – *Tiffany Lynch* – OIL ON CANVAS

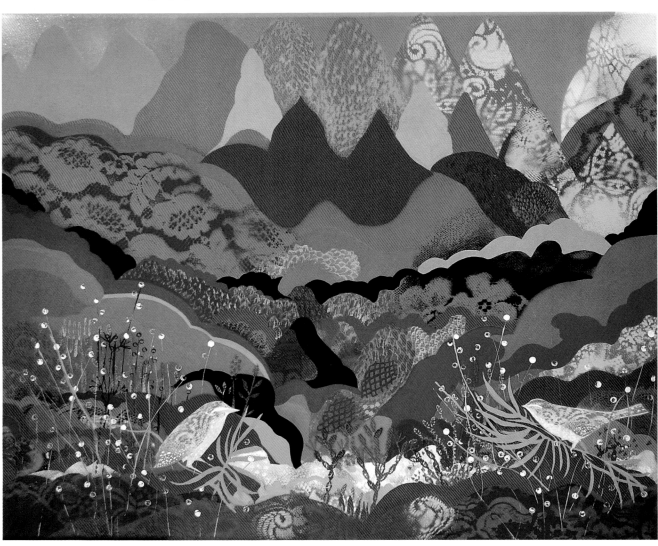

LOST BUSH WREN SONG – *Tiffany Lynch* – OIL ON CANVAS

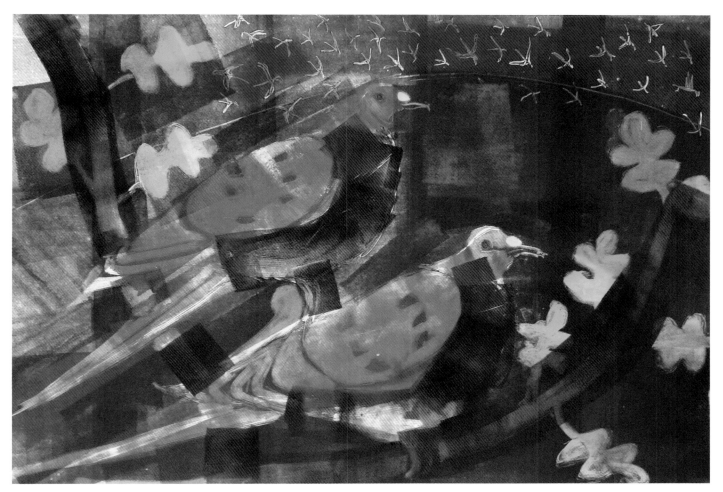

PASSENGER PIGEONS – *Kittie Jones* – MONOTYPE

'The starting point for any piece of work is usually making drawings in the field. I tend to draw from life and a day out with my sketchbook, binoculars, waterproof trousers and a hot flask of coffee is the normal way in which I would begin a project featuring a particular bird or birds. So, the first task was to find birds on the list that might bear some resemblance to British species that I knew well and had already drawn – if I wasn't going to be able to draw them from life I wanted to at least have some familiarity with their general form. Pigeons and wrens began to look likely. A bit of further research and I discovered that the National Museum of Scotland – a stone's throw from my flat in Edinburgh – had a number of important extinct bird specimens. My plan was to focus on the North American Passenger Pigeon. Part of the reason for this is that one of my favourite British birds is the Wood Pigeon. I love to see flocks of Wood Pigeons in the British countryside and I had read about the amazing flocks of Passenger Pigeons before they became extinct. The colourings of the male Passenger Pigeon was similar to our Wood Pigeon – the breast a bit redder; the tail was also much longer on Passenger Pigeons. I couldn't find any distinct images of Passenger Pigeons in flight so in my print the flock of birds in the distance are shown as simplified shapes. I managed to find a male and female on display in the museum and promptly made a number of drawings of them. I chose to depict two males in my print, for no other reason I'm afraid than I preferred the colouring of the male! I was fascinated to read about the behaviours of these sociable birds. John James Audubon wrote an evocative passage in his write up of the Passenger Pigeon about a flock of them arriving in a forest – he compares the noise they made upon arrival to the sound of a gale and then describes branches collapsing all around under the weight of hundreds of birds. Elsewhere I found a description of the sky going black as a vast flock of these birds flew over.

I hope my print does some justice to the memory of this fascinating bird and reminds people to look again at the flocks of Wood Pigeons we see in this country now.'

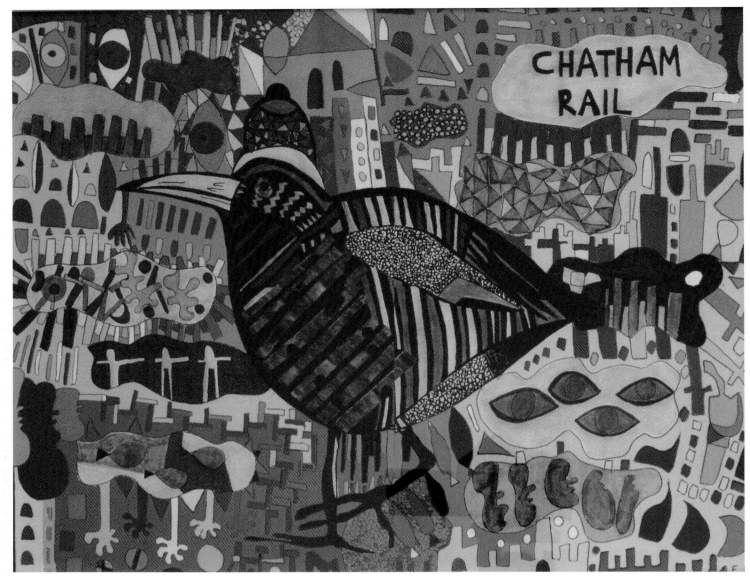

CHATHAM RAIL – *Ellie Rassia* – DIGITAL PRINT

'DODO' – *Emily Reader aka Rose Petal Dear* – PEN AND INK

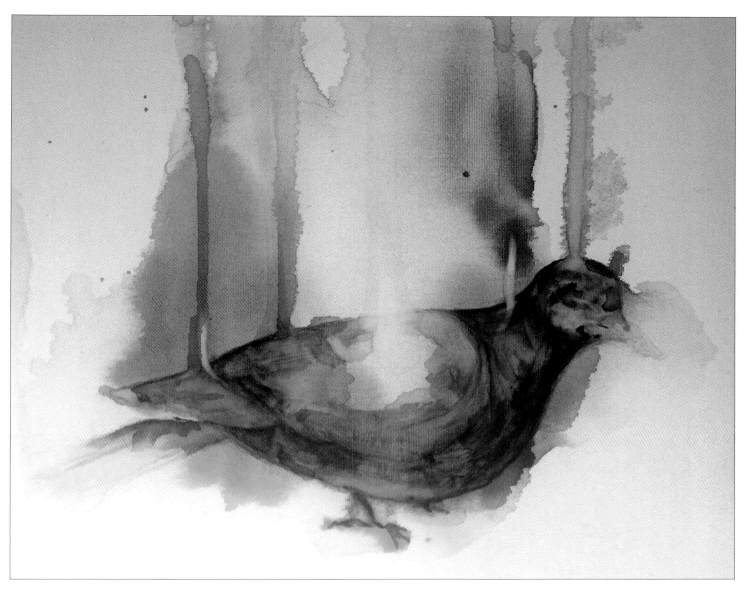

"BONIN WOOD PIGEON – COLUMBA VERISCOLOR ENDEMIC
(THE IMPROBABLE FLIGHT), DECEASED – *Amber Potter* – PENCIL, FOUND FEATHER AND INK DRAWING,
WATER COLOUR, RAINWATER ON LINEN

'The Improbable Flight was inspired by the once endemic Bonin Wood Pigeon.
A beautiful bird with iridescent colouring. My own practice is currently
focused on the humble city pigeons of Coventry and the woodpigeons of our
suburbia, part of the everyday, enigmatic, but for some seen as a blight or a
nuisance and often over looked, living ghosts of our landscapes of our own
island – so I was transfixed with the story of the Bonin and felt a need to
breathe life back into its story, a bird once endemic on a remote exotic island.'

DODO
(Raphus cucullatus)

DODO – *Mark Greco* – GICLEE PRINT

'The Dodo is probably one of the most well known of our extinct birds which is surrounded by many mythical stories. As such I thought that it would be the ideal bird to engage my audience with both bird conservation and the broader ecological debate.'

REUNION OWL – *Dionne Kitching* – HAND SCREEN PRINT

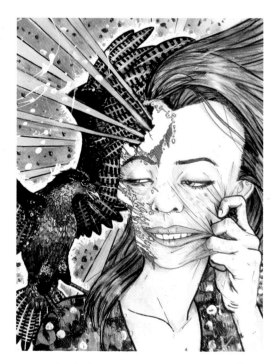

'RECONCILIATION WITH THE GUADALUPE CARACARA' – *Malena Aballay*

'Besides the colour and physiognomy what caught my attention was the conflictive and aggressive relationship of the bird with humans. In this work I represent the human being releasing the Guadalupe Caracara from its extinction and giving it life again so we can reconcile after a violent and conflictive past.'

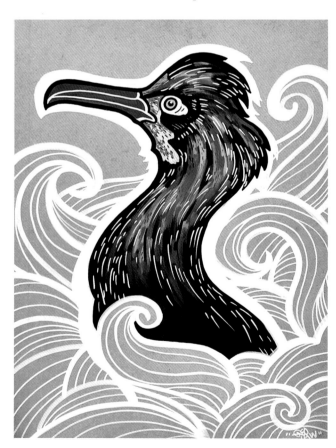

'PALLAS COROMORANT IN HIDING' – *Geo Law* – POSCA INK PENS & MDF BOARD

'The project serves as a reminder about the harsh realities of extinction and hopefully these thoughts can be passed on to others.'

'ONE OF WHAT WAS MANY' – *Sarah Yates* – AKA FAUNAGRAPHIC

'I choose olive wood because it creates a nice smooth texture to paint on and the grains in the wood can become part of the artwork. I painted the carrier pigeon because I find it fascinating how the most common and popular bird in America can be hunted to extinction... And I can't decide if its ignorance or accidental.'

LAUGHING OWL – *Jackie Hodgson* – HAND PRINTED TEXTILE COLLAGRAPH

AKIALOA – *Paul Beer* – MIXED MEDIA

DODO – *Jackie Hodgson* – HAND PRINTED TEXTILE COLLAGRAPH

WHOOPING CRANE – *Luke Thomas Smith* – MIXED MEDIA & BIRDSONG

WHOOPING CRANE, HAWAIIAN CROW, IVORY-BILLED WOODPECKER, HYACINTH MACAW, PALILA & KOKAKO
– Luke Thomas Smith – MIXED MEDIA & BIRDSONG

'This series of works features six digital prints of classical bird engravings that are masked by thin layers of Japanese paper. The amount of layers corresponds to the bird's endangered status in the IUCN (International Union for Conservation of Nature) Red List of Threatened Species.

Therefore the lower the species population, the less the bird is distinguishable and becomes more of a silhouette. Placed above the birds featured in the pieces are QR codes; a barcode which when scanned with software available on smart phones, links users to specific web pages, in this scenario a downloadable recording of the birds calls/songs. In addition, the transparencies of the QR codes also correspond to the birds IUCN status, being denser and more prevalent in the more threatened species. This work is inspired by and investigates the technological sublime, questioning the relationship between the physical world and the artificial domain created by humans.

The selection process with the birds featured in this series depended on several attributions, that overall systematically removed the majority of other species being an option. Firstly the species had to be listed in the IUCN list of Endangered species, either as endangered, critically endangered, extinct in the wild or extinct. Secondly an engraving had to exist of said bird that was created by a famous ornithologist, as I felt it was appropriate to feature the evolution of how we document the physical world.

Finally a recording of the bird's call/song had to exist which copyright allowed for the audio files to be edited and downloaded.

I originally wanted one of the works to include an extinct bird, so all that remained for the viewer was the barcode, however no such bird was able to fill all these attributions, maybe a wry, parallel comment on extinction. From the small selection of birds remaining I chose a set that not only had a broad range geographically but also vocally.'

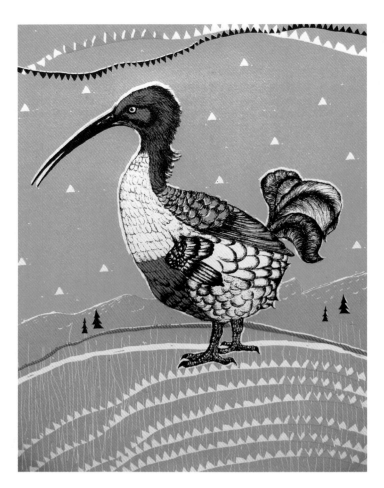

'RED SNAIL-EATING DODO' – **Camilla Westergaard** – AKA BUTTERSCOTCH & BEESTING

NEW ZEALAND BUSH WRENS – **Kittie Jones** – MONOTYPE

'Reading down the long list of birds that are no more, the Red Rail, Snail-Eating Coua and Dodo immediately put pictures in my head. But the few ageing images I found of these birds seemed to root them so strongly in the past it made them even more ghostly. Even more gone. What if I could take them out of the pages of history books and write them into an adventure instead? Then, like all good stories, they could live forever in my imagination. I pictured what would have happened if the Red Rail, Snail-Eating Coua and Dodo had joined the remarkable troupe of creatures that inhabit my fictitious Butterscotch & Beesting Circus. What adventures would the three birds have encountered? Would the Dodo have remembered how to fly? Would the Snail-Eating Coua have made friends with the McSwirl Brothers – the circus' resident family of acrobatic snails – or dined on them instead? Would the Red Rail have delighted the crowds by swinging across the big top with the trapeze caught in his extraordinarily long beak? Or what if they had encountered a wand-wielding monkey who had muddled them together with magic (as is his habit)? Then we might just have had... drum roll please... A Red Snail-Eating Dodo. Imagine the stories a Red Snail-Eating Dodo could have told: tales of horses ridden bare-back across tightropes; memories of fine feathers paraded around the circus ring; echoes of hundreds of spinning plates perched precariously on the end of his beak crashing to the ground. So this is my bird. He is all the adventures never embarked upon. All the lives never lived. All the futures never started. All the tales untold. All the birds gone.'

'With no intention of doing more than the Passenger Pigeons, my eye was caught by the fantastic New Zealand Bush Wren specimen on display in the adjacent cabinet at the museum. I have never been able to resist wrens – they are such compact birds. I love their shape, with their square tails pointing upwards and trembling rhythmically when they sing. So, some drawings were made and I was happy to translate these into the print which depicts these ground-nesting, almost flightless birds crouching under some fern-like forms. I was captivated by their lime-green colouring and of course that familiar shape. Notes on Monotypes: Monotypes are unique prints. They are made by inking up a perspex sheet. My prints are usually made up of two or three layers. The first layer is the bright colours, rolled out broadly and abstractly on the surface. The second layer is usually one dark colour which I make my drawing into - rubbing away areas to reveal the colours of the print underneath. Sometimes a third layer is required to complete the image. Working in layers allows colours to come through from underneath and unexpected colour relationships to occur – it adds a richness to the image.'

'THE BIRD FEEDER? (WAKE ISLAND RAIL. GALLIRALLUS WAKENSIS)'

– Roy Kelf –

NEWSPAPER, MASKING TAPE, WIRE,

COTTON THREAD, TOY SOLDIERS, BIRD FEEDER

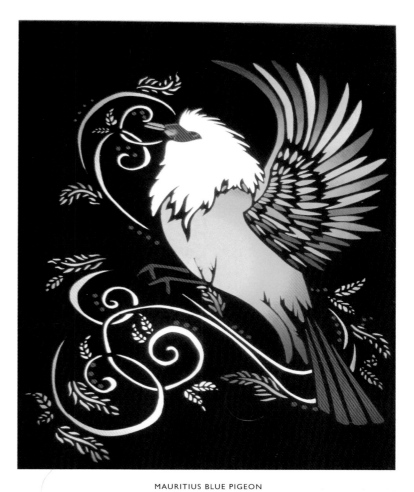

MAURITIUS BLUE PIGEON

– Stacey Jones – HANDMADE PAPERCUT, DIGITALLY COLOURED

'I chose this bird because I couldn't see many artists that had and I was attracted to its interesting plumage and colour scheme. There were also no photographs of this bird due to becoming extinct so early so I felt I had a lot of space for experimentation and artistic license.'

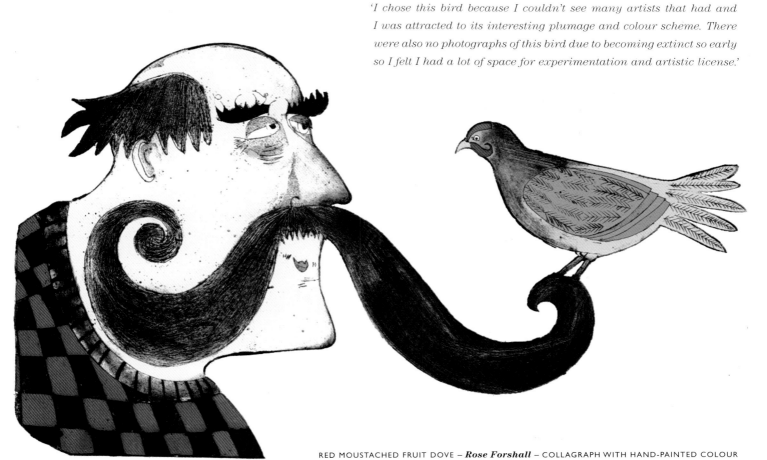

RED MOUSTACHED FRUIT DOVE *– Rose Forshall –* COLLAGRAPH WITH HAND-PAINTED COLOUR

'TUL' – *Jennifer Hooper* – OIL ON ATITLAN TUL

In search of Mama Poc *by Jennifer Hooper*

Anne LaBastille was an ecologist who emerged at a time when environmental concerns, along with women's rights movements, were becoming more prevalent worldwide. The extraordinary compassion and dedication she showed in her field led her to become a cult hero amongst generations of women from the 1970s onwards, inspiring them to engage with conservation and nature. She found a truth in the wild and rejected modern ways of life in favour of an extremely remote existence. Later in life she lived in a self-built cabin deep in the woods in the Adirondack Mountains. It was here that she wrote movingly in the book Woodman about the harsh beauty of solitude and surviving in the wilderness as a woman alone.

'Sometimes I sit in my log cabin as in a cocoon sheltered by swaying spruces from the outside world … Life seems to have no beginning and no ending. Only the steady expansion of trunk and root, the slow pileup of duff and debris, *the lap of water before it becomes ice, the patter of raindrops before they turn to snowflakes'*

I first encountered LaBastille and her book *Mama Poc* in the small, exquisitely beautiful country where she spent a large proportion of her life - Guatemala. An adventure through California and Mexico was coming to an end. My travelling companion Ned and I were close to the border between Mexico and Guatemala planning a final route back to the airport

and to London. It was then that I decided to take a slight detour - or so it seemed.

The day prior to making this decision I had opened an email from G.O.G.B, wherein a list of extinct birds was enclosed. To choose one of these birds was the artists' brief for the forthcoming exhibition. It is a long list, and seemingly gets longer by the day. A bird called the *Atitlan Grebe, Giant Grebe* or its indigenous name *Pato Poc* caught my eye. It had been endemic only to a small region in the country I was about to enter and its decline had been extremely rapid. A flightless aquatic diving bird that had evolved over 10,000 years into its non-migratory state, this 'Scientific curiosity' and 'Ice-age relic' as LaBastille refers to it was wiped out in a fraction of the time its evolution had taken. Its survival, as with all species, was dependent on a delicate balance of elements, but as it could not migrate its fate was determined by entrapment in its dwindling habitat, the *Atitlan* basin.

I was intrigued; the geographical coincidence I found myself in, along with the grainy black and white images taken by David G. Allen showing the beguilingly distinct and brave looking bird, drew me into its fated tale.

Not entirely sure of how to proceed, I scoured the available and limited internet at the hostal in *Quetzaltenango* or *Xela*, the second largest city in Guatemala. Finding an article about La-Bastille and an excerpt from *Mama Poc*, I realised that in order to understand the plight of the Giant Grebe I needed to read the rest. Last published in English in 1991 I considered that my chances of finding a copy anywhere in *Xela* were slim. But serendipity prevailed as I perused the delicious dusty shelves of a rare second hand English language bookshops in the city; I came across a rare copy.

Inside the front cover, which shows Anne and her iconic blond pigtails outside her cabin in *Panajachel*, - was an old map of the lake. The Grebe refuge sites that she had persuaded the government to establish were listed along with various other points of reference. I wondered how the geography of the lake would have changed in over 40 years and what would remain of LaBastille's legacy and her field work; both in the contours of the land and in the hearts and memories of the local people with whom she had worked so closely.

The title *Mama Poc* is the name that LaBastille had become affectionately known by and the book documents her 25 year battle to save the Giant Grebe. The work that she did was at the time one of the few studies where someone monitored the decline and extinction of an entire species. She began crucial work of great scientific value that is also a poignant and passionate story told from a unique perspective. Single handed she began the campaign to save the declining habitat of the Giant Grebe and documented the myriad of factors that were contributing to it. The work was incredibly brave, set against vast opposition and at one point the backdrop of a bloody civil war. I was inspired, and compelled to trace the footsteps of this remarkable woman.

As best can be determined I am the first ecologist to have systematically observed an animal go from a balanced, healthy population to zero.

And so that is how I found myself descending at thunderous speed, clutching the newly found second hand book, through the highlands and twisting vertical mountain roads that led from Xela to San Pedro La Laguna on the western side of Atitlan. The relatively short distance on the map would take six hours at least.

The thing about Guatemalan chicken buses is that they seem to have a life of their own, perhaps due to the many lives that they have previously led. Each one is completely unique and like each driver has a quite particular style. Through experience the best thing to do as the bus negotiates its way is to avoid looking out of the window, however glorious the view; a suspension of disbelief is necessary. So I attempted to read.

Atitlan is considered one of the most beautiful lakes in the world. Most descriptions of the lake begin with a similar sentence to the former, because it is as in the words of Aldhous Huxley *'at the limits of the permissibly picturesque.'* The Atitlan basin is a heady mix, stunning in its beauty and contrast; set against the dramatic backdrop of three volcanoes, on the most fertile and volatile land, where in recent history landslides and natural disasters are numerous. Despite this, magic exists there and life exudes. At the lake's centre, sapphire blue water runs a mile deep.

For decades now, threats to the water's delicate equilibrium and eco-system have continued to rise. Excessive quantities of contaminants flow into the crystalline water due to burgeoning human activity which includes the ever growing tourist industry. An ongoing absence of water treatment and septic systems mean that untreated sewage flows from rivers and estuaries, often directly into the lake. Inadequate refuge disposal sees that in places the shores are lined with rubbish, fuel from private motorboats leaves a greasy film. The non-biodegradable pig soap used by local people for the continual washing of their clothes is another pollutant.

A type of cyanobacteria or blue green algae called *Lyngbia* now blooms intermittently in the lake. The algae, present in nearly all water sources and one of the oldest forms of life is only a problem when it multiplies, absorbing all nutrients in a source. Scientists

say that the bloom in Atitlan is caused in part by pollutants and part by climate change which has increased the temperature of the water.

Copious residue from agricultural chemical fertilizer causes high levels of phosphorous and nitrogen which feeds the bacteria. In 2009 Atitlan was listed by GNF, (Global Nature Fund,) as the world's most threatened lake. That year, cyanobacteria covered over two-thirds of the lake with a repugnant noxious growth, more than three feet deep in many parts, rendering the water unfit for humans to swim or fish in. It was then that people came in hoards, showing remarkable solidarity, carrying plastic baskets, screens, bed sheets and nets; anything for sifting and removing the algae. They plunged into the water removing it with their bare hands, diving under and coming back to the surface with as much as they could hold. People in boats, canoes, and on the docks joined-a concerted effort by the entire community was made to clean their water.

The Atitlan basin is one of the poorest regions in Guatemala with at least 29% of the Maya people - predominantly Tz'utujil and Kaqchikel - living in extreme poverty. They are completely dependent on Atitlan's water. The ancient Mayan agricultural techniques ensured sustainable productivity but now there is reliance on the use of modern techniques; chemical fertilizers add to the pollution which may eventually cripple their means of economic survival. It is crucial that sustainable and non-chemical agriculture becomes common practice. Removing the algae and rubbish from the water is not a long term solution.

Over the past 50 years private land purchase and commercial real estate in the basin has boomed. Much of the development is founded on the Grebes' old habitat along the shore of the lake;

a decision which has recently come to haunt many of the occupants whose deserted homes or restaurants are part submerged. Over the past few years the water level has risen 3 meters, well over the average fluctuation of 1 metre. LaBastille documented that this type of construction had increased 1,100 percent in 20 years - and that was in the 1970's. It is hard to fathom what the increase might be today. The government surely needs to implement a limit on development and construction in order to conserve remaining habitats and prevent the basin from collapsing under its rapidly growing burden.

Atitlan reeds or Tul grew thick and abundantly around the lakeshore when La Bastille first set foot there in the 1960s. In the early 1980s of the 75 miles that La Bastille measured, only 15 had adequate vegetation. In 2012, around the shore and sites where the Grebe would have laid their eggs the Tul is sparse and skeletal.

For centuries the local reed cutters have harvested the reeds as a weaving material to make sleeping mats and other basic furniture, it was a plentiful and economical material, but

within these thick reeds was the only place where the Giant Grebe felt safe enough to nest and hatch young. LaBastille soon discovered this, and against initial opposition from councils managed to put in place an educational replanting program whereby the reeds would begin to be replenished, before too much damage was done. This process still exists but sadly now, as then, the reeds do not recover as quickly as they are cut. But there is hope. The local fisherman and farmers are more aware than ever of the vital need for the Tul in the Atitlan ecosystem. In addition to providing nesting habitats and fish nurseries, Tul cleans the lake by filtering and absorbing phosphate and nitrogen, the two elements needed by cyanobacteria to flourish. And so re-planting continues.

I needed to see what remained of the Tul and the result of the harvesting; where it ended up once it was cut. I was informed that presently there was an extreme shortage of reeds as not enough had grown back since the last harvest and that it would be hard to find any mats.

Scouring the local markets I inquired about where I could find Tul mats; this was challenge enough as I found my distinctly English-sounding Spanish understandably incomprehensible to most people. I wandered around the dazzling market in Santiago taking in the exotic smells and poring over a plethora of colours and produce including the largest avocadoes I have ever seen. With pleasure I persevered and happened upon a vendor of mats in various sizes. I paid 30 Quetzales, about a pound, for a piece of dwindling Atitlan. Not wanting to support the harvesting of the reeds or the destruction of vegetation but to highlight the ongoing problems facing the lake. I thought the mats could tell a crucial part of the story of the Poc's demise.

A couple of images stick in my mind

when I think about Anne in Guatemala. One is of her waist deep in the lake surrounded by thick reeds, immersed in her search for the elusive *Poc*. The other is her solitary silhouette navigating its way across the water in the small motorboat she used on patrol. In 5 years she documented a staggering drop in numbers, from 200 birds to 80. Something drastic needed to be done, with very careful negotiation the first wildlife refuge in the whole of Guatemala was set up around the southern shore of Atitlan in a secluded bay. In conjunction an official warden was hired to protect all of the endangered wildlife from hunters. Operation *Protection poc* was launched with avid support from the local communities.

How would I find the old grebe refuge site when the geography of the lake had changed so dramatically that it was unrecognisable from the map in the book - the only reference I had to orientate myself? I had considered that a more contemporary map might be useful but I enjoyed the simple linear drawing and the nostalgia entailed using Anne's as my guide. Thankfully a chance encounter with the right people at exactly the right time occurred; I met Tom and Vicki, a couple who had been living in Santiago Atitlan on the shore of the lake for the past 20 years.

I was striding along wielding my book when the Atitlan sky opened and the rain began to pour with fervour. Friendly voices beckoned from underneath a corrugated iron roof where a small congregation of the expatriate community were sheltering in a rustic cafe fashioned on the roadside. Over some cervezas, as we watched the daily downpour, stories were swapped. I was thrilled to learn that they had built their beautiful house overlooking a bay, which according to my map might be the site of the old grebe refuge. Excited to be so close to

where Anne had worked all those years and to be able to observe first-hand how it had changed we made our way through the rain to *Pachevac*.

The only way to really explore Atitlan and its shores is by *Lancha*, Insisting we should take their small motor boat out to see the bay properly Tom and Vicki introduced Pedro, who had worked for them for over 15 years. Pedro not only knew much about the *Pato poc* story but he had a cousin, Francisco, who had actually worked with LaBastille on the original conservation project all those years ago.

The next morning we were racing across the water with Francisco and as many others that could fit in the boat, heading for the location of where the Grebe had last been sighted. The *lancha* stopped amidst patches veiled with strewn reeds and scattered debris, the sun burned above us accentuating the bare shore and highlighting bright lurid green patches. Francisco was eager to explain that many other species are at risk and suffering as the Grebe did. Of the 261 bird species of Atitlan 28% of them are in the Red List of

Threatened Species (67 in total), 12 of these are endemic, one being the Resplendent Quetzal, the national bird of Guatemala.

The Atitlan Grebe has a place deep in the heart of Atitlan and its people; its ghost is alive, and sometimes on certain moonlit nights the distinctive mating call 'poc poc poc poc..' has even been heard igniting rumour of the birds continuing existence or return. Enough speculation has been uttered to fuel new field work examining this. One thing is clear; unless the lake survives, there is no possibility.

Why do we concern ourselves with the survival of individual species when the natural order of life dictates that they will evolve and cease to exist? All forms of life are temporal and transient and that is part of the fascination and beauty of their diversity. Perhaps it is fear of our own death that creates the desire to sustain, preserve and collect.

Whatever the reason, the natural balance between speciation and extinction has been tipped significantly by us. Scientists say that the world is facing a mass extinction; one so rapid that the evolutionary process is not going to be able to replace the loss of biodiversity. Eco-systems like Atitlan are teetering on a knife edge. The fragile circumstances making it possible for certain species to survive are being drastically altered to the extent that it is difficult to comprehend what is natural and what is unnatural.

Anne La Bastille was a pioneer who redefined the possibilities of our relationship with nature, fostering a deep understanding and appreciation of the world in which we exist. With vivacious and enduring commitment she battled on behalf of an individual species. Stories such as hers go some way to tipping the balance back, empowering and inspiring others to do the same.

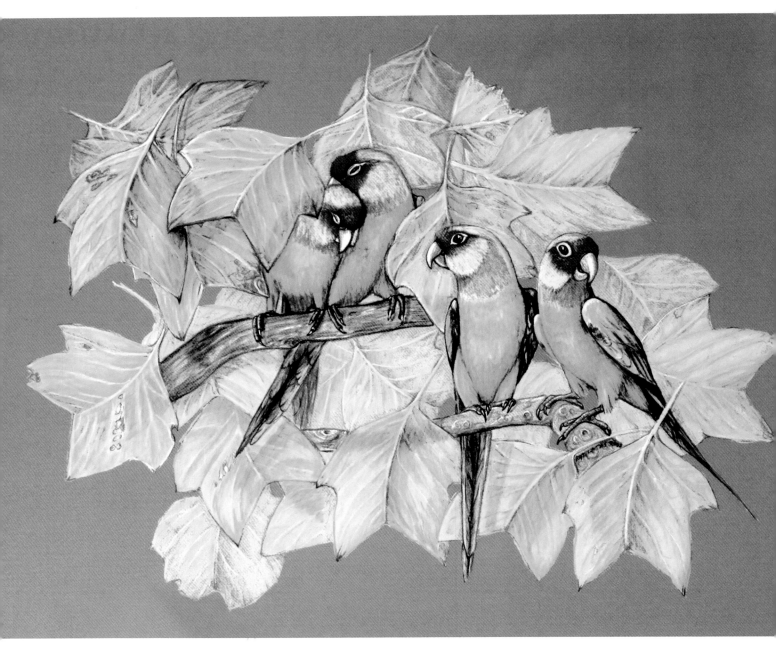

'CAROLINA PARAKEETS IN TULIP TREES' – *Dr Patricia J Latas* – PRINT

'The Carolina Parakeet struck me some years ago as a real, emotional loss. I had always known about them, and was sad to know what had happened to such a wondrous species. But reading Christopher Cokinos Hope Is The Thing With Feathers from our local small library, I found an actual feather marking the page with a pet Carolina Parakeet sitting under someone's chin (Mr. Bryan with Doodles pg 50) - I was sitting in the same position with an extant but closely related species of conure under my chin. It was a physical blow, to know these individual, affectionate, intelligent birds had been loved like I loved my little bird, and they were gone, gone, gone...and I have been haunted since. I put the feather back and returned the book to the library, then bought my own second-hand, well-thumbed copy.'

'My piece was inspired by looking through my dad's old stamp albums from the 1950s. A lot of the stamps featured beautiful illustrations of local flora & fauna. Some of the countries in the album don't even exist anymore, but hopefully the same cannot be said of their birds, flowers and wildlife.'

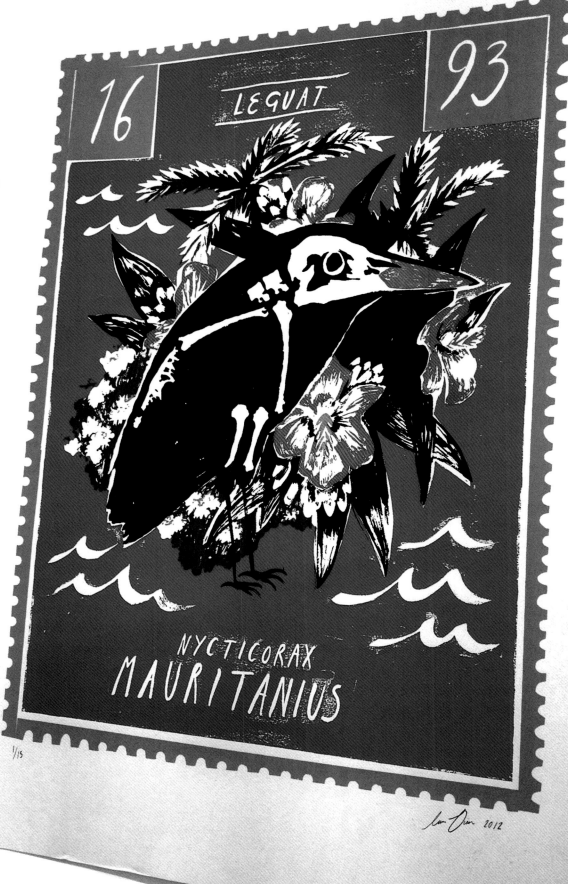

THE MAURITIUS NIGHT HERON – *Laura Dixon* – 7-COLOUR SCREENPRINT

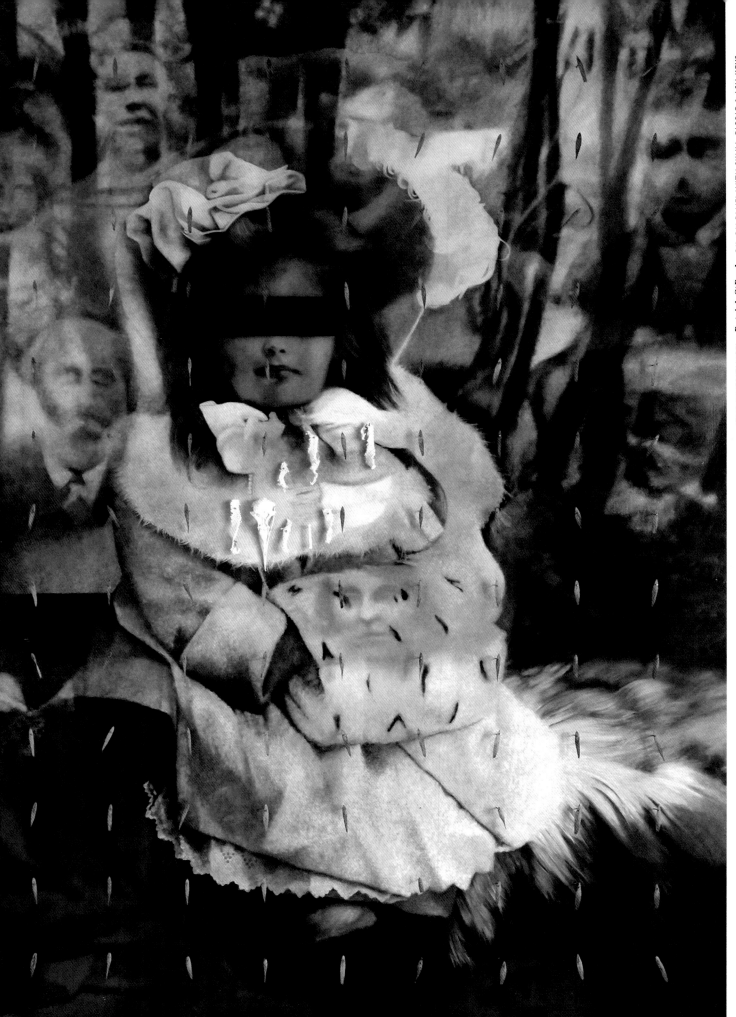

*'**The Inheritance** grew out of the Requiem pieces and owes a lot to Eliot's Four Quartets – something to do with 'laughter in the woods'. We, of course, are no less fragile than the world we inhabit and while none of us can imagine the world without us there will come a time when it will be'*

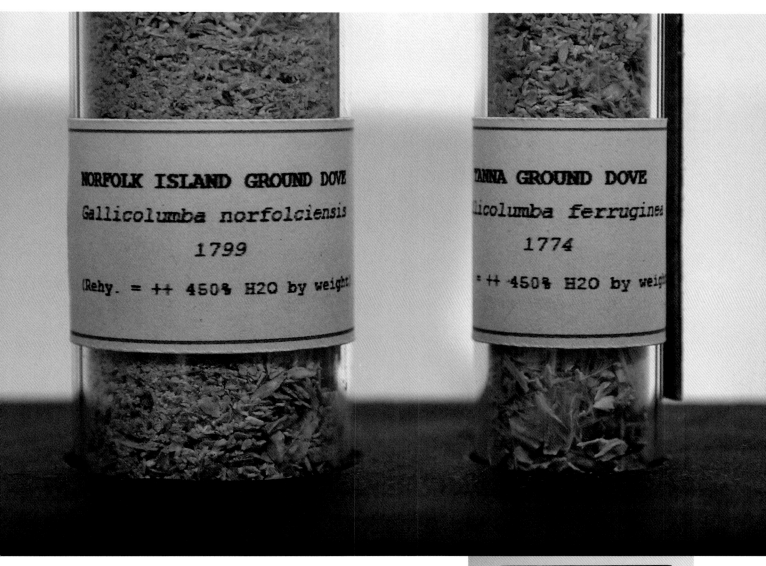

NORFOLK ISLAND GROUND DOVE
Gallicolumba norfolciensis
1799
(Rehy. = ++ 450% H2O by weight

TANNA GROUND DOVE
licolumba ferruginea
1774
= ++ 450% H2O by weight

TWO GROUND DOVES – *Patrick StPaul* – ONE PAIR TEST TUBES IN A WOODEN FRAME CONTAINING CRUSHED BONES AND FEATHERS

'The Tanna Ground Dove and the Norfolk Island Ground Dove, both from remote islands in the Pacific went extinct around 1800, almost certainly through overhunting. Very little is known about them and very few remains remain. They are the unromantic and unsung collateral damage of humankind's obsession with exploration, knowledge and order.'

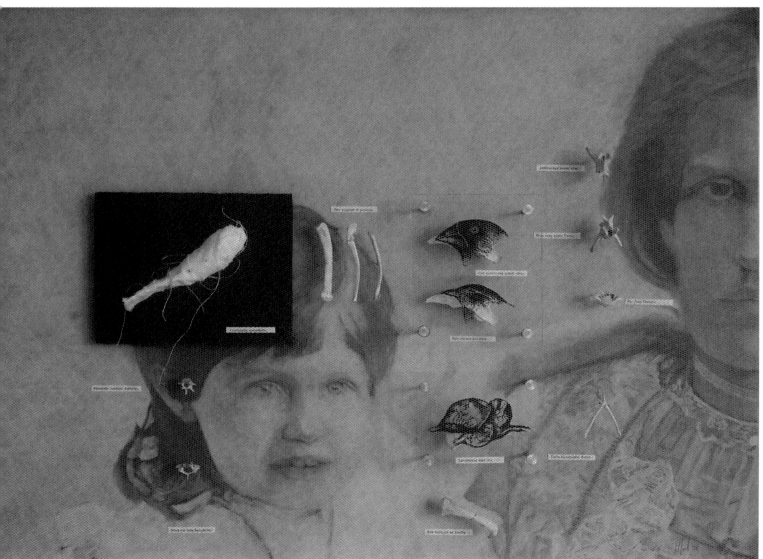

'FINCH'S REQUIEM I & II' – **Patrick StPaul** – OIL ON BOARD WITH BONES, COTTON & VELVET

'The Finch's Requiem paintings commemorate the passing of the humble Medium-sized Tree Finch onto the Critically Endangered list. The titles are taken from the first and last stanzas of the Anglican Mass For The Dead. When that great shooter of birds Charles Darwin first gathered a sack-full of Galapagos finches he didn't quite twig their significance. It was only the later prompting of a friend that led to their becoming a cornerstone of evolutionary theory - 'one might really fancy that... one species had been taken and modified for different ends.' This is a splendid observation and one that underlines the whole of our 'Humanity's Got Talent' world, but is it true? Modern genetics suggest that it might not be quite the whole story, but, does it matter? Science was only ever meant to be a hypothesis.'

'EL DORADO' – **_Cristina Guitian_** – DUCK EGG, SHEEP FUR, CLOCK BOX, GLASS

'The fact that the Choiseul Pigeon is known from six found skins and a single egg connected perfectly with my work. I recreated these elements in a glass box with a mirror, representing the 6 skins by fur, giving a more universal quality to the piece, and placing the egg in a cup upside down challenging the Laws of Gravity. The reflections generated by the glass box bring some life to the elements as if it was the glow of life of the pigeon's soul.'

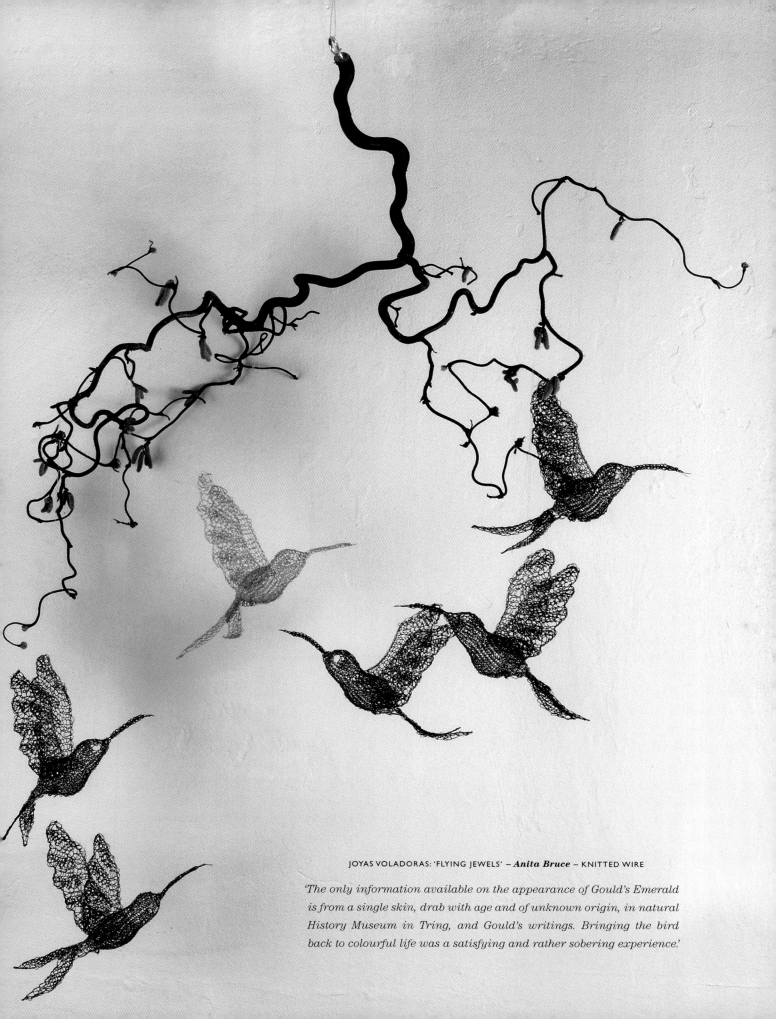

JOYAS VOLADORAS: 'FLYING JEWELS' – *Anita Bruce* – KNITTED WIRE

'The only information available on the appearance of Gould's Emerald is from a single skin, drab with age and of unknown origin, in natural History Museum in Tring, and Gould's writings. Bringing the bird back to colourful life was a satisfying and rather sobering experience.'

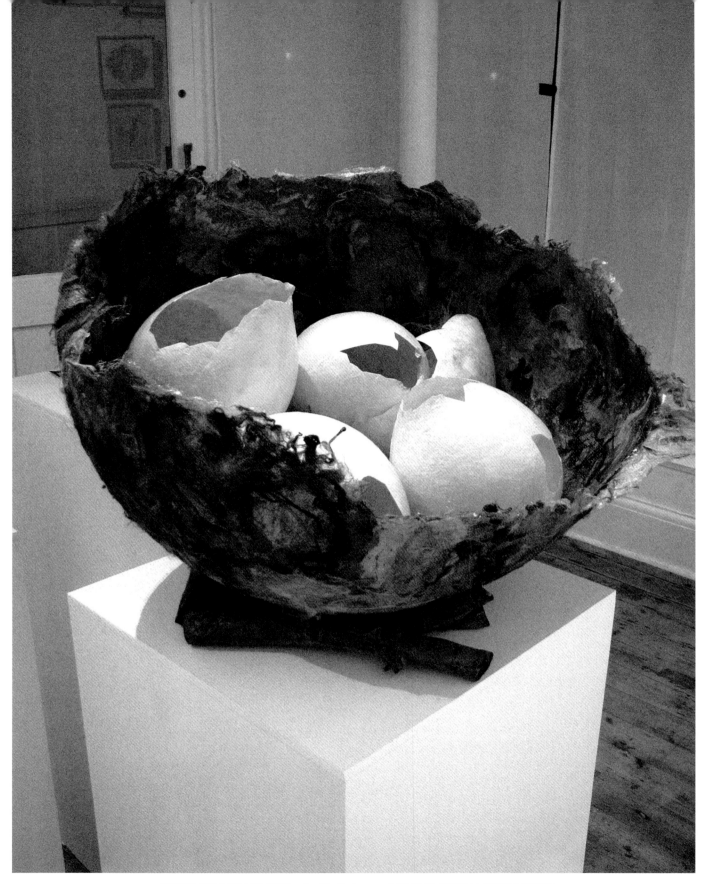

'DINNER FOR RATS AND CATS' – *Jackie Hodgson* – RAW SILKS, NATURAL FIBRES & STITCH

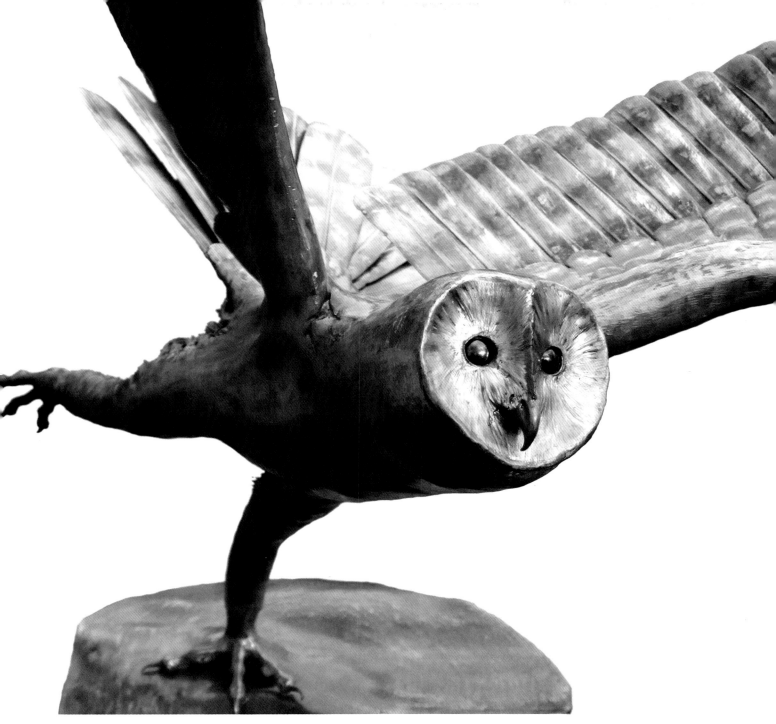

THE APPARENTLY LIFELESS FORM OF A STONE: ALBA, AFRICAN BARN OWL – *Piers Mason* – STAINLESS STEEL AND BRASS

'*Sub-atomic particle physics leads us to particles being vibrating waveforms appearing as dense formations of matter.* All that 'matter' is alive and essentially made of the same. Suspended within the sculptures is a solitary stone which is the force behind the artwork. The stone acts as a metaphor, that if we break everything down to its simplest constituent, as science is managing to do, then it becomes clear that everything is made of the same 'stuff.' Realising this link with everything is a massive leap in human evolution and consciousness where science and religion meet. In many ways, the work could be considered conceptual. A stone could hang in the middle of a gallery. But this is not enough, there is a need to search for form and contemplate the seemingly endless repetition that the process of carving a wing, comprised of countless detailed feathers, entails. It becomes a meditation, a practice in the unattainable pursuit of perfection within oneself and an awe like appreciation of life's ability to create conscious form. In many ways, the work could be referred to as traditional realist sculpture of animals. A shape carved out of metal. But this is not enough, there is a need to go beyond and delve into a world that explores the make-up of its origins - the philosophies, sciences and religions. The search for a better understanding of our place within it all has led us on an incredible journey. The beauty of it is, is that we are connected to it all, and are part of that journey. The boundaries between these lifelike animals and the philosophy of the works merge. Trying to capture and entice our understanding of the process of life and the fragility of a species, makes us recognise and value our place within it all. Capturing the grace, apprehension and anticipation of an animal in metal accentuates the life found within the material. As we start to see that the stone and everything is alive, the expression of unbounded life falls into place.'

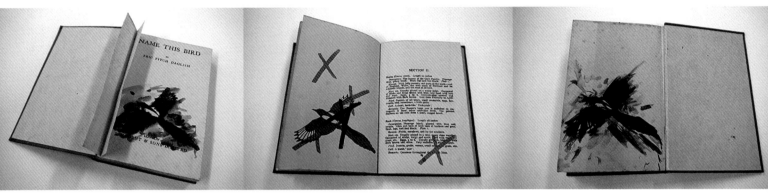

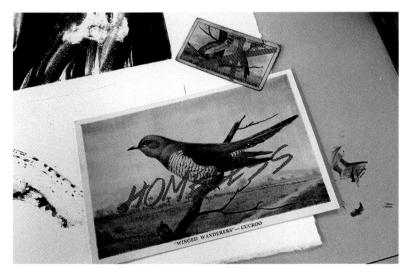

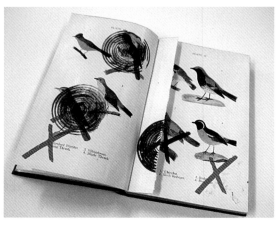

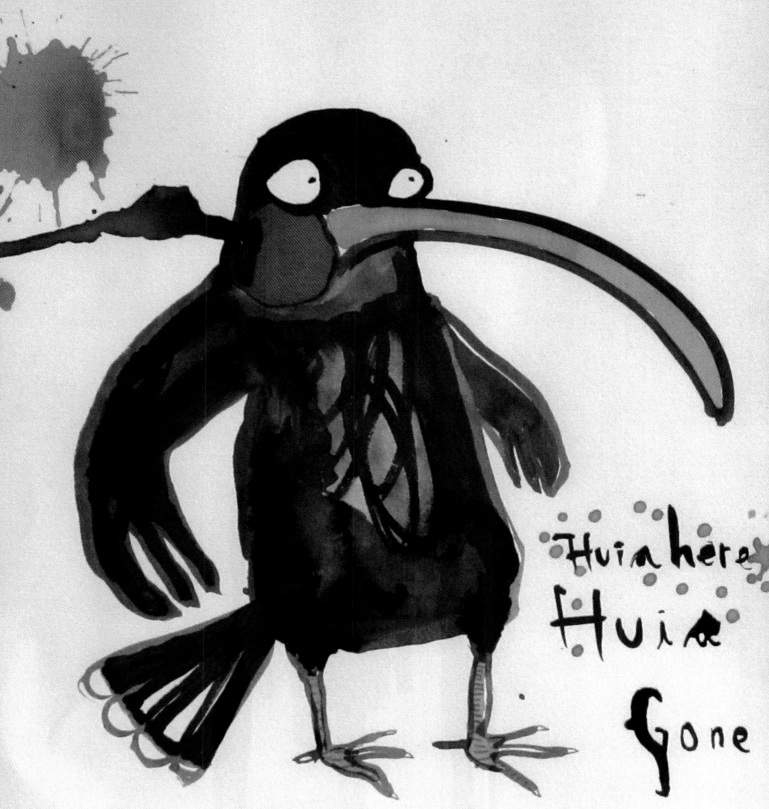

'HUIA HERE HUIA GONE'– *Karin Dahlbacka* – INK & PAPER

'The huia bird is such a visually stunning bird. I wanted to create sadness in its eyes. I feel sadness when I read about deforestation, hunting, European settlers and tail feathers for ladies hats. Native to New Zeeland and sacred to the Maori culture this bird is such a symbol of lost beauty, I kept on drawing this bird time and time again but could not get it right, and I thought yes why should I feel happy drawing something that is lost forever. It its right that I feel pain.'

'A BIRD IN THE HAND'– *Carolyn Drake* – PHOTOGRAPHY

'Every spring and fall, songbirds migrating across the eastern Mediterranean stop to rest in the gardens and orchards of Cypriot farmers and don't find their way out. The birds get trapped in nets and lime-sticks hidden in olive and fruit groves, and are later collected, de-feathered, and transformed into ambelopoulia, a traditional Cypriot delicacy that is sold in gourmet restaurants. Bird trapping is illegal in Cyprus, but the birds fetch a high price and are part of a Cypriot tradition.

Last April, I rented a cheap hotel room in Ayia Napa, a tourist destination on the south eastern tip of Greek Cyprus. This is a place British travellers know for its sandy beaches, raucous nightlife, and Mediterranean blue water, but I was here to join the Committee Against Bird Slaughter for their seasonal operation just a few kilometers away.

Every morning, we grouped into teams and trekked from farm to farm on the hills above the sunny beach. We moved in silence, ducking between bushes and fences in search of traps, nets, struggling birds. As we walked, my mind turned to the concrete sidewalks, asphalt lots, and strip malls below, and I wondered which was worse for the birds – touristic development or lime-sticks. Probably both, in equal measure.'

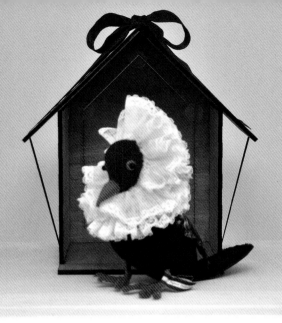

1.

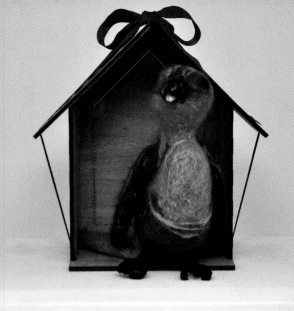

2.

1. *Catherina Petit-Van Hoey* – MAURITIUS BLUE PIGEON/PIGEON

2. *Ava Scott* – PARADISE PARROT

3. *Maxine Greer* – FIVE BLACK SPARROWS

4. *Richard Crawford* – PARADISE PARROT

5. *Jackie Hodgson* – SOUL BIRD

6. *Janet Clark* – HELENA GIANT HOOPEE

7. *Adam Bridgland* – DON'T MAKE ME THE TARGET

8. *Paloma Young* – NORFOLK ISLAND KAKA

9. *Lucy Wilson* – MARVELOOUS SPATULETAIL

10. *Alice-Enid McGougan* – SNAIL EATING COUA

11. *Kate Toms* – LITTLE BITTERN

Ghost Bird Boxes by Sammy Jo-Hutton

5.

8.

9.

4.

7.

0.

11.

Ghosts Swansea

A pop-up print exhibition IN COLLABORATION WIT

VAROOM! LAB

AND
SWANSEA
METROPOLITAN

GHOSTS OF GONE BIRDS

The Ragged school

It seemed fitting that in the deep midwinter of early 2013 we should find ourselves nestled in the snow-blasted valleys of South Wales, hunkered down in an ex-soup kitchen and home for underprivileged children.

Given the nature of our creative mission to resurrect long-gone avian species, there was a nice extra touch of karmic coincidence that the venue we settled on in Swansea should not only be an old Victorian poorhouse, but also presently be serving as the base for a spiritual healing and psychic education centre. Auras overlapped. Common energies combined: we instantly felt at home.

Downstairs the yoga classes continued, while upstairs the vaulted ceiling, rafters, raw-brick walls and strange mushroom-cloud scar that marked the ghost of a window on the far wall inspired a fresh hang of Gone Birds.

With the support of programme director Derek Bainton at Swansea Metropolitan and the illustration collective VaroomLab! we recruited another 50 artists to the *Ghosts* cause and launched a pop-up print show in Swansea on Thursday, 24 January.

In the city centre, the BBC invited us to use the giant Castle Square video screen to run a short animated film we'd created to promote the show. It was the first airing

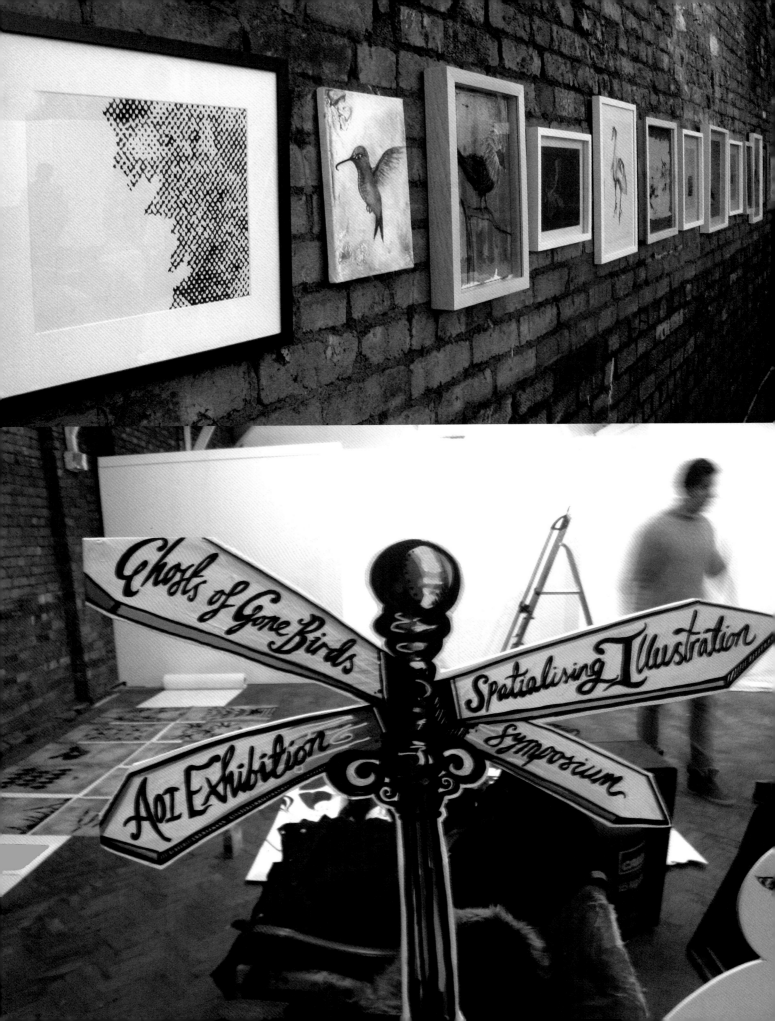

of our new story platform, 'The Ghost Tree' – an eerie, skeletal addition to the Swansea skyline in which the *Ghosts of Gone Birds* congregated and roosted for the ten days of the show, framed canvases and felt sculptures perching on and hanging from its blasted branches in artistic mimicry of their real-life cousins resting in nearby trees.

Extinct birdwatchers replaced the usual distracted shoppers, rugby fans and alfresco TV viewers gathering in front of the screen to catch a glimpse of Passenger Pigeons, Laughing Owls and the St Helena Hoopoe – long-gone species miraculously returned to digitally roost in the shadow of Swansea Castle.

The art on show was another wonderful mix of imagined portraits and deeper meditations on the theme of extinction. No more powerful a connection was made

between artist and subject than in the two pieces of work by Tracy Thompson created out of the discarded Victorian plaster walls of the house she lives in:

One in three billion (after Hayashi and Audobon)
'The paintings are intended to be sparse and futile, illustrating the emptiness of the skies, and are a metaphor for the isolation of the last Passenger Pigeon kept in the Cincinnati Zoological Gardens for all her 29 years of captive life. She died at 1p.m. on 1 September 1914. They are also about celebrating or honouring the individual imagined life of each Passenger Pigeon, rather than seeing them as a collective species, or a statistic. I will continue with this project regardless, doing a piece celebrating the life of each bird when I have time, up to the end of my lifetime probably!

When I researched all of the extinct birds, I found

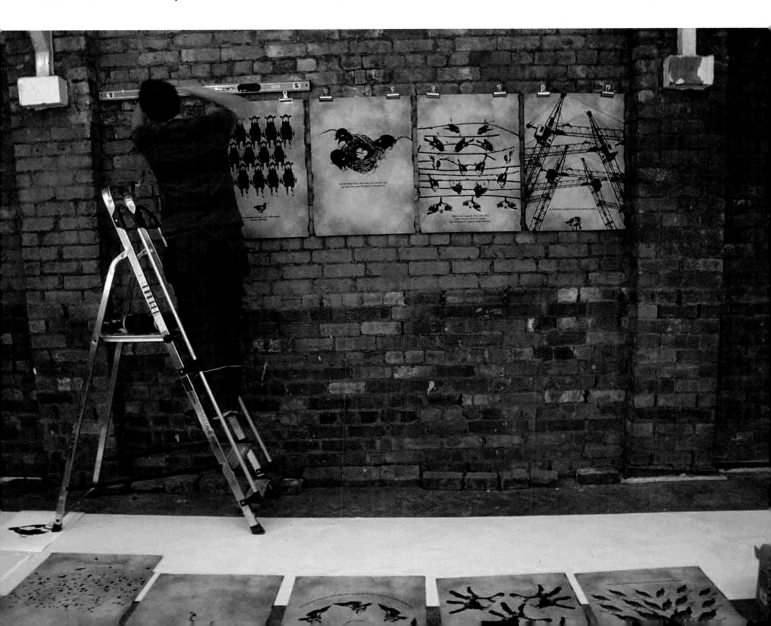

'I was immediately taken by the character of its form, the scale of its claws, its colouring and what looked like an inquisitive break.'

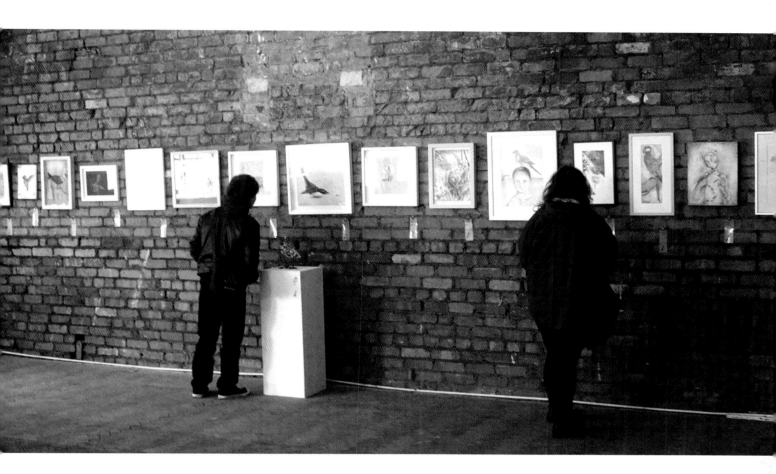

that for me the Passenger Pigeon summed up the whole madness of humanity: 3 to 5 billion birds, 1.5 million recorded as shot at a single shooting. The more I researched, the more I wept.

We categorise and put things in groups when they are numerous, with a classified name. Individuals are faceless. When rare, we then pay millions for them and covet their individuality. This is a weird development of the human brain – Martha was the last Passenger Pigeon that died at Cincinnati Zoological Gardens. No individual crooning over the other 2,999,999,999. Like paintings, if it is rare, no matter if it is dead, it is worth something over and above life.

As I researched the Passenger Pigeon a complicated story evolved that relates to my family – my daughter is very ill with chronic Lyme disease and the illness seems almost impossible to identify or cure adequately. The Passenger Pigeon ate beechmast and acorns. When it became extinct, deer-mice populations exploded as they eat the same foods. Deer mice are one of the main carriers of ticks and Lyme disease, and the bacteria *Borrelia* has exploded in America and now Europe and is set to be a potential epidemic. These are the results of one of the many imbalances caused by man's insensitivity to other life forms.

This project has seeded for me the start of my own research into the link between chronic Lymes disease, the bacteria *Borrelia* and the Passenger Pigeon'.

-Tracy Thompson, 10 January 2013

'ONE IN THREE BILLION
(AFTER HYASHI & AUDOBON)'
– *Tracy Thompson* –
DISCARDED VICTORIAN PLASTER
WALL COLLAGE,
RECYCLED GARLIC
TUBE PASTE AND MIXED MEDIA
ON CANVAS

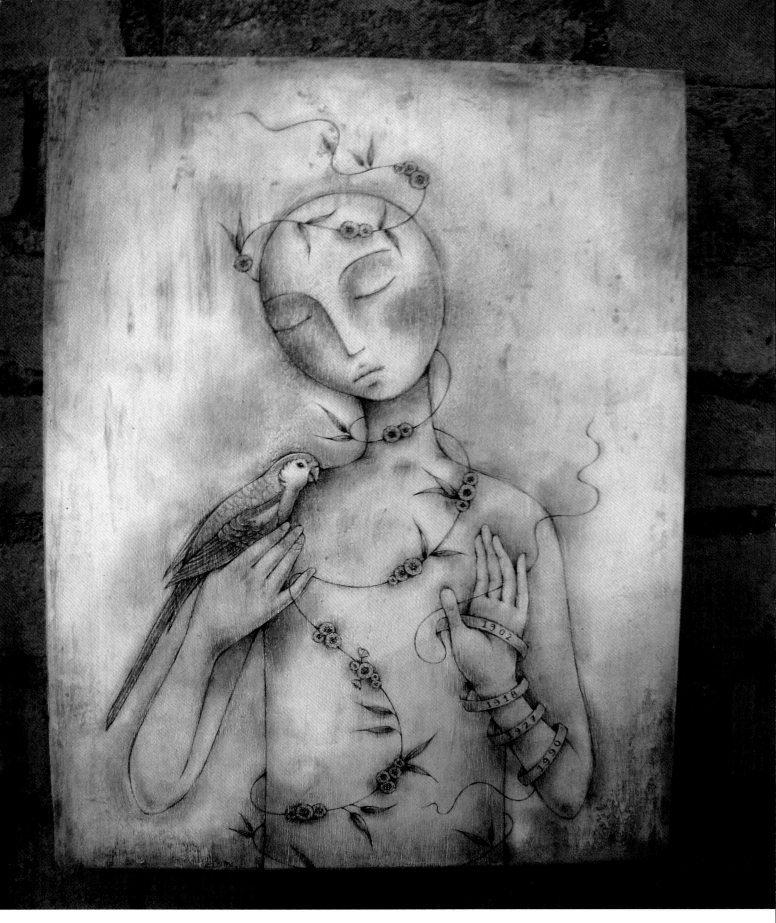

'PARADISE PARROT – PARADISE LOST' – **Leanne Ellis** – GRAPHITE & ACRYLIC ON WOODEN BOARD

'Firstly I loved the name!
I also liked the fact that it has been sighted several times since it was officially declared extinct.'

'AMAZONA MARTINICANA EXITUS' – *Duncan Mclaren* – OIL ON CANVAS

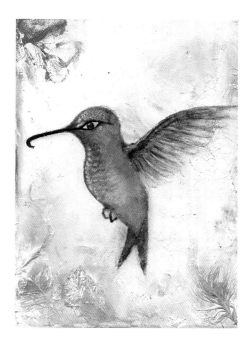

BRACE'S EMERALD – *Victoria Billet* – MIXED MEDIA ON CANVAS

'I have tried to encapsulate an essence of the bird's tropical home of the Bahamas within my piece. Using mixed media on canvas, I have used real feathers mixed with the paint on the background to suggest the loss of this beautiful bird.'

THE SNAIL-EATING COUA

– Chris Harrendence –

PEN & INK & OIL PAINT ON PAPER

'We must learn from the mistakes of our past. There are so many fragile species whose fate is in our hands. It is our duty to protect. Projects like the Ghosts of Gone Birds raises such awareness to an unaware society.'

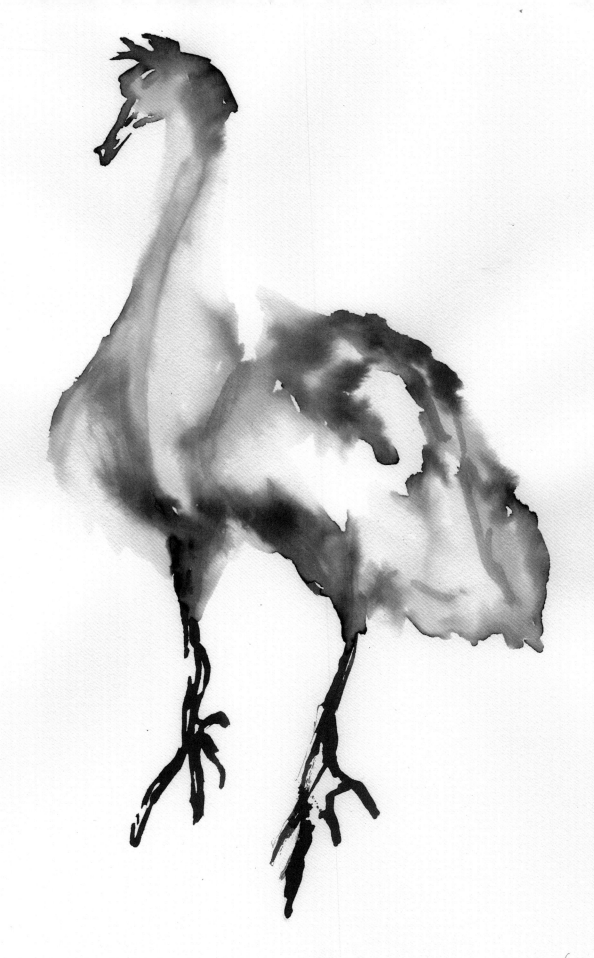

KING ISLAND EMU – *Matthew Otten* – INK ON PAPER

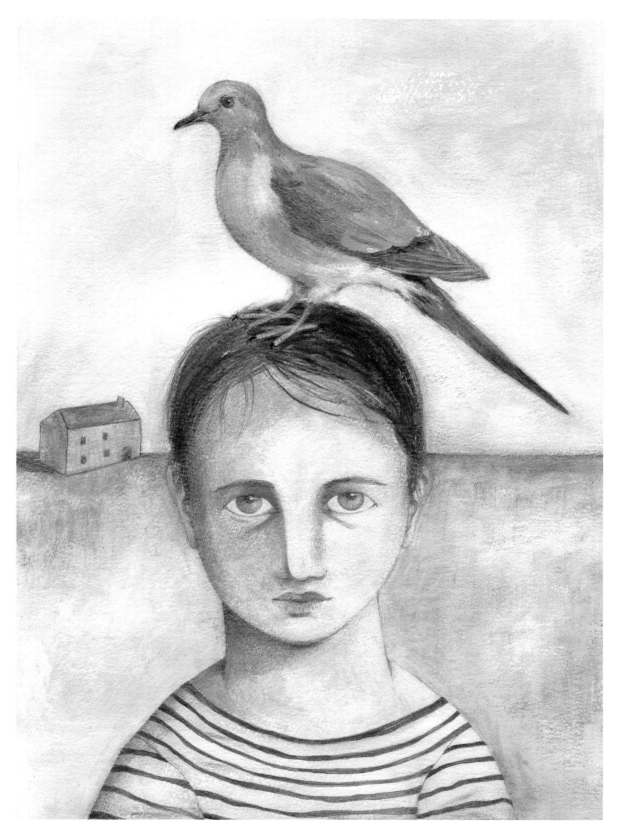

'THE PASSENGER PIGEON – ON YOUR HEAD BE IT' – *Delyth Lloyd Evans* – ACRYLIC & PENCIL

'The fact that the last passenger pigeon in existence had a name, Martha, made the connection more personal and intimate. Discovering that the demise of this species was a result of man's interests and needs clashing with nature added to this personal connection and, perhaps, collective guilt.'

PALLAS CORMORANT – *Abbie Stewart* – MIXED MEDIA

'SLENDER-BILLED GRACKLE – APOLOGY' – *Rebecca Jones* – COLOURED PENCIL

'ROAST OF THE RED PASSENGER' – *Sam Warden* – DIGITISED PEN AND INK COLLAGE

'The motivation of my piece was to hopefully help bring to life the dangers of over hunting and commercial exploitation. I decided to use the two birds, the Passenger Pigeon and the Red Rail, as they were both hunted for food, and I felt they both looked the most interesting.'

'THE LAST WHITE GALLINULE' – *Sian Jenkins* – ACRYLIC

'DAY GECKO' – *Chelsea Hopkins* – SOFT-COLOURED PENCILS ON BLACK HANDMADE (KHADI) PAPER

*'As I did more research about it I discovered how it was portrayed with
a patterned belly and ate Rodrigues Day Geckos, which are also now extinct'.*

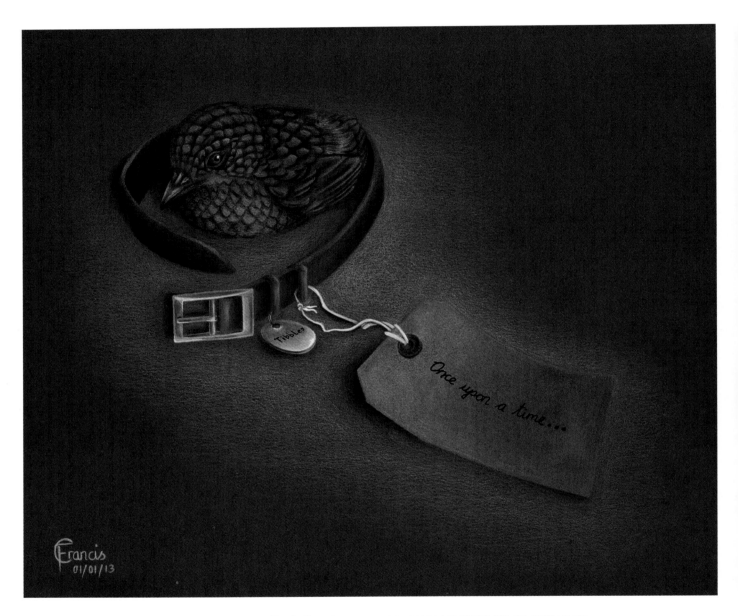

'WHAT A CAT-ASTROPHE' – *Carrie Francis* – COLOURED PENCILS AND WHITE INK ON GREEN PAPER

'This little bird was the one I thought of immediately to draw for this project. The Stephens Island Wren was already known to me because of the curious cause of its extinction, where it was apparently completely wiped out by the lighthouse keeper's cat, Tibbles. This version of events is the most widely known, and considered by some as a legend, who believe Tibbles was most probably only one contributor. This gives the words 'Once upon a time...' on the luggage tag a double meaning. The first interpretation is that the wren is now long gone and only lives on in stories, and the second interpretation is that the story of the main cause of its extinction may be a little exaggerated.'

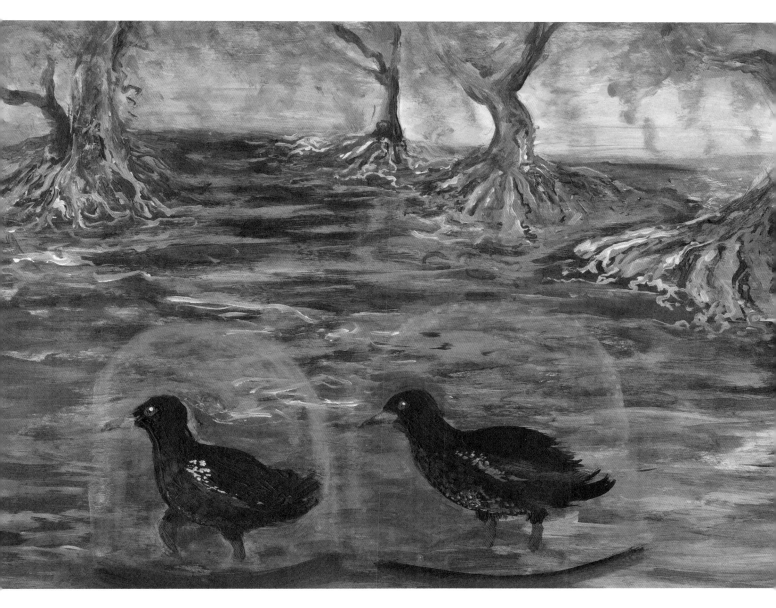

THE KOSRAE CRAKE – *Carina Roberts* – ACRYLIC PAINT AND PHOTOSHOP

'Choosing a bird from an inspiring habitat was essential for me to envisage it as a live creature, and the mangrove swamps of Micronesia instantly gave me an atmospheric mental picture to work with. As for the Crake itself, I was particularly fond of its mottled markings and had great fun matching it into its camouflaged background.'

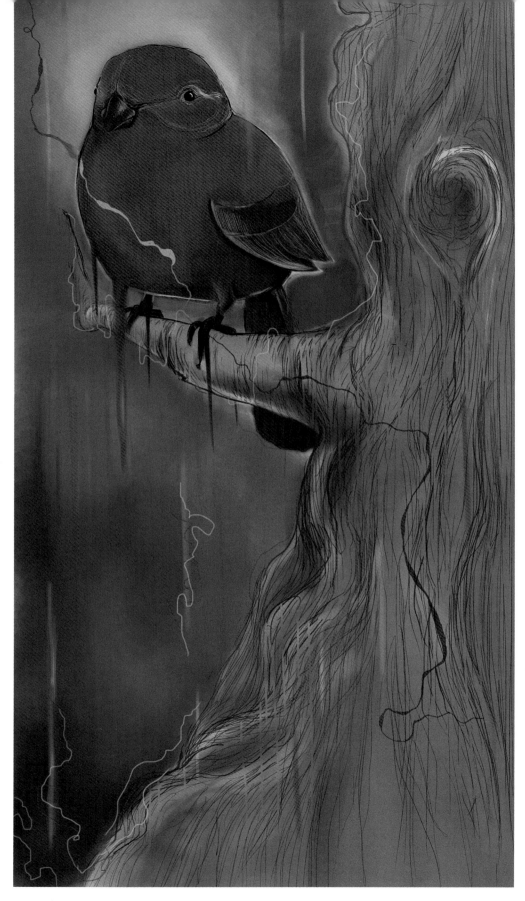

'RED BEACON' – *Claire Thomas* – DIGITAL PRINT

'The Kakawahie was discovered by Scott Barchard Wilson during a foggy day in the Moloka'i forest. The fog left Wilson lost, all that could be seen was a flash of red. I wanted to document how the bird's bright red feathers were able to burst through the fog, somewhat like a beacon.'

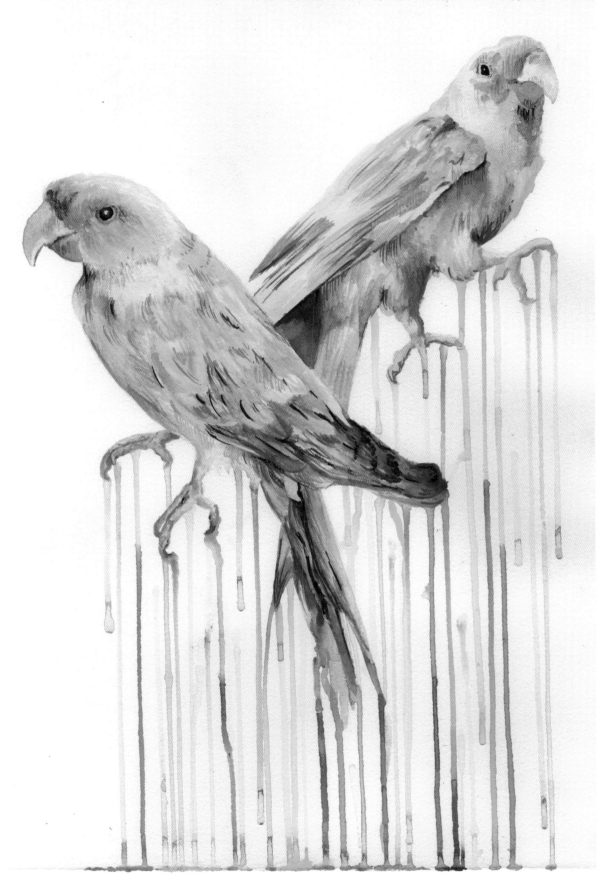

CAROLINA PARAKEET 'DRIBBLE AWAY' – *Anne-Marie Kemplay* – WATERCOLOUR AND INK

*'I incorporated the ink drips into the painting to represent the
species 'dribbling' away into extinction, bird by bird, drip by drip.'*

'REUNION OF REUNION PIGEON' – *James Milligan* – DIGITAL PRINT

'I felt that no one else would choose this bird and felt sympathy towards it. I'm more interested in strange normal things like this pink pigeon.'

CUBAN RED MACAW – *Georgia Roberts* – WATERCOLOUR & INK

SWEET PARADISE – *Hiroko Uemoto* – WATERCOLOUR

'I drew a bird called 'Ryukyu-pigeon' that had lived in the south of Japan. Japan is a small country, though it has fabulous different climates. In the north area, the weather is cool, same as the UK, but in the south area, it is as warm as a tropical rainforest. When I imagined their habitat, I thought how happily they lived in this paradise.'

'GONE WITH THE SHOTS' – *Anna Johnson* – HANDMADE INK DRAWING,
TEXTURES & COLOURS ADDED DIGITALLY

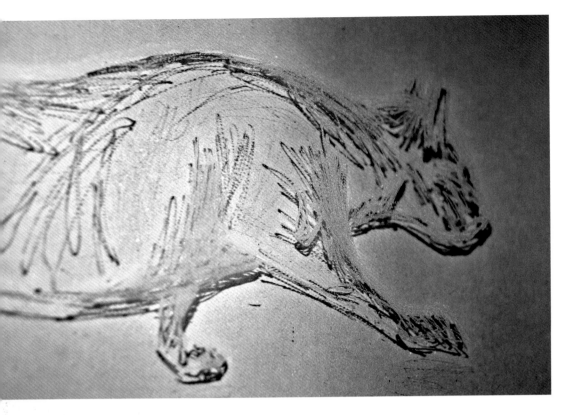
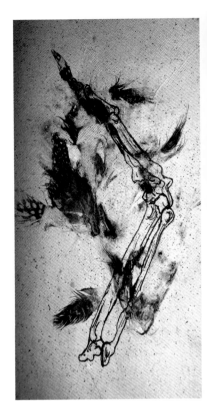
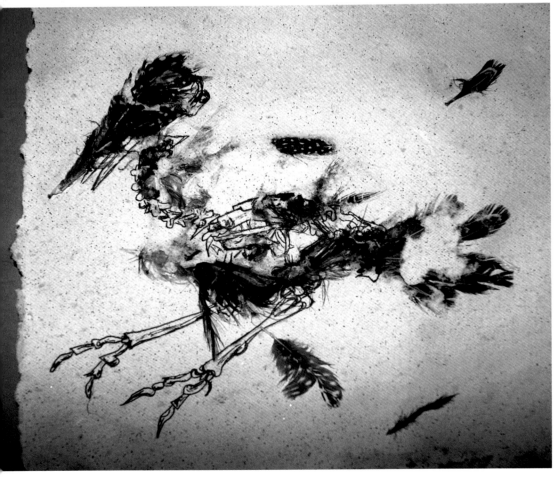

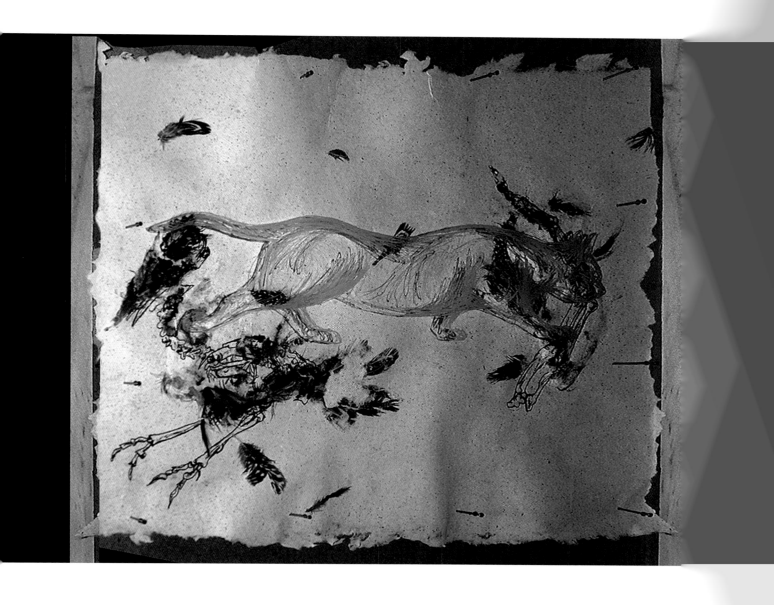

'STEPHEN ISLAND WREN, SPEEDILY STALKED' – *Claire Moore* – MIXED MEDIA, WIRE-SCULPTED FRAME HOLDING FEATHERS IN POSITION, SET INTO HAND MADE PAPER, GEL INK PEN DRAWING ONTO PAPER, GLASS ENGRAVING ON FRAME

'When first researching the reasons behind this bird's extinction, I misread the date stated as I am dyslexic. I read 1984 instead of the correct 1894, which caught my interest and bemused me, as that is the year in which I was born. After further research, I felt very moved by this poor bird's story. As a definite 'cat person', I could relate to the Lighthouse Keepers' need for companionship from his pet cat, but also the frustration he must have felt at the senseless killing of each individual little bird the cat brought home and presented so delicately as a special gift to him. I was rather taken by the fact that this one lone feline was responsible for both the discovery and the destruction of this particular species of bird on the island; and in such a short period of time too. This resulted in my decision to include an image of the cat in my piece also (instead of focusing on the bird alone), he is casting a shadow over specimens of the bird he was solely responsible for burying.'

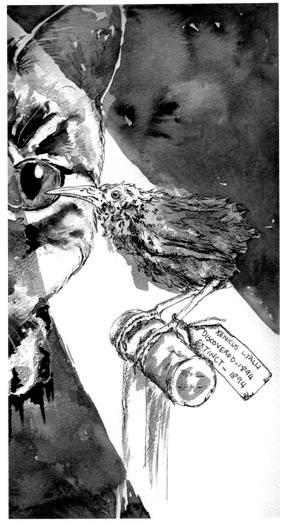

'KILLED BY THE LIGHT HOUSE KEEPER'S CAT'

– Diane Rees – MIXED MEDIA

'My picture was inspired by the tragic story of the Stephens Island Wren. I found it astonishing that in the same year of discovery this little bird became extinct. It fleetingly came into the spotlight in 1884 as an undescribed species. It was discovered by David Lyall a lighthouse keeper on Stephens Island, New Zealand, after he had become intrigued by the small carcasses his pet cat brought home. The little information known about this bird came from Lyall, the only person to see it alive. He observed, "It ran like a mouse" and "did not fly at all". It is unknown whether the responsibility of the demise of this bird can be laid solely at the 'paws' of Lyall's cat as by late 1894 news of the wren had circulated in the ornithological community and some collectors were willing to pay a large price for a specimen.'

'LOOK 'HOO'S' LAUGHING OWL' – *Abigail Parry* – PEN AND INK

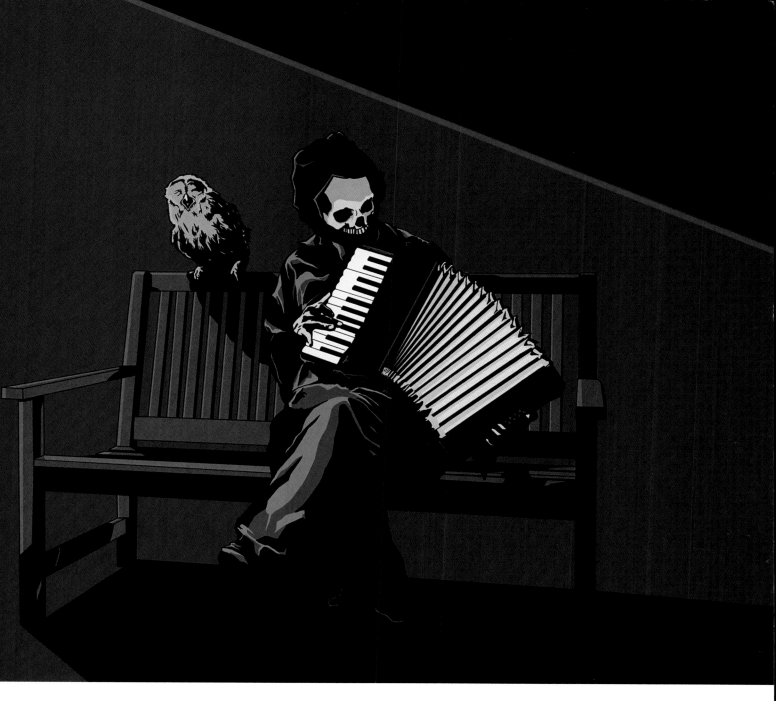

THE LAUGHING OWL – **Ben Hicken** – PRINT

'I chose the Laughing Owl because I was amused by the fact
that it could be attracted by playing the accordion. In this piece
Death is playing the accordion to symbolise the bird is extinct.'

'For my main practice I take photographs of local landscapes, mainly of nature walks that are close to my home and that I am very familiar with as I have grown up exploring these areas. These images are then altered in Photoshop, so that the image isn't instantly recognisable to the viewer. The image is then projected and painted onto a canvas using oil paint. The paintings need to be viewed from a distance for the image to become clear. I like that my paintings can be viewed from two different distances and that from each distance the image is different.'

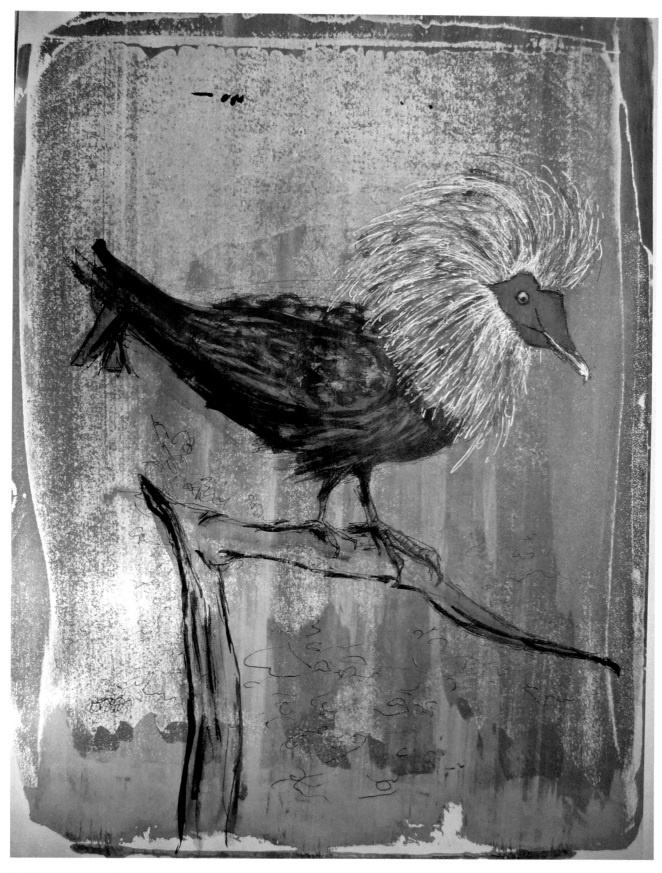

MAURITIUS BLUE PIGEON – **Ben Springham** – SCREEN-PRINTING MEDIUM AND ACRYLIC PAINT, DRAWING INK, DYES, PEN, COLOURED CRAYON AND PENCIL

*'I'm intrigued by its showy features such as the white hackles around its neck which
were raised into a ruff, and enticing colours of blue and red; all of which I felt were
most diverse from a lot of its predecessors and those that are extinct alongside it.'*

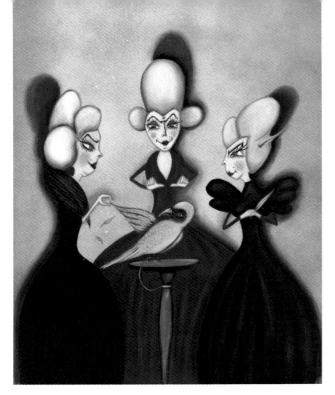

'BEAUTY LIES IN THE EYES OF THE BEHOLDER'
– *Susan Evans* – MIXED MEDIA

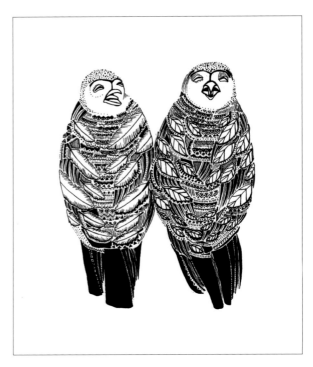

'DID YOU JUST TOOT YOUR HOOT?'
– *Chris Livings* – FINE LINER PEN

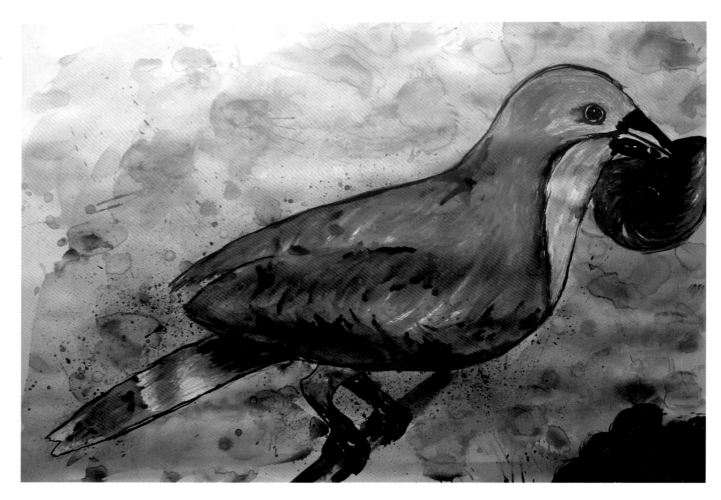

'LE ESCARGOT-EATING COUA' – *Lucy Read* – INK ON PAPER

'Its name brought a smile to my face with the idea that this bird ate so many snails that it just had to be named after its diet.'

STEPHENS ISLAND WREN

– Hayley Swann –

ACRYLICS AND COLOURED PENCILS

'THE HOOPOE & THE ARROW' – *Lee Court* – DIGITAL PRINT

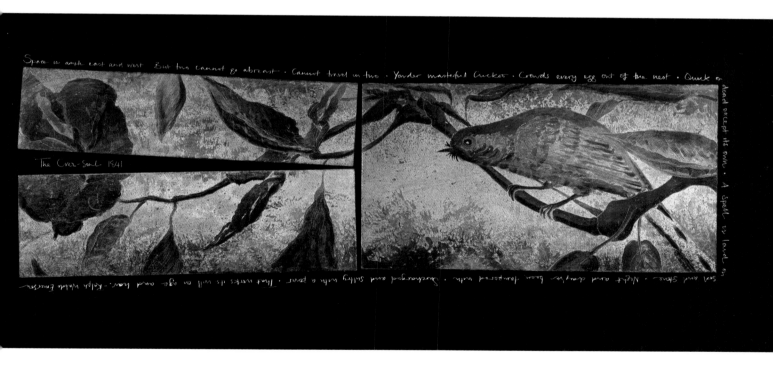

ST HELENA CUCKOO: 'HUMANKIND AS CUCKOO' – *Derek Bainton* – AQUATINT ETCH WITH PEN & INK

'The story of the St. Helena Cuckoo is somewhat of a synecdoche - its existence was identified by a single humerus discovered on St. Helena's island where it was once endemic. Its extinction was as a result of deforestation for settlement in the 18th century. The beguiling nature of the cuckoo might easily be compared to our own rather invasive behaviour: a worrying thought, given the state of the bird as species, is often considered an early echo of our own plight.'

Where to next?

Someone once asked us about newts. What were we doing about the endangered pond and wetland dwellers of the world? The dwindling number of amphibians? Would we consider championing the causes of under-threat creatures like the Chinese Giant Salamander, the Goliath Frog or the Western Leopard Toad? What about the Texas Blind Salamander? Would its subterranean life in aquifers and artesian wells inspire a creative outpouring similar to that for the Laughing Owl or Red-moustached Fruit Dove?

It was a good question. Would the stories of other species' habitat loss, predation and imminent demise generate the same committed creative army? We mused on it for a moment.

Ghosts of Gone Amphibians. The term didn't quite ring true for us. It sounded a little flat and uninspiring. Ghosts of Gone Birds sent the pulse racing, the imagination soaring – it seemed to offer up infinite possibilities of creative interpretation.

Ghosts of Gone Amphibians left you earthed, knee deep in some squelchy, dark, damp, water-logged forest floor. Which seemed unfair. Every endangered species deserved our attention at some point. Sure, birds were a great starting point. They had creative heritage – cultural currency stretching back centuries to some of the earliest cave paintings. Birds in art made sense.

Newts, however, were a creative challenge – though hopefully if you've stayed with us this far, you'll know that if there is one thing we enjoy, it's a creative challenge. So newts it is. And after that? Maybe spiders, or shellfish. Ghosts of Gone Molluscs – now that's a show that would take some organising, but perhaps we'll broaden the brief.

We'll look at habitats and ecosystems, partner up with conservation organisations that aren't species specific, but segment the natural world in a different way. Ghosts of Gone Forests could not only cover all-species loss, but also go further into the green, exploring the loss of myth and folklore, the fearsome and fabulous inhabitants of our imaginary forests. Ghosts of Gone Oceans might take us in another direction entirely, diving down into a realm beyond just marine-life extinction to confront the nursery seabed of all thought-forms. It could feature the ocean as originator of all life – and what present-day threats of pollution and political carve-ups say about our contemporary to-do lists.

So a lot to ponder – and plan for.

In the meantime, however, here's to the first volume of our avian resurrection project – we'll see you soon for *Ghosts of Gone Birds,* Part II.

Appendix (1)

The brief

The following pages reproduce the list that BirdLife provided when we first asked it for details of the birds that we should focus on for the *Ghosts* exhibition.

The list caught us all by surprise when it arrived – we read through each page in a hushed, disbelieving silence as we slowly got to grips with the enormity of the extinction stories before us. We couldn't help but be moved by the tragic tale of each lost species – vivid pen portraits of curious, beautiful creatures transformed into a litany of unnecessary loss.

Instinctively we knew that our artists would respond to these short, brutal obituaries. Their creativity would hopefully hook onto a small detail – a curious name, a bizarre life detail or a poignant instance in the bird's slide into extinction. These stories of loss would breathe life into the project before us and start to generate the art we were looking for.

We simply retitled the list 'Sad Stories and Cold Facts of Avian Extinction', and started mailing it out to our emerging creative army. It needed very little extra information from us; just timings and formats – logistical footnotes.

The birds themselves were the great persuaders. Their lost life stories would become the creative spark to ignite the interest and imagination of every artist we approached, whether in Liverpool, London, Brighton or Swansea. The seeds of the art and writing that appeared in each of those shows began with the following list.

Sad Stories

and

Cold Facts

of

Avian Extinction

King Island Emu
Dromaius ater

it's endemic to King Island in the Bass Strait, Australia. It was reported to prefer the shady margins of lagoons and the shoreline. Numerous skeletal remains have been found, but only one skin exists, collected by Baudin in 1802, and now in Paris. Its extinction must have followed shortly thereafter, presumably a result of being hunted by sealers for food

Kangaroo Island Emu
Dromaius baudinianus

it's endemic to Kangaroo Island, off South Australia. Peron, who visited the island in 1802–1803 with Baudin, wrote that the species inhabited 'the innermost recesses of the woods', but would visit the shoreline in the afternoon. Writing in 1837, Leigh reported that the species had not been seen for ten years. It was apparently systematically hunted to extinction by a settler, although habitat alteration by fire may also have contributed to its demise.

Colombian Grebe
Podiceps andinus

it's restricted to the Bogotá Wetlands at c. 2,600 metres in the Eastern Andes of Colombia. It is known from 18 or 19 specimens collected between 1939 and 1964. The species was still abundant on Lake Tota in 1945, but numbers crashed in the 1950s as a combined result of wetland drainage, siltation, pesticide pollution, disruption by reed harvesting, hunting and predation by introduced Rainbow Trout *Salmo gairdneri*. The last confirmed record was in 1977, and because intensive studies in 1981 and 1982 failed to find the species, it is now considered extinct

Atitlán Grebe
Podilymbus gigas

it's endemic to Lake Atitlán, Guatemala. Its population dropped from c. 200 to 80 as a result of competition and predation by Large-mouth Bass *Micropterus salmoides*, introduced into the lake in 1960, but it recovered to a high of 232 in 1975 when the numbers of bass plummeted. However, increasing pressure on breeding sites from local reed cutting and tourism development, along with the murder of the government game warden for the national park during the political unrest of 1982 and falling lake levels following the earthquake

of 1976, drove the population down to 30 by 1983, and extinction by 1986. Drowning in gill nets and disturbance by increasing boat traffic have also been suggested as contributory factors. It probably became extinct due to the arrival of people on the island in the 16th century, unlike Puffinus pacificoides, which is only known from very old deposits on the island and probably became extinct naturally in the Pleistocene epoch.

St Helena Gadfly Petrel
Pterodroma rupinarum

it's one of three petrel species known only from the fossil record of St Helena (to UK). It presumably became extinct due to predation by people and introduced species after the island was discovered in 1502.

Pallas's Cormorant
Phalacrocorax perspicillatus

it's restricted to Bering Island, in the Commander Islands, Russia, and possibly the adjacent coast of the Kamchatka Peninsula. Steller noted that it was common in 1741, but it was a poor flier and was heavily hunted for food by the Aleuts who settled on the island in 1826. The five known specimens were all collected between 1840 and 1850, and in 1882 Stejneger was told by the island's residents that the last birds had disappeared about 30 years before.

New Zealand Little Bittern
Ixobrychus novaezelandiae

it's endemic to New Zealand. It became extinct before 1900, for unknown reasons, on the South Island, while on the North Island it is only known from bones.

Réunion Night-heron
Nycticorax duboisi

it's endemic to Réunion (to France), described by Rothschild based on Dubois' (1674) descriptions of 'bitterns or great egrets…they have grey plumage, each feather tipped with white…and the feet green'. An incomplete tibiotarsus discovered on the island in 1974 confirms that Réunion did indeed hold an endemic *Nycticorax*.

Mauritius Night-heron
Nycticorax mauritianus

it's described from seven fossil bones (of which only a coracoid and a tarsometatarsus are available today), from Mauritius. Leguat's description of 'great flights of bitterns' in 1693 probably refers to this species, given

that the only two other species of Ardeidae known from the island are the Dimorphic Egret *Egretta dimorpha* and Green Heron *Butorides striatus*, which could in no way be described as 'bitterns'.

Rodrigues Night-heron
Nycticorax megacephalus

it's known from a number of bones, and from Leguat's 1708 and Tafforet's 1726 accounts, from Rodrigues, Mauritius. Leguat mentioned that it was easily caught (although it was not quite flightless), and hunting presumably caused its extinction. In 1761, Pingré specifically noted that there were no longer any butors on the island.

Réunion Flightless Ibis
Threskiornis solitarius

it's known from bones recently discovered on Réunion. It seems likely that the 'solitaire' known from numerous early accounts from Réunion was in fact this ibis, vindicating arguments for independent evolution of the Mascarene 'solitaires', in which case its extinction can be placed in the early 18th century, with the last account being that of Feuilley in 1705.

Mauritian Shelduck
Alopochen mauritianus

it's endemic to Mauritius. Although the only specimens of the species are two carpometacarpii, it is known from numerous travellers' reports. In 1681, it was noted to be plentiful 'in the woods or dry ponds', but it was presumably heavily hunted because it was described as 'not large, but fat and good'. By 1693, the species was rare, and by 1698 it was extinct.

Amsterdam Island Duck
Anas marecula

it's endemic to Amsterdam Island, French Southern Territories. It is only known from bones 'no more than a few hundred years old'. It was flightless, and was presumably driven to extinction by whalers stopping off on the island. A report of 'a small brown duck, not much larger than a thrush' from Barrow's 1793 visit to the neighbouring St Paul Island presumably refers to the same or a similar species.

Mauritian Duck
Anas theodori

it's endemic to Mauritius, and is known from a number of explorers' accounts, and from bones. In 1681, the 'gray teal' was found in 'great numbers' on lakes and ponds in the

woods, but it was presumably hunted to extinction, becoming rare by 1693, and last mentioned as extant in 1696. There are also numerous travellers' reports of *sarcelles* and *canards* from Réunion, so presumably this or a similar species also occurred there; it was extinct by 1710 at the latest, although no bones have been found.

Labrador Duck
Camptorhynchus labradorius

it's probably bred along the Gulf of St Lawrence and coastal Labrador, Canada, wintering from Nova Scotia south to Chesapeake Bay, USA. The birds presumably nested on sandbars and around sheltered bays and, in winter, foraged in shallow bays, harbours and estuaries. Shooting and trapping on the winter quarters were certainly proximate factors in the species' extinction. Overharvest of birds and eggs on the breeding grounds could also have been a factor. The last confirmed specimen was collected off Long Island, New York, in 1875 (or possibly 1878).

Auckland Island Merganser
Mergus australis

it's restricted to the Auckland Islands, New Zealand, by the time of its discovery in 1840, but subfossil remains of a *Mergus* species have also been found on South and Stewart Islands. It was largely a freshwater species, foraging in inland streams, estuaries and, occasionally, sheltered bays. Its decline was presumably caused by a combination of hunting and predation by introduced pigs, rats, cats and dogs – the species' incipient flightlessness made it especially vulnerable. At least 26 specimens were collected in total, the last in 1902; there have been no records since, despite intensive searches.

Guadalupe Caracara
Caracara lutosus

it's endemic to Isla Guadalupe, Mexico. The island was once heavily vegetated, but grazing by goats has almost entirely denuded it. However, the primary cause of the species' decline was direct persecution by settlers, and it was last recorded in 1900.

Double-banded Argus
Argusianus bipunctatus

is known only from a single portion of a primary feather described in 1871 from a shipment imported into London, and now in the British Museum. It has been suggested to have occurred on Java, Indonesia or on Tioman Island, off peninsular Malaysia, because of the absence of the genus from these islands. The cause of its extinction is unknown.

New Zealand Quail
Coturnix novaezelandiae

it's endemic to open habitats, especially grass-covered downs, on the North, South and Great Barrier Islands, New Zealand. It was considered fairly common until the mid-19th century, but declined rapidly to extinction by 1875. Extinction was initially thought to have been caused by large-scale burning, predation by dogs, cats and rats, and grazing by sheep. More recently, diseases spread by introduced game birds have been hypothesised to account for its rapid extinction.

Red Rail
Aphanapteryx bonasia

it's endemic to Mauritius, from where it is known from a number of travellers' accounts and illustrations, and from numerous bones. It was mentioned to have become rare by Leguat in 1693, and there were no further reports, so the species, which was flightless and palatable, was presumably hunted to extinction in around 1700.

Rodrigues Rail
Aphanapteryx leguati

it's restricted to Rodrigues, Mauritius. It is known from a number of bones and from several travellers' reports, the last of which was that of Tafforet in 1726. It was flightless and apparently excellent eating, and was heavily hunted, presumably becoming extinct in the mid-18th century – Pingré reported that it was extinct in 1761.

St Helena Crake
Atlantisia podarces

it's endemic to St Helena (to UK). It was large and flightless, and presumably became extinct soon after the discovery of the island in 1502.

Chatham Rail
Cabalus modestus

it's endemic to Chatham, Mangere and Pitt Islands, New Zealand. It was first discovered on Mangere in 1871, and 26 specimens collected there are known from museum collections. It became extinct on the island between 1896 and 1900. Its extinction was presumably caused by predation by rats and cats, which were introduced in the 1890s, and by habitat destruction to provide sheep pasture, which destroyed all of the island's bush and tussock grass by 1900, and from grazing by goats and rabbits. The species is also known from 19th-century bones from Chatham and Pitt Islands, where it has been suggested that its extinction resulted from competition with the larger Dieffenbach's Rail *Gallirallus dieffenbachii* (also extinct), but the two species have been shown to have been sympatric on Mangere.

Mascarene Coot
Fulica newtoni

it's known from numerous travellers' reports and bones from Réunion (to France), and also probably occurred on Mauritius, from where there were reports of *poule d'eau*, the contemporary name used for the birds on Réunion. The species was last reported on Réunion in 1672 and on Mauritius in 1693, and was presumably hunted to extinction despite the fact that it was 'not good to eat'.

Tristan Moorhen
Gallinula nesiotis

it's endemic to Tristan da Cunha (to UK). It was abundant up until 1852, but rare by 1873, and had become extinct by the end of the 19th century as a result of hunting, predation by introduced rats, cats and pigs, and habitat destruction by fire. At least 15 specimens are claimed to have been collected, including at least seven that have been traced, of which only two in Tring and one in Harvard are authentic beyond doubt. The similar Gough Moorhen *G. comeri* was introduced to Tristan da Cunha in 1956 and is treated as Vulnerable.

Dieffenbach's Rail
Gallirallus dieffenbachii

it's endemic to Chatham, Mangere and Pitt Islands, New Zealand. It is known from the type, in Tring, with one other specimen reported to be in Bremen, and from abundant subfossil material. The species was already scarce when the type was collected in 1840, and was extinct by 1872, presumably due to predation by introduced rats, cats and dogs, and habitat loss from fire.

Tahiti Rail
Gallirallus pacificus

is known only from Forster's painting from Tahiti, French Polynesia, in the British Museum, from Cook's second voyage in 1773, although there were reports from Tahiti until 1844, and from the nearby Mehetia until the 1930s. It was flightless, and its extinction was presumably caused by introduced cats and rats.

Wake Island Rail
Gallirallus wakensis

it's endemic to scrub on Wake Island in the central Pacific Ocean, United States Minor Outlying Islands (to USA). It was not uncommon before the Second World War, but was presumably eaten to extinction by the starving Japanese garrison between 1942 and 1945.

Bar-winged Rail
Nesocolpeus poecilopterus

it's known from twelve 19th-century specimens from Vitu Levu and Ovalau, and from reports from Taveuni and, in 1973, from Waisa, Vitu Levu, Fiji. However, two other (non-endemic) rails have become extinct in the islands due to predation by introduced mongooses and cats, so it seems very likely that *N. poecilopterus* is also now extinct.

White Gallinule
Porphyrio albus

it's known from two skins (in Liverpool and Vienna), several paintings and some subfossil bones from Lord Howe Island, Australia. Although not uncommon when discovered in 1790, the species was rapidly hunted to extinction by whalers and sailors, and had probably already vanished by the time the island was colonised in 1834.

Réunion Gallinule
Porphyrio coerulescens

it's endemic to Réunion (to France), from where it was described as *oiseau bleu* by six early travellers. It was probably not flightless, but was nevertheless easily hunted, and this presumably lead to its extinction by around 1730.

North Island Takahe
Porphyrio hochstetteri

it's flightless and endemic to the North Island, New Zealand, from where it is known from subfossil remains from a number of archeological sites and from one possible late 19th-century record. The decline of the species has generally been attributed to the increasing incursion of forest into the alpine grasslands through the Holocene epoch, although hunting by the Maori probably also played a role.

New Caledonia Gallinule
Porphyrio kukwiedei

it's known only from subfossil remains from New Caledonia (to France). However, a passage from Verreaux and des Murs written in 1860 notes the presence of birds the size of turkeys in marshy areas, so it is possible that the species survived into the 17th century.

St Helena Rail
Porzana astrictocarpus

it's only known from fossils from St Helena (to UK). It was driven to extinction by introduced predators soon after the island was discovered in 1502.

Kosrae Crake
Porzana monasa

was endemic to coastal swamps and marshes, taro patches and 'continually wet, shadowy places in the forest' on Kosrae, Caroline Islands, Federated States of Micronesia. Kittlitz collected the only two known specimens (now in St Petersburg) in 1827–1828, and regarded the species as uncommon even then. It declined to extinction over the next half-century following the arrival of rats from missionary and whaling ships in the 1830s and 1840s. Measurements of the carpometacarpii from X-rays of the two specimens suggest that the species was flightless.

Miller's Rail
Porzana nigra

it's known from two illustrations, one by Forster from Tahiti, French Polynesia, from Cook's second voyage (1772–1775), and the other by Miller from 1784, and by subsequent descriptions by Latham and Gmelin. It presumably became extinct soon after.

Laysan Rail
Porzana palmeri

it's found in grass tussocks and thickets on Laysan Island, Hawaii, USA, where it became extinct between 1923 and 1936 as a result of habitat destruction by rabbits and guinea pigs introduced by guano diggers. A similar bird was seen by Kittlitz on nearby Lisianski Island. Birds were introduced to Pearl and Hermes Reef and to Eastern Island in the Midway Atoll in 1891 and 1913, and from there to Sand Island in 1910, with failed re-introductions also reportedly attempted to Lisianski, Laysan and the main Hawaiian group. However, the Pearl and Hermes Reef colony was destroyed by storms in 1930, and rats, brought in by wartime activities, exterminated the Sand Island colony in 1943 and the Eastern Island colony in 1944.

Hawaiian Rail
Porzana sandwichensis

it's inhabited clearings in upland forest on the east side of Hawaii, USA, and may also have also occurred on Molokai. It is known from bones and a number of specimens, and was illustrated by Ellis on Cook's third voyage in 1777. The last specimen was collected in 1864, and the last report was in 1884 (or possibly 1893). This makes the suggestion that the species' extinction was caused by mongooses unlikely, as they were not introduced until 1883. More probably, it was due to a long process of predation by rats, cats, dogs and people.

Canary Islands Oystercatcher
Haematopus meadewaldoi

it's endemic to Fuerteventura, Lanzarote, and its offshore islets in the Canary Islands, Spain. It was last collected in 1913 and locally reported to have become extinct by the 1940s. It is now considered extinct because extensive surveys in the mid-1980s failed to find any evidence of its survival, despite four convincing reports (two from Tenerife and two from Senegal) between 1968 and 1981. Its decline was probably a result of overharvesting of intertidal invertebrates and disturbance by people, although predation by rats and cats has also been implicated.

White-winged Sandpiper
Prosobonia ellisi

it's known only from two paintings (both in London), by Ellis and Webber, each based on a specimen (both now lost) collected by Anderson on Moorea, in the Society Islands, French Polynesia, during Cook's third voyage in 1777. Like the Tahitian Sandpiper P. leucoptera, it presumably lived along streams and was driven to extinction by introduced rats in the late 18th century.

Tahitian Sandpiper
Prosobonia leucoptera

was endemic to Tahiti, in the Society Islands, French Polynesia. It is known from the type only, collected by Forster and painted by his son in 1773. The specimen is now in Leiden and the painting is in London. All that is known of the species' ecology is that Forster noted that the birds occurred along highland streams. Its extinction was probably caused by introduced rats.

Great Auk
Pinguinus impennis

it's occurred in naturally scattered colonies across the North Atlantic until the 19th century, breeding from Canada through Greenland (to Denmark), the Faeroe Islands (to Denmark) and Iceland to Ireland and the UK, with archeological records from the western coast of Europe from European Russia south to France; it wintered offshore south to New England, USA, and southern Spain. Details of how it was driven to extinction by hunting for its feathers, meat, fat and oil are well known. As the species became more scarce, specimen collecting became the proximate cause of its extinction. The last-known pair was killed on Eldey Island, Iceland, in 1844, and the last live bird was seen off the Newfoundland Banks in 1852. Historically, the birds bred only on remote, rocky islands, probably due to early extirpation in more accessible sites. They were flightless. Immatures probably fed on plankton, while adults dived for fish.

Rodrigues Solitaire
Pezophaps solitari

it's endemic to Rodrigues, Mauritius, from where it is known from numerous historical accounts, with those of Leguat in 1708 providing particularly rich detail, and many bones. The birds were heavily hunted and predated by introduced cats, and were very rare by 1755, when Cossigny tried to obtain one without success, but was told that the species did still survive. It was definitely extinct by the 1760s.

Dodo
Raphus cucullatus

it's known from numerous bones, specimen fragments, reports and paintings from Mauritius. It was mainly a species of the dry lowland forests, although possible mutualism with the upland Tambalacoque Tree *(now Sideroxylon grandiflorum?)* Calvaria major suggests that it may have ranged into the hills. The species was flightless, tame and very heavily hunted for food, and was last reported from an offshore islet by Iversen in 1662. All references to 'dodos' thereafter refer to the Red Rail *Aphanapteryx bonasia*.

Mauritius Blue-pigeon
Alectroenas nitidissima

it's known only from three skins and a number of descriptions and paintings, from Mauritius. It was first described by Harmansz in 1602, and persisted for more than two centuries thereafter. Milbert, writing in 1812, noted that he ate many in 1801, and Desjardins reported in 1832 that the birds were 'still found towards the centre of the island in the middle of those fine forests which by their remoteness, have escaped the devestating axe'. The last specimen was collected in 1826, however, and hunting and habitat loss presumably caused the species' extinction in the 1830s.

Rodrigues Blue-pigeon
Alectroenas rodericana

it's known from subfossil bones from Rodrigues, Mauritius, and descriptions from Leguat in 1708 and from Tafforet in 1726. It presumably became extinct in the first half of the 18th century, possibly due to the depredations of introduced rats.

Réunion Pigeon
Columba duboisi

it's based on Dubois' 1674 description of rusty-red pigeons from Réunion (to France).

Ryukyu Pigeon
Columba jouyi

it's endemic to Okinawa and Kerama, and the Daito Islands, in the Nansei Shoto Islands, Japan. It was described in 1887 from a type in the Tokyo Educational Museum, and is also known from three skins in Tring. It apparently declined rapidly (and inexplicably), and was last recorded on Okinawa in 1904, and on Daito in 1936.

Bonin Wood-pigeon
Columba versicolor

it's endemic to Nakondo Shima and Peel Island (Chichi-juma) in the Bonin Islands (Ogasawarashoto), Japan. It is known from four specimens, in Frankfurt, Leningrad and Tring. It

was last recorded in 1889, with its extinction presumably resulting from clearance of the islands' subtropical evergreen forest, and from predation by introduced cats and rats. The Japanese Wood-pigeon *C. janthina* has also become extinct in the Bonin Islands, and on Kita-iwojima and Iwo-jima immediately to the south, although it survives on other offshore Japanese islands.

St Helena Dove
Dysmoropelia dekarchiskos

it's known only from fossil remains from St Helena (to UK), where it presumably became extinct following the island's colonisation in 1502.

Passenger Pigeon
Ectopistes migratorius

it's found in forests in eastern and central Canada and the USA, occasionally wandering south to Mexico and Cuba. Over the 19th century, the species crashed from being one of the most abundant birds in the world to extinction. This was ultimately due to the effects of widespread clearance of its mast food, with the proximate causes being Newcastle disease, extensive hunting and the breakdown of social facilitation. The last wild bird was shot in 1900, and the last captive bird died in 1914 in the Cincinnati Zoo.

Tanna Ground-dove
Gallicolumba ferruginea

it's known only from Forster's 1774 painting, from Tanna Island, Vanuatu, in Tring.

Norfolk Island Ground-dove
Gallicolumba norfolciensis,

from Norfolk Island (to Australia), was painted by Hunter in 1790 and described by Latham in 1801 based on this and on correspondence from 1788–1790. Subfossil remains have subsequently been found and referred to this species. It presumably became extinct in about 1800, due to over-hunting and predation by introduced cats and rats.

Choiseul Pigeon
Microgoura meeki

it's endemic to Choiseul, Solomon Islands, from where it is known from six skins and a single egg. It has not been recorded since 1904 despite searching and interviews with villagers. Its extinction was presumably caused by predation by feral dogs and cats, as suitable habitat survives on the island.

Red-moustached Fruit-dove
Ptilinopus mercierii

it's endemic to forest in the Marquesas, French Polynesia, with the nominate subspecies on Nuku Hiva and subspecies *tristrami* on Hiva Oa. While the former is only known from the type collected during the 1836–1839 voyage of the *Venus*, the latter is known from at least 11 specimens, the last collected by the Whitney Expedition in 1922. The species was reported on Hiva Oa in 1980, but this was probably a mistake. Its extinction has been attributed to predation by the introduced Great Horned Owl *Bubo virginianus*, as well as by introduced rats and cats.

Liverpool Pigeon
Caloenas maculata

it's known only from one surviving specimen in the Merseyside County Museums, and one lost specimen, collected between 1783 and 1823. The provenance of the specimens is unknown, but it seems most likely to have been a Pacific species, given the main area of activity of its collectors. Its short, rounded wings suggest that it evolved on a small, predator-free island. It was possibly the bird described by the people of Tahiti in 1928 as being speckled green and white. It is likely to have been almost extinct before European exploration of the Pacific began. Nothing is known about it, although given its colouration it is likely to have been a forest dweller.

Martinique Amazon
Amazona martinicana

it's described from Martinique (to France) by Labat in 1742, and by Buffon in 1779, and named by Clark based on these descriptions. Labat wrote that 'the parrot is too common a bird for me to stop to give a description of it', so the species must have declined very rapidly to extinction in the latter half of the 18th century.

Guadeloupe Amazon
Amazona violacea,

it's not known from any specimens, was described in detail from Guadeloupe (to France) by, among others, Du Tertre in 1654 and 1667, Labat in 1742 and Brisson in 1760. It was named by Gmelin in 1789. It was heavily hunted and noted by Buffon in 1779 to be very rare, and presumably became extinct soon after.

Dominican Green-and-Yellow Macaw
Ara atwoodi

it's known only from the writings of Atwood in 1791, and was endemic to Dominica. Atwood notes that the birds were captured both for food and to be kept as pets, and presumably this persecution led to their extinction in the late 18th or early 19th century.

Jamaican Green-and-Yellow Macaw
Ara erythrocephala

it's described by Gosse in 1847 as occurring in the mountains of Trelawny and St Anne's, Jamaica, based on a bird 'procured by Mr White, proprietor of the Oxford Estate'. It was presumably hunted to extinction in the early 19th century.

Jamaican Red Macaw
Ara gossei

is known only from the work of Gosse in 1847 based on a 'specimen shot about 1765, by Mr Odell' in the mountains of Hanover Parish, about 16 kilometres east of Lucea, Jamaica. It was presumably hunted to extinction at around the end of the 18th century.

Lesser Antillean Macaw
Ara guadeloupensis

was described in detail by Du Tertre in 1654 and 1677, and by Labat in 1742, among others, but no specimens exist. It was endemic to Guadeloupe (to France) and Martinique (to France). The species was heavily hunted and trapped and was rare by 1760, and presumably became extinct soon after.

Cuban Macaw
Ara tricolor

it's endemic to the Isle of Pines and mainland Cuba, and probably also Hispaniola (Haiti and the Dominican Republic). Its extinction was caused by hunting for food and felling of nesting trees to capture young birds to be kept as pets. The last specimen was collected in 1864, and the last reports were in 1885. At least 19 specimens exist. Cuban Macaws are known from numerous historical accounts from Hispaniola, but all specimens are now apparently lost. Ritter, writing in 1836, was the last to record the species, in 1820. Presumably, it was hunted to extinction in the early 19th century.

Guadeloupe Parakeet
Aratinga labati

is not known from any specimens, but

was well described by Labat in 1724 from Guadeloupe (to France). Little is known about the species, but it must have declined to extinction through hunting in the second half of the 18th century.

Carolina Parakeet
Conuropsis carolinensis

it's endemic to the eastern USA, with the nominate race ranging from Florida to Virginia, and ludovicianus through the Mississippi–Missouri drainage. The birds were wide ranging, but their typical habitat was cypress and sycamore trees along rivers and swamps. They were still common at the beginning of the 19th century, but in 1832 Audubon noted their decline, which followed increasing human settlement moving inland from the east. The last specimens were collected by Chapman near Lake Okeechobee, Florida, in 1904 (although rumours of the species' survival persisted into the 1930s). The last captive bird died in the Cincinnati Zoo in 1918. The main causes of the species' extinction were persecution (for food, crop protection, aviculture and the millinery trade), and deforestation (especially of the bottomlands); they were probably compounded by its gregariousness, and by competition with introduced bees.

Raiatea Parakeet
Cyanoramphus ulietanus

it's only known from two specimens from Raiatea, French Polynesia, collected on Cook's voyage in 1773, and now in Vienna and Tring. It was presumably a forest species, as this was the native vegetation of all of the Society Islands. Its extinction was probably the result of the subsequent clearance of this vegetation, hunting or predation by introduced species.

Black-fronted Parakeet
Cyanoramphus zealandicus

it's known from Tahiti, French Polynesia, from three specimens (two of which are now in Liverpool and one in Tring) collected on Cook's voyage in 1773, a fourth collected by de Marolles in 1844, now in Paris, and a fifth collected by Amadis in 1842, now in Perpignan. Like the Raiatea Parakeet *C. ulietanus*, the species was presumably a forest bird. Its demise could have resulted from habitat loss, hunting or predation by introduced species.

Mauritius Grey Parrot
Lophopsittacus bensoni

it's described from a lower mandible, palatine and tarsometatarsus found in caves near Port Louis, Mauritius, and was almost certainly the small grey parrot described by numerous early writers. In 1764, Cossigny noted that 'the woods are full of parrots, either completely grey or completely green. One used to eat them a lot formerly, the grey especially...', but this was the last mention of the species, and presumably it declined rapidly to extinction through overhunting. There are also a number of reports of small grey parrots from Réunion that probably refer to this or a closely related species.

Broad-billed Parrot
Lophopsittacus mauritianus

it's known from numerous bones and travellers' reports and sketches from Mauritius. The birds were large and were poor fliers (but not flightless), and were consequently heavily hunted. Hoffman, writing in 1680 based on observations in 1673–1675, gave the last definite reports of the species.

Mascarene Parrot
Mascarinus mascarinus

it's described by numerous early travellers to Réunion (to France), and several captive birds were shipped to France in the late 18th century. The last accounts of wild birds were from the 1770s, and the species was not mentioned by Bory writing in 1804, so it may well have been hunted to extinction in the wild by then. The captive birds in Paris had also died by this time – three stuffed specimens remained – but a single bird survived in the King of Bavaria's menagerie until at least 1834. Two specimens survive today.

Rodrigues Parrot
Necropsittacus rodericanus

it's known from Rodrigues, Mauritius, from several early travellers' reports and a number of subfossil bones. Pingré wrote the last report in 1763 based on observations from 1761, and the species was presumably hunted to extinction soon after.

Norfolk Island Kaka
Nestor productus

it's inhabited rocks and treetops on Norfolk Island (to Australia) and adjacent Phillip Island. It was reportedly

tame, and hence heavily hunted for food by convicts and early settlers, and easily trapped to be kept as a pet, leading to its extinction in the wild in the early 19th century. The last recorded living bird was in captivity in London in 1851.

Paradise Parrot
Psephotus pulcherrimus

was found in open savanna woodland and shrubby grassland in central and southern (and possibly northern) Queensland, and northern New South Wales, Australia. The species was locally common although generally scarce in the 19th century, but then declined rapidly and was thought to have become extinct as a result of the drought of 1902 until it was rediscovered in 1918. The last confirmed record was in 1927 and, although Kiernan claims to have seen five birds in 1990, the species is considered extinct. Its decline was probably caused by a reduction of its food supply (native grass seeds) due to drought, overgrazing, altered fire frequencies and the spread of prickly pears, with disease, trapping, egg collecting, predation of nests by introduced and native species, and clearance of eucalypts by ringbarking also contributing.

Newton's Parakeet
Psittacula exsul

Leguat in 1691, but Pingré noted that it was scarce by 1761, and the last record was a bird collected in 1875. Two complete specimens survive, plus various subfossil bones. The species' extinction was presumably caused by a combination of habitat loss and hunting.

Seychelles Parakeet
Psittacula wardi

it's endemic to Mahé and Silhouette, Seychelles, with a sight record from Praslin. It was already rare when described in 1867. The last specimens were collected by Warry in 1881, and the last birds were recorded in captivity (on Silhouette) in 1883. The species was extinct by 1906 when Nicoll visited the islands. Clearance of forest for coconut plantations, and shooting and trapping (in particular to protect maize crops), were the main causes of the species' demise. At least ten specimens exist.

Snail-eating Coua
Coua delalandei

it's known from 13 specimens, all

apparently collected on Ile de Sainte-Marie (Nosy Boraha), Madagascar, with the most recent one dating from 1834. Reports from 1930 are unfounded, and it is now considered extinct. It was a terrestrial species of primary rainforest, and the complete deforestation of Ile de Sainte-Marie was presumably the ultimate cause of its extinction. Snaring for feathers and food, and predation by introduced rats, may also have contributed to the species' demise.

St Helena Cuckoo
Nannococcyx psix

it's described from St Helena (to UK) from a single fragment of a humerus. It was presumably a small forest cuckoo, which would account for its scarcity in the fossil record, and would explain its extinction as having occurred as a result of the deforestation of the island in the 18th century.

Réunion Owl
Mascarenotus grucheti

it's only known from fossils found on Réunion (to France), and presumably became extinct soon after the island's colonisation in the early 17th century.

Rodrigues Owl
Mascarenotus murivorus

it's described by a number of early travellers (with the last being Tafforet in 1726) as endemic to Rodrigues, Mauritius. The reports have been corroborated by the discovery of a number of bones, but the species has only recently been assigned to a genus.

Mauritius Owl
Mascarenotus sauzieri

it's only known from subfossil bones from Mauritius, and was described and sketched by a number of early travellers. Desjardins reported that it was fairly common in the island's woods even as late as the 1830s, but his 1837 reports were the last, and Clark specifically wrote that it was extinct in 1859.

Laughing Owl
Sceloglaux albifacies

it's endemic to New Zealand, with the nominate race on the South and Stewart Islands (with bones known from the Chatham Islands), and the subspecies *rufifacies* on the North Island. The species roosted and nested among rocks in open country and at forest edges. It was not uncommon until the first half of the 19th century,

but was becoming rare by the 1840s. The last specimens of *rufifacies* were collected in 1889 (with reports until the 1930s), and of *albifacies* in 1914 (with reports until the 1960s). The reasons for the species' extinction are obscure, but were possibly the result of habitat modification through grazing or burning, or predation by introduced rats.

Brace's Emerald
Chlorostilbon bracei

it's known only from the type, described in 1877 by Lawrence, from New Providence, Bahamas, although fossil hummingbird bones found on the island are probably also referable to this species. The cause of its extinction is unknown, but is presumably due to some kind of human disturbance.

Gould's Emerald
Chlorostilbon elegans,

it's described from a single specimen (in Tring) by Gould in 1860, was recently shown by Weller to be a valid species, presumably extinct, and possibly (by inference) from Jamaica or the north Bahamas.

St Helena Hoopoe
Upupa antaios

it's a giant, flightless hoopoe, endemic to St Helena (to UK). It is known only from bones and the causes of its extinction are unknown, but presumably it was hunted to extinction by people and introduced predators soon after the discovery of the island in 1502.

Bush Wren
Xenicus longipes

it's endemic to the three main islands of New Zealand, with **variabilis** of Stewart Island last recorded in 1965, **stokesi** of the North Island in 1949 and the nominate race of the South Island in 1972. On the mainland it was a species of dense montane forest, while on offshore islands it was found in coastal forest and scrub. Its decline was presumably caused by introduced predators, to which it was particularly vulnerable, being a ground-nester.

Stephens Island Wren
Traversia lyalli

it's only known from recent times from Stephens Island, New Zealand, although it is common in fossil deposits from both of the main islands. The species was flightless and restricted

to rocky ground. Construction of a lighthouse on Stephens Island in 1894 led to the clearance of most of the island's forest, and predation by the lighthouse keeper's cat delivered the coup de grâce to the species.

'Amaui
Myadestes oahensis

it's known only from the type, collected on Oahu, in Hawaii, USA, by Bloxam in 1825, at which time he reported that the form was common in forest. The specimen was lost, and subsequently relocated in Tring. Fossil remains have also been collected on the island. The cause of the species' extinction is unknown.

Grand Cayman Thrush
Turdus ravidus

it's known from four collections (21 specimens in total) from Grand Cayman, Cayman Islands (to UK). Its habitat was dense, 'knife-edged coral-rock, swamp, and mangroves, with patches here and there of the poisonous manchineel tree and of climbing cactus', and it presumably declined as the island's habitat was progressively cleared. The last specimens were collected (by Brown) in 1916, and the last sight record (by Lewis) was in 1938.

Bonin Thrush
Zoothera terrestris

it's only known from four specimens (now in Frankfurt, St Petersburg, Leiden and Vienna) collected in 1828 on Ogasawara-shoto (Peel Island, Bonin), Japan. It could not be found when the island was next visited by an ornithologist, in 1889, nor subsequently. Nothing is known of the species' ecology or extinction. Presumably it was confined to the forest floor, and was driven to extinction by introduced rats and cats.

Chatham Fernbird
Bowdleria rufescens

it's endemic to the low brushland of Pitt and Mangere Islands in the Chatham Islands, New Zealand. It was last recorded in 1900, presumably declining to extinction due to habitat loss caused by burning and overgrazing by introduced goats and rabbits, and to predation by cats.

Aldabra Warbler
Nesillas aldabrana

it's endemic to dense coastal vegetation on Ile Malabar, Aldabra, Seychelles. The species was only discovered in 1967, and the last records were in 1983. Intensive searches in 1986 confirmed that the species was extinct, probably as a result of rat predation and degradation of its habitat by tortoises and goats.

Lord Howe Gerygone
Gerygone insularis

it's an abundant endemic to the forests of Lord Howe Island, Australia, until the island was colonised by rats from a shipwreck in 1918. It could not be found on a visit in 1936, and there are no subsequent records. Presumably its extinction resulted from nest predation by the rats.

Guam Flycatcher
Myiagra freycineti

it's endemic to Guam (to USA), where it was common in forests until the 1970s. However, it plummeted to extinction in 1983, along with most of the island's native birds, due to the depredations of the introduced Brown Tree Snake *Boiga irregularis*.

Maupiti Monarch
Pomarea pomarea

it's known only from the type, collected on Maupiti, Society Islands, French Polynesia, by Blosseville in 1823. It presumably became extinct soon after, because it has not been recorded since. The Society Islands have lost most of their original vegetation and their avifauna has suffered greatly through competition and predation from introduced species, and it is not conspecific with the Tahiti Monarch *P. nigra*.

South Island Piopio
Turnagra capensis,

it's according to Buller, was common until 1863 in forest undergrowth on the South Island, New Zealand, from where it is known from numerous specimens. However, the species declined very rapidly in the 1880s, probably mainly due to predation by introduced rats, and the last sight record was from 1963.

North Island Piopio
Turnagra tanagra

it's endemic to the North Island, New Zealand. Buller described it as common in the 1870s, but few specimens were ever collected (specimens are only known to exist in Chicago, Tring, Philadelphia and Wellington), the last

being from 1900. Occasional sight records persisted until 1955. Presumably both habitat destruction and direct predation by people, cats and rats caused the species' extinction.

Robust White-eye
Zosterops strenuus

it's endemic to lowland forests on Lord Howe Island, Australia. It was common before 1918, but plummeted to extinction following the arrival of the Black Rat *Rattus rattus* on the island in that year.

Chatham Bellbird
Anthornis melanocephala

it's endemic to forest on Chatham, Mangere and Little Mangere Islands, New Zealand. The reasons for its decline are obscure, but were probably a combination of habitat destruction and predation by introduced rats and cats, despite the fact that Little Mangere – from where the last records came in 1906 – had neither predators nor extensive forest.

Kioea
Chaetoptila angustipluma

it's known historically only from the big island of Hawaii, USA, although fossil remains are also known from Oahu and Maui. It was restricted to montane plateau forest, and only four specimens were ever collected, between 1840 and 1859.

O'ahu 'O'o
Moho apicalis

it's restricted to forest on Oahu, Hawaii, USA. It is known from only about seven specimens, the last three of which were collected by Deppe in the hills behind Honolulu in 1837. Its extinction was presumably caused by a combination of habitat destruction and the introduction of disease-carrying mosquitoes.

Bishop's 'O'o
Moho bishopi

it's endemic to forest in the Hawaiian Islands, USA. It was last recorded on Molokai in 1904 by Munro, who received local reports of its survival until 1915, but could find no more birds despite numerous further searches up until 1949. There is very little historical information about its occurrence on Maui, and although a single bird believed to be this species was observed in 1981 on the northeast slope of Haleakala, there

been no further confirmed records despite intensive searching. Habitat destruction caused by conversion to agriculture and grazing by feral mammals inevitably initiated the species' decline, with the introduced Black Rat *Rattus rattus* and the spread of disease carried by introduced mosquitoes blamed for the population crash early in the 20th century.

Kaua'i 'O'o
Moho braccatus

it's endemic to Kauai, Hawaii, USA. It was common in forests from sea level to the highest elevations in the 1890s, but declined drastically during the early 20th century. By the 1970s, it was confined to the Alakai Wilderness Preserve. In 1981, a single pair remained, the female of which was not found after Hurricane Iwa in 1982, the male being last seen in 1985. The last report, of vocalisations only, was in 1987, and the species has not been recorded during subsequent surveys of Alakai. Habitat destruction and the introduction of the Black Rat *Rattus rattus*, pigs and disease-carrying mosquitoes to the lowlands were the probable causes of this species' extinction.

Hawai'i 'O'o
Moho nobilis

it's only found in forest on the big island of Hawaii, USA. It was last collected in 1898 and last seen in 1934. Its decline to extinction was presumably caused by both habitat destruction and disease.

Greater Amakihi
Hemignathus sagittirostris

was only found along the Wailuku River above Hilo on Hawaii, USA. It was discovered in 1892, and last recorded in 1901. It was restricted to dense, moist ohia forest at 152–1,220 metres. This forest was cleared for sugar cane, causing the species' extinction

Lesser Akialoa
Hemignathus obscurus

it's endemic to Hawaii, USA. It was apparently not uncommon until 1895, but declined rapidly, with the last report being in 1940. It inhabited mountain koa-ohia forest (500–2,000 metres). Its extinction was probably the result of deforestation and introduced disease-carrying mosquitoes, which are prevalent in the lowlands

Greater Akialoa
Hemignathus ellisiana
it's forms a complex of three subspecies, all of which are now considered extinct. The nominate form *ellisiana* was endemic to the mountains of Oahu, Hawaii, USA. It is known from only two specimens collected in 1837, although there were undocumented reports in 1937 and 1940. The subspecies *lanaiensis* was found on Lanai, Hawaii. It is known from only three specimens, collected in 1892. In addition, fossil material allied to this taxon has been found on Molokai and Maui. The subspecies *stejnegeri* was found on Kauai, Hawaii. It survived for the longest of any of the three subspecies, in Kauai's Alakai Wilderness Preserve, but has not been recorded since 1969. It inhabited montane koa-ohia forest. All three subspecies are thought to have been driven to extinction by habitat destruction and disease.

Ula-'Ai-Hawane
Ciridops anna
it's endemic to ohia and loulu palm *Pritchardia* forest on both the windward (Hilo District and the Kohala mountains) and leeward (Kona District) sides of Hawaii, USA. It is only known from five specimens, in Harvard, Honolulu, New York and Tring (the latter has two), with a possible sight record in 1937, although fossils of the genus have been found on Kauai, Molokai and Oahu. The last specimen was collected in 1892. Nothing is known about the causes of its extinction.

Black Mamo
Drepanis funerea
it's only ever seen in forest understorey on Molokai, Hawaii, USA, although fossils are known from the adjacent Maui. The species was last collected in 1907, and intensive searches in the subsequent few decades could find no sign of it. Its extinction was probably largely caused by the destruction of its understorey habitat by introduced cattle and deer, and by predation by rats and mongooses.

Hawai'i Mamo
Drepanis pacifica
it's endemic to forest (especially ohia forest) on the big island of Hawaii, USA, and was last recorded in 1898 above Hilo and in 1899 near Kaunana. It was heavily trapped by Hawaiians for its

feathers, but it is more likely that habitat destruction and disease were the ultimate causes of the species' extinction.

Lana'i Hookbill
Dysmorodrepanis
munroi is known from only a single specimen collected in 1913, and from single sightings in 1916 and 1918, all in montane dry forest at 600–800 metres on Lanai, Hawaii, USA. Much of Lanai was cleared for pineapple plantations in the 1910s, and this, along with predation by cats and rats, presumably drove the species to extinction.

Kakawahie
Paroreomyza flammea
it's endemic to forest above 500 metres on Molokai, Hawaii, USA. It was common in the 1890s, but became extinct over the first half of the 20th century, presumably due to habitat destruction and disease. The last record was in the Kamakou Preserve in 1963.

Kona Grosbeak
Psittirostra kona
it's endemic to naio forest on lava flows at 1,000–1,800 metres on Hawaii, USA. The species was already very rare when discovered, being restricted to only about 10 square kilometres, and was last collected in 1894. The reasons for its extinction are unknown. The genus is known from fossils from Kauai, Oahu and Maui.

Lesser Koa-finch
Rhodacanthis flaviceps
it's probably very rare when discovered, and is known from only a handful of skins (now in New York and London) from mountain koa forest in Kona, Hawaii, USA. It was discovered – and last recorded – in 1891. The cause of its extinction is unknown. This or a similar species is also known from the fossil record of Oahu and Maui.

Greater Koa-finch
Rhodacanthis palmeri
it's endemic to koa forest above 1,000 metres on Hawaii, USA. It was considered common by Palmer, Munro and Perkins in the late 19th century, but the latter's specimens from 1896 were the last, and even only ten years later it could not be found by Henshaw. Specimens

survive in Cambridge, Harvard, London, New York and Philadelphia.

Greater 'Amakihi
Viridonia sagittirostris
it's restricted to dense, moist forest along the Wailuku River above Hilo on Hawaii, USA. This forest was cleared for sugar cane, causing the species' extinction. It was discovered in 1892, and last recorded in 1901.

Slender-billed Grackle
Quiscalus palustris
had a small distribution in the Lerma marshlands, in the state of Mexico, Mexico, and probably also in Xochimilco in the Valley of Mexico. It was last recorded in 1910, and presumably became extinct soon after as a result of the draining of its tule-cattail and sedge habitat.

Bonin Grosbeak
Chaunoproctus ferreorostris
it's only known from specimens collected in 1827 and 1828 on Chichi-jima, Ogasawara-shoto (Peel Island, Bonin), Japan. It could not be found on Peel by Simpson in 1854, but may have survived until 1890, when it was reported to Holst by locals. Nothing is known of its ecology apart from Kittlitz's description: 'this bird lives on Bonin-sima, alone or in pairs, in the forest near the coast. It is not common but likes to hide, although of a phlegmatic nature and not shy. Usually it is seen running on the ground, only seldom high in the trees.' It seems likely, therefore, that its extinction was the result of the deforestation of the islands, and the introduction of cats and rats.

Kosrae Starling
Aplonis corvina
it's endemic to the mountain forests of Kosrae, Caroline Islands, Federated States of Micronesia. It is only known from two specimens, both collected by Kittlitz in 1828, and both now in St Petersburg. It was extinct by the time that Finsch visited the island in 1880, presumably as a result of depredation by introduced rats, which are abundant on the island.

Norfolk Starling
Aplonis fusca
it's endemic to Norfolk Island (to Australia) and Lord Howe Island, Australia. On Lord Howe Island, the population of the subspecies hulliana tumbled to extinction from numbering

thousands in 1913–1915 – it was not seen after 1918, probably due to the arrival of the Black Rat **Rattus rattus** on the island in that year. The extinction of the nominate subspecies on Norfolk Island, last recorded in 1923, is more puzzling, because R. rattus did not reach the island until the 1940s. It may have been a result of habitat destruction.

Mysterious Starling
Aplonis mavornata
it's known only from the type specimen, collected on Mauke, Cook Islands, by Bloxam in 1825 (not on Cook's voyages). The island was not visited by ornithologists until nearly 150 years after Bloxam's collection, by which time the species had become extinct, presumably as a result of predation by introduced rats.

Réunion Starling
Fregilupus varius
it's endemic to Réunion (to France). It was described by most visitors to the island from 1669 onwards, and was apparently common as late as the 1830s. However, the last specimen was shot in 1837, and the species became extinct between 1850 and 1860, possibly due to an introduced disease, combined with changing population pressure due to the emancipation of slaves in 1848, forest fires, drought and deforestation. Nineteen specimens survive.

Rodrigues Starling
Necropsar rodericanus
it's known only from bones from Rodrigues, Mauritius, which are presumably referable to the birds ('*Testudophaga bicolor*') described by Tafforet from Ile du Mât in 1726. The reason for its extinction is unknown.

Huia
Heteralocha acutirostris
it's endemic to the southern portion of the North Island, New Zealand. It was intensively studied by Buller in the second half of the 19th century, and is known from numerous specimens, but declined to extinction at around the turn of the century, with the last confirmed record being in 1907. The cause of its extinction is unclear, but it was probably primarily due to habitat loss, especially of dead trees on which it depended for extracting beetle larvae, possibly along with hunting and disease.

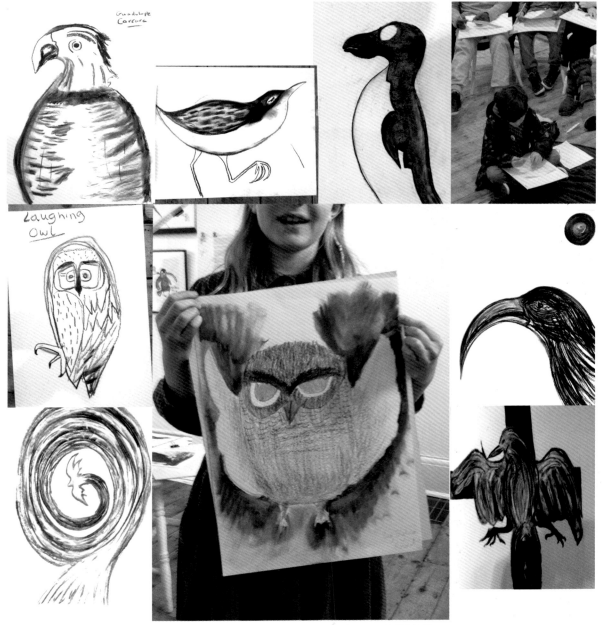

GHOSTS/ONCA ART WORKSHOP – BRIGHTON, JANUARY 2013

So there you have it – the facts we gave the *Ghosts* artists to inspire them for the task ahead.

For some artists it was sufficient just to find a strange, eye-catching name and launch into creating a portrait from that. For others, the Ghosts list was just a starting point for them to go deeper into the life story of their selected species, to do their own detailed research and explore the ghost life of their Gone Bird.

It's a simple, shocking list. But it's all you need to inspire a classroom of students to start recreating their own versions of the Ghosts stories – and if they do they'll be in good company. Ghosts is a living project so get in touch with us if you want to help us take it forward and raise an even bigger creative army for conservation.

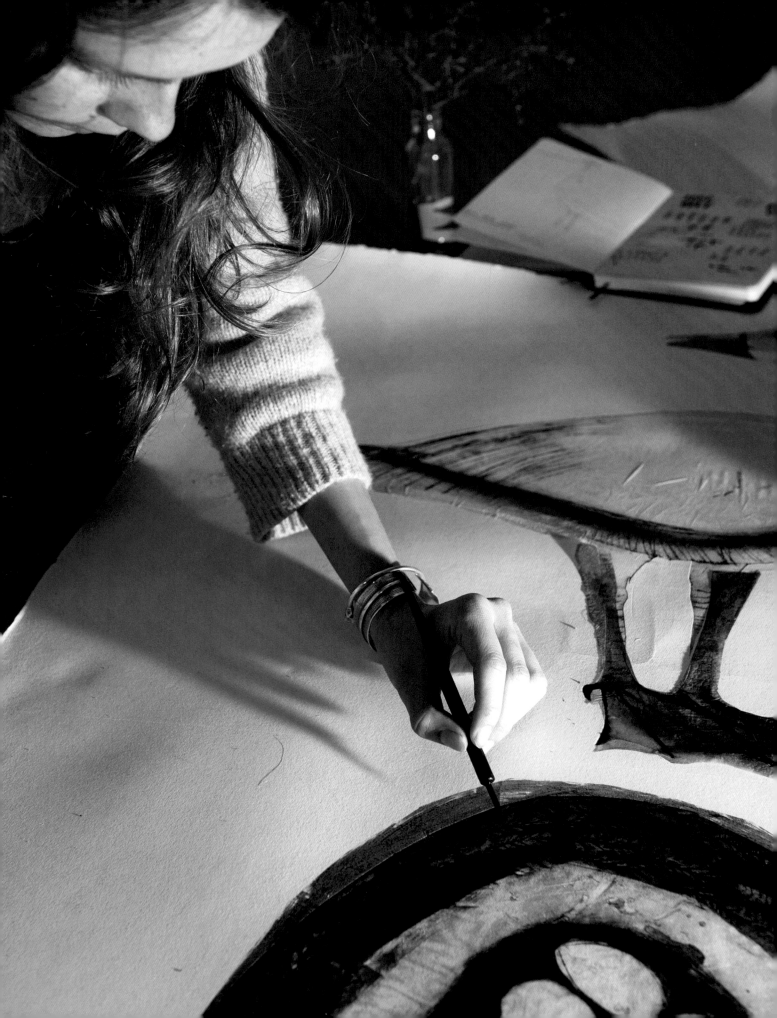

Appendix (2)

The creative army

Now that you know all the *Ghosts* birds, we'd like to take this opportunity to tell you a little more about the artists and writers who restored them to such splendid creative life. They're a diverse group – and from the start that's what we wanted.

A collection of creative talent as dazzlingly different as the birds we were asking them to resurrect – that was our brief. Keep it different, interesting and unexpected. A *Ghosts* show should never have a predictable line-up. We should be prepared to mix it up. Hang the famous alongside the just starting out. Put traditional and familiar wildlife artists canvas to canvas with the contemporary and urban and experimental. Dissolve the hierarchies, nationalities and regionalities. Do away with the genre tags and style labels. Just present an incredibly talented group of artists focusing their talents on one simple act of storytelling.

So here it is, as of 9 a.m. on Monday, 4 February 2013: the *Ghosts of Gone Birds* creative army.

(We list the artists alphabetically by first name, because we're the kind of project where first names are important.)

Abigail Brown

A textile artist and illustrator based in London, she uses new and used fabrics to create wonderfully detailed soft sculptures of animals. The majority of her time is spent studying the bird kingdom and bringing to life a vast array of species: to date she has made over 70, ranging from Blue Tits to Bee Eaters, Puffins to Parakeets. She crafts each piece entirely by hand using just fabric, a sewing machine, wire and stuffing. Small scraps of material are skilfully cut and layered to cover the bird's stuffed body, and then embellished with tiny hand-stitch detail to finish. Each piece is utterly unique and a labour of love.

www.abigail-brown.co.uk
abigail@abigail-brown.co.uk

Abigail Fallis

Abigail first came to public attention with her sardonic 'underwear sculptures', such as Cock Eyed Jack (2000). This framed series of men's 'Y-front' pants played on UK's 'Cool Britannia' reputation, referencing the British flag and other symbols of nationhood in stitched-on images and text. She has always been concerned with transforming surfaces and the idea of making, experimenting widely with materials ranging from silver and bronze to papier-mâché, fish skeletons and neon-lit tubing. Her works combine an unconventional beauty with subtle comments on the issues that trouble her: man's meddling with nature, mass consumerism, and environmental destruction.

afallis69@hotmail.com

Abigail Parry

Abbie has spent nearly 4 years in art-focussed education, with a BTEC in Art & Design, Foundation Studies and a BA Illustration degree.

abbieparry@live.co.uk

Abbie Stewart

The work Abbie produces is usually based around wild life with special attention to birds. She usually manages to create the pieces by using the method of paper cut-out. She usually starts off by using a photograph as reference and draws out an animal shape with detail to her liking. The whole shape is then drawn around to create a base before it is then cut out so the detail is in individual pieces. They are then traced around on the appropriate coloured card and stuck into place using double sided tape. To complete the overall presentation of the image it is then stuck onto thick card using hook and eye tape.

abbie-stewart@hotmail.co.uk

Adam Bridgland

Since graduating from the Royal College of Art in 2006, Adam has lived and worked as an artist in London, exhibiting widely in the UK, America, Europe and Asia. The British Museum, the V&A, UBS, Boeing Asia and Debbie Harry are just some of his collectors. In July 2009 he was awarded a first major public art commission by Futures Community College in Southend and Commissions East. Adam completed a second public art commission for SmartLIFE in Cambridge in November 2011.

www.adambridgland.co.uk
adam@adambridgland.co.uk

Al Murphy

Al Murphy graduated from the Liverpool School of Art in 1999 and since then has worked predominantly as a commercial illustrator but has also exhibited his work in Berlin, Australia, LA, London and New York. He is currently working on his first children's book. He lives in New York with his girlfriend Annie.

www.al-murphy.com
almurphy.tumblr.com

Alexia Claire

Alexia has had a love for being creative ever since she could hold a crayon. Her first ever drawing of a face is still on the family kitchen wall. A career in illustration and design was always the direction in which she wanted to go; Alexia graduated from De Montfort University in 2011 with a degree in Textile Design: Printed Textiles and has been designing and drawing ever since. She also has her own range of hand screen-printed and hand made products featuring prints of endangered British wildlife.

www.alexiaclaire.com

Alexandra Jako

Alex is a self-taught, contemporary illustrator and artist based in London. Her work approaches maximalism in execution and minimalism in design. Her drawings are hand-drawn predominantly using rapidograph-style technical pens and mechanical pencil on paper with average nib sizes of 0.05 - 0.1mm.

www.alexjako.com

Alex Malcolmson

Alex was born in Shetland and studied at Edinburgh College of Art. Having worked as a teacher and curator, he ran the Godfrey & Watt gallery for 25 years, and now concentrates on making box constructions and sculpture.

www.alexmalcolmson.co.uk

Alison Stolwood

Born 1983 in Colchester, currently based in Brighton, Alison is a photographic artist who uses both analogue and digital photographic technologies. Her work is based around themes of nature and landscape studies. She graduated from Falmouth College of Arts with a BA in photography in 2005, and completed an MA in Photography at the University of Brighton in 2011. Her work has been selected for awards such as The Bloomberg New Contemporaries 2011, the Catlin Guide 2012, and Fresh Faced & Wild Eyed 2012 shown at the Photographers Gallery, London.

www.alisonstolwood.com

Amber Merrick-Potter

As an MFA graduate and fine art painter Amber has a strong and varied visual arts background, having worked as a practicing artist and creative facilitator for over 8 years. She has shown work in solo and group exhibitions across the UK, and India. Amber recently completed an International Residency programme in India before joining Coventry Artspace as Artistic Coordinator.

Past explorations and research have focussed on opening up the dialogue, physical processes, history and materials of landscape and painting. Exploring and locating the paintings on the threshold, where one can see the landscape and then in the next moment be aware of the interplay of materials and surface. She researches and explores environments and landscapes though detailed research, field studies and explorations into ethnobotany, culture and myth making.

amber-merrick-potter@hotmail.co.uk

Angie Lewin

Angie graduated BA(Hons) Fine Art Printmaking from Central St Martin's in 1986. Followed by a Postgraduate in Printmaking, Camberwell School of Arts & Crafts (1986-87). She has worked as a commercial illustrator before gaining the RHS Certificate in Horticulture (1996-97) and City & Guilds Garden Design (1997-98). Angie founded St Jude's Gallery and fabrics with Simon Lewin in 2005. She is a member of the Royal Society of Painter-Printmakers, the Society of Wood Engravers and the Artworkers Guild. Working in linocut, wood engraving, lithography and screen print. Prints are developed from sketches, watercolour drawings and collages often inspired by skeletal plant forms seen against the sea and sky of the North Norfolk coast and the Scottish Highlands. In addition to her limited edition printmaking and fabric design for St. Jude's, she has also designed fabrics for Liberty and has illustrated for Penguin, Conran Octopus, Virago and Faber & Faber. Collections holding work: The London Institute, Ashmolean Museum, Victoria & Albert Museum, Aberystwyth University.

www.angielewin.co.uk

Anita Bruce

With a background in both the life sciences and textile arts, Anita explores the boundaries between the arts and science, particularly with reference to environmental change and its impact on biodiversity. She creates intricate sculptural textiles from fine copper wire, principally using hand knitting. Anita is a Member of the Society of Designer Craftsmen and been commissioned to create work for the Crafts Council. She has exhibited her 'Knitted Plankton' series in a Cabinet of Curiosities at the Courtauld Institute of Art. As a core reef contributor to the 'Hyperbolic Crochet Coral Reef' project, Anita exhibited at the Hayward Gallery and the Smithsonian Museum of Natural History in Washington DC.

www.anitabruce.co.uk
www.anitabruce.tumblr.com
textiles@anitabruce.co.uk
twitter: @nitabruce

Anna Johnson

Anna first started to get into Art and Design during her A levels and after doing a Foundation diploma in Art, went on to enter Arts University College in Bournemouth to do Illustration. She has always had a love for making art on the computer, through

Photoshop and other programs. Recently, she's been experimenting with ink drawings as well as trying to see her art work in a more medical illustration direction. At this moment she is quite inspired by Leonardo Da Vinci's medical drawings and the way in which he shades them.

anna_raspberry@hotmail.com

Anna Kirk-Smith

Anna is driven by her deep and abiding fascination for the phenomenological experience of nature. It is a realm of constant flux, strange beings and fantastic lifecycles within a rich ecological web of inter-specific interactions. She has dived, observed and drawn species underwater, created work onshore in all weathers, and compulsively collected both historic and contemporary scientific texts to interpret throughout her sci-art community experiences. Anna has also collaborated with organisations including The Wildlife Trusts, Marine Conservation Society and the RSPB, and explored ecosystem conservation and innovative ways of disseminating relevant science to public audiences using a fine art approach.

www.annakirk-smith.com
annakirk-smith@network.rca.ac.uk

Anna Selby

Anna Selby is a specialist in international poetry and is Editor of The World Record, an anthology of contemporary international poetry forthcoming from Bloodaxe, with a foreword by Simon Armitage. She was born in 1982 and has had poetry published in Magma, Smiths Knoll, The Rialto and the Cinnamon Anthology of Young British Poets. She is a graduate of the Creative Writing MA at the University of East Anglia, works as Literature and Spoken Word Co-ordinator at the Southbank Centre and is an associate artist of dance-film company, State of Flux.

Twitter: @Anna_Selby

Anna-Marie Kemplay

From an early age Anna-Marie has always had a passion for drawing and painting, which has continued and led her to study Illustration. She likes to experiment with lots of different media but has a special place in her heart for water colours and inks. She loves to use nature in her artwork, and find birds challenging and enjoyable to paint.

an-mari@hotmail.co.uk

Barbara Ana Gomez

Born in Spain in 1981, Barbara Ana studied Graphic Design and Advertising in Madrid. She moved to London in 2007 to study Illustration at the London College of Communication, where she graduated with a Distinction. She is currently a freelance Illustrator based in London, working for clients from around the world. Her technique is a mix of traditional materials such as Indian ink or acrylics, often contrasted with a hint of digital.

www.barbarana.com

Beatrice Forshall

Beatrice was born in South West France, where she spent most of her childhood. In 2003 she moved to Catalonia and in 2005

back to Britain. Beatrice is currently in her third year of illustration at Falmouth University. Ever since she was a child, she has been interested in wildlife and her work mainly revolves around animals and conservation. She finds the natural world an infinite source of inspiration.
beatricefoshall@yahoo.co.uk

Ben Hicken
Ben has always enjoyed drawing and art in general; he studied art and design at Gordano Sixth form and went onto do a foundation diploma in Weston College of Art. He is currently in his second year of studying Illustration at Swansea Metropolitan University.
Hicken22@hotmail.co.uk

Ben Springham
An aspiring illustrator and first year student at The Arts University College Bournemouth studying illustration, Ben previously studied a Level 3 BTEC National Diploma in Art and Design at Long Road Sixth Form College in Cambridge. He's inspired by the human form, the theatre, surrealism and movement.
ben-springham-94@hotmail.com

Bethmadethis aka Beth Dawson
Beth is a 30-year-old designer maker previously based in Leeds, recently relocated to Brighton. Trained and experienced in Graphic Arts and Design, her work is heavily concerned with narrative and covers a number of media, often investigating the recollected memory and lamentations of the past. She worked for 3 years as a Lecturer at Leeds College of Art before moving to Brighton to study on the full time MA Sequential Design & Illustration which she completed this September.
beth@bethmadethis.co.uk

Billy Childish
Since 1977 Billy Childish has released over 150 independent LP's, published 5 novels and over 45 collections of poetry, but his main job is painting. He has had solo and group exhibitions internationally including New York, London, Seoul and Berlin. He was included in British Art Show 5, which toured throughout four cities - Edinburgh, Southampton, Cardiff, and Birmingham. In 2010, he was the subject of major concurrent survey exhibitions at the ICA in London and White Columns in New York, and in 2011 he became Artist in Residence at the Chatham Historic Dockyard where he currently works.
www.L-13.org

Brandon Lodge
Brandon studied at Doncaster College with the original intention of pursuing graphic design before transferring to fine where he primarily worked with oil on canvas. He then studied Illustration at Plymouth University where he really discovered himself and the direction he wanted to take his artwork. Brandon almost entirely works in black and white using sumi-ink (and other black media) and a large variety of tools to create marks; Chinese calligraphy brushes, twigs, reeds, make-up brushes, homemade brushes, anything that he can make an interesting

mark with. He strives for his work to be full of energy, a reflection of the drawing process.
www.brandonlodgeillustration.co.uk

Brigitte Williams
Brigitte's mode of work investigates the codes and systems that influence the subconscious self and develop our cognitive relationship towards the world. Combining the creativity of language, the effect visual patterns have on the collective unconscious, she applies rules and formulas to challenge our perception of sensory understanding. Her strengths comes from this observation and the ability to deliver subjective ideas into images, which hover between 'language' and 'visual art'. Brigitte studied at The Slade School of Art where she graduated in 2006 with distinction. Winning the Catlin Art Prize in 2007 the work is extensively exhibited, appears in many publications, and is avidly purchased for public and private collections.
www.brigittewilliams.co.uk

Brin Edwards
Born in 1957 Brin has always been fascinated by the natural world and had a compulsion to draw and paint wildlife for as long as he can remember. His interest in birds probably dates from his early childhood spent in Singapore where he was captivated by the colourful tropical species in his back garden. In recent years he has developed a more personal and expressive way of depicting the natural world in his oil paintings. This looser and atmospheric approach acts as a kind of antidote to the precision of his illustration work. He is very fortunate to live and work in the beautiful Suffolk countryside and much of the inspiration for his paintings comes from close to home. In 2008 he completed a purpose built straw bale studio which is a truly inspiring work space as well as a classroom for his teaching.
www.brin-edwards.com

Bronagh Fegan
Bronagh Fegan is a Northern Irish short story writer currently based in London. Her work has appeared in publications including Oh Comely, BRAND and La Bouche, and more can be found at
bronaghfegan.wordpress.com
Twitter: @bronaghfegan

Bruce Pearson
An award winning visual artist and field naturalist who for 35 years has worked on a range of subjects and themes in the Arctic, Antarctica, Africa, and the Americas. It is the rhythm and restlessness of the natural world that fascinates, both in wild landscapes and places where people and human activity interact with habitats to create interesting themes. A painting might be completed directly in the field, while volumes of sketches and studies provide ideas and fresh starting points for painting and printmaking work in the studio. He has lectured and exhibited work widely in the UK and overseas.
www.brucepearson.net

Camilla Westergaard aka Butterscotch & Beesting
Camilla is an illustrator and designer in love with storytelling. She sets her work in an imaginary circus called Butterscotch and Beesting, which is run by Betty Butterscotch – a fictitious former trapeze artist turned confectioner – and her best friend and magician of worldwide renown, Bumblewick Beesting. The circus is also home to troupes of rather unusual magical animals, many of whom have been mixed up and muddled by magic. She is interested in the way stories and pictures hang together, so all her products, prints and patterns tell their own tale.
www.butterstings.com

Cally Higginbottom
Cally graduated from Liverpool John Moores University. Initially she noticed that the last sighting of the Bachman's Warbler was the year that she was born; she wanted to start with a personal connection. During her research of the Warbler she fell in love with its cute, petite features and its happy, yellow colour. She's always been passionate about birds, even more so since the exhibition and going to Malta for the conservation work. She really got into photography whilst over there: after all when there are Bee-Eaters flying around it's silly not to get out a camera.

Carolyn Drake
Carolyn's photo career began at the age of 30 when she decided to leave her multimedia job in New York's Silicon Alley to learn about the world through personal experience. Within a remarkably short time she was selected as an emerging photographer by both PDN and the Magenta Foundation. 2008 saw Carolyn win a World Press Photo award, two POYi awards and the Lange-Taylor Prize for her project on Uighur identity. In 2010 she won two further POYi awards and a prestigious Guggenheim fellowship.
www.carolyndrake.com

Carrie Francis
For Carrie, art is her life – she draws, therefore she is. She is a final year illustration student, a journey she started almost four years ago. She wants to make a living through what she loves and has done since she could pick up a pencil
teulufrancis@aol.com

Carina Roberts
Currently studying at Swansea Metropolitan University, Carina hails from a small coastal town near Bristol where the seasons change with a slow air of steadiness. It has everything in terms of natural scenery; as a result she has always been very interested in animals and the natural world. This has formed the main inspiration for her work, particularly in college, when she studied traditional folk tales that were based around animal spirits. In addition, inspired by positive thinkers, great storytellers, poetry and the world we live in, she works mainly in paint and line with a sprinkling of digital influence.
mysterycheese66@yahoo.com

Carry Akroyd
Carry Akroyd is a painter and printmaker whose subject is wildlife and the farming landscape, with a focusing on colour and composition. After studying for an MA in Fine Art, and illustrating two collections of John Clare's poetry ('The Shepherds Calendar' and 'The Wood is Sweet') Carry continued her connection with Clare's poetry in a series of lithographs made at Curwen Studio. Carry wrote her own illustrated book 'natures powers & spells' and also edited 'Wildlife in Printmaking', a book in which she drew together work by 22 artists. Carry exhibits regularly with the Society of Wildlife Artists.
www.carryakroyd.co.uk

Catherine Wallis
Catherine Wallis grew up in Jamaica and spent her early working life as a journalist, but discovered an aptitude for detailed natural history studies. This obsession was inspired by a collection of bones and skeletons she found. Her drawings are as detailed as possible in an attempt to take captive the intense beauty to be found in the patterns and textures of natural objects. She has shown her work at various exhibitions in London and the South of England.

Charming Baker
Baker's work explores well-trodden and intrinsically linked themes; life, love, death, terror, joy, despair - with an underlying reference to the classics and a dark humour. Although primarily a painter with an interest in narrative and an understanding of the tradition of painting, in recent years Baker has produced sculptural pieces in a wide and varied choice of materials, (from the anciently traditional to the not so). Baker is also known to purposefully damage his delicate painting, including drilling, cutting and occasionally shooting them with a shotgun, intentionally and inadvertently putting to question the preciousness of art, and adding to the emotive charge of the work he produces.
www.charmingbakerstudio.com

Chelsea Hopkins
Chelsea grew up in the Wye Valley and Forest of Dean and always doodled mythical creatures all over her schoolbooks. Her Year 7 art teacher would encourage her to attend the 6th form after school art clubs and really inspired her to continue drawing, though she always knew she would do something creative for a living, Illustration became her calling.
chelseaeleanor@me.com

Chris Harrendence
After spending many years looking for creative inspiration and a creative style, Chris returned to University to study Illustration. He has been able to nurture his love for drawing and painting while also exploring new possibilities in the field of traditional printmaking and digital art.
batmansam@ntlworld.com

Chris Livings
His first inspirations from art came from skateboard designs, illustrations in zines and

80's movies. The graphic designs and quality of the lines used pushed his work into a more linear based style, which he continues to develop in his work. Chris takes pride in his ideas and enjoys drawing his illustrations in a non-conventional manner. He prints and sells his own t-shirts as an ongoing project, which he plans to carry on after he graduates. During his spare time he likes to illustrate murals.clivings.
117898@students.smu.ac.uk

Chris Rose
Chris is a wildlife artist who specialises in wildlife within the landscape. He is the secretary of the Society of Wildlife Artists, based in London and served for six years on the board of governors of the Federation of British Artists. Chris has exhibited widely throughout the UK and had several one-man shows at the Wildlife Art Gallery, Suffolk. He recently held an exhibition at a Mayfair Gallery in collaboration with the RSPB in support of albatross conservation. He has had work shown in France, North America, Singapore and Japan. He has won several awards including British Birds journal Bird Illustrator of the Year and was twice winner of Birdwatch Magazine's Wildlife Artist of the Year.
www.chrisrose-artist.co.uk

Claire Brewster
Claire Brewster was born in 1968 and grew up in Lincolnshire, studied tapestry weaving at Middlesex University and lives and works in London. Brewster's work has featured in numerous group exhibitions, most recently, the First Cut, Manchester Art Gallery and Mind the Map, The London Transport Museum. She has featured in numerous publications including Paper: Tear, fold, Rip, Crease, Cut (Black Dog Publishing, Vogue, World of interiors and Marie Claire Maison. Her work is in the collections of the Corinthia Hotel, London, London Transport Museum, The London Clinic, Bury Art Gallery and private collections all over the world.
www.clairebrewster.co.uk

Claire Moore
Having always had a love of drawing and experimenting with materials, Claire finds it satisfying to create something meaningful out of everyday items. Being further inspired by her introduction to the idea that 'drawing' is not just classically taking pencil to paper, but rather capturing the essence or form of a subject using any materials you can, in any way you can. She enjoys mixing mediums together, to see how they can interact in new and interesting ways, and applying traditional crafts in unusual contexts. She tries to retain an element of humour or playfulness in all of her work.
fliberjit@gmail.com

Claire Thomas
A study of illustration in university has lead Claire to explore narrative and aesthetic qualities in her work. Without sacrificing content, her aim is to create work that is intriguing and attractive to look at.
c.thomas99@hotmail.co.uk

Cristina Guitian
Cristina is a Spanish multidisciplinary artist, who works across sculpture, assemblage, installation and illustration. As a child Cristina lived very much in her own imaginary world and she created her own universe that allowed her to become an illustrator after moving to London in 2004. Since then Cristina combined her illustration commissions with the development of her own work that involved drawings and installations. In 2010 Cristina started to create sculptures out of her collection of objects. Kensington Palace commissioned Cristina in 2012 to create some installations for their permanent exhibition about Queen Victoria, Victoria Revealed.
mail@cristinaguitian.com

Dafila Scott
After training as a zoologist, Dafila Scott turned to drawing and painting. Most of her work is inspired by wildlife and landscape and features animals or places with which she has become familiar. As a member of the Society of Wildlife Artists, she has exhibited regularly at their annual exhibition at the Mall Galleries as well as at other galleries. Her work includes both figurative wildlife paintings and abstract landscapes inspired by visits to Wales and to the Kalahari. However, she is equally happy to gain inspiration at home in the garden or on the surrounding fenland.
www.dafilascott.co.uk

Dareen Rees
Darren Rees studied Mathematics at Southampton University and taught the subject for a short time before pursuing a career in art. As a painter he is self-taught. His work has attracted many awards including Bird-Watch Artist of the Year, Natural World Fine Art Award, RSPB Fine Art Award and a winner in the BBC Wildlife Artist of the Year. His first solo book Bird Impressions was also short-listed in the Natural History Book of the Year Award. He is a member of the Society of Wildlife Artists in London and is a regular contributor to Bird Art & Photography magazine. He has participated in Artists for Nature Foundation/WWF projects in Holland, Poland, Peru and Ecuador, and he leads wildlife tours to Europe, the Americas and the Arctic.
www.darrenrees.com

Deborah Moon
Within her work, Deborah explores the transcendental elements of journey, combining personal memory and nostalgia. Her work deals with public, private spaces and the exploration of our urban and natural environment. Taking ordinary everyday events and seeing the extraordinary, the little unseen miracles that happen day to day. Previous exhibitions and features have included, Kobe City Museum, Japan, Habitat, Urban Outfitters, Mercury Gallery, Cork Street London, Rivington Gallery, Shoreditch, London, U Of A Edmonton, Canada and Amelia's Magazine, Grafika 1973Ltd Paper Collaboration.
www.moonko.co.uk

Delyth Lloyd-Evans
After graduating with a degree in Graphic Design she became a freelance illustrator working through a London illustration agent, mainly in the area of advertising and design. Clients included Heinz, Cadbury, and Barclays. In the 1990s she set up an award-winning small house publishing business producing 3D and die-cut greeting cards and gift stationery. The company exported to over twenty countries and exhibited regularly at the major trade fairs. Delyth now lecture at Swansea Metropolitan University.
delyth.lloydevans@smu.ac.uk
delyth@papercats.net

Derek Bainton
His early illustration background was in studying Natural History Illustration, although like many he enjoys the liberation of approaching the subject in a more contemporary and playful way. Derek is currently programme director on the BA (Hons) General Illustration at Swansea Metropolitan and founding member of VaroomLab, an on-going international research project which fosters research activity in all areas of illustration.
derek.bainton@smu.ac.uk

Desmond Morris
Desmond Morris was born in Wiltshire in 1928 and held his first solo exhibition in 1948. In 1950 he shared his first London show with Joan Miro and has remained an active surrealist painter ever since. He has exhibited internationally and his work in now in public collections in five countries, including the Tate and the British Museum in London, the Gallery of Modern Art in Rome, and the Yale Center for British Art in America. Eight books have been published about his work. He has also enjoyed a separate career as a zoologist and has published a number of scientific papers on bird behaviour. He has written over 60 books, including one on owls. He also presented over 500 television programmes on animal and human behaviour between 1956 and 1998.
www.desmond-morris.com

Diane Maclean
Diane Maclean is a sculptor and environmental artist, working mainly in the landscape and in architectural settings. She has completed many public sculpture commissions and exhibited her work in exhibitions and symposiums all over the world. Stainless steel, coloured stainless steel and aluminium are favoured materials, sometimes combined with stone. Reflection, colour, light, sound and movement are frequently incorporated into sculptures and installations. Recently bird-life has become a major theme, resulting in interpretations of parts of the bird as separate entities. 'Preen' is such a piece, inspired by the still visible iridescent green feathers on the neck of a long extinct bird.
www.dianemaclean.co.uk
sculpture@dianemaclean.co.uk

Diane Rees
Diane is a 3rd year part time student at Swansea Metropolitan University studying BA Illustration. She started this degree course quite late in life to the surprise of her family and friends with the phrase 'mid life crises' mentioned many times. Drawing and painting has always been a passion of hers. Diane has been lucky enough to illustrate a children's book 'Myth and Melody' by Dylan Adams. She has also recently designed kindle skins.
www.dianerees.com

Dionne Kitching
Dionne is a 23 year old illustrator based in London. Interested in patterns, nature, science and animals. She makes screen prints in her garage and enjoys riding a bike everywhere she goes. She graduated from Middlesex University in 2012 with a BA hons in illustration.
www.dionnekitching.co.uk
dionnekitching@hotmail.co.uk

Duncan McLaren
Duncan Mclaren studied graphic design at Blackpool College of Art in the early 60's, winning the Graphic Design prize in his final year. Following employment in a variety of industries working as a studio designer, he became Design and Advertising Manager for the Bodley Head publishers in London where for the first time he discovered the world of book, and in particular children's illustration. During the 80's he was senior designer in an international design group before moving to Wales where he established his own consultancy. From 2000 to 2012 he was the Programme Director of the Illustration Degree course at Swansea Metropolitan University. He has illustrated over 25 books for children, written a number of children's stories and produced illustrations for a broad spectrum of commercial clients. A successful painter, he has had numerous exhibitions in London and Wales and his paintings and drawings are in a number of public and private collections throughout the UK and France.
duncanmclaren@freeuk.com
duncanmclarenart.co.uk

Ed Kluz
Ed Kluz is an artist, designer, illustrator and printmaker. His interests lie in the historical objects, buildings, landscapes and folklore of Britain. His paper sculptures, collages, scraperboards and paintings reimagine the traces of the past through contemporary eyes and means.
www.edkluz.co.uk
edkluz@hotmail.com

Edd Pearman
Edd graduated from the RCA in 2002 with an MA in Fine Art. He continues to live and work in London. He also works as a visiting tutor to colleges across the UK. He has had two solo exhibitions in London; 'Social Studies' at Catto Contemporary (2003) and 'Nude & Bird Studies' (2005), and has been included in a number of group exhibitions in the UK, New York, Berlin and Japan, including Bloomberg 'New Contemporaries' (2002) and the 'New Artist Unit' at the Tokyo Metropolitan Art Museum (2006). His curatorial

projects include two successful group shows: "Sea Change' (2005) at the Mark Jason Gallery, which was featured by the BBC and 'Manderley' (2009) at the John Jones Project Space, which received a 'Pick of the Week' in the Guardian. His work has been published in The Guardian, The Independent and The Times and features in collections around the world including the V & A, the Chapman Brothers family archive and the Bazil Alkazzi Foundation.
www.eddpearman.co.uk
eddpearman.wordpress.com

Eduardo Fuentes
Eduardo is an illustrator working mostly in digital, although he likes to give his illustrations a warm, little handmade touch. Most of his illustrations are made for books and magazines although Eduardo loves to participate in exhibitions and collaborative projects. He is also co-founder and regular contributor of Happy Wednesday (happywednesday.co.uk), an illustration and design e-zine.
www.edufuentes.com

Ellie Mason
Ellie is currently attending the Arts University Bournemouth and started an Illustration degree but has now progressed onto Costume with Performance Design where she will go on to become a theatre designer.
elliemason92@hotmail.co.uk

Ellie Raissa
Ellie's work is strongly influenced by surrealism, nature and incidents of everyday life. She usually creates intense drawings using bright colours and strong lines, patterns, collage and abstract shapes. She is currently working as a Graphic Designer in the food company Gousto, based in London. Her future aim is to build her own studio.
www.ellierassia.com

Emily Reader aka Rose Petal Deer
Emily started her creative career with Art & Graphics A levels at King Edward VI Stourbridge College, before completing an Art Foundation at Stourbridge College, then leading her to study Printed Textiles for Fashion at Brighton University. She is now in her final year working on her final collection. Emily has a huge passion for fine line drawing.
www.blogger.com/rosepetaldeer
Twitter: @rosepetaldeer

Emily Sutton
Emily Sutton is a York-based artist and illustrator. Her work takes influence from mid-20th century illustration as well as english and american Folk Art. She has worked on illustration projects for clients. Her fabric sculptures were featured in World of Interiors magazine. Emily studied illustration at Edinburgh College of Art and Rhode Island School of Design. Since graduating in 2008 she has exhibited at various galleries in the UK as well as undertaking private and commercial commissions in Europe and the USA.
www.emillustrates.com
www.stjudesgallery.co.uk

Erin Petson
Erin's individual handmade textural style draws inspiration from the landscapes of her youth, and the contradictions therein. Her childhood in Middlesborough was framed by the clash between the industrialisation of British Steel and the bleak beauty of the North Yorkshire Moors and the harsh possibilities of the North East coastline. Her work was further shaped through time spent in London and exploring Istanbul and her love of Turkey; the people, the landscape and the colour palette bleed indelibly on her mind's eye.
www.erinpetson.com

Errol Fuller
Errol Fuller is an artist and writer, the author of Extinct Birds and two other books on extinct creatures, The Great Auk and Dodo – From Extinction to Icon. He often collaborates with the celebrated New Zealand artist Raymond Ching, and recently joined forces with David Attenborough to produce a book on birds of paradise called Drawn from Paradise. He regularly departs from natural history themes, and has written a large scale monograph on Hedley Fitton, an etcher of architectural subjects. Errol's own paintings are usually – although certainly not exclusively – of sporting subjects, and often feature boxing, snooker and other slightly disreputable sports.

Esther Tyson
Born in 1973, Esther Tyson was brought up in a small town at the edge of the Lake District, Cumbria. She currently lives and works in the South Peak District, Derbyshire. Esther studied at Carlisle college of Art and Design, Carmarthenshire College of Technology and Art and London's Royal College of Art. She is a painter whose work responds to the natural world and reflects the rich variety of subjects she finds there. Esther seeks to capture the essence of her subject matter, responding to the smell, sights and sounds of each environment with thought toward her subject and the marks she makes. She states 'I am apart from nature-a mere observer, but this is my re-connection-my rediscovery of it.'

Faunagraphic aka Sarah Yates
Faunagraphic currently lives and works in Sheffield, South Yorkshire England, She grew up in Yorkshire, surrounded by rolling countryside in a small town called Todmorden; it is clear where her inspiration came from. Her beautiful and delicate paintings feature birds, organic shapes, animals, nature and character with an element of fantasy. With her Partner Rocket01, the creative duo collaborate on most projects, and run their art studio in the heart of Sheffield city. They have completed art projects and commissions for a number of companies including Converse, Channel 4, UGG Australia, Gadget Show, Desperados Beer, Brugal Rum, For Boarders by Boarders. In November 2011, she was asked to paint a mural for Converse footwear, on the largest wall ever painted in Manchester city Centre at 27 meters high and 22 meters wide.
www.faunagraphic.co.uk

Felt Mistress aka Louise Evans
Felt Mistress AKA Louise Evans is a UK based stitcher and prolific tea drinker who creates a range of one-off bespoke creatures with her partner, illustrator Jonathan Edwards. Originally trained in fashion design and millinery, Louise has brought many of the skills learnt through years of work as a couture dress maker to the world of character design. As well as original Felt Mistress characters Louise has also collaborated with a variety of other artists including Jon Burgerman, Jon Knox (Hello, Brute)and Pete Fowler. Her work has been exhibited in the UK and internationally and in 2010 was given her own window on Oxford Street as part of Selfridges' Christmas display. She states her main interests as sewing, Japan, buttons, creatures, cake and Mr Edwards. When not sewing she likes to dream she'll live to see the day when you can download French Fancies "off of the Internet".
www.feltmistress.com

Gail Dooley
Gail is a London based ceramic sculptor. Specialising in stoneware sculpture inspired by birds, animals/humans, her latest work involves albatross conservation, specifically the plight of the albatross and long-line fishing.
www.gaildooley.co.uk
info@gaildooley.co.uk

Geo Law
Geo studied graphic design at Nottingham Trent University after which he worked in Prague for Evocreative. In 2009 he returned to Sheffield to become a freelance illustrator and since worked for clients such as Converse, Sumo Digital & Rolo Tomassi.
www.getaloadageo.co.uk
Twitter: @getaloadageo

Georg Meyer-Weil
Having studied communication design at Folkwang in Essen, Germany – where he specialized in fine art painting and calligraphy – Georg came to London where he graduated with a Master's degree in Fashion Design from the Royal College of Art. Georg has worked continuously as an artist and has won numerous awards for his work with subsequent exhibitions, such as the Lonely Planet photography prize and the honorary Trailblazer award by the campaign for drawing. Major shows have taken place at Hockney Gallery London, Henry Moore Gallery London, Michael Commerford Gallery Sydney and the Kunstmuseum Bonn in Germany.
www.meyerweil.com

Georgia Roberts
Georgia has always been creative since a young age but she did not consider art and design as a career path until the end of school. It was not until college that she learnt about illustration courses which made her start thinking seriously about what she wanted out of life. At university Georgia's illustrative abilities grew at an astonishing rate. She found that she had a proclivity for watercolours, which previously she had found quite challenging - near the end of her first year she discovered her style and has not

looked back. After graduating her goal is to venture into the world of children's picture books.
www.georgiaroberts.daportfolio.com

Ghostpatrol
Born in Hobart, Tasmania, he works and lives in Melbourne, Australia. Ghostpatrol creates worlds across mediums exploring ideas of space exploration, cosmic scale and the super future. His visual worlds invite ideas and questions to methods of seeing beyond our own existence scale and atomic configuration, through the concepts of curiosity lead science and quantum physics.
www.ghostpatrol.net

Giulia Ricci
Giulia Ricci's work explores disruptions and tactility within geometric patterns, across a variety of media, with a focus on drawing. She has shown her work extensively and was shortlisted for the Jerwood Drawing Prize in 2010 and 2011.
www.giuliaricci.eu
giulia.ricci@yahoo.co.uk

Greg Poole
Greg is an artist/illustrator born in Bristol in 1960, living and working there again now. His artwork derives from much field sketching of the natural world, then studio printmaking gives a way of re-living/interpreting the field experience using different sets of tools.
www.gregpoole.co.uk

Gregori Saavedra
Gregori was born in Viladecans (Barcelona, Spain) in 1968. He graduated in Information Sciences from the University of Barcelona in 1992. He started his professional career in advertising becoming creative director of various agencies such as Pongiluppi & Guimaraes, Valverde/De Miquel, J. Walter Thompson and Lorente Euro RSCG. As an illustrator, Gregori Saavedra´s artwork has been published by Die Gestalten Verlag, IdN, PigMag, DPI Taiwan, Dazed and Confused, Time, Rojo, NEO2, Bis Publishers, Ling, Gustavo Gili, Actar, Die Ziet, Collins Design, New Graphic China and The Gutenberg's Quarterly. In 2007, the curators of ILLUSTRATIVE, the most important illustration international forum, selected him as one of the most relevant illustrators worldwide. Later, in 2009, UNESCO granted its CODE prize to Gregori as one of the 20 Best Illustrators of the Year. He moved to London in 2010.
www.gregorisaavedra.com
info@gregorisaavedra.com

Guy McKinley
Guy McKinley is an illustrator/concept artist/painter who has, since graduating in 2003, been involved in lots of diverse projects relying on his strong character work. He initially began (and continues) producing hand drawn & digital work used in editorials, pre-production concepts, character design and more commercial images for promotional and advertising campaigns, but more recently he has also been taking part in live exhibitions & gallery shows with his more personal paintings and illustrative work.
www.guymckinley.com
info@guymckinley.com

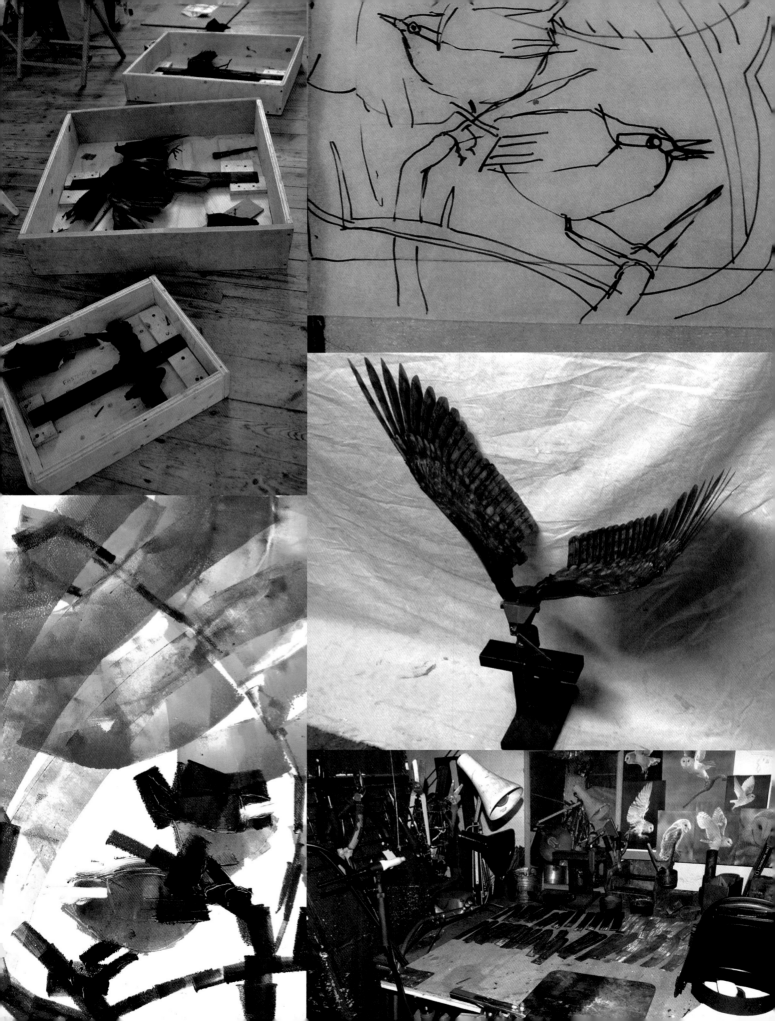

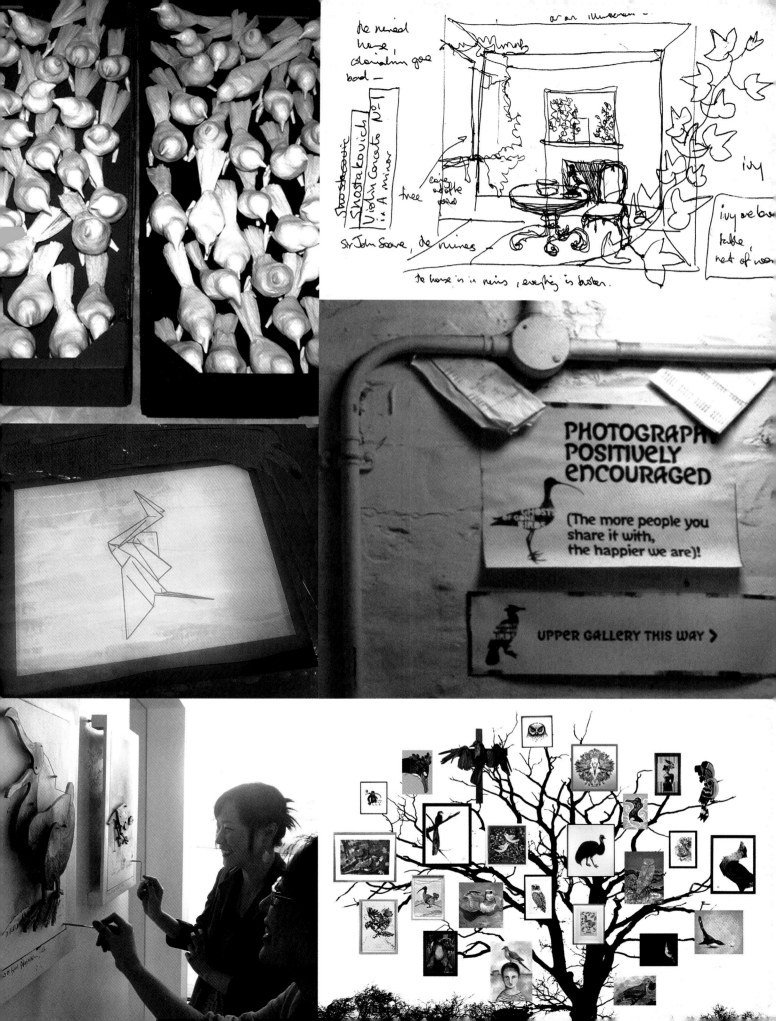

PHOTOGRAPHY
POSITIVELY
ENCOURAGED

(The more people you
share it with,
the happier we are)!

UPPER GALLERY THIS WAY >

Hayley Swann

Hayley's love for art began when a friend introduced her to graphic novels and the rag dolls she used to sew. Hayley was inspired and started drawing more; she even tried her hand at stitch. As she reached further education her inspiration grew into many more fields of art. Both her and her twin study illustration - back in college it was always interesting to see how different they would answer a brief - and even now when they are studying in different places, they still find it nice to compare their work and help each other out.

hswann.art@aol.co.uk

Hannah Bays

Hannah Bays is a London based painter and illustrator. Born in 1982 she studied illustration at the London College of Communication and is currently studying for a post-graduate diploma in fine art at the Royal Academy. Bays' commercial work switches between, and combines, painting, drawing and collage, and has graced a number of record sleeves, most notably for bands The Libertines and Babyshambles. Other clients from across the entertainment spectrum include Rough Trade, Mercury, Gibson, PPQ and Harper Collins. Alongside this commercial work Bays continues on her personal trajectory of painting and image-making, mining the psychological landscapes begotten of our modern consumer age.

www.hannahbays.tumblr.com
www.hannahbays.com

Harriet Mead

Harriet is an English Wildlife Artist specialising in metal sculptures. She received formal art education during a foundation year at St Albans College, followed by a degree in Fine Art at the Norwich School of Art. Mead's work is inspired by animals and birds. From an early age she was encouraged to observe and develop a keen interest in British wildlife due to the influence of her late father, Chris Mead who was a well-known author and broadcaster. Harriet uses personal experience and direct observation to provide inspiration for her work. The countryside and wildlife around her home in rural Norfolk and her travels to various places around the world, including Asia and Africa, provide subject matter for her work.

www.harrietmead.co.uk

Harry Adams

Harry Adams is the pseudonym used to present the collaborative work of artists Adam Wood and Steve Lowe. These artists have worked together over many years creating a body of work that they choose to present with a singular authorial voice. Since 2008 Harry Adams has focussed almost entirely on making paintings, whilst also collaborating closely with Billy Childish on making and curating the International Art Hate Archive. Some paintings are undertaken individually, others are painted together or in turns, and the resulting works, steeped in the traditions of mark & picture making, are an ongoing commitment to the search for significance within this tradition.

www.L-13.org

Helen Fowler

Helen's creative background is still at the development stage; she has just returned to higher education as a mature student. She is currently in her last year of study for a BA Hons Illustration degree. Exhibitions to date include painting work in the Three Towns exhibitions in Llanelli, July 2010 and 3-D work in The Miscellaneous Sideshow (SMU) March 2011. Published work includes a picture book, Shadows, from Canolfan Peniath in 2012.

helenvicf@aol.com

Hello Von

Whilst having worked primarily as an award winning illustrator Von has begun to make a name for himself on the gallery circuit in recent years having been collected by both high profile figures within, and outside of, the art world. Influenced by nature and popular culture, his artwork is both detailed and abstract, being able to flawlessly walk the line between surrealism and documentary portraiture capturing a mood in what appears to be a fleeting moment in time. Von has been featured in numerous publications across the globe, released sell out screen prints & collector's box sets and has exhibited in such prestigious venues as Shepard Fairey's Subliminal Projects Gallery, Colette, StolenSpace, The London Design Museum and Agnes B among many others.

www.shopvon.com

Hiroko Uemoto

Hiroko's main interest lies in the beauty of nature, such as flowers, foliage, and how light and shade play on them. Whereas shapes change, the basic nature of the subject remains the same. She wants to convey the intuitive beauty of the natural world. Hiroko likes to use watercolour. Every time she uses this medium, she can create a fantastic variety of hues. She is now studying illustration at The Arts University College at Bournemouth. She wants to be an illustrator/artist to express the joy of daily life.

rokohiroko55@gmail.com

Holly Betton aka Death by Tea

Death by Tea is designer, illustrator and professional colour-in-er Holly Betton. She graduated from Nottingham Trent University in 2010 with a degree in Textile Design, holding a particular interest in drawing and print making. The majority of her work starts as a simple mono-print, and this method of printing gives the naive mark and line that forms the basis of her work. Colour is then added and combined with playful text and composition to create a range of unique and charming home and giftware. Holly's range includes a selection of printed tea towels and aprons, fine bone china mugs and cards.

www.deathbytea.com

Hugo Wilson

Hugo Wilson is one of the UK's promising young artists. He came to international attention in 2010 at the Busan Biennale, and in 2011 and 2012 respectively was offered solo exhibitions at Project B Gallery Milan, and Nicodim Gallery, LA. Wilson works across mediums including drawing, painting, installation and sculpture. He is decidedly contemporary, even avant-garde in his committed pursuit of discovering meaning in today's world. However, Wilson is clearly affected by history; not simply the chronology of the past, but the complicated story of art's relationship with religion, science and the politics of Church and State. Recent investigations have drawn him into the world of ethnographic classification, and the symbolic associations of objects of faith, talismans and totems.

www.hugowilson.com

Ian Penney

For many years Ian worked as an illustrator, mainly in publishing. In 1990 he wrote and illustrated "A Shop Full of Kittens" and produced a number of titles for The National Trust. In 2008 Ian created his first paper cut and has been doing them ever since. Ian loves making images of the natural world with a little touch of magic and whimsy. He is represented by the Rebecca Hossack Gallery who sell his work all over the world.

www.ianpenney.co.uk

Jack Teagle

Jack Teagle is an illustrator, painter and comic artist living in Cornwall. He works in thick layers of acrylic when painting, to create a bold, simple look to his work. Jack likes to combine the fantastic with the mundane in his work, and often combines pop culture with his life experiences. Jack is a big fan of Golden and Silver Age comics, old sci-fi B-movies, and outsider art. He is also a borderline hoarder and has a huge collection of action figures, cigarette cards and comics.

www.jackteagle.co.uk
jackteagle@hotmail.co.uk

Jackie Hodgson

Jackie's work over the last few years has been split between exhibiting and working on large ecclesiastical commissions. It is generally graphic in style. She works with both hand and machine embroidery on a large range of materials. Jackie also uses felting, printing and photography, collage and papermaking. Her subjects include the personal (the decline of her mother through Alzheimer's), the universal (concerns of climate change and the environment), and the aesthetic beauty of religious iconography and dance and movement. Jackie Hodgson is a member of the Prism exhibiting group, the Embroiderers Guild and Herts Visual Arts.

jackie.hodgson@virgin.net

James Milligan

James started drawing from an early age and studied at SMU. His work is mostly animation-based and illustration is an important part of that. He prefers to come up with an idea and then go from there, thinking of as much as he can and then putting the best ideas into the final image.

www.youtube.com/user/MillywiggZ

Jamie Hewlett

Jamie Hewlett was born in 1968, the Year of the Monkey. Creator of comic book military chick Tank Girl and co-creator of Gorillaz, Hewlett has forged a distinctive visual style and a unique place in British pop culture. Tank Girl was his first major commercial success, a character he created for Deadline Magazine in the late 1980's. Hewlett also created the visual concept behind the multi-award winning project Gorillaz; their ever more inventive videos and live appearances have cemented the band's reputation for musical and visual innovation. In 2006 Hewlett won the Design Museum's Designer of the Year Award for his work with Gorillaz, matching critical acclaim with commercial success. He is influenced and inspired by Chuck Jones, Ronald Searle, Stanley Kubrick, Hunter S. Thompson, zombie films and is currently working on several individual projects and collaborations.

www.jamiehewlett.com

Jennifer Hooper

Jenny studied painting and photography at Camberwell College of art and anatomy at UCL. She has had various apprenticeships and teaches photography part-time outside of her studio practice that is predominantly painting. Her work addresses our relationship to the natural world and place within it.

www.jenniferhooper.co.uk

Jeremy Mynott

Jeremy has explored the variety of human responses to birds, from the ancient world to the present day, in Birdscapes: Birds in Our Imagination and Experience (Princeton University Press, 2009), a book described by reviewers as 'the finest book ever written about why we watch birds' (Guardian), 'a ground-breaking work' (British Birds) and 'wonderful rumination on birds and birders through space and time for anyone interested in our relationship with nature' (THES). He has broadcast on radio and television, was a leading contributor to the BBC series, Birds Britannia and is a founding member of New Networks for Nature.

www.jeremymynott.org
rjmynott@cambridge.org

John Barlow

John is a poet, editor, publisher and designer. The author of several collections, his book Wing Beats: British Birds in Haiku, written and compiled with Matthew Paul, was one of The Guardian's 'Best Nature Books' of 2008, while works he has edited have been honoured by the Haiku Society of America and the Poetry Society of America. A regular contributor to Caught by the River, he also serves on the steering group of New Networks for Nature, a broad alliance of individuals whose work draws inspiration from the natural environment.

www.wingbeats.co.uk

John Keane

John Keane was born in Hertfordshire in 1954 and attended Camberwell School of Art. His work has focused on many of the most pressing political questions of our age, and he came to national prominence in 1991 when he was appointed as official British war artist during the Gulf War. His work has always been deeply concerned with conflict - military, political and social - in Britain and around the world and his subjects have included

Northern Ireland, Central America, and the Middle East, sometimes working with organisations such as Greenpeace and Christian Aid. More recent subject matter has addressed difficult topics relating to religiously inspired terrorism such as Guantanamo Bay, the Moscow theatre siege, and home-grown acts of violence against civilians. In recent years he has also become known for commissioned portraits of notable individuals such as Mo Mowlam, John Snow and Kofi Annan. He lives and works in London.
www.johnkeaneart.com

Jon Burgerman
Jon is one of the prominent key artists who traverse the disciplines of urban art, design, illustration and entrepreneurism. His award winning artwork can be seen globally from gallery and bedroom walls to cinema and iPhone screens. His art is instantly recognisable, combining fluid and lyrical lines, with distorted character forms and radiant pop colour schemes. A sense of British self-deprecation, dry humour and modern-day anxiety imbues his work along with an enthusiasm for salad. Jon exhibits internationally and has shown work alongside contemporary artists including Banksy, Damien Hirst, Vivienne Westwood and Gerald Scarfe. His work is widely collected and is in the permanent collections of The Victoria and Albert Museum, Nottingham Castle Museum and The Science Museum in London. Jon lives and works in New York and online.
www.jonburgerman.com

Jonathan Edwards
Jonathan's work first appeared in 1993 in Deadline and Tank Girl Magazine with strips such as Dandy Dilemma, Simon Creem, The Squabbling Dandies (with Richard Hoiland) and one pagers about, amongst others, Scott Walker, Sly Stone, Nancy Sinatra, Kraftwerk and The Beach Boys. Since then he has worked for the Guardian, Mojo, Q, Mad, The Black Eyed Peas, A Skillz & Krafty Kuts, The Jungle Brothers, The Glastonbury Festival, etc. His comics include Aunt Connie & The Plague of Beards, A Bag Of Anteaters (with Ian Carney) and Two Coats McWhinnie (also with Carney). Jonathan has also been a regular contributor to the Guardian since 1999 and illustrated the Hard Sell weekly column in the Guide from 2002 - 2011. His character design work includes collaborations with his partner, Louise (AKA Felt Mistress), and his vinyl toy, Inspector Cumulus.
www.jonathan-e.com

Jonathan Gibbs
Jonathan was educated at the Central School of Art and the Slade. He works in wood engraving, drawing and painting - living in Scotland, he regularly exhibits in Edinburgh and London and is Head of Illustration at Edinburgh College of Art. His visual language is fastidious, linear and deeply sensitive to place.
j.gibbs@ed.ac.uk

Julia McKenzie
Julia's work is primarily drawing based layered with paper cuts and collage. She also makes limited edition screen prints. She is interested in drawing and recording what she can find in her immediate environment. Julia looks for the evidence of nature she can hold in her hand from her suburban garden to what she can find on her travels to the sea or the countryside. She is interested in natural forms that are fragile, buffeted and broken down. The more you look, the more beautiful they become. She is fascinated by our wildlife, even in the city we are enveloped with nature, its cycles and rhythms.
www.juliamckenzie.co.uk

Julian Hanshaw
Julian Hanshaw began his career as an animator. After some thirteen years in the industry working on personal projects and Bafta winning studio series work, Julian's break in the comic industry came when he won The Observer / Comica award. Two graphic novels followed for Jonathan Cape: The Art Of Pho and I'm Never Coming Back. Julian's third graphic novel Tim Ginger is currently being drawn for American publisher Top Shelf Comix. Julian is also working on TV scripts, children's books and illustrates for the 'Pho' restaurant chain. Julian lives on the South Coast with his wife.
mrjulianhanshaw@hotmail.com

Julian Hume
After becoming established as a professional artist specialising in reconstructing extinct species, Julian undertook a BSc and PhD in bird palaeontology, which not only provided an opportunity to scientifically describe new species, but also to reconstruct them in art. This combination of two disciplines fulfilled his aim of merging the arts and the sciences. He works predominantly on oceanic island fossil bird faunas, especially those on Hawaii, Mauritius, Rodrigues and Madagascar, which has resulted in many worldwide field trips, TV presentations, numerous scientific papers and published illustrations, and two co-authored books.
www.julianhume.co.uk

Justin Wiggan
Justin is an artist who works across sound, visual media and the written word, predominantly as a sound artist under the guise of roadside picnic, creating 4th stream immersions pieces and with Dreams of Tall Buildings. He was commissioned by Vivid Projects to launch 33 REVOLUTIONS. Revolution 01, 'Ladies and Gentlemen, How Long Will They Last?', in collaboration British dancer/choreographer Rosie Kay and Brazilian dancer Guilherme Miotto. He has just published his first book of poetry, " Of Bulls and Mathematicians.'His works are artefacts and documents of his reaction to the shouts, screams, shrieks, wails, hoots, howls, death rattles and sobs that are all soaked up by his surrounding unfinished structure of space and complicated collapsing systems. This work engages with swollen cityscapes, human moral struggle, and discovering the links between the internal tourist and the external explorer. One cuts the path through conviction and belief, the other gnaws on the path for convenience. These investigations embrace a sense of evolution and eradication of a problem that goes way beyond cultural breakdown, addressing the problem with an end of a system. Our culture is reduced, our hands are tied.
www.dreamsoftallbuildings.com
www.cottoncandyhousefire.tumblr.com

Karin Dahlbacka
Karin studied illustration at University of Westminster although her interest for birds and drawing dates back to when she was growing up in a small village close to the nature in Finland. Since graduating she has been involved in many project often local to where she lives in South London. At the moment she is doing illustrations for Transmitter magazine, and writing and illustrating a children's book. Her way of illustrating is very hands on using ink, paint and collage exploring characters and creating stories.
www.karindahlbacka.com
www.karindahlbacka.blogspot.co.uk

Kate Fortune Jones
Born in Liverpool, Kate moved to London to study Fine Art at Goldsmiths College and now lives in the capital as an artist and printmaker. Kate has spent many years in the animation industry, working for the likes of Warner Brothers and Disney and more recently on many popular children's television series such as Peppa Pig and the new Snowman film. Nature and birds in particular have been an absolute passion of Kate's since earliest memories. Kate spent much of her childhood outdoors, mucking around in the undergrowth, peering into trees and hedges in search of critters, the feathered variety being her favourite. As a young birder, Kate made seasonal lists and illustrations of the birds in the neighbourhood, was in the RSPB's Young Ornithologists Club, built makeshift hides out of deck chairs, attempted to catch a swallow in a pond-dipping net and once stood for an hour in a large sack (with eye holes) holding a bag of nuts to attract blue tits. These days Kate takes a slightly more professional approach to her bird watching, still enjoys drawing them and wants to do everything in her power to protect them.
www.katefortunejones.co.uk

Katrina van Grouw
When she was invited to participate in Ghosts, Katrina van Grouw (formerly Katrina Cook) was completing her magnum opus The Unfeathered Bird, so it's not surprising that bird anatomy was on her mind. A qualified bird ringer, taxidermist, and former curator of the ornithological collections at The Natural History Museum, Katrina's background neatly bridges art and science. Her formal training, however, was in art. Katrina is also an enthusiast of historical bird illustration and has written a book on the subject. Her next illustrated book, entitled Unnatural Selection is all about how man has changed the structure of our domesticated animals. Expect Chihuahuas, Arabian horses, all manner of pigeons, and a very unusual short-legged cat.
www.unfeatheredbird.com

Kevin Waldron
Kevin Waldron was born & raised in Dublin. After graduating with a degree in graphic design from D.I.T., he moved to London to study for an MA in Illustration at Kingston University. Having decided there that children's book illustration was for him, Kevin found a studio in central London & got to work. His first book, Mr Peek and the Misunderstanding at the Zoo (Templar Publishing), won the Bologna Ragazzi Opera Prima Award in 2009. He illustrated Tiny Little Fly (Walker Books), a witty book of rhyme by Michael Rosen which won the Bull-Bransom Award in 2011. That same year he was also named one of the Booktrust best new illustrators. The next instalment in the Mr Peek series is out in 2013. Kevin now lives in New York.
www.kevinwaldron.co.uk
kevin@kevinwaldron.co.uk

Kieran Dodds
Kieran decided to become a photographer after studying monkeys in Malawi for his university degree. On graduating, he trained as a newspaper photographer in his native Scotland until winning a World Press Photo award opened the door to going freelance. He has worked across the world covering life in its fullness but focusses his long term work on humanitarian approaches to wildlife conservation. He is also committed to shooting interesting stories on his doorstep.
www.kierandodds.com
www.panos.co.uk

Kim Atkinson
Kim Atkinson lives on the westernmost headland of Ll n, North Wales, and works as a painter and printmaker, wildlife and habitat being her main subjects. Born in Bath, England in 1962, brought up on Bardsey Island and then in Cornwall, she was educated at Falmouth and Cheltenham Colleges of Art, and completed an MA in Natural History Illustration at the Royal College of Art in 1987. In 1992 she was elected to membership of the Society of Wildlife Artists; also in that year she joined the Artists for Nature Foundation (ANF) project in Poland, and has participated in many ANF projects worldwide since.
kim.atkinson257@btinternet.com

Kittie Jones
Kittie graduated in 2008 from a Fine Art Degree at Edinburgh College of Art and Edinburgh University. Since then she has started to develop a body of work inspired by British nature – mainly documenting the diverse array of birds that inhabit this country and her experience of them. Printmaking is a major discipline she has been working with, mainly screen printing and mono-typing. Kittie also makes drawings and paintings.
www.kittiejones.com

Laura Dixon
Laura started drawing when she was little and simply never stopped! Since graduating from Edinburgh College of Art in 2011, she has worked as an Illustrator and printmaker.

Her work is colourful and playful, and inspired by mid-century design and a lifelong love of the natural world.
laura dixon_illustration@yahoo.co.uk
Twitter: @lauradee_123

Leanne Ellis

Leanne has been working as an illustrator and artist for the past 8 years, and is currently studying an MA in Fine Art. Her artworks usually focus around the figure. She tries to portray quiet moments of reflection and contemplation.
www.leanneellis.carbonmade.com

Lee Court

Lee is currently a third year student at Swansea Metropolitan University. Due to his inquisitive nature he is compelled to experiment with methods and the application of imagery. Lee enjoys combining strong narrative and raw aesthetics to create both thoughtful and desirable pieces of artwork. He sees his current position on his creative journey as quite fresh and looks forward with anticipation and excitement.
Leecourt@hotmail.co.uk

Le Gun

Established in 2004, LE GUN is an art collective consisting of five artist illustrators and two designers who met as graduates at London's Royal College of Arts department of communication art & design. As a team of illustrators they create idiosyncratic imagery which blends a punk, occult, pop and surrealist aesthetic. As well as being the producers of their cult self-titled magazine, the group is internationally recognised for their enigmatic installations, performances, design projects and art shows. They have exhibited in London, Paris, Brussels, Basel, Stockholm, Berlin, Munich, Istanbul, Beijing, and Tokyo.
www.legun.co.uk

Linda Scott

Linda is an established illustrator and academic. For more than twenty years, since graduating from The Royal College of Art, she has worked with a broad range of quality clients to produce images within the areas of editorial, advertising, design for print and web and publishing. In 2012 she was commissioned to produce four beautifully illustrated maps for the interiors of a World Buffet Restaurant. Elements of the maps were used to embellish posters and menus. Linda has exhibited nationally and internationally at galleries including The ICA , The Mall Galleries, The Rochelle Gallery, The Poetry Café (Covent Garden), London Transport Museum and William Morris Museum and in 2009 illustrated a life size fibreglass cow which was exhibited at The Hall For Cornwall and auctioned for charity. Linda has taught illustration at many well regarded British arts institutions and currently teaches at University College Falmouth and Plymouth University.
www.lindascott.me.uk

Little Theatre of Dolls

Theatre of Dolls is a creative partnership of visual artists Frida Alvinzi and Raisa Veikkola. Frida Alvinzi was born in Stockholm, Sweden and Raisa Veikkola in Helsinki, Finland. They met ten years ago while studying at the University of the Arts and are based in London. Theatre of Dolls creates other-worldly visual experiences and 4-dimensional art pieces, using puppets as storytellers and their own bodies as sculptural landscapes, creating the illusion that alternative realities are alive. Using found objects from nature and charity shop treasures as materials, all puppets, costumes and sets are carefully handcrafted by the artists. Theatre of Dolls has performed at the Barbican, Tate Modern and Victoria & Albert Museum and also in galleries, festivals and events worldwide. They also produce drawings and murals that haunt the same uncanny mysterious world as their performances. Works have been shown in galleries across Britain including New Art Gallery Walsall and the Hayward Gallery.
www.theatreofdolls.com

Liz Adams

Liz Adams was born in Chichester in 1984. She has an MA in Creative Writing from the University of East Anglia, and her work has appeared in Iota Fiction, The Frogmore Papers, morphrog, and Stand. Her first collection of poems, Green Dobermans, was published in 2011. She lives in Devon and is currently at work on a novel.
Twitter: @LizAdamsPoet

Lucy McRobert

Lucy, First Class environmental history graduate (University of Nottingham), is a passionate naturalist, nature writer and events coordinator, committed to encouraging and engaging with a young generation of nature conservationists through her project, A Focus On Nature, which offers equipment, projects and the opportunity to interact with a diverse team of professionals to people aged 16 to 30. Lucy enjoys conveying her passion for British nature to others through writing and environmental journalism, working in conjunction with the Wildlife Trust movement, 2020Vision and New Networks for Nature. She was runner-up in the BBC Wildlife magazine 2012 Nature Writer of the Year competition.
www.afocusonnature.org.uk
lucy.mcrobert@hotmail.co.uk

Lucy Read

Lucy is a creative artist from the south west of England, having moved to Swansea to do her BA in Fine art in 2006 she is now based in South Wales. She is currently doing an MA in Contemporary Dialogues Textiles pathway at Swansea Metropolitan University, her work concentrates on the ideas comfort and nourishment using a variety of mediums.
spongemonkey22@hotmail.com

Lucy Willow

Lucy was born in 1967 in Whitstable, Kent. She lives and works in Cornwall and has exhibited widely. Her work first received acclaim with a series of Dust carpets made on location and for specific environments - Smithfield abattoir (2005), Old Romney Church (2005), Make it Real, Whitstable, Kent (2006), Art Now Cornwall, Tate St. Ives commission (2007). In 2001 Lucy won the BAMS (British Art Medal Society) award for contemporary medal making. She exhibited at the Royal Academy summer show (2002) whilst still a student. She has also shown at Newlyn Art Gallery (2005), and has had a solo show at Salt Gallery (2007). Her photographic work was presented for the first time at a solo show at Millennium Gallery, St. Ives (2009). She was selected in 2009, with seven artists representing Cornwall, to show in London in a project called Gloria to coincide with Zoo Art 2009. In 2012 she became lecturer in Fine Art Sculpture at Falmouth University.
www.lucywillow.com
www.lucywillow.org

Lucy Wilson

By reviving traditional aspects of image making, symbolism within nature forms the foundations and the soul of Lucy's work. With dramatic use of symmetry it is versatile and always a craft, featuring illustration, bookbinding, pattern, and wallpaper design. Bookbinding in particular provides a platform for her intricate but strong illustrations and typography. Practicing a contemporary style, Lucy's work still grasps the nostalgia in tradition. She believes Ruskin, who thought that to draw nature correctly you must understand, love and respect the subject for the subject to be drawn in its bare and true form. She also loves to teach and encourages bookbinding around the country.
www.elizabethsheart.com
elizabethsheart@hotmail.co.uk

Luke Pearson

Luke is a comic book artist and illustrator. His books include the Hilda series of children's comics (Hilda and The Midnight Giant, Hilda and The Bird Parade) and the 'graphic novella 'Everything We Miss.
www.lukepearson.com
thatlukeperson@gmail.com

Luke Thomas Smith

Luke studied BA Hons Printmaking at the University of Brighton where the relation between humans and birds was a long-standing subject of interest. The work produced was awarded the Santander-Abbey Award for Excellence & Achievement in Art and Design and was purchased by the Aldrich Collection. As well as exhibiting work internationally, Luke has also curated and organised exhibitions under the Arts Council's 'Art in Empty Spaces' initiative. Most recently Luke has completed a qualification in Heritage and Conversation in the Heritage Lottery Funds prodigious 'Skills for the Future Program', in association with the Whitechapel Gallery.
www.lukethomassmith.com

Lyndall Phelps

Lyndall completed her Bachelor of Education in Art, and MA's in Art and Art Administration at the College of Fine Art, Sydney. She has been living and working in England since 1999. She has had solo exhibitions in both Australia and England, including Canary Wharf, London; firstsite, Colchester; Leamington Spa Art Gallery and Museum; Milton Keynes Gallery; the Natural History Museum at Tring and University of Hertfordshire Galleries. Her work is represented in Arts Council England, East's Art Collection, Leamington Spa Art Gallery and Museum's Medicate Collection and the University of Hertfordshire Art Collection. She has created public art commissions for Arts Co, London; King's Lynn, Norfolk; the Great Eastern Hotel, London and the Wilberforce Heath Centre, Hull.
www.lyndallphelps.com

Makerie Studio aka Julie Wilkinson & Joyanne Horscroft

Julie and Joyanne are The Makerie Studio, a creative collaboration producing unique three dimensional paper sculptures for both commercial and artistic purposes. Using specialised papers and intricate detailing, they design and create structural showpieces for window installations, advertising, editorials and private collectors. Inspired by forgotten worlds, rare prints and the beauty of details, The Makerie Studio create distinctive pieces using uniquely developed techniques, precision and passion.
www.themakeriestudio.com

Malena Aballay

Malena is an Argentine artist, born in Buenos Aires in 1988. Illustrator, painter and musician, she works on album covers, posters and illustrations. She loves faces, eyes, colours and skulls and she defines her work as Crazy Anatomy.
www.malena.aballay.com

Marcelle Hanselaar

Born in Rotterdam, the Netherlands, Marcelle studied briefly at the Royal Academy of Arts in The Hague. She lives and works in London. She enjoys a close bond with the tame wild birds visiting her studio courtyard. Her work as a painter and an etcher is often quite dark. It explores the bleaker, more unsettling aspects of life coloured however by an ironic twist. She has won many international awards both in painting and printmaking and has work in many collections such as the British Museum Prints Collection; V&A Prints Collection; V&A National Art Library, Ashmolean Museum and New Hall, Cambridge.
www.marcellehanselaar.com

Marcus Oakley

Originally from Norfolk, a coastal county in England's south-east, Marcus's work is inspired by many things: both retrospective and contemporary. His influences include folky, harmonic and melodic music of all kinds; the pastoral and folkloric delights of the countryside the joys of cycling; the stimulations of tea; the dizzy geometries of architecture and design; and overall the wonders of making stuff.
www.marcusoakley.com

Margaret Atwood

Margaret was born in 1939 in Ottawa and grew up in northern Ontario, Quebec, and Toronto. She received her undergraduate

degree from Victoria College at the University of Toronto and her master's degree from Radcliffe College. Throughout her writing career, she has received numerous awards and honourary degrees. She is the author of more than fifty volumes of poetry, children's literature, fiction, and non-fiction and is perhaps best known for her novels, which include The Edible Woman (1970), The Handmaid's Tale (1983), The Robber Bride (1994), Alias Grace (1996), and The Blind Assassin, which won the prestigious Booker Prize in 2000. Atwood's dystopic novel, Oryx and Crake, was published in 2003. The Tent (mini-fictions) and Moral Disorder (short stories) both appeared in 2006. Her non-fiction book, Payback: Debt and the Shadow Side of Wealth, part of the Massey Lecture series, appeared in 2008, and The Year of the Flood, in the autumn of 2009. Ms. Atwood's work has been published in more than forty languages, including Farsi, Japanese, Turkish, Finnish, Korean, Icelandic and Estonian. She currently lives in Toronto with writer Graeme Gibson.
www.margaretatwood.ca

Mark Greco
After completing his Fine Art degree in the early 90's and training as a printmaker, Mark quickly became involved with what was then the emerging industry of 'New Media' providing illustrations for CD ROM and designing bad websites. He did, however, manage to keep the more exploratory and experimental side of his practice alive and collaborated with others on such projects as 'Ice Cream for Everyone'. In the past two years he has enjoyed a personal renaissance and switched from a largely digital practice to analogue - from where his series 'A Natural History' has been born.
www.anaturalhistory.co.uk

Matt Sewell
Artist Matt Sewell is an avid ornithologist, regular contributor to the CAUGHT BY THE RIVER website and author of the bestselling book Our Garden Birds and Our Songbirds. He has illustrated for The Guardian, The V&A, Levis and painted walls for Helly Hansen, Puma and the RSPB and exhibited in London, Manchester, Tokyo and Paris.
www.mattsewell.co.uk
info@mattsewell.co.uk

Matt Underwood
Painter and printmaker Matt Underwood studied at Salisbury College of Art and Camarthenshire College of Art. He began printmaking in 2010 after reading a book on Japanese woodblock printmaking which uses watercolour as ink, a complete contrast to his work as a painter in oil. Matt has exhibited widely including; Royal West of England Academy, Royal Academy Summer Exhibition, Medici Gallery, The Bianco Nero Gallery in Stokesley and St. Barbe Museum and Art Gallery. Matt has been a member of the Society of Wildlife Artists since 2001. His woodblock print Winter Visitors won the Birdwatch Art Award in 2010.
www.mattunderwood.info

Matthew Killick aka Mat Humphrey
Matthew Killick lives and works in London. His work for the last three years has been predominantly black and white oil paintings, inspired by diving around the UK, light refraction through water, geology and the workings of the human body. His work is now held in worldwide collections including those of Bryan Adams, Damon Albarn, Simon Fuller, Roland Mouret, Suzette Field and Viktor Wynd.
www.matthewkillick.co.uk

Matthew Otten
Matthew is currently an undergraduate at Swansea Metropolitan. His work is influenced by the natural environment. His choice of materials is carefully considered, primarily using water based inks, and experimenting with laser and water jet cutting.
mail@matthewotten.co.uk

Maxine Greer
Maxine has a first class degree in Textiles from Loughborough, has lectured in drawing at Edinburgh, Winchester and Birmingham and worked in mental health for the past ten years. Her recent work has focussed on birds. Paper sculpture, screen prints, photographs and sketches have featured in exhibitions both in the UK and abroad. Maxine's work was recently featured by Liberty. She has featured in magazines including Elle Decoration and Selvedge and was awarded the People's choice award by Peterborough City Gallery 2012.
www.maxgreerdesign.co.uk

Melanie Tomlinson
Melanie Tomlinson is an award winning artist who trained in illustration at Birmingham School of Art. She combines illustration and metal to create vibrant, intensely detailed sculptures and three dimensional dioramas that reflect her deep love and passion for nature. Her interests include the role of traditional folk narrative to explore the complex relationships between communities and the natural world. Aspects of Romanian culture find its way into her work as she has personal links with the country. "Romania is close to my heart", she confesses "and I like to step into different worlds to explore the unfamiliar and this sense of mystery and otherness."
www.melanietomlinson.co.uk

Mike O'Shaughnessy
Mike is Senior Lecturer in Graphic Design and Illustration at the Liverpool School of Art & Design / LJMU. His latest work includes Perfume & Drawing published 2013 - one of a series of personal projects around the theme of Drawing and Illustration Practice, and collaborative projects 2012-2013: Liverpool Everyman & Uniform. Illustration & Design clients have included Harper Collins / Penguin Books / The Royal Mail / Vogue / Macallan Whisky / The Observer / Sony / Static Caravan Records / Elbow V2 & Universal Music.
www.moshaughnessy.co.uk

Mike Warren
'Michael Warren has been a professional artist for forty years, specialising in paintings of birds in their natural habitats. He has been a member of The Society of Wildlife Artists since 1971. He is President of Nottinghamshire Birdwatchers. Michael is a member of ANF (Artists for Nature Foundation), a Netherlands based organisation that uses art to focus on conservation matters. He has had six books published, the most recent 'American Birding Sketchbook' (2012). He has designed postage stamps for the British Post Office and The Republic of the Marshall Islands, also conservation stamps including a series for the National Audubon Society in USA.
www.mikewarren.co.uk

Natalie Stewart
For her main practice, Natalie takes photographs of local landscapes, mainly of nature walks that are close to her home and that she is very familiar with as she has grown up exploring these areas. These images are then altered in Photoshop, so that the image isn't instantly recognisable to the viewer. The image is then projected and painted onto a canvas using oil paint. The paintings need to be viewed from a distance for the image to become clear. Natalie likes that her paintings can be viewed from two different distances and that from each distance the image is different.
natalie-stewart92@hotmail.co.uk

Neal Jones
Born in Liverpool, Blackpool raised, Neal subscribed to the RSPB magazine as a child (as well as Star Wars monthly and Smash Hits). He studied Fine Art in Canterbury before packing it in to live aboard a 1920's wooden pinnace, travel Britain in a van and survive on DIY and gardening work. He returned to painting via a year at The Prince's Drawing School, becoming a John Moore's prize-winner soon after. He now grows food organically on his allotment garden in North London and paints there daily using reclaimed skip-wood in his shed.
www.nealjones.co.uk

Nia Davies
Nia Davies is a poet and fiction writer based in London. Her pamphlet of poems will be published by Salt in autumn 2012.
Twitter: @niapolly

Nick Blinko
Nick is a British musician, lyricist, and artist best known as the lead singer, lyricist and guitar player for the British band Rudimentary Peni. He is also known for being an "outsider" artist. Nick draws intensely dense and detailed compositions of faces, figures and obsessive patterns, which at times also incorporate fragmented phrases.

Nicola Boulton
Nicola graduated from Nottingham Trent University in 2011 with a degree in Zoo Biology. During her third year at university she was thrilled and daunted when asked to write a piece for Ghosts of Gone Birds Exhibition. Trying to bring hope to the project, and add in some flare from her South American background Nicola decided to write about Fuertes Parrot. Today Nicola is stationed in the western coast of Scotland providing wildlife tours to eco tourists and in her spare time she still contributes to other multimedia conservation projects with her creative writing and artwork. Her first fully illustrated book was published in late 2012 called 'The Monkey's Fart'- a nonsense poetry book for dyslexic children and adults, like herself.
nicola_boulton@hotmail.com

Olga Brown
Olga Brown was born in Ukraine and received a MA in art and textiles from the Academy of Fine Art, Lviv, Ukraine in 1982. Since 1997 she has worked and lived in London, winning awards for her figurative works and paintings of London. Olga's works are very popular with collectors. She has exhibited successfully since 1982 taking part in exhibitions in the UK and abroad. In her works for the 'Ghosts of Gone Birds' exhibition she reflected on our responsibility to live in a harmony with nature, depicting numerous spices of extinct birds, as carnival costumes in 'Carnival' or humanoid-birds in 'Passers by'.
www.olgabrown-art.com
olga@ogabrown-art.com

Oliver Harud
Illustrator and story teller.
www.oliverharud.com

Oliver Hibert
American artist Oliver was born in Seattle, Washington in 1983. He has shown his paintings, designs and illustrations in numerous galleries, museums and retail stores around the globe. He has worked with many clients such as - Disney, MTV, Nike, Adidas, Diesel, Fender Musical Corp, BBC, The Flaming Lips, Procter & Gamble, Salomon Snowboards and Yellow Book, to name a few. Currently, he resides in Scottsdale, Arizona on his desert farm of cacti and albino peacocks.
www.oliverhibert.com

Oliver Jeffers
Oliver grew up in N.Ireland and now lives and works in Brooklyn, New York. From figurative painting, collage and installation to illustration and picture-book making, Oliver's practice takes many forms. His paintings have been exhibited in multiple cities, including the National Portrait Gallery, London and the Brooklyn Museum, New York. HarperCollins UK and Penguin USA publish his award winning picture books, now translated into over 30 languages, including the New York Times Bestsellers Stuck & This Moose Belongs to Me. Working in collaboration with Studio AKA, Oliver's second book, Lost and Found, was developed into an animated short film, which has received over sixty awards including a BAFTA. Oliver won an Emmy in 2010 for his collaborative work with video artist Mac Premo.
www.oliverjeffers.com
hello@oliverjeffers.com

Omar Fadhil Al-Sheikhly
Omar Fadhil Al-Sheikhly teaches at the Department of Biology in the University of Baghdad. He is a lecturer and wildlife expert at the Iraq Natural History Research Center and Museum, full member at the International Union of Conservation of Nature IUCN/SSC

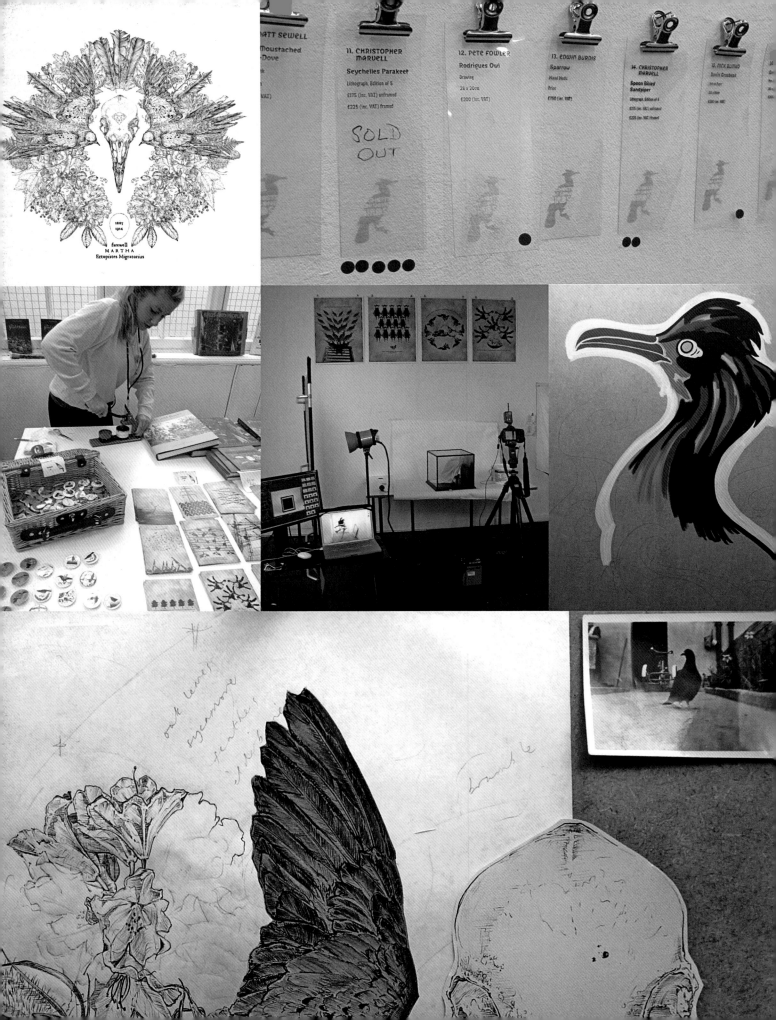

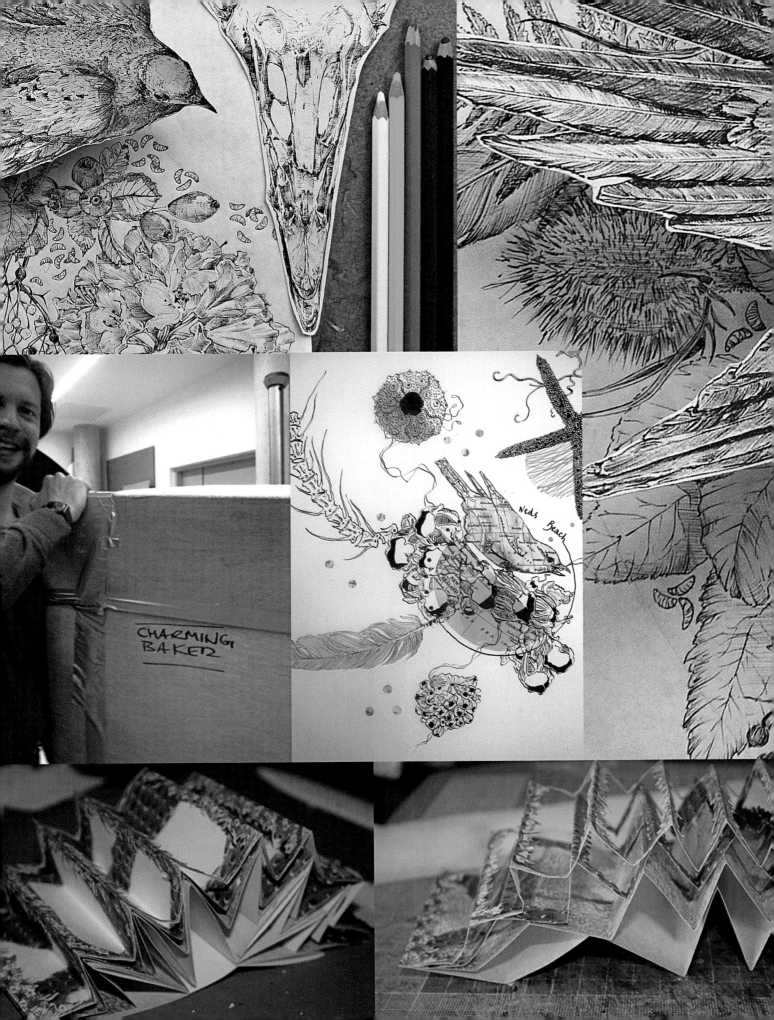

CHARMING
BAKER

Neds Beach

-Otter Specialists Group OSG. He has trained many young Iraqi biologists, working at Iraqi environmental and academic institutes and the Iraqi Ministry of Environment on wildlife field methodology. Omar has photographed most of the birds and mammals of Iraq, and published books and papers on them. He was the team leader of Nature Iraq's first field surveys in Southern Iraq (Mesopotamian Marshes - 2005-2008) and in Northern Iraq (Kurdistan Region -2007-2008). In spring 2006 he carried out the first field surveys in the western desert of Iraq in Salahadin province searching for the critically endangered Sociable Lapwing. The surveys were supervised by the Faculty of Science at the University of Baghdad. In the following year he became the project manager and senior team leader for the Sociable Lapwing surveys for the RSPB and Birdlife International overseen by Nature Iraq
alsheikhlyomar@gmail.com

Patrick StPaul
Patrick StPaul studied art sometime in the last millennium and worked for many years as an image-grinder in advertising and design, before running away to the wilderness. From a barn in Scotland he emerged dressed as some kind of shaman, with a taste for oil paint and bones. Now based in London his work is shown internationally and is in many private collections.
www.patrickstpaul.com

Dr Patricia J. Latas
Dr Pat has worked as an avian-only vet for nearly 25 years, and preached conservation and preservation of wild psittacines and their habitats for the duration. She knows these birds personally, and in the wild. She has seen wild populations diminish radically in her lifetime and knows she will witness extinction. She worked with the critically endangered kakapo and knows them personally and affectionately - and what their loss as a species would mean to her on a basic, human, emotional level. Much of her illustration work is donated to conservation efforts.
www.antshrikestudio.com
PatLatasIllustrator.com

Paul Beer
Paul was born in Wandsworth London and studied at The London College of Printing. Worked at Saatchi & Saatchi, HHCL during the 80's and 90's as a Typographer/Designer. Paul is part of the team who created the book you are now reading!
paulbeer2.blogspot.co.uk/

Paul Jepson
Dr Paul Jepson is course director of the MSc in Biodiversity, Conservation and Management at the University of Oxford. Prior to this, he held Senior Research Fellowships with the Environmental Change Institute and the Skoll Centre for Social Entrepreneurship at the Said Business School. He transferred into academia after a successful career in conservation management and policy. He consulted for a wide range of inter-governmental and non-governmental organisations and was Indonesia Programme Coordinator

for BirdLife International. He started his career as a local government countryside officer developing new urban conservation initiatives in Manchester and Shrewsbury.

Philip Hardaker
Philip was born in Harrogate in North Yorkshire in 1954. He graduated from North Staffs University in 1977 with a degree in Fine Art Sculpture. He then went to the Royal College of Art from 1977 – 1980 with an M.A in Fine Art Ceramics. He had a studio in Bruton in Somerset for 3 years before moving to Stoke on Trent in 1983 where he established his studio. He has completed hundreds of community, school, hospital and university art projects in the West Midlands area as well as creating his own private works and commissions.
www.philhardaker.co.uk

Phil Knott
British-bred, Brooklyn based photographer Phil has been producing images for well over 15 years. Rich in content and creativity, he presents a style that is beautiful, soulful and honest in its capacity to extract what is raw from his subjects. Embodying this not only in portraiture, but also in the fusion of fashion, lifestyle and music, Phil has invented a style for himself, attracting a wide range of clients including Paramount Pictures, Versace sport and fragrance, the Times, Guardian, ID, Raygun, Stool Pigeon, Atlantic Records, Universal, rca, EMI and Virgin Records. His more personal endeavours include cultural studies rooted in street culture and music, documenting the scooter boy crews in the east end and the lowrider bike culture in New York. Turing his hand to video/the moving image Phil has produced videos for the New York artist Vanessa Bley with two videos. 6 years ago he started to get into art work, inspired by the paper art that adorns the walls and streets in New York, working for clients such as Nike, Stussy, Flaunt, and Complex. The natural shift into art direction lead to the production of his art newspaper titled tally ho. Phil continues to diversify the range of his portraits from Justin Timberlake ,50 cents, David Gray, Jude Law, Christian Bale, Clive Owen, Sienna Miller, Jonathan Rhys Meyers, Piper Perabo.
www.philknott.com

Piers Mason
Piers trained as a painter exhibiting in London, Barcelona, and Nairobi. A few years ago he discovered welding and got a bit carried away: he found a way to combine his conceptual ideas with a new found appreciation of 3-Dimensional form, endangered animals inspired from his time in Africa, and a new medium. Piers' lack of formal training in metal has led him to develop some unique techniques. So he finds himself embarking on a new journey, attempting to unite traditional sculptural forms with scientific, religious/spiritual and conceptual philosophies.
www.piersmason.co

Polly Morgan
Polly Morgan was born in Banbury, Oxfordshire

in 1980. In 1998 she moved to East London to read English Literature at London University. As an undergraduate she became acquainted with many prominent artists working in the area, and inspired by their example she took up taxidermy and began making sculptural work in 2004. Having studied with Scottish taxidermist George Jamieson, Morgan began to play with and dismantle taxidermy traditions, creating sculptures that brought her work to the attention of many notable collectors and curators both in Britain and internationally.
www.pollymorgan.co.uk

Rachel Lovatt
Rachel worked as a textile designer before making the decision to concentrate on her own art, the craft influence still weaves its way into her pieces. She employs mixed media techniques, a combination of obsessive pattern, fragile drawing, collage and stitch to create her visual language. Story telling is at the heart of her practice, each of her pieces have a narrative often influenced by folk tale, myth or fable. She likes to create ethereal creatures mixing collage and drawing together. She invites both adults and children to lose themselves in the other worlds she creates. She completed her MA in book illustration at the Cambridge School of Art in 2011.
www.lovattcloud9.blogspot.com
Twitter: @Lovattcloud9

Rebecca Fenton
Rebecca Fenton is the founder of wordPLAY London, a spoken word night which champions the virtues of great writing, with an emphasis on literature's rising stars. Herself a performance poet whose day job revolves around audiobooks, Rebecca has had a lifelong obsession with storytelling. For this she thanks her late Grandfather, Leonard Burchill, and his wonderful bedtime yarns.
Twitter: @wordplayLondon

Rebecca Foster
Rebecca studied at Central St Martins and Wimbledon School of Art. She is interested in ideas of beauty, unusual juxtapositions of images and repetition of form. She works in drawing, painting, film and photography and these mediums often overlap within her work. Alongside working as an artist her background is in producing, art directing, graphic design and prop making on a number of feature films, commercials and TV programmes. She was BAFTA nominated for her work on the children's art programme SMart and has exhibited internationally.
www.beccafoster.co.uk
Twitter: @rebeccafosterart

Rebecca Jewell
Rebecca's work is based on careful observational drawing as a way of seeing, recording, investigating and analysing. During her time at the Royal College of Art she worked mainly in watercolour, drawing bird skins at the Natural History Museum and ethnographic artefacts made from feathers at the British Museum. Her interest in feather artefacts stems from a year spent living in the High-

lands of Papua New Guinea (in 1982) and subsequently studying social anthropology at Cambridge University. Rebecca is artist in residence at the British Museum, Department of Africa, Oceania and the Americas (AOA). From 2005-2010 she was part of a research group at the British Museum working on the relatively little-known Melanesian collections. Rebecca's work is about exploring the shared histories between the people that made these artefacts, the explorers, anthropologists and travellers that obtained them and the museum that now houses them. In storage the object is numbered, labelled, catalogued, photographed and measured; yet its aesthetic qualities can still be appreciated.
www.rebeccajewell.com

Rebecca Jones
Rebecca did her Art Foundation course at Hereford College of Arts. She is currently studying General Illustration at Swansea Metropolitan University. Growing up in the atmospheric surroundings of the Black Mountains, Wales, the magic that ran through the hills flowed through to her fingertips and was soon applied to paper via brush strokes of watercolour and pencil markings.
www.rebeccakateart.wix.com/illustration

Richard Crawford
Richard studied Art at Hornsey College of art in the 1960's and has practiced as an artist and art educator since then. He has exhibited widely. Since the 1970's he has rented SPACE studios; his current studio in Stoke Newington, where he lives. On his MA course at City & Guilds he started making birds out of plastic, bringing together two lifelong interests: birds and art. Richard makes displays that present birds in certain ways; as both beautiful, threatened and threatening. He is interested in museum displays and the way in which the form of display frames the meaning of the subject.
richard.elaine18@gmail.com

Rob Lambert
Academic, naturalist, broadcaster, expedition ship lecturer. Dr Rob Lambert is a multi-disciplinary academic at the University of Nottingham, working in environmental history and tourism & the environment. He holds a MA (Hons) in Modern History and a PhD in Environmental History from the University of St. Andrews in Scotland. From 1998-2000 he held a Leverhulme Research Fellowship at St Andrews in the field of British environmental history studying the historical relationships between grey seals and people. Rob is also Senior Honorary Research Fellow at the University of Western Australia where he delivered the prestigious Alexander Lecture in 2006, taking as his theme 'Contested Nature in the modern British countryside'. He is a very keen British and global birdwatcher and cetacean-watcher, with around 30 years of field experience, and is passionate about showing people wildlife. Rob lives in Long Clawson in Leicestershire, regularly watching birds at Rutland Water and Eyebrook Reservoir, and has attended the British Birdwatching Fair at Rutland Water

for many years, the past few years as part of the Events Marquee team. Rob is Vice-President of the Isles of Scilly Wildlife Trust, and one of the national Ambassadors for the wider Wildlife Trusts movement.
robert.lambert@nottingham.ac.uk

Rob Ryan
Rob was born in 1962 in Akrotiri, Cyprus. He studied Fine Art at Trent Polytechnic and at the Royal College of Art, London where he specialised in Printmaking. Rob is mostly known for his intricate papercuts which he has been creating since 2002. These delicate hand-cut works consist of a single sheet of paper and can take anything from 1-200+ hours to make. These papercuts are then used to produce screenprints and often adorn other items such as; book jackets, ceramics, fabrics and more recently wallpaper. In addition to his own projects, Rob has collaborated with many prestigious names such as Paul Smith, Lulu Guinness, Liberty of London and Vogue. His work has been described as 'Romantic, yearning and wistful' And he himself explains that his works are 'Tiny worlds of meaning and mystery'. Recent exhibitions have included "The Stars Shine All Day Too" at London's Air Gallery. An exhibition of papercuts and ceramics at Charleston Gallery, East Sussex and a solo exhibition at SOHOTEL Artspace Gallery, New York.
www.misterrob.co.uk

Robert Gillmor
Robert Gillmor started his long career as an illustrator at the age of 15, with drawings for the monthly magazine British Birds. He illustrated the first of over 150 books in 1958 while an Art student at Reading University. He was a Founder Member and later President of the Society of Wildlife Artists. In 1966 he was appointed Art Editor of the 9 volume "Birds of the Western Palearctic". After moving to North Norfolk in 1998 he concentrated on printmaking and designing book jackets, including the Collins "New Naturalist" series. In 2010/11 he designed 42 stamps for Royal Mail's Post & Go service.
robert.gillmor@googlemail.com

Robert Ramsden
Rob illustrates and animates, weaving a host of activities into a variety of images which sometimes move and sometimes do not. Illustration and animation are loose terms for what he does as he draws, builds, digitises, writes, prints, paints his way through commissions and fanciful projects. For the 'Ghosts of Gone Birds' project Rob started to use water colour, in fact wrestling with water colour is what he'd call it, and this is fairly typical of how he goes about illustrating and animating. Rob is currently producing artwork for children's picture books.
www.robertramsden.co.uk

Rose Alexandra Forshall
Rose grew up in rural France and returned to England to study illustration at University College Falmouth. In 2009 she was awarded a grant from The Queen Elizabeth Scholarship Trust to further her studies. She received her masters in 2011. She currently lives in Cornwall and works as an illustrator/print-maker. Her work explores new directions in printmaking and the presentation of illustration in unusual contexts. RoseI loves the sea.
www.roseforshall.com

Roy Kelf
Roy likes to work with materials or objects that he considers ordinary or plain, like paper, wire, sticky tape, flour, water, cardboard - and combine them. He often uses bird imagery when he paints and sculpts to carry his ideas. He completed a degree course in printmaking at the University of Brighton in 1996 and studied at Duncan of Jordonstone University in Dundee for a Masters in Fine Art. Since leaving university he has worked with people with learning disabilities as an art and crafts instructor for West Sussex county council, presenting students work for exhibition. He has now returned to his own practice.
roykelf66@aol.co.uk

Roy Wright
Roy Wright was born in Hornsea, East Yorkshire and went to Hull College of Art and Design. He works mainly in charcoal and specialises in drawings of natural forms such as trees and landscapes as well as large, detailed cityscapes. His work has appeared in numerous group shows and art fairs around the world. He had his first solo exhibition in 2010 and a two-person show in 2011, both at the Rebecca Hossack Gallery in London. He has won many awards including the Royal Academy Summer Exhibition Drawing Award in 2001 and was recently shortlisted for the John Ruskin Prize - A New Look at Nature (2012).
www.roywright.co.uk
info@roywright.co.uk

Russell Maurice
Russell's early works were rooted in romanticism, exploring the themes of energy, growth patterns, shape, diversity and cycles in the natural world. The central focus of these works was the relationship between modern society and nature. His work is now concerned with the more metaphysical aspects of these themes, particularly the spirit world, concepts of ghosting and theories on the afterlife. Analyzing what form a spirit could take, and what forms are generally accepted to represent them in culture, objectifying the non-solid. The imagery used is indexical; some works are using the way in which Alchemy is recorded, conveying information in a method that hides the answer, adding to the already present ambiguity. His body of work holds an abstract narrative with a presence of the phantasmal which indicates a desire to re-enchant or mythologize contemporary reality.
www.russellmaurice.com

Sarah Day
Sarah lives in London, where she works as a science writer. She is currently working on a novel based on the final voyage of Vitus Bering, inspired by the Ghosts of Gone Birds project.
Twitter: @geowriter

Sam Warden
Illustrator currently studying at The Arts University College at Bournemouth.
3263407@live.aucb.ac.uk

Sergio Fernandez Gallardo
As a graphic designer, Sergio has a passion for taking data and information and using it to form beautiful info-graphics for clients such as IBM, Kaplan, the Mayor of London, OgilvyOne and The Guardian. Gallardo's work extends beyond info-graphics to print design and even packaging.
www.sfgdesign.com

Showchicken aka Nick Sheehy
Nick Sheehy is an Australian-born artist and illustrator living in the south-east of England. After studying bronze sculpture in the wilds of Tasmania, Nick gave up on art only to re-discover his love of drawing whilst living in London, sparked by an interest in the city's low brow art, illustration, street art and graffiti. In his work, Nick explores the dreamlike, sometimes semi-autobiographical scenes and oddball characters that echo from his childhood imagination. Employing a laborious technique, building up layers of texture and thin colour, his work infuses precision and attention to detail with random abstraction and clumsiness. He enjoys drawing various weird things for himself, exhibitions, publications and occasionally the odd client.
www.showchicken.com

Si Scott
Si's renowned for his unique style, blending hand-crafted and hand-drawn artwork that has gained him numerous awards and a prestigious client list. So far in his career he has completed projects for Matthew Williamson, Vogue, Nike, Tiffany & Co and Sony to name a few. Si has recently taken time out to develop his skills further. Challenging the 2D perspective of his work by rendering his hand drawn creations in 3D form. A visiting lecturer at Leeds College of Art & Design on the 3rd year BA Hons degree in Visual Communications, Si has given talks and exhibited his work at institutions in cities around the world including Tokyo, New York, Brazil and Sydney.
www.siscottstudio.com

Sian Jenkins
Sian passed with Merit on an art foundation course at the University of Glamorgan before joining Swansea Metropolitan University, where she is currently in her second year of study. Sian created her own business in 2011, Cuteez Gifts, selling items that she had designed. This also involved designing her own website. This business has since led her to several commissions. Recent work involves designing and creating advertising posters for a small local business.
www.cuteezgifts.weebly.com

Stacey Jones
Stacey graduated with a first degree in illustration from Northampton University in the summer and has always been interested in illustrating animals. She began experimenting with paper cuts in her second year of university and has loved it ever since. She juxtaposes the handmade quality of a paper cut with the digital feel of using the light box and acetate to colour each piece. Her work is graphic as well as decorative.
staceyjonesillustration@hotmail.co.uk

Stephen Melton
Stephen lives and works between Ramsgate and London. Graduating from Camberwell College of Art and then the Royal College of Art, he then worked for Eduardo Paolozzi as one of his personal sculptors. After teaching for 15 years within higher education, he now runs the fine art production studios, Meltdowns. Stephen produces sculpture and installations in mixed media, from bronze to resins and found objects. He has long had an interest in ecology and man's relationship with the natural world, and each series of work investigates a particular idea or scientific investigation. This has lead to public commissions around the UK and his work can be found in many private collections.
www.meltdowns.co.uk

Stuart Whitton
Stuart Whitton is a rising Welsh freelance illustrator and visual artist based in London who enjoys nothing more than creating imagery for personal and commercial clients globally. An advocate of the traditional, he utilises media to create meticulously hand drawn ethereal illustrations, many of which have been included in international publications and exhibitions. With a growing client list and ongoing projects Stuart is focused on making his artwork known to the world.
www.stuartwhitton.co.uk

Su Blackwell
Su gained an MA in Textiles at the Royal College of Art in London in 2003. She works predominantly with paper, and in particular, with second-hand books, which she cuts, folds, and sculpts. Blackwell finds her books while browsing through second-hand book shops. The books inspire the work. Often Blackwell is drawn towards books of Flora, Fauna, Ornithology, Fairy Tales and Folklore. Her works are displayed in wooden boxes, with lights inside. The tools used for making her book-sculptures are simple; she uses a craft-knife, cutting mat, and glue. The emphasis is not on illustration, but rather a conceptual response to, or interpretations of, stories, characters and texts. Her work includes advertising campaigns for Cartier, Crabtree and Evelyn, and Kenzo, and illustrations for magazines such as Vogue, Tatler and Harper's Bazaar.
www.sublackwell.co.uk

Suky Best
Suky is an artist based in London. Working with print, animation and installation, she has exhibited nationally and internationally. She has shown at the Baltic Gateshead & Art Now Lightbox at Tate Britain and has had solo exhibitions and publications, including The Return of the Native. Commissioned works include, Early Birds for Animate Projects and Channel 4, About Running for

The Great North Run, Stone Voices, for the Devils Glen in Ireland, From the Archive, for University College Hospital London and Horses For Great Ormond Street Hospital. She is in the final stages of an MPhil research degree at the Royal College of Art London investigating relationships between birds and film.
www.sukybest.com

Susan Evans
Susan is a graduate of Swansea Metropolitan University. Whilst working as a freelance, commission-based illustrator she decided to return to university to also study for the MA in Visual Communication. She works in mixed media, spray paint, acrylic and whatever else makes the right mark!
sueevans1008@hotmail.co.uk

Susie Wright
Susie Wright is an illustrator and printmaker based in Edinburgh, Scotland. Susie studied at Edinburgh College of Art and Central Saint Martins, graduating from the MA Communication Design course in 2006. Susie's work is inspired by her Scottish heritage, natural history, architecture and geography. She creates new landscapes from places where she has drawn on location, photographed and researched. Her illustration often features Scottish wildlife, as a reaction to missing Scotland when living in London for a number of years. Susie's distinctive style of illustration has developed from working with screen printing and an interest in architectural imagery.
www.susiewright.co.uk

Tiffany Lynch
Tiffany studied at St. Martins School of Art and Design, freelanced and worked in-house in London. After travels in India and Nepal, she decided to move to Brighton and started up an art co-operative – Studio Greenhouse with nine other artists, where she worked for the past nine years. She has shown paintings in many group shows - The Summer Exhibition, The London Group, RCA, The Mall Galleries, Battersea, Chelsea, Brighton Art fairs, Brighton Open House festival. She has had work published by John Lewis Publishing, Virago press, Camden Graphics, Magma Publishing, Penguin, Coast Magazine, Woodmansterne Publishing and Paperchase.
www.tiffanylynch.co.uk

Tim Birkhead
Tim is a professor of animal behaviour and evolution at the University of Sheffield and has studied guillemots and other auks throughout his entire career.
www.sheffield.ac.uk/aps/staff/acadstaff/birkhead

Tim Dee
Tim is the author of The Running Sky and co-editor of The Poetry of Birds. He is writing a book about four fields around the world.

Tom Barwick
In 1996 Tom set up an illustration practice in London. Tackling mainly editorial and design based briefs he worked in several key areas of illustrative practice, Portraiture, Fashion Illustration, Life-style, Music Packaging, Skateboard Design, Comic Books, Interiors and Architecture. His practice straddles an eclectic skillset, from innovative digital image making through to traditional materials such as reed pen, bamboo pen, graphite black ink. Often working with a hybrid of all of the above. This diversity is all underpinned by a central interest in drawing in all its many forms. From academic life-drawing and anatomical study, to bold explorations of the subconscious, that can be used to generate imagery that communicates in powerful, fresh and enlightening ways. The aim? To seek a shared vision (Finis Aspectus) between illustrator and client.
www.thomasbarwick.com

Tony Husband
Tony husband is an award winning cartoonist with over 15 awards to his name. He has worked for Private Eye, The Times, The Sunday Express, The Sun, Playboy, Punch and many more. He has had over 30 books published including a book for the EIA to support their campaign to save the Rhino. Other things he has done include co-devising and editing Oink comic, co-creating and writing children's TV programme Round the Bend. A play he co-wrote with David Wood toured the country and he tours the country with poet Ian McMillan with their cartoon and poetry show. He has worked with the EIA on a number of projects and feels passionately about the preservation of endangered species.
www.tonyhusband.co.uk
cartoons@tonyhusband.co.uk

Tracy Thompson
Tracy has always worked in Art/Conservation and ecology. She combined science and art as an MA at the RCA specialising in natural history illustration. Having lived in Yemen for four years, she went on to do a PhD at the RCA in 1990 looking at the human ecosystem using the city of San'a, Yemen as a visual metaphor. Questioning specialisation, she explored pattern similarities between cities, cells and malignancy, connecting to both philosophy and psychology. Currently her work involves owning and living in an 1838 workhouse within thirty acres of conservation land on the West Wales coast. The building and land are her "canvas". She draws and paints on the walls and in surrounding landscapes. People book to stay in her three dimensional continually evolving collaged fresco artwork.
tracy.thompson@smu.ac.uk

Victoria Billett
Victoria is a third year illustration student at Swansea metropolitan university, inspired by nature and the world around her. She is a firm believer in traditional methods and likes to work in mixed media. Fabric, inks and watercolours tend to be reached for frequently but she does not like to limit herself. She relishes any excuse to make a painterly mess!
monkeylava@hotmail.com

Victoria Foster aka The AviaryVictoria Foster is an illustrator and designer-maker with a background in contemporary fine art practice. She lives and works between fields and a forest in South East England. Fascinated by the seemingly ordinary; beauty found in the everyday and the overlooked, work often references rural environments, familiar objects from domestic life, snippets of history, half-truths and folklore. Her intricately drawn pieces employ repetition, layering, collage and abstraction, often suggesting a gentle sadness at the passing of things. Victoria also runs The Aviary, a small creative business specializing in illustrated jewelry, accessories and keepsakes made from vintage ephemera, breathing new life into once-loved items.
www.the-aviary.co.uk

Vicki Turner
Vicki is an Art Director, Designer and Illustrator. She lives and work in Lewes, East Sussex, whilst working with clients worldwide. She believes in courageous design that instils stories, truth and character to products and brands. Solving problems holistically and with purpose. She loves to dream, do, run, bird-spot and travel. She co-founded and creatively directed the playful design studio Supafrank before leaving in 2013 to travel the Far East. Her work has been exhibited at the London Design Festival, Clerkenwell Design Week, Vitra and The Onca Gallery. And published in: Design Week, Digital Arts, The Telegraph, Elle Deco, Living Etc, Grand Designs, Working Title's Designlicious, Homes and Gardens, Woonideeën and Remedy Magazine.
http://www.vicki-turner.com
info@vicki-turner.com

Viktor Wynd
Viktor is a multidisciplinary artist working in the fields of installation and relational aesthetics, often creating and manipulating vast and elaborate subversive social situations involving casts of up to 200 performers and many thousands of participants. He read History at London's School of Oriental & African Studies specialising in the Medieval Islamic Middle East under David Morgan, G.R.Hawting & Colin Heywood, then took a foundation course in art and design at the John Cass before being awarded the Rosenquist Fellowship in Fine Art and pursuing a M.F.A. at the University of South Florida. Whilst living in Florida he produced three elaborate installations in Miami Galleries before moving to London where he has worked extensively with social structures. The basis of much of his work is draughtsmanship and poetry and he considers himself a novelist manqué with an inherent interest in narrative structures with his projects always planned as books. Much of the work is to do with the absurdity, pathos, misery and pointlessness of everyday life. There was originally a deep quest to understand the world, to see some sort of meaning in the chaos. Since probably abandoned. As Viktor Wynd he has also become an Impresario, Collector, Dealer & Curator.
www.viktorwynd.org

You Byun
Artist, Author, Illustrator You was born in Queens, New York, and received her MFA from the School of Visual Arts in NYC. Her illustrative storytelling is achieved through delicate details with rich colours, patterns and decorative ornaments. Her work has been recognized by various awards, magazines and competitions, including Society of Illustrators, Communication Arts, Ai-Ap amd SCBWI (winning both Grand Prize and Tomie DePaola Award). She now lives in Brooklyn, New York and works on advertisement and editorial assignments, gallery pieces, books, and stationery products. Her first picture book Dream Friends was published by Penguin Books in 2013.
www.youbyun.com
www.twitter.com/youbyun
www.youbyun.tumblr.com -

BLOOD, SWEAT & THANKS

To all those who made it happen.

For GHOSTS EVERYTHING:

Peter Hodgson

Pierre Humeau

Paul Beer

Arita Celma

Efrem Yamamoto de Paiva

John Fanshawe

Tim Fennel

Ceri Levy

For GHOSTS LIVERPOOL:

Mike O'Shaughnessy
@ Liverpool School of Art & Design

Dr Clem Fisher

Jim Wardill @ RSPB

Jimi Goodwin & The Bird Effect
Ensemble.

John Barlow, Lucy Willow,

Paul Jepson & Rob Lambert

Mik Handa

For GHOSTS LONDON:

Mike Carney & Paddy Gould
@ The Rochelle School

Jeff Barrett @ Caught By The River

Kirsten Canning &

Michael Barrett @ The Press Office

Dario Illari, Ellie Phillips,

Matthew Rich

& Adam Bridgland @ Jealous Studios

Frances Cowdry, Jackie Ankelen

Stan Gruel

Andrew Rutland, Gill Foot,

Jackie Hodgson & Gail Dooley

Luke Sapsed @ Brockman's Gin

Tristan Reid

Etienne Pansegrauw

Jason Morais

Oliver Caruthers @ Rich Mix

Jon Scott @ Measure

Hattie, Tilly and Noah Aldhous

Pierre and Nancy Humeau-Wieringa

For GHOSTS BRIGHTON:

Laura Coleman @ ONCA

Deborah Moon @ Moonko

Tamara Fletcher

Monica Rennie

Fanny Wobmann-Richard

Jessie Jermyn

Rebecca Fenton @ wordPlay London

Alice Clayton

Francesca Sears,

Adrian Evans & Harry Hardie @ Panos

Persephone Pearl & Feral Theatre

Joanna Coleman

Petr Eurik Gilar

The Brighton Therapy Centre

Chris Hill

Charles Degenne

Thibaut Degenne

For GHOSTS SWANSEA:

Derek Bainton @ Swansea
Metropolitan

James Davies, Glen Sherwood

Alan Bower & Sarah Tierney

Jonathan Johns & Jane James
@ Swansea Spirit

Tracy Thompson

Chris Harrendence & Lee Court

VaroomLab

Ade Long, Martin Fowlie

& Jim Lawrence
@ BirdLife International

Photo Credits All photos

© Chris Aldhous

© Noah Aldhous

© Stan Gruel

© Arita Celma

© Alison Stolwood

© Laura Coleman

© Emily Dennison

© Charles Degenne

© Sonja Niemeier

- unless otherwise stated.

Collecting Ghosts

To own an original Ghosts artwork,

***signed limited edition print or
one of 25 box sets,***

go to our online shop at

www.ghostsofgonebirds.com

Or contact us at

gonebirds@goodpilot.co.uk

A percentage of all profits from sales goes to supporting frontline conservation projects selected in conjunction with BirdLife International.

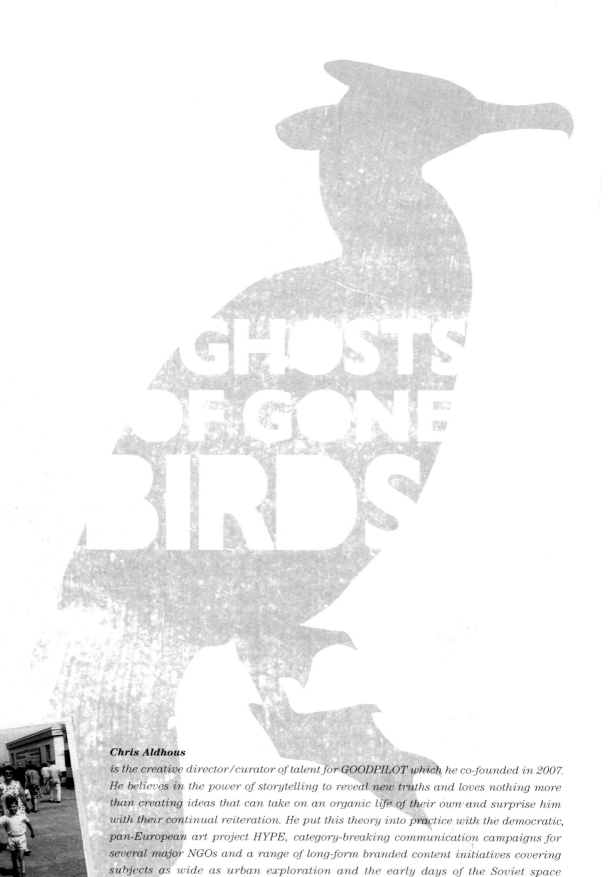

Chris Aldhous

is the creative director/curator of talent for GOODPILOT which he co-founded in 2007. He believes in the power of storytelling to reveal new truths and loves nothing more than creating ideas that can take on an organic life of their own and surprise him with their continual reiteration. He put this theory into practice with the democratic, pan-European art project HYPE, category-breaking communication campaigns for several major NGOs and a range of long-form branded content initiatives covering subjects as wide as urban exploration and the early days of the Soviet space programme. He part-traces his idea for Ghosts of Gone Birds back to summer holidays spent with his grandfather, birdwatching along the Norfolk coast.